THE ELEMENTS OF PHOTOGRAPHY

SECOND EDITION

Understanding and Creating Sophisticated Images

ANGELA FARIS BELT

ELSEVIER

AMSTERDAM • BOSTON • HEIDELBERG • LONDON
NEW YORK • OXFORD • PARIS • SAN DIEGO
SAN FRANCISCO • SINGAPORE • SYDNEY • TOKYO

Focal Press is an imprint of Elsevier

Focal
Press

Focal Press is an imprint of Elsevier

225 Wyman Street, Waltham, MA 02451, USA

The Boulevard, Langford Lane, Kidlington, Oxford, OX5 1GB, UK

Notices

Knowledge and best practice in this field are constantly changing. As new research and experience broaden our understanding, changes in research methods, professional practices, or medical treatment may become necessary.

Practitioners and researchers must always rely on their own experience and knowledge in evaluating and using any information, methods, compounds, or experiments described herein. In using such information or methods they should be mindful of their own safety and the safety of others, including parties for whom they have a professional responsibility.

To the fullest extent of the law, neither the Publisher nor the authors, contributors, or editors, assume any liability for any injury and/or damage to persons or property as a matter of products liability, negligence or otherwise, or from any use or operation of any methods, products, instructions, or ideas contained in the material herein.

Library of Congress Cataloging-in-Publication Data

Faris-Belt, Angela.

 The elements of photography : understanding and creating sophisticated images / Angela Faris Belt. — 2nd ed.

 p. cm.

 ISBN 978-0-240-81515-2 (pbk.)

 1. Composition (Photography) 2. Visual perception. 3. Photographs. I. Title.

 TR179.F37 2011

 770—dc23

 2011018513

British Library Cataloguing-in-Publication Data

A catalogue record for this book is available from the British Library.

ISBN: 978-0-240-81515-2

For information on all Focal Press publications visit our website at www.elsevierdirect.com

12 13 14 15 16 5 4 3 2 1

Printed in China

Contents

"Photography" is a *big* word. I wonder if Sir John Herschel could have imagined that the term would grow to encompass such a vast range of uses, processes, media, and *intentions* when he popularized it in 1839. From the beginning, our beloved "painting with light" was diverse and ever changing, and it has grown into a spectrum that spans art, documentary, family snapshots, advertising, pornography, scientific research, and a thousand gradations and variations in between. It includes nearly a hundred distinct photographic processes (so far!), ranging from daguerreotype to Hipstamatic, and is presented on an impossibly wide array of media and substrates, including glass, metal, paper, and LCD, to name just a few.

So how do we make sense of all this potentiality? How do we provide an effective framework for photographers to investigate these worlds without getting lost or distracted by photographic "politics"? Why debate the virtue of one technique over another—daguerreotype versus ambrotype, platinum print versus silver, film versus digital—when the real question is, how can we learn to use the camera as what Minor White called "a metamorphosing machine"? How do we make images that take advantage of the elegant and universally understood visual syntax we share as humans to create something beautiful—such as songs, poems, and stories in photographs—or show others things we have seen, or manifest our dreams on paper?

You teach people to fish. I love this book because it gets us thinking about "why to" rather than "how to." Naturally, the book includes plenty of practical information (and wonderful examples to illustrate the text), but more important, it delves into the *thinking process* that underlies the making of all good photographs. By emphasizing four immutable elements, derived from and rooted in the biological hard wiring of human perception, *The Elements of Photography* provides a timeless structure—a practical framework for exploring photography, regardless of process

or technique. This book not only accommodates but also embraces the fact that cameras, darkrooms, and software are constantly changing, so step-by-step tutorials inevitably fail. Understanding how to redirect attention with light, focus, and geometry, however, is a completely non-version-specific form of visual alchemy.

Angela Faris Belt has done a beautiful job of providing workable instructions for practicing this kind of photographic magic by distilling more than a century of hard-won photographic wisdom into a couple of hundred pages. She focuses, literally, on the big picture: teaching photographers how to analyze and deconstruct the building blocks of photographs in order to develop the critical skills necessary to evaluate and improve their work, and find their own style. She provides a starting point for exploring pictures, and a way for photographers to begin to train themselves to see each successful or unsuccessful picture as the result of numerous distinct and conscious choices, rather than a single intuitive leap. It has taken me the better part of three decades to understand what it means for a picture to work on every level—why some pictures are great, while others "almost" work. This book expedites that process by helping photographers figure out what, exactly, might be missing from their pictures, and what to do about it. Once we understand that, the sky's the limit.

Jean Miele

ACKNOWLEDGMENTS

Several years of more and less tangible work go into writing a book, and many people played significant roles in this book's creation; I offer my sincere gratitude to them here. To my father, James Michael Faris, and to my mother, Charlene Brown Faris, who taught me by example the importance of discipline and hard work, and who nurtured my dreams unconditionally. For your years of belief and encouragement and for sharing the gift of your lives with me, I acknowledge my family, Jim Faris, Mary Stine, and Ahndrea Pett, and the few I call friend, in particular Rachel Paul, Greg Marion, and Dennie Eagleson; and my mentor, Sean Wilkinson. To Randy Wolf, my dear friend from our first conversation about cats and dogs, who departed this world in 2011, for demonstrating the true meaning of courage and reminding me that life is lived in the moment. Heartfelt thanks to three wonderful spirits—Angie Buckley, Jill Mott, and Elaine Blackmer—for your wisdom, faith, and honest reflection during the past few years.

Most humble thanks to all of the photographer-artists and photography contributors to this book; your amazing works are more telling of the nature of photography's depth and power than my words could ever be.

Thanks to Frank Varney and to my students and colleagues at the Art Institute of Colorado for your patience while I once again diverted time and energy to revising this book. Thank you also to three fabulous women, Cara Anderson, Stacey Walker, and Laura Aberle, and all involved in production at Focal Press for your dedication to quality photography publications and patient assistance in the difficult task of preparing them.

Most important, my undying love and gratitude to my husband Dave, for your support and encouragement, for sharing the depth of your wisdom and being, and for your eagerness to explore, understand, and embrace the Universe from which we came and to which we will finally return.

> ONE FACT THAT IS NOT IN DISPUTE IS THAT THERE IS A...GULF BETWEEN ART AND COMMERCIAL PHOTOGRAPHY, BETWEEN PROFESSORS AND PROFESSIONALS.
> —BILL JAY FROM *OCCAM'S RAZOR*

I began the first edition with a discussion of the dichotomy existing between commercial and fine art photographic practices. (Although commercial photographers are commonly referred to as "professional photographers," I avoid the term because both commercial and fine art photographers are professionals in the field.) The response was notably mixed among educators, commercial photographers, fine artists, and students, at times turning into impassioned polarized debate. Much of the debate centered on how photographic practices are defined and what I meant by "fine art." I decided I hadn't provided clear distinctions in the first edition, so I'll attempt to do so here.

Consider this: commercial photography can be defined as *any work created with commerce as its primary goal* (hence the shared root word). This includes most photography from advertising to editorial, consumer portraits to high fashion, architecture to public relations, and corporate and decorative art made to adorn public and private spaces. Under this definition, commercial photographers are like prose writers—their work has commercial or functional value in society. Commercial photography has direct, tangible economic value; its purpose in many ways is to provide images for its intended contribution to society. Fine art photography, on the other hand, can be defined as *any work created with poetic, self-expressive, research, or innovative use of visual language as its primary goal*. This includes most museum, academic, and documentary photography. Under this definition, fine artists are like their academic and research counterparts in any other field, but whereas these researchers express their theses', findings, and

IMAGE © ANGELA FARIS BELT, *Found (Some While Different)*, 2009.

conclusions using written language, fine artists express them using visual language. The purpose of fine art, like other research, is to increase our knowledge, to promote positive social change, and to contribute to humankind's collective growth, understanding, and wisdom. As such, the commercial value of fine art photography is often secondary, although many fine artists can and do profit from their work through display in galleries and museums, and through commercial and editorial use gained by marketing.

Unfortunately, the commercial versus fine art dichotomy is perpetuated via the historically prevalent model of photography education; and while the exception is becoming more the rule, many educators still advocate one discipline's value over others. I believe that hierarchical positions regarding fine art and commercial photographic practices are detrimental to students' success, but I want to take a moment to clarify my position for those who feel my critique is too harsh.

I'll begin by stating that I don't advocate abandoning programs or curricula that adhere to a single, specific discipline. Photography encompasses a vast field of practices, and as such a range of educational philosophies helps to maintain a healthy and diverse professional dialogue; this includes concentrated programs of study whose goal is to graduate students with specific expertise. Second, I'll state that this book is for the entire range of photography practitioners, and although photographic language is based on technical attributes that *all* camera-made images share, there are some practices I don't discuss. Specifically, in scientific, biomedical, and forensic fields, objectivity supersedes any commercial, expressive, or subjective use of the medium. This is true for photojournalism as well, although enlightening, expressive, highly emotive photojournalistic and scientific images are made every day in which degrees of objectivity are maintained.

The commercial versus fine art definitions can be illustrated through an analogy of two types of written language: prose and literature. Just like uses for photographs, there are a multitude of uses for written language. If, for instance, I need a technical manual to help me operate a piece of machinery, then I don't want it written in poetic form. I don't want to learn about its history or potential existential meaning. I need the manual's author to use straightforward language, and I need the information to be clearly delineated so that I can use and troubleshoot the machine. Similarly, if I want to read a biography of the historical figure who invented said machine, I don't want the author to embellish about the

inventor's life; I want to trust in the accuracy of the author's written word so that I have a clear picture of the inventor and perhaps draw my own conclusions about her. On the other hand literature, a novel or poem, say, written about the same inventor, could be characterized by its imaginative, metaphoric, or inventive use of the same language applied to the author's research and interpretation. I might read said literature for enjoyment or to enlighten my understanding of the nature of invention, machines, or anything the writer related to the inventor. All types of written language—from technical manuals to biographies to literature—are constructed using the same grammatical rules and the same vocabulary, but each serves its own purpose in the world. There is no hierarchical structure; they simply serve to achieve different goals. This analogy is good to keep in mind when referring to photographic practices.

The observation that throughout photography's history practitioners have been segregated into commercial or fine art practices is not new. Since the medium's invention, photographers have taken great pride in their type of practice, to the point of disavowing contributions made by photographers on "the other side of the aisle." But in the 21st century, where the odds of success necessitate that photographers diversify their practice to ever greatening degrees, the dichotomy is becoming increasingly detrimental. The constant dissemination of innumerable images via the Internet and social media, film and television, print media and advertising, galleries and arts organizations, as well as an increasingly global culture has created a generation of photographers who don't feel constrained by discrete disciplinary boundaries. Their approach to photographic practice reflects the expansive melting pot of influence in which they were raised.

But counter to this contemporary model of photographic practice, a vast number of commercial practitioners still fail when vying for art world representation, and an equal number of fine artists fail when trying to support themselves in the commercial fields. One reason for this is that their photography program adhered to a single disciplinary line, with commercial schools concentrating on technical training and business operations, and fine art schools concentrating on aesthetics, theory, and interdisciplinary education. This approach is ideal in some instances because specialized education enables graduates to rapidly advance in a specific field of photography. One drawback to this approach, however, is that in a diversified contemporary

marketplace, graduates' chances of success decline without the useful carryover of techniques and ideas between disciplines. Taken to the extreme, photographers emerging from narrowly focused programs practice photography in relative ignorance of the myriad ways in which the medium's "other half" could inform and enhance their work, and all viewers suffer from the unexplored potential.

Graduates from commercial schools are adept at using the most complex, state-of-the-art equipment and materials; they produce images demonstrating perfect technical execution with eye-catching style. But many of their best photographs lack substantive meaning, and at worst they *miscommunicate* because these graduates were undereducated in the areas of art history, visual literacy, critical theory, and aesthetics. To quote the conceptual fine art photographer Misha Gordin, "The poor concept, perfectly executed, still makes a poor photograph." On the other side of the educational spectrum, fine art school graduates fully understand the theoretical and historical underpinnings of photographic work; they produce images filled with insight, passion, depth, and meaning. But many of their best photographs lack sophisticated technical accomplishment because they are underpracticed in the medium's technique, mechanics, equipment, and materials. Technically poor

images are like poems written with poor grammar—they may have volumes of insight to convey, but they have difficulty doing it successfully. To paraphrase Misha Gordin, the blend of talent to create a concept and the technical skill to deliver it is necessary for making successful photographs.

To complicate matters, the advent and rapid evolution of digital technology has created a relatively new fissure within photographic practice, this one based on photographic media itself. Reflecting this, many academic programs have been forced to choose between two discrete light-sensitive media—traditional or digital—the majority choosing digital. The decision is in part based on their need to maintain relevance within their particular discipline or industry, but it's also due to the unavoidable financial pressures that bear on academic institutions such as hiring for faculty expertise, limited curricular time to cover a vast amount of material, and space limitations for darkroom and digital facilities. Many programs (and practitioners) have chosen to adopt an either/or approach, suggesting that abandoning traditional for digital media will advance those leaders who embrace it and retire those relics who don't. But this approach can limit the medium's collective advancement in several ways. First, students tend to learn and practice only the technologies available to them

through their academic program, so the unique visual outcomes of alternative media options often go unconsidered even after they graduate. Also, an either/or approach neglects careful examination of the broader potential offered by *both*. Maintaining a balance between technical and aesthetic, traditional and digital, historical and contemporary, provides solutions allowing more expansive use of the medium.

In addition to polarized academic approaches and the proliferation of new media, many students unwittingly set themselves up for failure in a particular branch of photography because they are unfamiliar with the dichotomy when they enter a college program. Every professor knows scores of students who did not consciously choose the type of photography program they found themselves in. That is, they did not make informed decisions by sufficiently defining their future goals and applying to institutions that, through research, they learned would best help them to meet those goals. Two years and tens of thousands of tuition dollars later these students begin to understand what direction they wish to take in their photography career. Unfortunately, too many of them simultaneously discover that they are not in a program specifically designed to get them there.

IMAGE © ANGELA FARIS BELT, *LIGHTS*, 2008.

So what's the good news? The negative effects of these combined problems—polarized academic emphases, the pressure to adopt solely digital media, and students' unknowing of the range of programs and potential careers in photography—can all be mitigated through courses that simultaneously balance and broaden the way we engage in photographic practices. One way to accomplish this is through courses that integrate hands-on practice in photographic technique with simultaneous study of how the

inherent visual outcomes create meaning. By engaging a more holistic approach to photography education, graduates emerge armed with sound knowledge of the range of available tools, are historically and conceptually informed, and are better able to define and redefine the emphasis of their photographic practice throughout their careers.

This book provides such a course. It allows practitioners to gain a better-rounded, contemporarily relevant education in the medium. Originally designed as an intermediate-level portfolio development course, *The Elements of Photography* solidifies technical skills while deepening conceptual awareness and expanding visual literacy. Based on four immutable elements (outlined in the Introduction) inherent to the making of *all* photographic images, this course remains successful even as photographic materials continue to change and evolve. How is this possible? Because the principles that make a photograph, well, photographic, never change.

The approach outlined in this book, which anyone can learn, is based on a single theory: *photography is a unique form of visual language based on a specific technical grammar.* Anyone who studies a language intently begins to understand its grammatical structure and can use it to

This book examines four elements specific to every image created through the action of light. These elements form what I call *the grammar of photographic language*, because they constitute the technical foundation, as well as dictate the visual outcome, of all photographic images. They are: the photographic frame and its borders, the aperture or lens and its effects on focus and depth of field, shutter speed and its effects relative to time and motion, and the physical media used to create the aggregate image. Together these elements answer a three-part question that defines the essence of photographic language: "What are the essential technical elements inherent to photographic image making, how do those elements dictate discrete visual outcomes, and what meanings do those outcomes suggest in relation to the subject?" To fully mine the medium's potential, these grammatical elements must be expertly addressed by photographers, regardless of media choice and the intended use of the images.

communicate more precisely. A photographer with a curious and conceptual mind who understands the grammar of photographic language can effectively use it to share insights and interests. The most successful fine art and commercial photographers—those whose work has the power to enlighten and educate, to persuade and advance

change, and to heighten our perception of people, places, events, and things—share a common characteristic: their work acknowledges that the power of photographic image making lies in the interconnection between the medium's technical structure and its visual outcomes. When photographers learn to integrate technique and aesthetics, they become better able to create successful, meaningful images in any branch of the profession.

I have shared this course and its methods with a broad audience of educators through the first edition of this book, and the quality of their students' images and growth in understanding have been as impressive as that of my own students. Using this book helps educators to bridge the institutional gap between technical and fine art practices, as well as the gap between traditional and digital media, and helps to ensure that students receive a comprehensive education in photography that will serve them well in any branch of the profession they gravitate toward. But this book isn't only for college photography students; self-taught and practicing professionals have also used it to broaden their approach to image-making, and they've done so with excellent results.

This second edition expands greatly on the first, and is organized to allow beginning photographers easy entry to the principles outlined within. The format of this book, its principles and content are outlined in the Introduction. Also found there is advice about how you can gain the most from the reading and the practical exercises. As you embark on this photographic exploration, remember to enjoy the process as you celebrate your progress!

INTRODUCTION

LIKE ALL ART, PHOTOGRAPHY CREATES ITS OWN REALITY. AND THE BEST PHOTOGRAPHS ARE NOT THOSE WHICH SUCCINCTLY RECORD WHAT HAS BEEN SEEN, BUT THOSE WHICH UNDERSTAND HOW TO STRUCTURE THIS ACCORDING TO RULES AND LAWS SPECIFIC TO THE GENRE. —FROM *ICONS OF PHOTOGRAPHY*

There is just "something about" certain photographs, isn't there? If you're like me, you pause at the sight of them in magazines and journals, on gallery and museum walls, in family archives and in antique stores, and marvel at that "something." What makes them so intriguing is difficult or impossible to describe verbally because it exists as a strictly visual construct. But even if we can't describe it, we know when we see it. It occurs when the *form* of a photograph inextricably ties its *subject* and *content* together (we'll explore this in Chapter 1). This cohesion, particular to photographs possessing "that something," is created most often by photographers who see photography as a visual language, and who use its grammatical elements to express meaning.

WHAT ARE THE ELEMENTS OF PHOTOGRAPHY?

Grammar can be defined as "the foundational elements that comprise a science, art, discipline or practice," so in addition to its ability to strike fear into the hearts of grade-schoolers, grammar is the basis upon which every form of language is built. That's what this book is about—*the grammar of photographic language*—that is, the elements that make up the technical foundation, as well as dictate the visual outcome, of all photographic images. These elements are: the photographic frame and its borders, the aperture or lens and its effects on focus and depth of field, the shutter speed and its effects relative to time and motion, and the physical media used to create the aggregate image.

IMAGE © ANGELA FARIS BELT, *I HEART*, 2007.

The elements do not operate in a hierarchical or sequential manner; they each play a unique role as they combine to form a coherent visual statement. This book explains the nature of the four photographic elements as well as how to control them technically. It demystifies their compositional and visual outcomes, and it examines their communicative and conceptual implications. Consciously employed by a skilled photographer, these elements will add advanced levels of depth, dimension, and meaning to your photographs.

WHY THE ELEMENTS MATTER

Just as avid readers don't gain much enjoyment or insight from novels written with little command of the language in which they're written, avid viewers don't gain much enjoyment or insight from photographs made with little command of photographic language. It's because just as combining parts of speech dictates the form and meaning of sentences, combining photography's grammatical elements dictates the visual properties of photographs, which is how they communicate meaning. The relative success or failure of a photograph can be attributed to two things: what the intent behind the image is, and how well the image fulfills its purpose or communicates its message. Quite simply, *photographs structured on the grammatical elements of photographic language as they relate to specific subjects are more likely to communicate successfully.* A photographer's control of the medium's grammatical elements acts as a filter through which viewers see the world; often transparent to viewers, they are the primary means through which we transform our world into photographs. Insofar as a filter's significance lies in how it alters something, the degree to which a photographer understands, employs, and manipulates these elements dictates the degree to which their photograph successfully communicates.

Beyond using grammar to structure and filter information, additional parallels can be made between written and photographic language, and their uses. For example, both types of language have practical and expressive uses. We use both written and photographic language to describe the world around us in informative ways; further, we use them to encapsulate, summarize, and communicate that information in ways that others can understand. We use them to "sell" others on ideas and commodities and as a means of propaganda and influence. We use them to record our personal and collective histories, to preserve them and share them with others, and to carry them into the future. We use both written and photographic language to interpret and evaluate events as they happen in our lives and in the larger world;

we use them to theorize, synthesize, and conjecture, and even to obfuscate or to pose unanswerable questions. We use them scientifically, to research and express our findings. We also use them for the purpose of making art, as a means to express our personal perceptions of the world—its beauties and its horrors—and to experiment with unconventional uses of the language, thereby broadening and shaping our collective understanding of subjects and the language itself.

Whether we're composing a technical manual (which we might equate with scientific or forensic photography), prose (photojournalism, documentary, or advertising photography), a personal journal (wedding or portrait photography), or a collection of poems, a novel, or research (fine art photography), the formal basis and structure of the language we use—its grammar—remains consistent consistent. Like the grammatical rules of written language, the grammatical rules of photographic language remain consistent regardless of how or to what end we use them. For all these reasons, photographers address the elements of photographic grammar, to the best of our ability, in order to fully mine the medium's potential. At a time when more people than ever are making photographs professionally, to set yourself above the rest it's imperative to study the elements upon which photography is based, and to implement those

elements as communicative tools so that you can make visually literate images.

As previously stated, the four key technical elements that constitute the grammar of photographic language are: the photographic frame and its borders, the aperture or lens and its effect on focus and depth of field, the shutter speed and its effects relative to time and motion, and the physical media used to create the aggregate image. Because these elements are inherent to cameras and the physical media upon which images are captured, they provide an excellent framework for studying photography. In the end, photographers who understand these elements can successfully distill images from ideas; photographers who control and consciously put them into practice in their work can create images that perfectly represent their vision.

HOW TO USE THIS BOOK: A CHAPTER OUTLINE

Chapter 1, "Before You Begin," examines and explains how to use subject, content, and form—the three aspects that comprise any kind of composition. This part of the chapter guides you in selecting a single subject to explore throughout the exercises in the book. It also discusses what I call *finding your thread*—knowing what drives you to make

photographs—through collecting tear sheets, forming critique groups, and writing artist statements.

Chapter 2, "Metering and Exposure," provides a solid background in photography's essence: using light to create images. It covers in-depth the methods for controlling and interpreting image density and histograms, as well as how to select the proper ISO, aperture, and shutter speed for a given situation. This chapter is a must for anyone who is relatively new to photography, but even if you've been making photographs for years, you can refresh your technical knowledge by starting here.

Chapter 3, "Framing, Borders, and Multiple Frames," is written in three parts. First it studies the most fundamental means through which we transform the world we see into a photograph—the frame. The frame is the first photographic element because the camera's imposed viewfinder is immediately placed between the photographer and the world. The first part of this chapter, "Framing," discusses how to organize the frame using picture planes, vantage point, and juxtaposition—all natural outcomes of the camera's translation of our three-dimensional world into a two-dimensional representation of it. This section also discusses frame format, media dimensions and cropping. Part two, "Borders: the Exterior Edges of the Frame," examines the

outermost boundaries of the frame—the borders of the media and print—because they contribute significant visual information relating to the image itself. Part three, "Using Multiple Frames," teaches you methods of expanding on the photographic frame by exploring single images created through gestalt, including diptychs, typologies, contact sheet images, and multiframe panoramics.

Chapter 4, "Apertures: Focus, Lenses, and Clarity," examines the nature of apertures as a portal through which the image is transported. It examines types of lenses to focus the image, as well as the relationship between the lens plane and media plane. This chapter discusses pinhole cameras, various nontraditional lenses, and several notions of clarity associated with lens quality, focus, and depth of field.

Chapter 5, "Shutter Speeds: Time and Motion" examines the world of motion as it appears when recorded onto static media (light-sensitive film, paper, or sensor). Part 1 outlines numerous technical considerations in order to demystify the process of successfully recording the range from frozen to blurred images. Part 2, "Multiple Moments in Time," looks beyond a single exposure to the potential offered by multiple-exposure techniques, the use of sequences, and the use of single frames viewed over time.

Finally, Chapter 6, "Materials, Processes, and Presentation: The Aggregate Image," deals with the physical attributes of the printed image and the meanings suggested by both capture and output media. Part 1, "Going Back to the Beginning," examines attributes of size and scale, and grain structure, tint and tone. Part 2, "How Images Exist in the World," expands on this discussion to include the means through which we display and share our images with viewers, in particular in gallery settings. Here I discuss several contemporary presentation methods as options to the traditional window mat, glass, and frame.

The book concludes with a discussion of the work of a single photographer, David Taylor, and how he uses all the elements of photography in ways that enable him to communicate his ideas to a diverse audience.

FORMAT

The format of *The Elements of Photography* will lead you to greater understanding of how photographs communicate by progressing from technical considerations to visual outcomes to potential for meaning through each chapter in succession.

Throughout the book you'll find "Image Discussions" that explore various attributes of photographic language and use them to determine the meaning of the image.

Additionally, each chapter contains "Chapter Exercises" designed to help you engage, experiment, and create using the technical, visual, and theoretical information provided in the chapter. These exercises encourage you to broaden your thinking about how use photographic language to express your ideas.

Finally, each chapter ends with inspirational "Portfolio Pages" with selections from several photographers' work intended to enrich the chapter's information. I have written a brief "Elements" introduction to each portfolio to facilitate understanding and discussion of how the photographers successfully use photographic language to make their images. The photographers have provided Artist

This is not an Adobe Photoshop text, but its principles can be mimicked using image-editing software programs such as Adobe Photoshop. If you wish to mimic camera techniques using digital means, it's best to know what those techniques look like when they're created through authentic means. The way to go about this is to use keywords from the chapter contents to research tutorials that mimic the techniques believably. Image editing after the fact can be made to look the same, but as every professional photographer knows, it's more costly and time consuming than getting the image right in-camera. And that's what this book is all about!

Statements addressing their work's creative and conceptual meanings. These photographers' work is not *about* the elements of photography, but they use the elements expertly in a wide variety of ways to illuminate viewers about the intended meaning of their work. The Portfolio Pages primarily represent fine art photography, but they also include documentary and commercial-editorial work to provide readers with an idea of the possibilities that control of these elements offers all photographers.

I have taught photography for more than a decade using this approach, and I am consistently amazed at the power of the imagery, both technically and creatively, that engaged practitioners achieve once they begin to explore the world through the grammar of photographic language. Using this approach, you too will become practiced in photographic technique, gain a more concrete understanding of photographic visual literacy, and build a strong body of work with which to demonstrate your unique vision to viewers including portfolio reviewers, employers, and image buyers. You will build confidence with the medium's technical principles and how those principles translate into visual images, and you'll develop a working method that is proven to be engaging and successful when exploring a subject photographically. You will stop "taking pictures" and begin "making photographs" because while anyone can take pictures, photographers understand and consciously utilize the medium's grammar to make photographs. Through practice you will begin to make photographs that accurately communicate your message whether it's political, personal, poetic, spiritual, aesthetic, or journalistic. Using the techniques outlined in this book, you'll be well on your way to making the photographs you envision, successfully and with a sense of personal style.

I strongly advocate to image makers the necessity of incorporating interdisciplinary studies into your practice. I cannot emphasize enough the importance of carefully reading this and any book relevant to your field of study and thoughtfully researching any work about subjects that ignite your passion. Be inquisitive; be willing to explore. Don't limit your research to direct information about your subject; look into how it influences or is influenced by broader cultural history, religion, philosophy, politics, sciences, social sciences, literature, photography, and other arts. Seek out information shared by others who are passionate about similar subjects to the point that they have researched and studied, written or made art about it. Using an interdisciplinary approach to understanding your subject is a photographer's best asset; it informs your work in ways that visual exploration alone cannot.

EQUIPMENT AND EXPERIENCE NEEDED

The information and techniques included here were developed for photographers at any level who possess a basic foundation in the technical aspects of camera operation, as well as a fundamental working knowledge of darkroom printing or Adobe Photoshop (whichever suits your preference). The techniques explored in *The Elements of Photography* can be practiced with historical, traditional, digital, or a combination of media. Advanced practitioners can use this text to develop a portfolio that reflects a broader visual and theoretical perspective. These techniques are by no means an exhaustive study of photographic image making; rather, they are tools for developing a deeper understanding of the possibilities inherent within photographic practice.

Additional equipment such as specialized filters, alternative lenses, and tripod heads are discussed throughout the book. Most of these supplements are affordable and have the potential to enrich your exploration, but they are not required in order to practice and create an impressive body of photographic work. Above all, have fun and expand your photographic ideas to the limit!

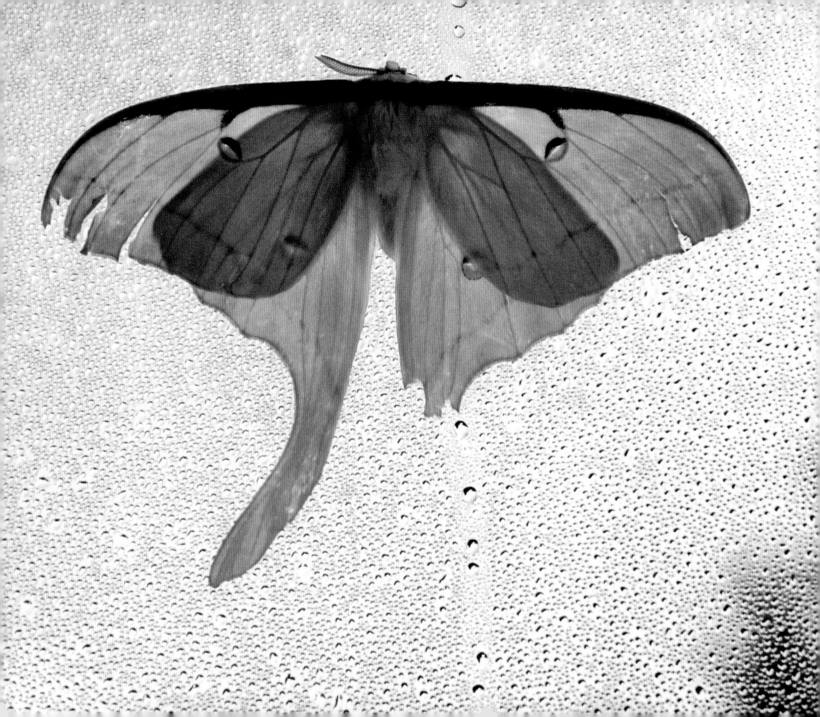

BEFORE YOU BEGIN

> TO ME, PHOTOGRAPHY IS AN ART OF OBSERVATION. IT'S ABOUT FINDING SOMETHING INTERESTING IN AN ORDINARY PLACE I'VE FOUND IT HAS LITTLE TO DO WITH THE THINGS YOU SEE AND EVERYTHING TO DO WITH THE WAY YOU SEE THEM. —ELLIOTT ERWITT

WHAT IS THE PHOTOGRAPHIC IMAGE?

Simply stated, *the image* is made of three components: *subject, content*, and *form*. In fact, they constitute every work of art—including other two-dimensional and three-dimensional art, music, literature, and performance. Although the naming conventions used to describe them vary, it's understood that subject, content, and form combine to create the complete image or artwork.

The *subject* can be defined as *what the image is about—its meaning or concept*. In literature, the subject is often referred to as *the theme* of the work. A photographer's interest in a particular subject is the reason he or she makes images to begin with; as photographer David Hurn says, "photography is only a tool, a vehicle, for expressing or transmitting a passion in something else." Just as literature operates for writers,

In art, the word "content" has traditionally referred to a work's theme, and the word "subject" has referred to the work's contents. But to me this usage seems contradictory, so I adhere to the words' root definitions. Which terms you use matters less than understanding the three components that comprise the image.

photographs allow artists to convey a message. If the subject is literal, such as a specific person, and you make that person's portrait, it's pretty straightforward for a viewer to interpret. But it's possible for the subject of a photograph to not be visibly present in the image. An abstract or conceptual subject (such as *hope* or *dreams* or other things which are not nouns) might only be conveyed through skillful consideration of the other two components: content and form.

While the subject is what the image is about, the content refers literally to the image contents. Image *content* (also referred to as *subject matter*) can be defined as *persons, places, or things that are visibly present or identifiable in the image.* Artists who understand subject and content as separate yet interdependent image components can combine them more thoughtfully to convey meaning. The best photographers closely consider how all image contents relate to their subject for several reasons. First, all content, like every word, carries meaning that operates on connotative and denotative, subjective and objective, psychological, intellectual, spiritual, cultural, political, and many other levels. Second, like

individual words in a sentence, each piece of image content has the potential to either clarify or obscure meaning when juxtaposed. Therefore, consciously choosing and including content that refers to your subject is more likely to successfully communicate your message to a wider audience. However, like the subject of a work of art or literature, content can be abstract or nonrepresentational too. In these cases the remaining component of the image—its form—might itself be the subject or might afford the viewer a great deal of insight about it.

To illustrate the difference between subject and content as I define them, I ask students if they are familiar with the novel or film *The Shawshank Redemption.* Most are. Then I ask, "What is the subject of the work?" Invariably they reply that the subject is an innocent man who is sent to prison and escapes through "a river of … stuff." Next I ask them to describe its content, and they're stumped. I suggest that the *subject* of the work is something we can't literally see—*hope* or perhaps *the nature of redemption.* The innocent man imprisoned, his experiences and the experiences of those around him, as well as his distinctly unpleasant path to freedom all fall under the category of *content*—the concrete, identifiable aspects of the work that carry its subject (theme, meaning) across to readers/viewers. Recognizing the distinction allows artists to choose and structure content to more accurately communicate about a subject. And how artists arrange and structure contents is almost universally called *form.*

The third component of the photographic image, its *form*, refers to *all means through which various content is arranged, unified, and presented.* Form encompasses the design methods used to compose a work of art. Since the formal arrangement of content dictates the appearance of an image, an intrinsic aspect of photographic form is "the elements of photography." Also called *composition*, form in a photograph includes the traditional design elements (line, shape, value, texture, and color), to which I would add quality of light and vantage point. I would also add the media with which the image is made to the list of formal elements, as well as those things that characterize the way the object exists in the world (more on this in Chapter 6). Through conscious use of formal arrangement, successful photographers translate our three-dimensional, objective world into two-dimensional images of it. In so doing, we create subjective interpretations of the world imbued with new meanings.

The interrelationship between subject, content, and form denotes meaning, so it's important to understand how. Specific to photography, form, is in large part created by the grammatical elements of photographic language, which is what this book is all about. We'll study this interrelationship as we examine other photographers' work, so that it comes to mind when you're making your own photographs.

EXAMINING SUBJECT, CONTENT, AND FORM: THREE PHOTOGRAPHS

Just as content (words) and form (grammar and syntax) allow readers to interpret a subject, these same attributes allow viewers to understand and interpret photographs. By "reading" a photograph's component parts we can derive meaning. Let's read the content and form of three photographs and try to determine their subjects. Interpreting photographs can be a complex undertaking, but this method makes it easier.

Image Discussion 1: Interpreting a Subject by Examining Content and Form

Describing the contents and formal arrangement of an image provides a helpful basis for understanding and interpreting it. Throughout this text there are Image Discussions that use the chapter contents to help you analyze how the elements of photographic language communicate about the image subject.

In this case, photographer Dan Estabrook has created a *diptych* (covered in Chapter 3, Part 3) that is as meaningful as it is hauntingly beautiful. The most significant content of the image is two figures who could represent any of us, since both are dressed as the "Everyman" and neither face is recognizable. Because the image is not a portrait of the person depicted, we can assume he is not the subject. The sharper figure in the right-hand frame, his face scrubbed out in an act of permanent anonymity, is reaching outside his world (the world of the frame), his hand (we presume) extending into the left hand frame toward his twin figure. The twin, whose face is unrecognizably obscured by Estabrook's use of shutter speed

to blur, is fading behind the intruder's forceful hand above his shoulder. The ghosted, blurred figure is essentially being hailed, though neither acknowledges the other overtly. It's as though they exist on different planes, which is suggested through the use of two discrete frames. Materially, the diptych is distressed through Estabrook's use of the tintype process, suggesting historic times; the angles of the prints are offset, not square, underscoring the sense of angst created by the interrelationship of content and the residual evidence of process. All of this I draw from simply describing the image content and form. Through this process we might interpret the subject as the weight of mortality bearing down upon us.

I do not believe there is a single correct interpretation, only more or less accurate ones, and without knowing the artist's intentions, the proof can only be derived from the photograph. As you proceed through this text you'll learn how the elements of photography affect subject, content, and form to create meaning, and you'll begin to implement them more consciously in your own work. (See more of Dan Estabrook's work in the Portfolio pages of Chapter 3.)

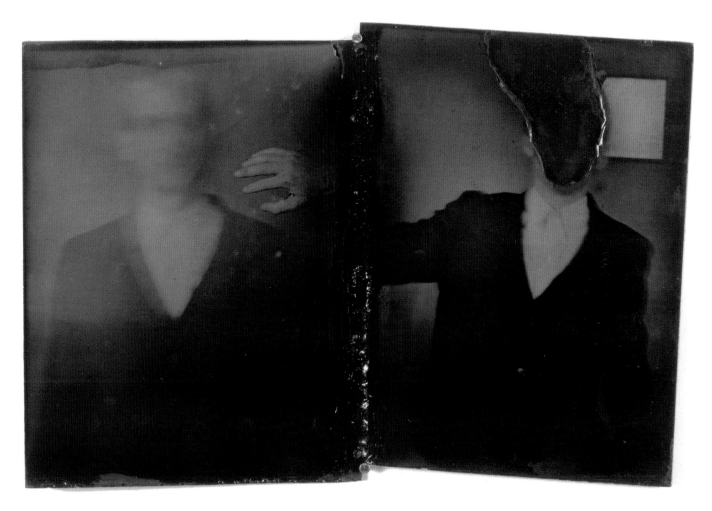

IMAGE © DAN ESTABROOK, *UNTITLED TWINS (JOINED)*; TINTYPES ON STEEL, 10" × 14".

Image Discussion 2: Interpreting a Subject by Examining Content and Form

Some images seem more difficult to interpret than others; just remember to describe the identifiable contents you see in the frame, characterize them as best you can, and determine what they mean to you. Images like this one use photographic language metaphorically as opposed to documentarily, but being open to understanding all photographic practices (from commercial to fine art to documentary and everything in between) serves to inform your own practice.

In this still life by photographer Victor Schrager, the placement of objects reduces a sense of depth; they are textured but otherwise austere forms in bright colors (the only recognizable form being an illuminated light bulb). Schrager arranges nontraditional, abstract contents using relatively traditional still life sensibility. Beyond that, the most noticeable thing is that nearly all the contents are out of focus (deliberately so).

There is nowhere sharp for our eyes to rest; even the mirrored surface prevents us from pinpointing a single focal point. What is all this about? Well, maybe that the artist avoided showing us detail—through his choice of nondescript objects, mirroring, translucence, and soft focus—indicates that it isn't about anything seen in the image contents. As a more abstract image, with its attention to lighting quality, color interaction, and design, I might conclude that the subject is an exploration of aesthetics through formal arrangement, or something along that line. Victor Schrager's images just *feel like* art, which also influences interpretation.

We might not understand every image we see, but the more images we examine this way, the more of them we do understand. As you move through the exercises in *The Elements of Photography,* your work will reflect increasingly more conscious, sophisticated use of photographic language and the ability to create meaning in your images. (See more of Victor Schrager's work in the Portfolio pages of Chapter 4.)

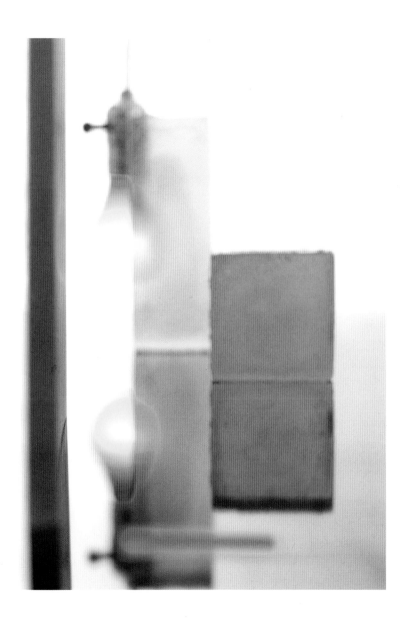

IMAGE © VICTOR SCHRAGER, UNTITLED #325, 2008;
FROM *THE WHITE ROOM* SERIES.

Image Discussion 3: Interpreting a Subject by Examining Content and Form

Some images seem more straightforward to interpret than others, but don't stop with a superficial reading. There is often more to a professional photograph than initially meets the eye. Image content and form not only imbue images with meaning, but they also affect our emotional and intellectual responses as viewers.

You now know that making successful photographs requires merging subject, content, and form in conceptual ways. This is as true for documentary images as it is for commercial and fine art work. This image by photojournalist Jill P. Mott expresses the feeling of the scene by purposefully structuring its framing, vantage point, depth of field, and motion (all aspects of photographic language). The vantage point from within the moving car includes a man in the corner of the frame—an anonymous driver, out of focus, nearly silhouetted in darkness—looking sideways at three women in an open window. Additionally, the instant the shutter was released one woman stares back at the man with a look of confident defiance. The slight motion and crooked framing of the image underscores the feeling of a "drive-by" that occurs regularly in this area of Lima, Peru, known for prostitution. It just *looks like* a documentary image, capturing people interacting in a particular place in time, and depicting an unsettling voyeuristic view from a vantage point we rarely see, as Mott places us viewers inside the car as well.

No matter what kind of photography you do, using the elements of photography will help you connect your viewers emotionally and intellectually with your subject. Practicing your recognition of photographic language in other peoples' photographs reinforces your ability to consciously employ it in your own. Continue this practice on your own, and now that you know the basics of describing content and form, you can move on to the next steps: selecting your subject, and photographing it using each of the successive elements of photography.

HOW DO I SELECT A SUBJECT?

You are encouraged from the onset to choose a single topic, genre, or theme on which to concentrate throughout the exercises in this text. In considering topics or related themes, choose something that will interest and engage you both visually and conceptually, since you will spend considerable time building a body of work around it. Try to choose something that you think could be of interest to others as well, since you'll likely want to share the portfolio of work with an audience.

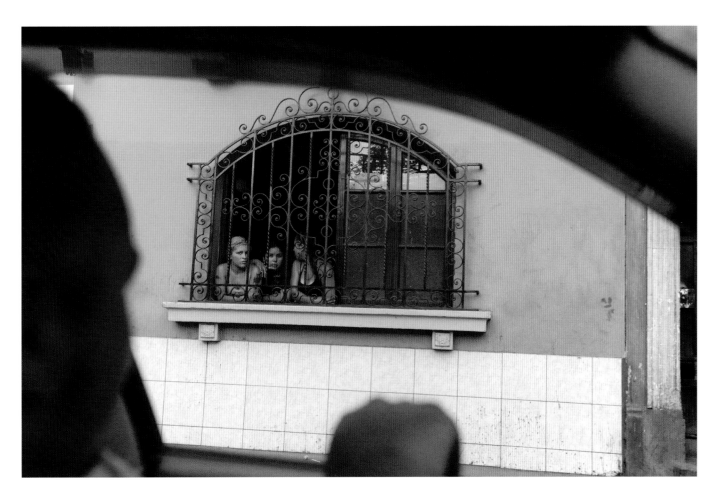

IMAGE © JILL P. MOTT, *LIMA, PERU*, 2009.

The chapter exercises provide a framework for approaching your subject methodically, and concentrating on a specific subject allows you to dedicate energy usually spent wondering what to shoot on the more important task of making photographs. By adhering to your chosen subject throughout the chapter exercises, you will deepen your understanding of that subject, create a portfolio of images thoroughly exploring it, and demonstrate an advanced level of control over the aesthetic appearance and communicative effectiveness of your photographs. Also, upon completion of the exercises you will have an impressive body of work possessing a natural thematic coherence.

Remember our premise that all photographs are about some subject? Well, of the innumerable potential subjects in the world, how do you begin to choose? That's what this section will help you do. Answering the following questions can help you define a subject that's right for you, or if you already have a general topic in mind they can help you refine it.

1. What are your interests outside of photography? What are you passionate about, what do you read about or think about aside from your photographic practice?

2. Why are you interested in it, and what particular aspects of it most interest you? Is it how it looks, the way it makes you feel, or does something about it intellectually, philosophically, politically, spiritually, or otherwise resonate with you?

3. Which broad genre of pictures most interests you—landscape, portrait, or still life? Are your favorite images conceptual or representational, discovered or staged? Which of these types of pictures do you most enjoy making?

4. How might you merge your interests outside of photography with the type of image making that most interests you? What would you like to study or communicate photographically, and what methods might you use to do it?

FLOWCHART METHOD: MOVING FROM SUBJECT TO SHOT LIST

Another framework for selecting a subject, and one that will help you delineate the content and form necessary to communicate it, is outlined in the simple flowchart that follows. Though not all subjects can be neatly and predictably outlined, this means of brainstorming can still be of help.

First, select a subject by answering the question posed previously. Let's assume your answer is that "suburbia" interests you. This becomes the broadest definition of your subject.

From there, break it down into the most relevant component parts that comprise suburbia. These component parts will help you hone in on the next level of the chart and bring you closer to defining potential contents. In this case, you might answer, "The three things that make

SELECTING A SUBJECT AND DETERMINING CONTENT EXAMPLE

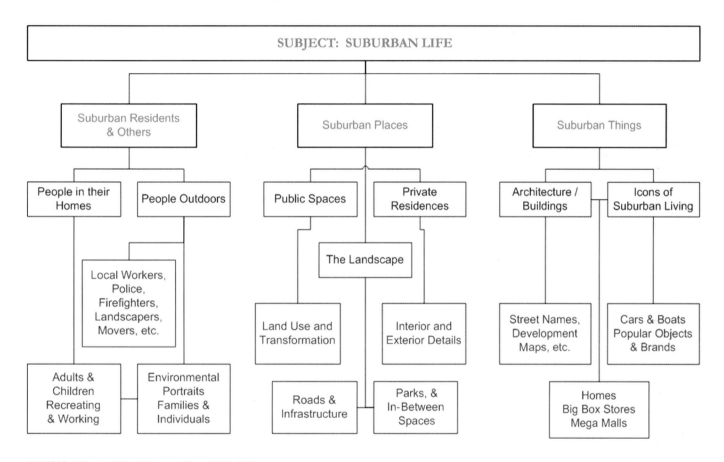

CONCEPT AND ILLUSTRATION © ANGELA FARIS BELT.

Chart your subject ideas. Making a simple flowchart that breaks down your subject into component parts can help you define the aspects you really want to explore and why. It can also indicate potential content for your photographs. Perhaps you are only interested in one aspect of suburban life, or perhaps you are interested in all of them. Regardless, putting your interests down in writing gives you a tangible form to help you think about them.

up suburbia are residents, places, and things, but people interest me most." Write all three categories beneath the Subject on your flowchart, but you'll concentrate most on what falls beneath "Residents and Others" Filling out all three aspects, however, provides additional brainstorming to help you more fully understand your subject.

Next, once you have defined the major components of your subject, you can begin to list their attributes—these attributes will become *image content* in its broadest sense. In our example, "Residents" might include people in their homes or outdoors, as well as other people working, recreating, etc.; "Places" might include public spaces, private residences, and aspects of the suburban landscape; and "Things" might include architecture and other icons of suburban living. Because your primary interest is in suburbia's residents, you'll want to continue distilling that into increasingly specific parts.

At the bottom-most levels of your flowchart will emerge what many commercial photographers refer to as a "shot list." This is a list of images that you might make in order to "cover" or begin exploring your subject. A shot list acts as a general guide; don't feel as though you are locked into the things you have listed in your flowchart. As you shoot, your understanding of and engagement with your subject will increase, guiding you to refine your shooting or redefine your subject. In the case of residents, your shot list might range from families recreating and attending to daily chores,

to city employees helping and maintaining the community. You can choose to approach shooting from a documentary standpoint, or you might decide that your subject is best served through staged portraiture and scenes. The form and style are up to you.

Keep in mind, you can't just make a flowchart, shoot, and be finished with your project (unless your project covers a one-time event). You'll want to shoot, examine, and edit your results using contact sheets and work prints (which we'll cover in Chapter 3), and learn from what they and a critique group of peers (more on this coming up) suggest to you. Then shoot some more, examine, edit, learn, and so on. The photographic editing process is similar to the writing process; rarely is your first draft your final draft; through editing and revision you refine the statement you're making about your subject. The more you practice writing (or photographing), editing and rewriting (editing and rephotographing), the more efficient you'll become at hitting your target.

FINDING YOUR THREAD

In addition to study and a lot of practice, a few more things can help you gain more from the chapter exercises and on your path to becoming a successful photographer—tear sheets, interdisciplinary research, a strong critique group, and writing an artist statement. These things help you understand the nature of your photographic interests—something I call *the thread*.

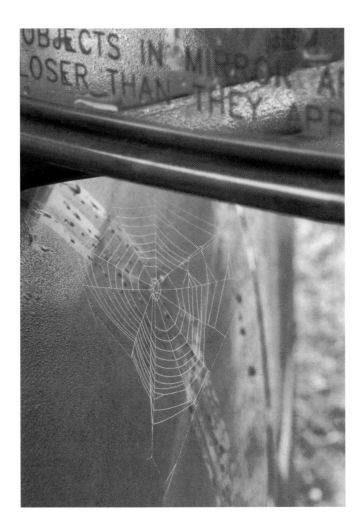

IMAGE © ANGELA FARIS BELT, *OBJECTS IN MIRROR*, 2007.

The thread is the singular overarching concept or theme that I believe runs throughout nearly every serious artist's work. Although you might have numerous portfolios, there is likely a single thematic thread running through all of them. If you're new to photography, then pay attention for your thread to emerge; the sooner you identify it, the sooner you'll be making the pictures that lie along the path of your real interests.

For example, I've defined the thread in my own work; it deals with the dialog between humankind and nature and the ways in which photographic language can translate and interpret it. You'll see hints of this thread evidenced in the frontispieces and my other images throughout this book. And although my three primary bodies of work (shown in entirely on my website), range from representational to abstract to digitally altered, this same thread connects them all. I didn't force my work to fit the thread; rather, the thread grew organically from years of practicing photography in exploration of my own interests. And the same will happen for you.

Finally, in order to help find your thread, I advise young photographers to keep your various photographic undertakings physically separated. If all of your serious photographic work is thrown together with all of your snapshots in binders of negatives or on hard drives, and all of your prints are randomly intermingled in boxes, then how can you think about it clearly? To allow you the clarity to really examine your work, it helps to maintain an organized workflow and filing system and physically separate it into discrete portfolios. Start now; it's far easier

to organize a few years of photographic work now and maintain organization, than it is to reorganize the inevitable mountain of work you'll have accumulated ten years down the road.

Tear Sheets

The first step in helping you find your thread is to collect *tear sheets*. These constitute a record of the images that inspire you; they come from magazines, the Internet, and from other sources. I keep an image library on my computer, categorized by the photographer's name, with titles, dates, and media information. I also have some three-ring binders of images saved from subscription magazines and other sources. When collecting tear sheets, don't discriminate between photography and other media; if the image attracts you, keep

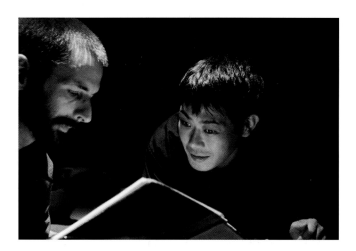

IMAGE © JON LYBROOK, *CRAFTING A RESPONSE*, 2010.

it. Look to these images for inspiration whenever necessary. As a collection, they have the potential to reveal aspects of your own interests and aesthetic sensibilities that you may not realize by viewing and contemplating your own images.

Interdisciplinary Research

I mentioned in the Introduction that conducting research on any topics related to your subject, especially across disciplinary boundaries, is invaluable to your photographic practice. It helps to reinforce and inform your thread, broaden your knowledge base about your subject, and deepen the intensity of your images. So to reiterate, start your research practices by carefully reading this and any book relevant to your subject, thoughtfully study any work about subjects that ignite your passion, and be inquisitive and willing to explore. Avoid limiting your search to information about your subject alone; research how it influences and is influenced by the broader culture, history, religion, philosophy, politics, sciences, social sciences, literature, and other arts. Seek out information shared by others who have been passionate about similar subjects to the point that they have researched and studied, written, or made art about it. Using an interdisciplinary approach to understanding your subject is a photographer's best asset; it informs your work in ways that empirical visual exploration alone cannot.

Critique Groups: Gaining Feedback

Another method for helping you find your thread is to discuss your work with others. If you never get outside feedback until the day you try to publish, exhibit, or sell your work, how can you

gauge its effectiveness or what an appropriate audience response might be? In this respect, critique is an indispensable tool for improvement as a creative professional. At its best, everyone (those critiquing and those whose work is being critiqued) learns and grows as a result of active participation in the process.

If you're not in a formal educational setting, it's a good idea to find a few trusted colleagues who can act as sounding boards for your work and for whom you can do the same. Smaller groups of, say, three to five people work very well; it creates a good dynamic and allows ample time to discuss each member's work in depth. Choose people whose work and opinions you respect, people who can bring unique perspective to the discussion and whose work you find interesting as well. You don't need to find photographers who do work similar to yours; the idea is to get a breadth of opinions from people who love and are knowledgeable about photography. Discuss the prospect of forming a critique group with them, and set a schedule and goals for your meetings. Above all, hold one another to task.

The critique process can be difficult and challenging, but artists need it in order to grow. The following guidelines should help you better understand critique, provide better criticism for others, and gain more from the process yourself.

When Critiquing Another's Work

- Start with what you know. Describe the image, what you see in it, and how it is formally arranged. Address the work as it relates to the photographer's goals, observing technique, aesthetics, concept, and overall image quality. Then try to determine whether these components add up to a successful photograph. Does the photograph communicate what it was intended to? Be as specific as you can about why or why not.

- Avoid statements such as "I like it" and "I don't like it." Liking or disliking an image is not the point; we all have personal preferences. Analyzing and verbalizing what works *and* what doesn't is what's important. Don't judge your observations as right or wrong; offer them honestly.

- Critique is not personal; don't make it that way. Direct comments *toward the work* produced and presented, not *at the person* who made it.

- Ask questions of the artist whenever necessary to facilitate your own understanding. Also, draw on your related knowledge and your knowledge of contemporary photography in art and popular culture.

- Critique must be honest, thorough, and to the point if it is going to be effective. Negative feedback is necessary, so don't be afraid to voice such comments in a constructive way, even to friends; this allows them to objectively see problems in their work.

- When pointing out areas for improvement, also offer ideas and solutions about how the work might be improved.

- Remember to discuss what *does* work in the images. Critique is an opportunity to celebrate successes and provide positive reinforcement as well.

WHEN YOUR WORK IS CRITIQUED

- Be brave. If you've given your work 100% effort, then you have nothing to fear. Make work knowing that peers will critique it, and request that feedback to be honest and thorough.

- Critique is not personal; don't take it that way. Critique is about the work you've done and the progress you've made, not about you personally. Although it's your work being critiqued, remember that everyone in the group learns from the discussion.

- Critique isn't intended to make you feel good or bad; it's intended to help you learn and grow by indicating areas in need of improvement and celebrating accomplishments and successes.

- Remember that negative critical feedback is necessary and that others in the group are experiencing their own challenges. Identifying and discussing problems helps you and others avoid similar problems in the future. Don't make excuses for shortcomings or failings; accept legitimate criticism as a means to help you grow.

- Identify what kinds of constructive criticism have helped you improve and use the same methods when you provide criticism for others.

- Take notes on comments about your work, and implement changes you feel are relevant.

Artist Statements: Writing about Your Work

Your initial objectives are to identify a subject for your photographic exploration, and then concentrate on making images and getting feedback. But once you begin to progress and have a number of successful images, you'll want to have a coherent statement that addresses your work. This statement is not just for others; it will help you as well.

Not all photographic work requires an artist statement; commercial work generally doesn't. But if you do fine art, decorative art, or documentary photography, you'll likely be asked to provide one for someone at some point. But since being a visual artist is not equivalent to being a writer, for many artists writing an artist statement is the most dreaded aspect of presenting work. There is; however, a benefit to the exercise of writing an artist statement. It offers us the opportunity to think about our work from a linguistic perspective, thus deepening our understanding of it. The real task is in how to translate visual explorations and understandings into coherent written form that will elucidate and contextualize the work for diverse audiences while not limiting their opportunity for personal interpretation.

Artist statements have their own purpose and life in the world. They are available for viewers at art exhibitions and on websites, they are sent to gallery directors when requesting representation, and they are printed alongside publications

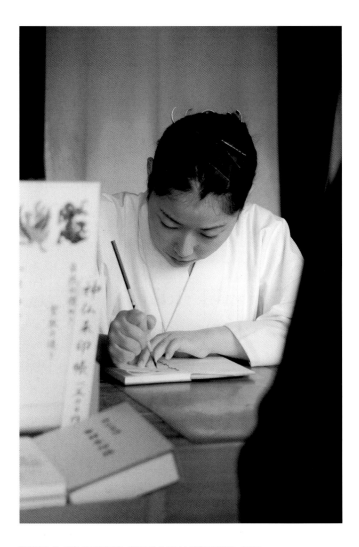

IMAGE © JON LYBROOK, *TEMPLE CALLIGRAPHER*, 2010.

of the work. Wherever they appear, they are intended to provide insight into the images.

There are no strict rules for writing artist statements; however, there are approaches that generally work and others that generally don't. Here are some guidelines:

- *First impressions.* As with any first impression, your artist statement should hook the readers and make them want to read more. From this standpoint, less is more. Be brief and to the point, and use language that most audiences will understand. Don't try to either elevate or obfuscate the work's meaning with academic language. A statement that's too complex, theoretical, or impersonal tends to alienate people and prevents them from connecting with your work on a meaningful level.

- *Explain your perspective.* Write about your work *as you see it.* Your statement should address your understanding of the subject and the work you've created about it. Your interdisciplinary research should give you solid material to go on. If your statement doesn't really reflect what the work itself is doing, that's an indication that you're on the wrong track.

- *Respect your audience.* Avoid telling viewers how to respond, how to feel, or what to think about your work. Grant them open access to experience the work and allow room for their interpretations.

- *Be specific*. You are communicating information, so be as straightforward as you can. For example, if your art is "inspired by fundamental characteristics of the natural world's inner side" (a ridiculously vague statement), then say which fundamental characteristics, what you mean by the "inner side," and how this inspires you. A salon or critique group can be a good proofreading resource before you publish your statement.

- *Address the work; don't tell a story*. Anecdotal or allegorical explanations have their place in literature but rarely (and then only briefly) in an artist statement. Audiences don't need to know the minutia of how you came to be interested in doing this work. And they never need to know that you have loved photography since you were six years old or that you started a certain body of work as a class project.

- *No time for excuses*. Artist statements do not exist as a way to validate creative work or to ask for audience approval. Write from the standpoint that your work is valid and worthy of appreciation as it exists. Don't make excuses or point out shortcomings that you see in the work (remember, we're our own worst critics); avoid saying, "I tried to …" or "I wanted to.…"

- *It's about your work, not you*. Avoid comparing yourself to other artists, citing aspects of your résumé or professional experience, and any form of self-aggrandizing. Allow the work to make its own place in the art world, and allow its quality to speak to your own accomplishment as an artist.

- *Keep process statements separate*. There is no need to discuss process and technical aspects of your work unless these things are integral to what the work is about. Instead, concentrate on your subject and content, your interest and research in it, and your unique approach to it.

The best way to learn about artist statements is to read a lot of them—good and poor ones—so that you're familiar with what works and what doesn't. A great source for excellent artist statements is the Portfolio pages of this book, where each artist has provided an accompanying statement addressing their work. Many fine art gallery websites list artist statements alongside the work they represent as well.

CHAPTER EXERCISES: SELECTING A SUBJECT

1. Choose several photographs you admire—they could be your own or someone else's. Describe their content and form to help you interpret what the image might be about. Share the images with your critique group and discuss your descriptions and the interpretations you come up with.

2. If you already have a tear sheet collection, reexamine it to try to determine if it reveals your thread. Even though the images may be by different artists, there are reasons why you collect the images you do, and they might help you define your subject. Are there recurring genres or themes that you tend to collect? Are these themes reflected in the types of literature you read or in other activities you engage in?

3. Answer the four questions posed in the "How Do I Select a Subject?" section.

4. Based on those answers, design your own flowchart that covers as many possible aspects of your subject as you can think of. Use the most specific aspects of the chart as a shot list to provide clues as to where you might begin.

5. Write a brief (one paragraph) thesis statement outlining the subject you intend to investigate throughout the exercises in this book. Include why you are interested in it.

Over time and a few revisions, this will become your artist statement. (*You should revise this statement as you proceed throughout the chapter exercises, forming an artist statement as you go. We start with a descriptive paragraph, because it's not really possible to write an accurate artist statement until you've created the work.*)

6. Be prepared to begin exploring your chosen subject during the Practical Exercises in Chapter 2. Remember to enjoy the process as you learn!

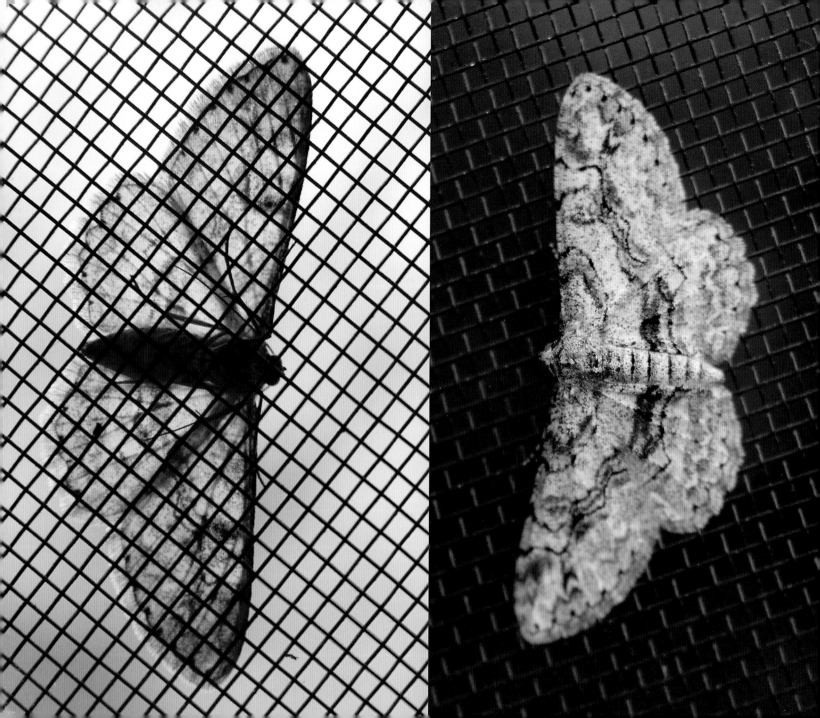

Metering and Exposure

> UNLIKE ANY OTHER VISUAL IMAGE, A PHOTOGRAPH IS NOT A RENDERING, AN IMITATION OR AN INTERPRETATION OF ITS SUBJECT, BUT ACTUALLY A TRACE OF IT. NO PAINTING OR DRAWING, HOWEVER NATURALIST, BELONGS TO ITS SUBJECT IN THE WAY THAT A PHOTOGRAPH DOES. —JOHN BERGER

To beginning photographers in my college courses and workshops I say, "In order to make successful photographs, you first have to understand basic technical aspects of exposure." And they reply, "Why should I do that when my camera figures out exposure for me? All I have to do is use Program mode!"

The answer is simple. *The technical aspects of exposure are intrinsic to the appearance and meaning of your images.* Using your camera's Program or Auto mode relinquishes your creative control, which you want to retain so you can make meaningful photographs.

Although learning the technical aspects of exposure seems intimidating at first, I've created a guide that's straightforward and easy to use. Armed with this knowledge, you'll make successful images while you enjoy a more rewarding photographic practice.

As you proceed, be sure to have your camera with you, set to Full Manual mode, and have your camera manual handy to help you identify and manipulate the various exposure controls as you learn them. Once you've completed the chapter you'll know how to read a light meter, and you'll be able to use your camera's technical controls to make good exposures. Let's get started.

WHAT IS EXPOSURE?

Photography literally means "light writing." Through exposure to light, we transcribe an image of the world directly onto light-sensitive media. In photography, the word "exposure" has dual meanings. First it refers to the amount of light that strikes and alters the photographic media, and then it refers to the resulting *density* (the overall lightness or darkness) of the image. There are four factors working together to determine exposure. After just a little study and practice, using them becomes second nature.

FOUR DETERMINANTS OF EXPOSURE

1. Amount of light in the scene

2. ISO (defines the photographic media's *sensitivity to light*)

3. Aperture (controls the *intensity* of light striking the media)

4. Shutter speed (controls the *duration of time* the media is exposed to light)

First, take some time to locate your camera's exposure determinants and familiarize yourself with how to manipulate them. Once you've done that, you'll have to understand one important term that relates to all of them in order to use them well—"stops." In photography, *a "stop" refers to the relative change in exposure to light caused by altering any of the four determinants.* Stops are specific and predictable, which makes calculating exposure much easier. Any 1-stop change in one direction will double the exposure to light; moving in the other direction will cut the exposure in half. Adding exposure will brighten the image, while subtracting exposure will darken it. Although cameras usually allow you to make finer exposure changes—{1/2} or {1/3} stop—while you learn it's easier to keep it simple and use the whole numbers for practice. As you proceed, I highly recommend memorizing the "whole stop" numeric designations that will be discussed.

The Amount of Light in the Scene

The amount of light in the scene is the first determinant of exposure. Light is either *ambient*—light already existing in the scene—or it's added using flash or strobe. Ambient light, also called available light, includes sunlight, moonlight, indoor lighting (such as tungsten, fluorescent, halogen, etc.), firelight, candlelight, and so on. Although flash and strobe

Light meter indications

Underexposure

Correct exposure

Overexposure

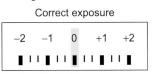
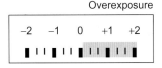

ILLUSTRATION © ANGELA FARIS BELT, 2010.

In-camera light meters indicate the degree to which a given combination of exposure determinants renders good exposure, underexposure, or overexposure. Camera meters may look different, but they all work the same way. Underexposure renders a darker image, overexposure renders a lighter one, and good exposure is "just right."

equipment offer added control over photographic lighting, learning exposure control is far easier using ambient light. Once you really understand exposure, you can advance to using artificial light, whose principles are built upon those of ambient light exposure.

To determine how much light is in the scene, you'll use your camera's *reflected-light meter*. This tool "reads" the amount of ambient light reflected toward you from the scene to determine how much is needed based on the ISO (the next exposure determinant). Based on these two factors, the meter then recommends an aperture and shutter speed combination to render good exposure density.

Meters indicate degrees of exposure from underexposure (too little light), to proper exposure, to overexposure (too much light). When you look inside your camera's viewfinder at the meter's exposure indicator, notice that it responds when you change your aperture or shutter speed, or when you point your

camera toward lighter and darker areas of a scene. This is your meter at work. There's no need to try controlling it just yet; as we move further into exposure you'll learn how to use it to get the exposure you need. You'll also learn to recognize those situations when your meter might be fooled, and to correct for that as well.

ISO (Also Known as Film or Sensor Speed)

Although you don't always control the amount of light in the scene, you do control the other three exposure determinants, starting with the ISO. As you already know, photographs are made using materials that are *sensitive to light*. The ISO identifies just how sensitive to light a particular medium is.

When using traditional film, you normally choose the ISO corresponding with the film's sensitivity and maintain that setting throughout the entire roll. With digital media, you can change the ISO at will, depending on your lighting requirements.

ISO	Lighting Requirements	Visual Qualities
50	Extremely slow response to light Good for still life and flash/strobe work Requires long shutter speeds or wide apertures	Film: Very fine grain Digital: Very low noise Both: Excellent fine detail
100	Slow response to light Great for bright light and still-life work *Two times faster than 50 ISO* *Half the speed of 200 ISO*	Film: Very fine grain Digital: Very low noise Both: Very fine detail
200	Medium-slow response to light	Film: Medium-fine grain Digital: Low noise Both: Very good, fine detail
400	Medium-fast response to light General-purpose; good in fluctuating light *Two times faster than 200 ISO* *Half the speed of 800 ISO*	Film: Medium grain Digital: Barely perceptible noise Both: Good fine detail
800	Fast response to light Good for stop-motion and fast-moving subjects	Film: Larger grain Digital: Some apparent noise Both: Less fine detail
1600	Very fast response to light *Four times faster than 400 ISO* *Two times faster than 800 ISO*	Film: Very large, coarse grain Digital: Visible noise Both: Very little fine detail
3200	Extremely fast response to light *Two times faster than 1600 ISO*	Film: Extreme, large, coarse grain Digital: Distractingly visible noise Both: Little to no fine detail

The ISO chart outlines the "whole stop" ISOs, describes the speed at which they respond to light, and explains the visual qualities of each. These numbers are pretty straightforward because they make mathematical sense: ISO 100 responds to light twice as fast as ISO 50; ISO 200 responds to light twice as fast as ISO 100, and so on. Although there are ISO's available in between whole-stops, if you memorize these you'll always know where you stand in terms of light-gathering ability.

From the ISO chart you see that the slower the light-gathering abilities of the media (film or sensor), the more exposure to light is required to record adequate image density. The primary advantage to slow ISOs such as 50 or 100 is their very fine image detail and clarity; however, it's difficult to impossible to freeze moving subjects or achieve adequate exposure in low lighting conditions. Slow ISOs are best for still life, flash photography, tripod work, or if you intend to blur the contents of the frame.

A medium ISO speed such as 400 has sort of best-of-both-worlds light sensitivity. It offers very good image detail and clarity, it's fast enough to shoot in most lighting situations, and most movement can be frozen by choosing appropriate aperture/shutter combinations (which we'll learn about in the next section). It's best to choose your own ISO settings rather than allow your camera to automatically select one for you.

ISO settings also affect the visual appearance of the image due to film grain and digital noise. The higher the ISO, the more grain or noise. Traditional media's light sensitivity increases as ISO increases because it literally has more light-sensitive material (usually silver) in it. For this reason, the material particles (grain) become larger and more visible as the image is enlarged.

Digital noise is similar to film grain, but the media works a bit differently. Digital sensors capture light according to an optimal ISO setting where image quality is its highest. Setting your digital camera's ISO slower or faster than the sensor's optimal setting amplifies an electronic signal created by exposure to light. The image clarity is therefore reduced and noise increased; the farther away you are from the optimal setting, the worse it gets. It's similar to turning music up above your speakers' optimal level; the volume gets louder but the sound quality gets worse. Refer to your camera's manual for its optimal ISO and stay as close to it as possible, given the lighting conditions. The disadvantage to digital noise it that, unlike film grain which can have a visually pleasing random distribution, digital noise rarely has a pleasant appearance. However, the advantage is that you're not necessarily stuck with it. Many high-end digital cameras have little apparent noise even up to 800 ISO, and your camera's software, Adobe Lightroom and Photoshop, and some excellent third-party plug-ins offer noise reduction capabilities that work very well to minimize or eliminate noise even up to 3200 ISO.

100 ISO: Increased clarity and detail

3200 ISO: Decreased clarity and detail

IMAGE © ANGELA FARIS BELT, 2007.

Film grain and digital nose are similar in that they reduce detail and clarity in the image. The two images following are enlargements of the frame above shot at 100 ISO and 3200 ISO.

These are the common, whole-stop ISO numbers. Like the whole aperture and shutter speed numbers, each 1-stop change (from one number to the next) either doubles the media's sensitivity to light or reduces it by half. Slower ISO's need more exposure to light than faster ISO's to achieve proper exposure and image density.

50 100 200 400 800 1600 3200

Apertures/F-Stops

The second determinant of exposure, the aperture, is commonly called an *f*-stop. It is the size of the opening through which light enters the camera. Normally located in the lens, the aperture controls the intensity of the light that will strike the photographic media for a given length of time (which is controlled by the shutter). The common, whole aperture numbers are as follows:

f/2, *f*/2.8, *f*/4, *f*/5.6, *f*/8, *f*/11, *f*/16, *f*/22, *f*/32, *f*/45, *f*/64

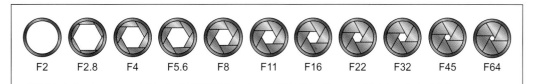

| F2 | F2.8 | F4 | F5.6 | F8 | F11 | F16 | F22 | F32 | F45 | F64 |

Opening the aperture increases exposure
Makes the image brighter

Closing the aperture decreases exposure
Makes the image darker

ILLUSTRATION © TOBY COCHRAN, 2007.

From left *f/2* to right *f/64*: Illustrating an aperture closing, or "stopping down" inside a lens. As aperture numbers increase, their size becomes smaller. So larger numbers are referred to as smaller apertures. As apertures become smaller, less light strikes the media, reducing the exposure. Also, as apertures become smaller, depth of field increases throughout the image. This will be covered in depth in Chapter 4.

Note that while *f/2* is a small number it is a large aperture and lets in the most light; while *f/64* is a large number it is a small aperture and lets in little light. I know it sounds backward. Knowing how the numeric designations came to be doesn't matter; remembering their interrelationship does. *Each whole aperture number lets in exactly half or two times the amount of light let in by the whole number directly before or after it.* For example:

- *f/2.8* lets in half the light of *f/2* and two times more light than *f/4*.

- *f/5.6* lets in half the light of *f/4* and two times more than *f/8*.

- *f/16* lets in half the light of *f/11* and two times more than *f/22*.

Knowing these relationships and memorizing the whole aperture numbers make exposure calculation much easier and enriches your photographic practice. Although most lenses don't offer the entire aperture range (some may offer *f/4* to *f/22* only, others from *f/2.8* to *f/16* only), they do allow you to set the aperture in between full stops for finer control.

Learn how to change your camera's apertures, and determine whether it allows you to make {1/2} stop or {1/3} stop changes in between whole aperture numbers. Try to determine what your meter is telling you when you change apertures; for instance, your meter should indicate that as you close the aperture you are reducing the exposure to light, and as you open the aperture you are increasing exposure to light.

ZOOM LENSES AND VARIABLE MAXIMUM APERTURES

With zoom lenses, the maximum aperture (smallest number) may vary depending on the zoom range. For instance, a 28–70 mm, $f/4$–5.6 zoom lens has more light-gathering ability at 28 mm (where the aperture will open to $f/4$) than it will at 70 mm (where it will only open to $f/5.6$). This makes the lens lighter weight, smaller diameter, and less expensive; however, lenses with very wide zoom ranges have reduced image quality. When buying lenses, look for a prime lens (non-zooming), or short zoom ranges for best quality, and look for the largest maximum aperture you can afford to give you more exposure control and creative flexibility.

Shutter Speeds

The third determinant of exposure that you control in-camera is the shutter speed. Normally located in the camera body just in front of the media, the shutter controls the duration of time the media is exposed to light. When you depress the shutter-release mechanism, a curtain within the camera

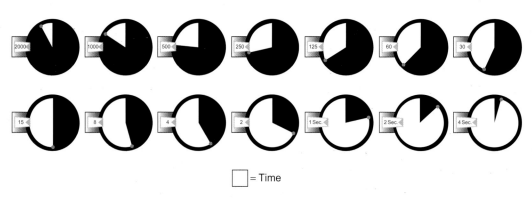

☐ = Time

Faster shutter speeds let in less light Slower shutter speeds let in more light

ILLUSTRATION © TOBY COCHRAN, 2007.

From top left 1/2000 of a second to bottom right 4 seconds: Illustrating the shutter speed slowing down in 1-stop increments. As the shutter speed slows down, light strikes the media for a longer time, which increases exposure. The faster the shutter speed, the better your chances of freezing motion in the image; the slower the shutter speed, the more likely you are to blur it. This is covered in depth in Chapter 5.

opens, allowing light coming through the aperture to strike the media for a specific amount of time. The aperture and shutter speed are used to balance the intensity of light and the duration of exposure to it. The relationship between the whole shutter speeds is just like the relationship between whole apertures, that is, any 1-stop change will either double or cut in half the amount of exposure to light. This comes in very handy when you're trying to determine proper exposure.

The common, whole-stop shutter speeds are as follows:

1/8000, 1/4000, 1/2000, 1/1000, 1/500, 1/250, 1/125, 1/60, 1/30, 1/15, 1/8, 1/4, 1/2, 1 sec. 2″ 4″ 8″ …

On nearly all shutter speed indicators, the number "2" refers to one half of a second, the number "30" one thirtieth of a second, the number "1000" one one-thousandth of a second, and so on. In photographic terms, 1/30 is considered a slow shutter speed (too slow to avoid a blurry photograph unless you're really steady, have image stabilization lenses, or use a tripod). Average shutter speeds range from 1/60 to 1/500 of a second, depending on the lighting situation. Because the shutter speed determines the duration of time that light is allowed to strike the media, it makes sense that slower shutter speeds add exposure whereas faster shutter speeds reduce exposure.

Take some time to learn how to change your camera's shutter speeds, and determine whether it allows you to make {1/2}-stop or {1/3}-stop changes in between whole shutter speed numbers. Try to determine what your meter is telling you when you change shutter speeds; for instance, your meter should indicate that as you speed up the shutter you are lessening the exposure to light, and as you slow down the shutter you are increasing exposure to light. Work with your camera's aperture and shutter speed settings together under bright lighting conditions to manipulate exposure so you see how to move the meter indicator to proper exposure.

CAMERA SHAKE: AVOID BLURRY PICTURES AT SLOWER SHUTTER SPEEDS

Camera shake refers to creating a blurry picture from using too slow a shutter speed while handholding the camera. Beyond using a tripod, you can still avoid it. Here's the basic rule: *Always use a shutter speed that is the numerical equivalent or faster in relation to the focal length of the lens, and never go slower than 1/60.* It's best to err on the side of too fast a shutter speed if you don't want blurry pictures. For example:

- If you're using a 100 mm lens, use a shutter speed of at least 1/125.

- If you're using a 200 mm lens, use a shutter speed of at least 1/250.

- With any focal length of 50 mm or shorter (say, 16 mm) you should still use a shutter speed of at least 1/60 to avoid camera shake.

- If you use a tripod in conjunction with a cable release or the camera's onboard timer, you can use just about as slow a shutter speed as necessary as long as the subject isn't moving.

Types of Shutters

There are two basic types of shutter mechanisms: leaf and focal plane (also called curtain) shutters. Leaf shutters are located within the camera's lens and are most commonly found in medium- and large-format cameras. Focal plane shutters are located inside the camera body, just in front of the film or sensor plane, and are most common in SLR cameras. The two kinds of shutters have several different attributes that are significant when using flash or strobe. Focal plane shutters are limited to the flash synch speed or slower in order to expose the entire picture plane, because this is the fastest speed at which the entire image area is open to light simultaneously. You can find the flash synch speed for your particular camera in your camera's manual, and it's usually 1/60 to 1/250 of a second. Leaf shutters, on the other hand, can be used with a flash or strobe at any speed, because the aperture opens from the center outward, a significant advantage for studio and commercial photographers. However, because of this functionality, leaf shutters also have a slower minimum shutter speed than do focal plane shutters. That is, while focal plane shutters commonly expose as fast as 1/4000 of a second, leaf shutters are about 1/500 of a second at their fastest. Most all photographers using this text are using focal plane shutters, so you won't need to worry about the differences here.

UNDERSTANDING YOUR LIGHT METER

If you're working with in-camera meters, it's helpful to understand how they work. In-camera through-the-lens (TTL) meters are a type of *reflected-light meter;* they read *reflectance value,* or how much light is reflected off the surface of the subject. Your camera's light meter is a tool, a guide to help you determine what the proper exposure will be for a particular scene under a particular quantity of light. Once you understand how your light meter works, it becomes an indispensable tool.

For a light meter to guide you properly, it first needs one vital piece of information: the ISO sensitivity setting. Based on this information, the light meter "reads" the amount of light reflected from within its field of view and determines how much of that light it needs to properly expose the media. Your meter assumes every scene is an average scene, containing a range of tones from black to white, so when interpreting its exposure recommendation, there is one characteristic you can always count on: *Your light meter averages any light that it reads to middle gray (also known as 18% gray).* It doesn't matter whether it's really an *average scene,* a *high-key scene* (a predominantly light-toned scene, for instance, a white dog in a snow drift), or a *low-key scene* (a predominantly dark-toned scene, say, a black cat on a dark stone path). Your meter will average the light reflected from within its field of view and give you an exposure

recommendation to render the scene middle gray. Although it might seem odd, this fact is actually a benefit to you.

High-key and low-key scenes consist of tones that "fool" your reflective meter. A high-key scene is up to two stops (four times) brighter than an average scene, and a low-key scene is up to two stops darker than an average scene. The result of exposing at the meter reading in these cases is called *subject failure;* that is, *the reflectance value of the subject fails to produce a middle-gray reading* and the density of the image is wrong. Your meter will recommend exposures that will render even high-key and low-key scenes gray. Of course, you don't always want the scenes you shoot to look gray (i.e., you want the white dog in the snow drift to look white, not gray; and the black cat on the stone path you want to be a predominantly dark to black scene, also not gray). In these situations you have to override your meter's recommendation, adding up to two stops of exposure to high-key scenes to brighten them, and subtracting up to two stops for low-key scenes to darken them. Because your meter does the averaging whether you want it to or not, there are a couple of simple rules you can follow so that your photographs render the tones you want. Read on.

PUTTING IT ALL TOGETHER

At this point you have a good idea about how ISOs, apertures, and shutter speeds work, and how to manipulate them. You'll notice that as you change these settings your camera

meter indicates how close you are to exposing for the correct density. There are essentially three ways to expose photographic media:

1. Normal exposure (N) means the exposure is correct; an average-tone scene should contain all tones with proper density and detail.

2. Overexposure (+) means the medium will receive more light than is needed to average to middle-gray, and so will become increasingly lighter.

3. Underexposure (–) means the medium will receive less light than is needed to average to middle-gray, and so will be increasingly darker.

Your goal is to expose properly *based on the tonal range of the scene,* and because the exposure relationship between whole shutter speeds and whole apertures is the same, any number of *equivalent exposures* exist for a single scene.

What this means is that if an exposure of *f/8* at 1/125 is correct, then an exposure of *f/4* at 1/500 will also be correct, as will an exposure of *f/32* at 1/8. In other words, if you close the aperture to let in one stop less light, and you slow down the shutter speed to let in one stop more light, then the resulting exposure densities will be the same. There are reasons to choose one exposure combination over others, and the chapters on apertures and shutter speeds cover this in depth. The following example of water moving over a rock will help to demonstrate.

| Your initial meter reading has the right exposure, but a noncommittal image in terms of the rushing water as it relates visually to the still leaves. You want either blurred or frozen motion to choose from. | So you decide to blur the water using a slower shutter speed. You change your ISO to the slowest, and your aperture to the smallest, so that your shutter speed can be longer, creating the most blur you can get from your camera. | Finally you decide to freeze the motion of the water as best you can. So you change your ISO to the fastest, and your aperture to the largest, so that your shutter speed can be shorter, causing the water to be frozen in time. |

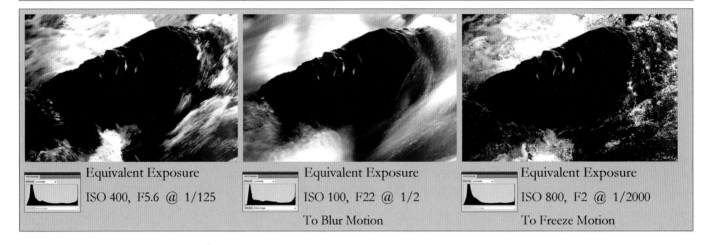

Equivalent Exposure	Equivalent Exposure	Equivalent Exposure
ISO 400, F5.6 @ 1/125	ISO 100, F22 @ 1/2	ISO 800, F2 @ 1/2000
	To Blur Motion	To Freeze Motion

IMAGE © ANGELA FARIS BELT.

These images were made with equivalent exposures; each has the same amount of tonal density. Any number of ISO-aperture-shutter combinations will provide equivalent exposures, but they will produce different visual effects, which are clear to see here. How to control these effects is covered at length in the chapters on apertures and shutter speeds.

Bracketing to Ensure Proper Exposure

Even with advanced metering systems, to ensure that you record an accurate exposure, *bracketing* may sometimes be in order. *Bracketing means making several different exposures of the same scene.* In a way, this is the opposite of equivalent exposures; you bracket to capture a range of exposure densities so you have several to edit from later. To bracket, make an exposure at the camera's recommended meter reading,

then make a second exposure at {1/2} to 1 stop over the meter reading (for a lighter image), and then make a third exposure at {1/2} to 1 stop under the meter reading (for a darker image). This technique is often used to find the right exposure for high-key and low-key scenes (which is demonstrated in the next section) and to cover your bases if you're not sure of the proper exposure.

Evaluating Exposure with Digital Cameras

The very best advice: never, never, ever—never ever—trust your LCD monitor. Always refer to your histogram (explained in the following section) to judge your exposure.

Advanced Metering Systems

Many contemporary metering systems are good at guessing the tonal range of a scene. Those that are provide a much more accurate meter reading than older analog meters. For instance, I own a camera whose meter is accurate to within {1/2} stop of the correct reading even in high-key and low-key situations, so if I add or subtract the usual two stops I will have gone too far. To guarantee proper exposure, you'll want to practice in various tonal range scenes to determine how your camera's meter responds.

DIGITAL MEDIA HISTOGRAMS DEMYSTIFIED

Histograms provide a graphic representation of how the image's tones are distributed throughout the tonal range possible to capture. They are the only accurate way to decide if your exposure is correct.

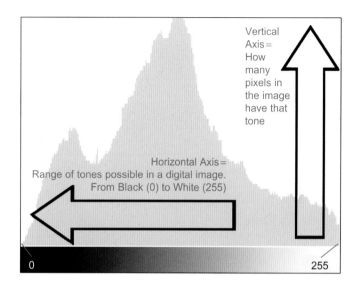

A histogram's horizontal axis shows the tones possible to capture in the image. These tones range from black (0) to white (255). The vertical axis "stacks" the number of pixels within each of these tones you have captured.

A histogram's horizontal axis shows the tones possible to capture in the image. These tones range from black (0) to white (255). The vertical axis tells you how many pixels within each of these tones you have captured. Histograms aren't right or wrong—they just are. They are a reflection of the tones in the scene as they will be rendered in the image. Average scenes, accurately exposed, will have an average distribution of pixels throughout the tonal range (left to right). High-key scenes will have the majority of their pixels to the

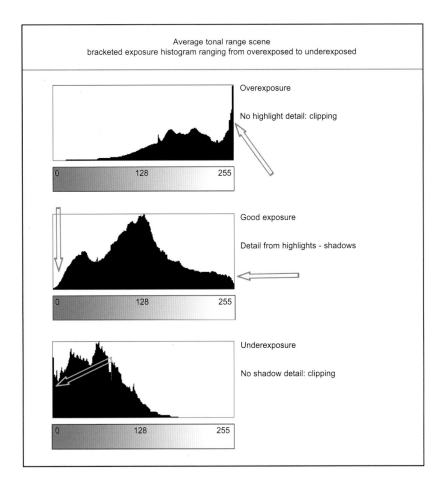

Average tonal range scene
bracketed exposure histogram ranging from overexposed to underexposed

Overexposure

No highlight detail: clipping

0 128 255

Good exposure

Detail from highlights - shadows

0 128 255

Underexposure

No shadow detail: clipping

0 128 255

ILLUSTRATION © ANGELA FARIS BELT.

Average-tone scenes will have a relatively even distribution of pixels throughout the histogram from left (black) to right (white). Clipping occurs when the image is underexposed or overexposed, and the histogram indicates this by stacking pixels against its sides. A histogram with too many pixels to the right indicates that another exposure to less light is required. A histogram with too many pixels to the left indicates that another exposure to more light is required.

right side of the histogram, and low-key scenes will have the majority of pixels to the left side of the histogram.

Clipping

If your histogram presses against the top of the chart, there is no need to worry; you simply have more pixels in these tones throughout the image. If your histogram presses up against the left or right sides of the chart, then the image is missing some shadow or highlight detail. If there are only a few pixels stacked vertically against either side of the chart, then there are only a few pixels too dark or too bright to record detail. If there are a lot of pixels pushed against the sides of the chart, then a lot of the image is either too light or too dark to record detail and will be rendered as either solid white or solid black.

THREE TONAL RANGES: EXPOSURE AND HISTOGRAMS EXPLAINED

Average Scenes

As exposure decreases, the image becomes darker; as exposure increases, the image becomes lighter.

You are looking at an "average" scene, one in which there are tones varying from white to black—highlight to shadow—throughout. Your camera meter indicates that an exposure of *f*/5.6 at 1/60 is correct. You could expose at this setting; however, you want more depth of field (that is, you want more in focus from near to far within the scene). You simply move the aperture to a setting that will allow you to have more depth of field, say, *f*/11. But now your meter indicates this setting will underexpose the image by two stops. The remedy is to slow down your shutter speed to compensate for the change in aperture, so the shutter speed for *f*/11 is 1/15. The amount of exposure is exactly the same; the only difference is the configuration: you're letting two stops less light in through the aperture and balancing that with two stops more light via a longer shutter speed, so the density of both images will be consistent. Unlike making equivalent exposures, bracketing makes a range of exposures. See the sample images of the chili peppers drying to help you envision under, proper, and overexposure.

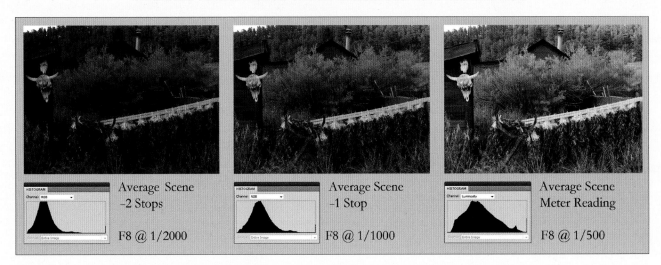

AVERAGE TONAL RANGE SCENE BRACKETED TO UNDEREXPOSE

Average Scene
–2 Stops

F8 @ 1/2000

Average Scene
–1 Stop

F8 @ 1/1000

Average Scene
Meter Reading

F8 @ 1/500

The saturation of the red chili peppers caught my eye, so I captured this average scene with bracketed exposures to ensure detail throughout the tonal range. *From right:* Normal exposure, −1 stop underexposed, and −2 stops underexposed. The histogram proves that the meter reading provided the best exposure, with only minor clipping in the top left sky. As exposure decreases, the image becomes darker, and the histogram shows more and more pixels beginning to lose detail.

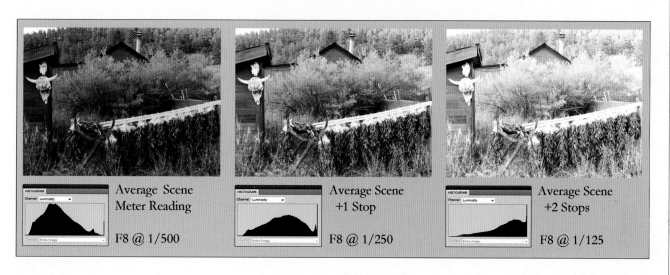

AVERAGE TONAL RANGE SCENE BRACKETED TO OVEREXPOSE

Average Scene
Meter Reading

F8 @ 1/500

Average Scene
+1 Stop

F8 @ 1/250

Average Scene
+2 Stops

F8 @ 1/125

IMAGE © ANGELA FARIS BELT.

As I was there I also captured this average scene with bracketed overexposures. *From left:* Normal exposure, +1 stop overexposed, and +2 stops overexposed. The histogram proves once again that the meter reading provided the best exposure. As exposure increases, the image becomes brighter, and the histogram shows more and more pixels beginning to lose detail.

HIGH-KEY SCENE BRACKETED

High Key Scene
Meter Reading

F16 @ 1/250

High Key Scene
+ 1 Stop

F11 @ 1/250

High Key Scene
+ 2 Stops

F8 @ 1/250

IMAGE © ANGELA FARIS BELT.

A high-key scene with an initial exposure at the reflected-meter reading, then bracketed at +1 stop overexposed, and a second at +2 stops overexposed. A high-key scene is one that is predominantly light in tone. For scenes such as these, you might need to overexpose—that is, add more light than the meter reading indicates so that your image has bright white tones and doesn't look too gray.

High-Key Scenes

A high-key scene is predominantly light in tone. For scenes like these, you might need to overexpose—that is, add more light than the meter reading indicates so the scene looks light.

You are looking at light aspen tree branches covered in snow. It's a bright, foggy day and the whole scene is light in tone. Your camera meter indicates that a good exposure would be *f*/8 at 1/250. If you made the photograph at this setting, the image would likely be very gray overall with a gray landscape that would resemble snow and fog if only the image were lighter. That's no good. To remedy the situation, you would need to *overexpose*—that is, allow more light to get to the medium (sensor or film), thereby rendering the high-key scene light in tone. Remember, your meter thinks every scene is average gray, so you have to interpret and override it. Depending on the medium, overexposing by 1{1/2} to 2 stops is sufficient. To do this you could either open to a larger aperture such as *f*/4 at 1/250, or you could slow to a longer shutter speed such as *f*/8 at 1/60. Either decision would brighten the image and render its tones closer to what they were in the scene.

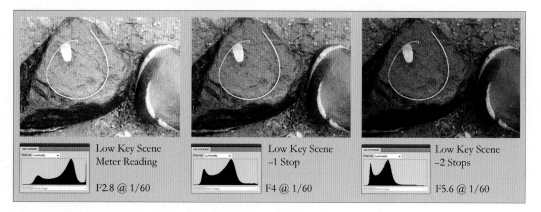

LOW-KEY SCENE BRACKETED

Low Key Scene
Meter Reading

F2.8 @ 1/60

Low Key Scene
–1 Stop

F4 @ 1/60

Low Key Scene
–2 Stops

F5.6 @ 1/60

IMAGE © ANGELA FARIS BELT.

A low-key scene with an initial exposure made at the reflected-meter reading, then bracketed at –1 stop underexposed, and then –2 stops underexposed. A low-key scene is one that is predominantly dark in tone. For scenes such as these, you might need to underexpose—that is, provide less light than the meter reading indicates so that your image has rich black tones and doesn't look washed out.

Low-Key Scenes

A low-key scene is predominantly dark in tone. For scenes like these, you might need to underexpose—that is, provide less light than the meter reading indicates so that the scene looks dark.

You are looking at black stones on dark ground with a lovely curved leaf. It is a dark scene, but you can make out all the details in the dark shadows. Your camera meter indicates that an exposure of *f*/2.8 at 1/60 would be fine. If you made the exposure at that setting, the stones would be washed out and the dark ground would be a washed-out gray tone. To correct the situation, you would need to *underexpose*—that is, allow less

light to strike the medium, thereby rendering the low-key scene dark in tone. Remember, your meter thinks every scene is average gray, so you have to interpret and override it. Depending on the medium, underexposing by 1{1/2} to 2 stops is sufficient. To do this you could either close to a smaller aperture such as *f*/5.6 at 1/60 or you could move to a faster shutter speed such as *f*/2.8 at 1/250. Either decision would darken the image and render its tones closer to what they were in the scene.

Understanding proper metering and exposure for your particular photographic materials is essential, prior to attempting to manipulate them for creative or communicative effect. The

technical elements of the photographic process—in particular aperture and shutter speed combinations—are the foundation upon which photographic images are made. Use the exercises at the end of this chapter to practice metering and bracketing average, high-key, and low-key scenes to better understand how your camera's meter responds and how to interpret histograms. This will enable you to create images as you conceive them to be.

ADVANCED EXPLANATION OF EXPOSURE

A basic understanding of exposure is usually sufficient to allow you to expose a range of scenes accurately. However, many photographers benefit from understanding exposure in more in-depth terms. If you're one of them, the following section might be for you.

Reflectance Value

Your in-camera meter is reading reflected light in shades of gray; it isn't taking color into account. Certain tones reflect a certain percentage of the light striking them, and this, combined with how apertures and shutter speeds interrelate, is very convenient. In addition to any one-stop change in aperture or shutter speed doubling or cutting in half the

ILLUSTRATION © ANGELA FARIS BELT, 2010.

You should note that this chart is designed to assist you in understanding metering and exposure. Resources pertaining to the *Zone System* might also be of value for photographers wanting more extensive practice in complex exposure control for both film and digital photography.

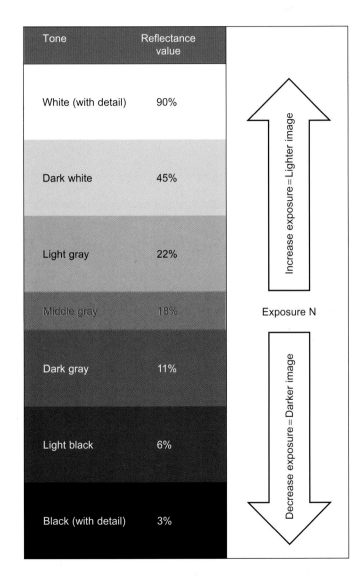

Tone	Reflectance value
White (with detail)	90%
Dark white	45%
Light gray	22%
Middle gray	18%
Dark gray	11%
Light black	6%
Black (with detail)	3%

Increase exposure = Lighter image

Exposure N

Decrease exposure = Darker image

amount of exposure to light, there are five whole stops between black and white tone, each reflecting double or half the amount of light of its tonal neighbor.

This tonal relationship is a good reference point for calculating accurate exposure in high-key and low-key conditions and to correct exposures that are wrong. Essentially, white tone with detail reflects about 2{1/2} stops more light than middle gray, and black tone with detail reflects about 2{1/2} stops less light than middle gray. This means when you're shooting an average scene, you will usually go with what your meter indicates. When you're shooting a high-key scene, you'll usually want to add exposure (up to +2{1/2} stops) to what the meter indicates so that bright tones are rendered as bright. When you're shooting a low-key scene, you'll usually want to subtract exposure (down to −2{1/2} stops) from what the meter indicates so that dark tones are rendered as dark. Remember, your meter makes exposure recommendations to render any scene as an average one, so when you interpret it and decide to override its recommendation you need to know which way to go.

Stops and Factors

We already know that in photographic terms, a "stop" refers to a relative change in exposure to light that can be made by altering any of the four determinants of exposure. Stops are specific and predictable, and their "whole" numeric designations are a good baseline to memorize, although often you can make finer exposure changes in between stops. Any whole stop exposure change in one direction will double the exposure to light while moving in the other direction will cut the exposure in half.

Figuring exposure beyond a single stop change can be challenging for beginning photographers, but there is a mathematical chart—called the stop-factor chart—that can help. With any whole-stop exposure change, a multiplication factor is applied. The chart is useful in many situations and will be referred to when necessary throughout this book. You will also find reference to it in nearly any studio lighting manual.

A one-stop exposure change = two times or half the amount of light striking the medium. Therefore, changing exposure by more than one stop changes the amount of light by an exponential factor.

Stop	0 stop change	1 stop change	2 stop change	3 stop change	4 stop change	5 stop change	6 stop change
Factor	1× No change	2× or {1/2}	4× or {1/4}	8× or {1/8}	16× or {1/16}	32× or {1/32}	64× or {1/64}

Contrast

The stop-factor chart is used when describing the difference in stops between highlights and shadows in the same scene. It is also used to describe the range of tone from highlight to shadow that different media can record. This is a complex subject beyond the scope of this text, but it helps to understand that if there is a wide difference between highlights and shadows in a scene, your medium might not hold detail throughout the entire tonal range. These scenes are referred to as *high contrast*. Other scenes don't use the medium's entire tonal range; these are referred to as *low contrast*. The following scenes and histograms describe what high-contrast and low-contrast scenes might look like with proper exposure:

High-contrast scene. One with a broad tonal range from highlight to shadow. These high-contrast scenes

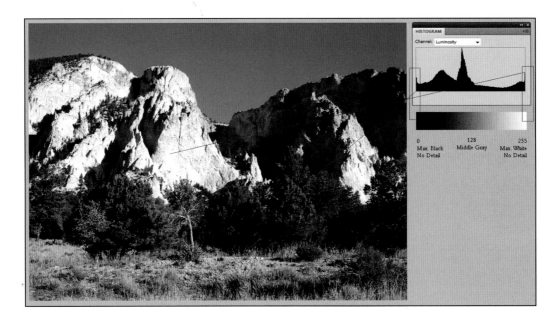

IMAGE © ANGELA FARIS BELT, 2010.

In this image, the histogram indicates a very high contrast scene—the tones extending into the bright highlights and dark shadow areas are being clipped, or running off the edges of the histogram. The image was shot under specular light, which produces a high ratio. The medium could not hold detail throughout this wide tonal range.

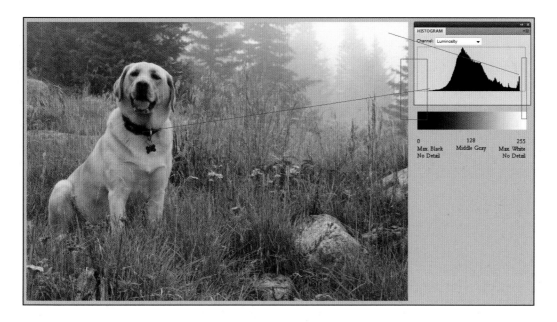

Channel: Luminosity

0
Max. Black
No Detail

128
Middle Gray

255
Max. White
No Detail

IMAGE © ANGELA FARIS BELT, 2007.

In this image, the histogram indicates a very low contrast scene—there are no tones extending into the bright highlights or dark shadow areas. The image was shot under diffuse light, which produces a low ratio. If there are no very dark shadows or very bright highlights in the scene, then with proper exposure these tones don't appear in the histogram.

sometimes have a tonal range too extreme for media to record while holding detail at both ends.

Low-contrast scene. One with a narrow tonal range from highlight to shadow. Not all scenes contain the entire tonal range from black and white. These low-contrast scenes have detail only toward the center of the tonal range.

CHAPTER EXERCISES: METERING, EQUIVALENT EXPOSURES, AND BRACKETING

Before you begin, remember to choose a specific subject or topic to concentrate on throughout all the chapter exercises. In the end you'll have a portfolio with continuity that explores each of the elements of photographic language.

Begin exploring your subject (selecting one is outlined in Chapter 1) using the following exercises to help you master your camera's technical operations and exposure.

This text assumes that you have an understanding of how to process and print your chosen media, and as such does not explain these things for the traditional or digital darkroom. This text centers specifically on controlling visual language through the camera's technical attributes; however, there are plenty of other resources on processing and printing that you can refer to if needed.

For each of the following exercises, choosing a still subject and using a tripod will ensure that each frame's composition stays the same, and makes seeing the comparisons we're after easier. Also, if you are outside under natural light, be sure that clouds are not moving in and out or your exposure readings will change.

1. Equivalent Exposures

Equivalent exposures means making several exposures of the same scene using different aperture and shutter speed combinations and maintaining the same density throughout the images.

Find an average scene representative of your chosen subject, frame it in your viewfinder and focus, and with your camera on a tripod, make the following three exposures:

- An initial exposure at the meter's recommended setting.
- A second exposure opening your aperture one stop to allow in more light while speeding up your shutter speed one stop to let in less light.
- A final exposure opening your aperture another stop to allow in more light while speeding up your shutter speed another stop to let in less light.

When done correctly, your meter should indicate that each exposure is the same as the others, and the density of all three images should be nearly identical.

Find another average scene representative of your chosen subject, frame it in your viewfinder and focus, and with your camera on a tripod, make the following three exposures:

- An initial exposure at the meter's recommended setting.
- A second exposure closing your aperture one stop to allow in less light while slowing down your shutter speed one stop to let in more light.
- A final exposure closing your aperture another stop to allow in less light while slowing down your shutter speed another stop to let in more light.

When done correctly, your meter should indicate that each exposure is the same as the others, and the density of all three images should be nearly identical.

2. Average Scene Bracket

Bracketing a scene means making several different exposures of that scene in order to have the same image with a range of densities.

Find an average scene representative of your chosen subject, frame it in your viewfinder and focus, and with your camera on a tripod, make the following underexposure brackets:

- An initial exposure at the meter's recommended reading.

- A second exposure closing the aperture one stop (do not compensate with the shutter speed). The meter should indicate underexposure, and the image should become darker.

- A third exposure closing the aperture another stop (again not compensating with the shutter speed). The meter should indicate further underexposure, and the image should become even darker.

Without moving the tripod, make the following overexposure brackets:

- An initial exposure at the meter's recommended reading.

- A second exposure opening the aperture one stop (do not compensate with the shutter speed). The meter should indicate overexposure, and the image should become lighter.

- A third exposure opening the aperture another stop (again not compensating with the shutter speed). The meter should indicate overexposure, and the image should become even lighter.

When done correctly, you should have two equivalent exposures at the meter reading and brackets extending two stops over and under the correct exposure, similar to the chili peppers image bracketed earlier in the chapter.

3. High-Key Scene Bracket

High-key scenes are predominantly light in tone; their contents are lighter than average scenes, and as such they might require a degree of overexposure to accurately represent the tones in the scene.

Find a high-key scene representative of your chosen subject, frame it in your viewfinder and focus, and with your camera on a tripod, make the following exposures:

- An initial exposure at the meter's recommended setting.

- A second exposure at +1 stop above the meter's recommended setting by either opening the aperture *or* slowing down the shutter speed by one whole stop.

- A third exposure at +2 stops above the meter's recommended setting by either opening the aperture *or* slowing down the shutter speed by another whole stop.

When done correctly, these scenes should get progressively lighter, and you should be able to determine which exposure is best. Keep in mind that sometimes the best exposure is in between whole stop changes. This exercise will help you to learn how accurately your meter responds to high-key

scenes and, if you're using digital media, how to interpret your histograms for such scenes.

Once you've shot one high-key bracket, find another high-key scene and repeat.

4. Low-Key Scene Bracket

Low-key scenes are predominantly dark in tone; their contents are darker than average scenes, and as such they might require a degree of underexposure to accurately represent the tones in the scene.

Find a low-key scene representative of your chosen subject, frame it in your viewfinder and focus, and without moving the tripod, make the following exposures:

- An initial exposure at the meter's recommended setting.

- A second exposure at −1 stop below the meter's recommended setting by either closing the aperture *or* speeding up the shutter speed one whole stop.

- A third exposure at −2 stops below the meter's recommended setting by either closing the aperture *or* speeding up the shutter speed by another whole stop.

When done correctly, these scenes should get progressively darker, and you should be able to determine which exposure is best. Keep in mind that sometimes the best exposure is in between whole stop changes. This exercise will help you to learn how accurately your meter responds to low-key scenes and, if you're using digital media, how to interpret your histograms for such scenes.

Once you've shot one low-key bracket, find another high-key scene and repeat.

Framing, Borders, and Multiple Frames

PART 1: FRAMING

> PHOTOGRAPHY IS ABOUT FINDING OUT WHAT CAN HAPPEN
> IN THE FRAME. WHEN YOU PUT FOUR EDGES AROUND SOME
> FACTS, YOU CHANGE THOSE FACTS. —GARRY WINOGRAND

INTRODUCTION: FRAMING, THE FIRST PHOTOGRAPHIC ELEMENT

Once we photographers understand metering and exposure, we're most interested in creating images that apply our technical knowledge in meaningful ways. While the traditional elements of design aid composition, there are additional aspects within *the process of making photographs* that require examination because this process leads to a final image that is *created all at once*. That is to say, while other 2-dimensional arts reveal traces of their additive and subtractive processes over time, finished photographs have no such reference, even though the process plays an equally important role in their creation. This means photographers have

to be even more aware of the process until the moment of exposure, covering all of our visual bases while designing the image, because once the moment has passed, there is no opportunity to refine it.

Designing a photograph requires doing so while seeing, while formally arranging contents within *the photographic frame—the imposed confines of the camera's format.* This process applies to all photographs made with all camera formats; and although they range widely in size, camera formats generally "crop" the image to the shape of the viewfinder placed in front of your eye. But using a camera to translate the three-dimensional world onto two-dimensional media, and doing it well, isn't as easy as it might seem. That's what this chapter is about: mastering the first element of photography—framing. Part 1 explores how to meaningfully arrange contents and depth within the photographic frame, Part 2 addresses the edges of that frame, and Part 3 moves beyond the single frame to combining multiple frames into a single image.

One certainty is that *every camera imposes a frame*; as soon as you place it between the world and your eye, you engage with the first photographic element that directly affects the visual outcome and meaning of the image. Like a formally structured work of written language (a haiku, sonnet, etc.), the camera encapsulates part of the world within a defined structure. Framing reveals a photographer's decisions regarding image content; it's the transition point between the world and an image of it.

CONSCIOUS FRAMING, VISUAL QUALITY, AND PHOTOGRAPHIC MEANING

Here's the rub: *the frame contains the content that viewers see and interpret regardless of the attention paid to it by the photographer.* Photographers make framing decisions based upon their opinion of the important aspects of the scene; once captured, the image contains all the content it will contain. This is important to keep in mind for two reasons. First, the contents of the frame are a viewer's only reference to what was in front of the camera. Visually literate viewers assume the photographer intentionally included everything he or she saw in the image, and through framing the photographer tacitly states that all contents refer to the meaning of the image. Imagine that someone shows you a picture of a group of people and says, "Just ignore that guy. I don't know who that is." Well, ignoring that guy can be difficult and problematic because he is captured in the frame along with the intended people. In this respect, framing the contents of a photograph is like composing a work of literature; conscientious authors avoid random words and unnecessary sentences because non sequiturs misdirect readers' interpretation. Meticulous readers interpret each sentence (indeed each word) of a novel to derive meaning, and meticulous viewers interpret every aspect of a photograph's content to derive meaning as well.

The second reason why image contents are important is that while the photographer experiences all the events

surrounding the making of the image, the viewers don't benefit from that expanded context. Their experience is confined to the final image. So your experience as a photographer "being there" can't invade your judgment about the quality or communicative effectiveness of your photographs. This gap in experience is well explained by Annie Dillard in *The Writing Life:*

"Every year the aspiring photographer brought a stack of his best prints to an old, honored photographer, seeking his judgment. Every year the old man studied the prints and painstakingly ordered them into two piles, bad and good. Every year the old man moved a certain landscape print into the bad stack. At length he turned to the young man: "You submit this same landscape every year, and every year I put it on the bad stack. Why do you like it so much?" The young photographer said, "Because I had to climb a mountain to get it."

Framing is the building block of photographic language in that viewers interpret what is in the frame, not what isn't. *But from the photographer's perspective, framing is also subtractive.* The process of capturing a photograph has as much to do with what we choose to "frame out" as what we choose to "frame in." In this way photographers distill the content of the image to its essentials. It is for these reasons that a photographer's shift in attention from "seeing" to "seeing through the camera" is worth cultivating. And that's what framing is all about.

IMAGE AND ILLUSTRATION © ANGELA FARIS BELT, 2010.

The world extends beyond the frame. Camera formats confine the image to the area of even illumination within a circle of illumination projected through the camera lens. Although the photographer's field of vision is as boundless as the world we move throughout, our photographs have definite boundaries. Framing requires decisions about both what to keep in and what to leave outside of that boundary.

ORGANIZING THE FRAME: PICTURE PLANES, VANTAGE POINT, AND JUXTAPOSITION

The frame does more than include and exclude potential content; *it plays an indispensable role in organizing that content.* Since we're projecting our 3-dimensional world onto a 2-dimensional media plane, we force content at varying spatial distances into new and interesting relationships with one another. When we change our position in space, we also alter those relationships. This fact touches on three important aspects of framing: *picture planes, vantage point,* and *juxtaposition.*

Picture Planes

The first organizational aspect of framing, *picture planes—the flat, physical surface on which the image is captured*—delineate the way three-dimensional space is ordered when it's projected through a single lens onto a two-dimensional plane. Picture planes contain only *the illusion* of distance (near to far) and volume (an object's mass). This illusion is so powerful that viewers refer to objects in images being "in front of" or "behind" other objects, when in fact everything in the image exists on a single, flat plane. So as photographers, how do we decide whether to minimize or emphasize the illusion of space within the picture plane, and once we decide how do we accomplish it?

In addition to translating space and volume, picture planes also play an important role in setting the pace at which the viewer's eye moves through the image. In other words,

there is also an illusion when looking at a photograph that our sense of focus literally advances and recedes with the foreground and background distance relationships in the image. Will the picture plane encourage the viewers toward lingering contemplation or move them more rapidly through the image content? Which pace best reflects your subject?

IMAGE © JON LYBROOK, 2009.

The illusion of depth. This landscape image illustrates how powerful the illusion of depth is when we view a photograph. Here you don't feel as though everything is the same distance from your eye, with the mountains above the ground, and the clouds above the mountains on the same plane. You *feel* as though your focus recedes into space from the bottom of the image (where the rocks at the bottom of the frame seem to be just before our feet), rises up with the mountains, and then focuses closer to you as you progress to the clouds moving toward the foreground. But everything in the image is resting on a single plane—the image surface—so it's really only your attention that refocuses into and out of the pictorial space. The way our 3-D world is projected onto a flat plane can be a powerful asset when constructing photographs.

The answers to questions regarding depth in a photograph depend on how you arrange three-dimensional space within the frame. There are three types of picture planes: *parallel, diagonal,* and *overlapping,* and each has unique characteristics. Like most aspects of the elements of photography, picture planes operate on a continuum. Few pictures fall strictly into a single category, because various contents within the frame relate to one another differently depending on vantage point. However, when you know you want to create a particular degree of perceived depth within the frame, approaching its contents from a well-considered place in space is how to do it.

Parallel picture planes emphasize the two-dimensionality of the image; in them the image content runs horizontally, vertically, or flat against the picture plane, limiting the illusion of depth or receding space. Parallel picture planes

often contain contents that are all at the same distance from the camera, or they are made from a vantage point where the background feels like it's on the same plane as the foreground. On the one hand, these images can be quiet and meditative; on the other hand, they can be stagnant and boring; in part the result depends on the image content. To limit or eliminate the sense of receding space in a photograph, approach content straight on, such that from your vantage point three-dimensionality is minimized. Think of photographing a building from directly in front of it; it would look like a stage set cutout facade as flat as the two-dimensional pictorial plane itself.

Diagonal picture planes provide a sense of receding space by placing image content diagonally in the frame. A real or implied diagonal line through the image that, aided by the diminishing scale of objects as they move into the distance,

Parallel picture plane.

Diagonal picture plane.

Overlapping picture plane.

PHOTO © DAVID BECKERMAN, *BECOME YOUR DREAM*, NEW YORK, 2005.

Parallel picture plane. This image faces all the content of the frame head on. The image forcibly refers the tall background tenement buildings to the hand-scrawled "become your dream" graffiti. There is great distance between the foreground and background, but except for depth of field that distance is negated because everything is parallel to the picture plane.

PHOTO © DAVID BECKERMAN, *CROSSING BROOKLYN BRIDGE*, 1993.

Diagonal picture plane. The image composition creates dramatic depth in receding space, because the frame's primary content runs diagonal to the picture plane. Your eye moves from the man to the vanishing point of the bridge in the background. The direction of the subject's movement toward the corner of the picture activates the composition in the other direction, leading the viewers' eyes rapidly forward where we view a significant piece of secondary content—the overturned trashcan.

conveys a sense of rapidly receding space. Your eye follows a fast course from contents in the foreground to those in the background. Think of moving from directly in front of a building to its side where you can simultaneously see both the front and the side receding into the background; a photograph from this angle creates the illusion of the building receding into the pictorial plane.

Overlapping picture planes contain a sense of depth as a result of the image content overlapping from foreground to background. In these cases, the viewer perceives depth as a result of some content being in front of other content from the camera's point of view. In other words, as viewers we perceive objects as closer to us when they block our view of other objects. Our eye starts at foreground content and gradually moves back, skipping from content to content in succession. Think of standing in front of three buildings that are getting progressively farther from you; by photographing from a position where you see one building partially in front of the other, you create the illusion of depth within the pictorial plane.

As you look at photographs day to day, practice analyzing them through the elements of photographic language. Pay attention to the pace your own eye takes into picture planes so you cultivate better awareness of how to arrange contents when making your own photographs, not only to control the illusion of depth, but to set the pace at which viewers' eyes move through your images, and to create a mood. Do you want a quiet, serene picture? Try making it with a parallel picture plane. Do you want to relate a series of contents at different distances from the camera? Try overlapping planes. Do you want a highly energetic picture? Try a diagonal picture plane.

PHOTO © DAVID BECKERMAN, *MANHATTAN MALL, NEW YORK*, 2006.

Overlapping picture plane. In this image, planes at varying angles overlap to juxtapose the place name in relation to other contents with the frame. It describes the crowded nature of the place and gives the viewer a definite sense of foreground (in front of) to background (behind) relationships in the image plane.

Vantage Point

While picture planes operate on a continuum from negating to exaggerating the illusion of three-dimensional space within the frame, vantage points determine the actual contents within it and how those contents interact. *Vantage point—the position and distance of the camera in relation to the image contents—*is altered by simply moving your own position in space. You can move horizontally (right or left), vertically (higher or lower), or change your depth (closer into or farther away) in relation to your subject. These options let you organize the frame by creating hierarchies within the frame's contents, creating juxtapositions, and adding or eliminating content.

Vantage point helps you communicate your feelings and ideas about a subject and carries powerful connotations worth considering. For instance, if you're making a portrait of someone you admire and whom you want the viewer to admire, you might adopt a slightly lower vantage point and *literally look up to the person,* placing your subject above (from your vantage point) other content in the frame; conversely, if you want to diminish the subject of the portrait, you might literally adopt a vantage point looking slightly down at the person. With vantage point, subtle changes make a big difference.

Vantage point is also a means of distributing image contents from foreground to background. Because overlapping occurs from the point of view of the camera, photographers can choose to either avoid or create visual tangents, e.g., the classic tree in the background that appears to sprout from the head of someone in the foreground.

Juxtaposition

Juxtaposition creates meaning through the relationship and interaction among discrete contents. It results from consciously organizing contents with respect to both picture plane and vantage point. As photographer Stephen Shore stated in his outstanding book, *The Nature of Photographs*:

"[Photographers are] confronted with a complex web of visual juxtapositions that realign themselves with each step the photographer takes. Take one step and something hidden comes into view; take another and an object in the front now presses up against one in the distance. Take one step and the description of deep space is clarified; take another and it is obscured. In bringing order to this situation, a photographer solves a picture more than composes one."

Juxtaposition is a key component in any language. The solitary word or isolated image content leads to narrow meaning and interpretation. But the relationship between multiple words or image contents creates higher levels of meaning. Rarely do words or objects exist in isolation, so juxtaposition of contents is a powerful tool in building more

Image Discussion 4: Vantage Point

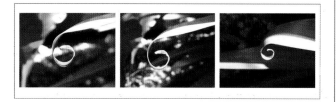

While in a botanic garden, I noticed a plant's leaf struck by beautiful light and recognized it was in the first stages of dying—curling into itself at its ends. For me the juxtaposition between intense light and dying holds powerful connotations that I wanted to capture through the formal beauty of the scene. I took the first picture from where I saw it, the vantage point of my own height. Then I took my time consciously reframing the image from lower and closer vantage points. I made four pictures in all, gradually progressing to where background darkness envelops the sunlit leaf, and there are no visual distractions behind or intersecting its lighted form. The final image composes the scene most clearly; but perhaps more important, its simplicity better communicates my intention to viewers.

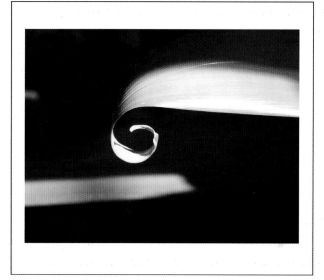

ANGELA FARIS BELT, *TURN INWARD,* **2009.**

potent images, more complex statements. Conscious awareness of all contents within the frame helps you to adopt a vantage point to conceptually and creatively relate them to one another. If the image is staged, such as a still life, you can research and think about contents and how to juxtapose them to reinforce to your intended meaning. If not, then awareness of the realignment of contents throughout the shooting process is paramount.

Image Discussion 5: Vantage Point

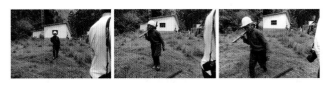

While in Peru, photographer Jill Mott's train was stopped because of a mudslide. While waiting for a rescue, she did what any dedicated documentarian would do—she made photographs. Upon seeing a man walking toward the train with a pickax over his shoulder, she put her camera to her eye to frame the scene and focused on him. In the few seconds that passed, she continually changed her vantage point by moving horizontally to her left to reposition her subject as he moved forward within the frame. The final image creates an active composition that hones in on the man's weathered features and concerned expression, while supporting content moves the viewer's eye throughout the frame and provides a contextualizing environment. In so doing, she created an "environmental portrait" rather than a simple picture.

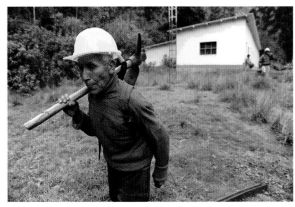

IMAGES © JILL P. MOTT, *NEAR MACHU PICCHU, PERU*, 2009.

PHOTO © DAVID BECKERMAN, *MAN AND WOMAN, SUBWAY, NEW YORK*, 1993.

Juxtaposition of contents. This photograph uses juxtaposition within the frame to create meaning. The contents were already there, but the photographer recognized and framed them in a conscious way. The subway passengers gazing passively downward—heads visually connected by a line behind them—and the sign with eyes intensely peering back at us juxtaposes two disparate contents. The combined contents' larger meaning could refer to the active nature of our own gaze upon others in the public sphere.

Image Discussion 6: Juxtaposition

Brazilian artist Alexandre Orion's work relies on the nature of juxtaposition; the contents within his carefully composed frames reference one another in mutually beneficial ways in order to create humor or irony. In so doing, the artist photographically explores the relationship between his painting and the scene that interacts with it. In this image, the artist painted onto a wall in São Paulo graffiti of a man shouting into a bullhorn. With regard to meaning through juxtaposition, it doesn't matter whether the artist staged the man sleeping beneath the painting or whether the man actually fell asleep there on the street. What matters is that the painting juxtaposed with the man creates a new level of meaning that could not exist with the painting on an empty street or the man alone with no interactive painting above. (Orion's work also uses the "decisive moment," discussed in Chapter 4, and can be found in that chapter's Portfolio Pages.)

IMAGE © ALEXANDRE ORION, FROM HIS SERIES *METABIOTICA*.

VISUAL VARIETY

Knowing how to organize and juxtapose contents within the picture plane is just the beginning of framing. The rest involves insuring you get what you need inside the frame while you're there, because you might not have a second chance. One way to do this is to adopt a practice that many photographers call "covering your subject," which essentially encourages you to add variety to your approach. This doesn't mean taking rapid-fire shots at everything you see; it means engaging *framing as a process* so you're more likely to make images that really say what you want them to say. As Henri Cartier-Bresson observed in *The Decisive Moment*:

You shouldn't over-shoot. It's like over-eating or over-drinking; you have to eat, you have to drink but over is too much. Because by the time you press and arm the shutter once more maybe the picture was in between. It's a fraction of a second; it's an instinct.

That instinct refers to knowing the "decisive moment" to release the shutter (we'll cover that aspect of it in Chapter 4), but it also refers to positioning yourself in the right place to make the contents within the exposed frame meaningful. Visual variety not only affords you the opportunity to understand your subject through exploration, but it also produces a broader range of images from which to edit.

There are three simple methods that, if you remember to employ them, can help you achieve visual variety in your images. I call them *macro to micro, outside in to inside out,* and *looking up to looking down.* These methods of framing will combine with the other elements of photography as you expand your exploration of your subject to become increasingly more adept at visual communication.

Macro to Micro

One of the best ways to add visual variety is to explore the scene from macro to micro views. With respect to framing, *macro (meaning large or long) means making photographs of the overall scene.* In photographic essays and journalism, these views are called "scene setters." Macro views are pulled back from the details to capture an overall image that aids in contextualization. Macro views provide "the big picture," at times confining the subject to a very small portion of the frame (maybe 10%) and using the rest of the frame to provide important information about it. The opposite of macro, *micro (meaning small or close) means photographing the details.* These details provide all the textures and information to reinforce the macro views. Most micro views get in close enough to literally define the frame area using the subject itself. Micro views often fill the frame edge to edge (100%) with the subject, though if you want the viewer to be able to identify what's there, take care not to get so close as to abstract it.

But macro to micro isn't an either-or proposition; it's a process that includes all the images in between. By starting farther away from your subject, you give yourself a better overall view and can begin to figure out the best vantage points. As you move closer in, you'll continue readjusting your vantage point and changing your frame orientation to best suit the content of each image.

Outside In to Inside Out

A second easy way to add visual variety and more thoroughly explore your subject is to see if you can shoot from an outside vantage point looking in or from an inside vantage point looking out. This doesn't always mean indoors and outdoors; it could mean from behind and in front of your subject. In so

Image Discussion 7: Macro to Micro

These three images progress from relative macro-to-micro views. The outcome is greater variety from which to edit. You can use a range of lenses to help you achieve visual variety, or you can simply move closer to your subject, and it doesn't require a micro or macro lens.

In the example of pink roses, I used only a 35 mm focal length lens. The first image is a relatively "macro" view; it contextualizes the scene of flower petals falling along a brick path. The second image focuses on the flowers themselves and moves us close enough to see raindrops on the flowers. The final image, made at the lens's closest focusing distance, is close enough to concentrate on the raindrops and a single flower's

textures, shape, and subtle color variations. By choosing to shoot the micro view of this particular flower, I single it out as the ideal flower representing this scene. Although finding the ideal isn't always the reason to choose a specific micro view, it's a big consideration. After all, who wants to examine the details of an inconsequential part of a scene?

The visual variety created by shooting just three macro-to-micro views of even a small scene demonstrates the ease and benefits of this method. Additionally, changing frame orientation from vertical to horizontal composes the image contents of each view best. The macro-to-micro approach to visual variety gives you a number of choices when editing. Any of the images is successful, so editing down to one is a matter of personal choice and the context in which the image is to be used.

IMAGES © ANGELA FARIS BELT, 2009.

Technical Discussion 1: Go Micro with Extension Tubes

The closer the better when it comes to the details. Whereas most bellows cameras allow you to focus very close in by extending the bellows farther out from the camera body, most SLR camera lenses do not. If you want to focus as close as actual size (called 1:1) or even closer (creating an image on the medium larger than actual size) with an SLR camera, there are simple and inexpensive tools that allow you to get closer than you thought possible. They're called *extension tubes, stackable tubes sold in incremental lengths that attach between your camera body and the lens.* Using extension tubes allows you to focus very close on your subject simply because the lens is placed farther away from the media plane. Extension tubes are inexpensive because they have no optics inside—they're hollow tubes. And they don't degrade the image quality because there is no additional glass to focus through, as there is if you use a close-up filter.

Extension tubes are designated for your camera's brand and model. To use them, mount one or more between your camera body and lens. Once attached, use manual focus, focus on infinity (∞ is the longest focus distance for your lens), and slowly move closer while looking through the viewfinder until your subject looks sharp. Using a tripod is helpful because the

Three extension tubes attached together. These are 12 mm, 28 mm, and 36 mm extension tubes. An advantage to extension tubes over close-up filters is that they attach to any focal length lens and can be used separately or stacked together to make even closer micro views possible. They don't degrade image quality because they are hollow, and they connect to the camera's electronics so your meter still operates. When using extension tubes, you'll want to use a sturdy tripod and you might want to use your camera's mirror lockup, if the option is available, to prevent camera shake (covered in Chapter 5). If mirror lockup isn't an option, a self-timer or cable release is helpful. Fine focusing is a must, because depth of field is very shallow (covered in Chapter 4), so take your time and focus carefully.

50 mm lens only

50 mm lens with 12 mm extension tube

50 mm lens with 28 mm extension tube

50 mm lens with 36 mm extension tube

area of focus is very narrow the closer you are to a subject, and the tripod will allow you to hold your position once you achieve accurate focus. There will be more information about extension tubes and lenses in the next chapter, but for framing micro views, they can let your lenses get closer than they've ever gotten before!

IMAGES © ANGELA FARIS BELT, 2011.

Getting micro with extension tubes. The image on the left is shot at the closest focusing distance with a 50 mm lens; the image on the right is shot with that same lens and 12 mm + 28 mm + 36 mm extension tubes stacked between it and the camera body.

IMAGE © JON LYBROOK, *BONNIE IN THE HOT SPRING*, 2009.

From the outside in. As photographer Jon Lybrook's wife, Bonnie, enjoyed a hot springs spa, he noticed her from an outside hallway. Her direction facing away from us toward the water's reflection makes her feel solitary and unaware, and the glass between them made the scene even quieter. Going inside could disturb her peacefulness and would change the vantage point that first urged him to make a photograph. His choice to shoot from the outside looking in communicates the quiet introspective feeling of the scene.

doing, you place the viewers in the position you want them to be. At a ballpark, say, sometimes the most interesting part of being there isn't the game itself, it's the crowd. By turning your camera away from the game and toward the spectators, you broaden the viewer's sense of what it's like to be at the game.

Looking Up to Looking Down

We're used to seeing the world from our own height. We look straight ahead, often seeing just what we expect to see. But sometimes the most significant things about a particular scene are just above our heads or under our noses, and we'd capture them if only we remembered to look above and below our usual field of vision. It seems simple enough, but when trying to describe your subject, simply looking up and looking down add the visual variety and dimension that looking ahead just can't. This simple process works on a continuum like macro to micro seeing. Exploring not just what is directly above and below but also what is between and beneath contents in the scene helps you to discover the best image. By looking to (or from) different heights, you discover new vantage points to adopt along the way.

Go Where the Image Is

Sometimes even changing vantage point and approaching a subject with visual variety aren't enough to get the best image. To create visual variety, think about vantage points you haven't explored yet, even the ones you think are impossible

Image Discussion 8: Visual Variety

The only thing as beautifully solitary as a cabin in the woods is waking to the morning light through its windows. These are from a series of photographs throughout which I maintain parallel picture planes to underscore the quiet nature of these places. For this reason the series could get redundant, so I add visual variety in other ways—macro to micro views, frame orientation, and so on. These photographs demonstrate how expansive the description of a subject (in this case a place) becomes by simply moving from outside in to inside out. By photographing outside the cabin on a morning when simple white sheets hung to dry against its rough-hewn siding, I juxtaposed the textures and tones that describe the building and hint at the austerity inside. Subsequently moving to an interior view describes the warm light filtering through the trees. There is no need to literally look outside the window; I'm trying to describe the place by exploring its range of views. The interior photograph describes what's outside through shadows cast on the textured walls and the empty picture frame inside. When seen in context with other images from the series, viewers gain a broader understanding of these rustic places.

IMAGES © ANGELA FARIS BELT, 2010.

Looking up to looking down. While shooting the image of the curled leaf at the botanic garden (*from the earlier vantage point discussion*), I made these two additional images. From where I was standing I simply looked up to make an image of diffuse light filtered through a leaf that defined its structure beautifully, and then I looked down to make an image of the surface of the same kind of leaf with contrasting fallen leaves that had scattered on it. The range of different images that describe a single subject add dimension to your viewer's experience of it, often without you having to take a single step.

or "off-limits." This is what I call "seeing with your mind's eye;" it's your ability to conceptualize adopting a vantage point where your feet alone can't go. And you might have to leave terra firma to get there.

Image Discussion 9: Fisheye and Bird's-Eye Views

Like all great photojournalists and documentary photographers, Jill P. Mott conceptualizes "the big picture" from fisheye to bird's eye views in order to place viewers exactly where she wants them to be. These views exemplify her methods.

Fisheye View

Sometimes you really have to think outside the box to envision the best vantage point. This image documents an underwater ballet club on a day when dads are invited to join in the swim. A spectator's usual view of underwater ballet is from above water, but a significant part of the ballet takes place below the water's surface, so Mott found a way to get there. Her solution—use an empty fish tank that happened to be nearby. By partially submerging the tank, she was able to get her camera just below the surface of the water to describe the scene uniquely and successfully. We are seeing the view participants see. If you do a lot of underwater photography, there are specialized waterproof housings designed for camera

Jill P. Mott; Alpine Angelfish Synchronized Swim Team father-daughter event.

Jill P. Mott; Deodo and Gail Schipper fly antique planes from antique fields.

gear, though some are quite expensive. Otherwise, just be creative in your maneuvering.

Bird's-Eye View

This image follows two biplanes from the air. Mott had the opportunity to photograph the planes before takeoff, but when she received an offer to ride in the air beside them, she was already thinking about vantage point and visual variety. These midair images give viewers perspective that just can't be achieved from the ground looking up. The horizon provides a minimal sense of depth within the frame because of the vantage point (imagine if the planes weren't there,

how flat the picture plane would seem), and the planes add that illusion of depth. The biplanes overlap the ground, and although they don't overlap one another, the diminishing size of the yellow plane adds to our sense of depth and references the distance from the ground. Like going underwater, going into the air places viewers out of the sideline spectator position and into that of the participants. In terms of *using the elements of photography to interpret the subject* of images like these, keep in mind that the primary purpose of documentary photography isn't to operate metaphorically; the purpose is to take you there so that you as viewer can experience something as close to the reality of it as possible.

As the first photographic element, framing seems so simple as to need no explanation. That's because whether we put to camera to our eye or not, if we press the shutter we get a picture. In all seriousness, if you hand a chimpanzee a camera, he or she will likely return it to you with pictures recorded. But as a photographer, once you really begin to employ the element of framing—from picture planes to vantage points to visual variety—you begin to engage the process of *really communicating something significant*. Framing doesn't work in a vacuum, and it doesn't end here. It combines with the other elements of photographic language—when employing depth of field, time and motion, and so on, framing remains an integral part of making successful pictures. As you progress through each chapter's exercises, remember to use this chapter's information to structure your images while adding depth and dimension using the other elements of photography.

CONTACT SHEETS: KEY TO CHOOSING THE BEST FRAME

Once you capture and process images in your traditional or digital darkroom, the next step, and a tremendously important one, is to edit. And making *contact sheets—prints with several small images on them*—is an indispensable way to help you choose your best images. Contact sheets allow photographers to really examine the sum of their images printed side-by-side and choose those that most successfully represent their ideas. Also important, contact sheets track your progress throughout a shoot, revealing your own strengths and weaknesses in your *process of seeing through the camera*. If you look to your contact sheets for feedback about your process, you become increasingly more conscious of how to improve your approach the next time out.

Unfortunately, when digital media became widespread, making contact sheets became more rare, in part because photographers are capturing positive images and they don't see the need to print them. They just try to edit from their LCD camera screen and their computer monitors. But I know from nearly two decades of teaching that *photographers who look at contact sheets make better editing decisions and learn more about their own process than do photographers who edit only from images on a screen*. Looking at negatives or screen images is a fine start, but actually printing contact sheets (with images large enough to see detail in individual frames) provides invaluable perspective during editing. It's easier to note subtle technical and formal differences from frame to frame—changes in exposure, focal length, distance, vantage point, shutter speed, and depth of field—which significantly affects the image as the photographic process unfolds. In the contact sheets, the photographer's growing awareness and sharpening of composition from frame to frame is more apparent. Also, whereas negatives are tonal reversals and digital files move fleetingly past, *printed contact sheets of your best edits allow you to concentrate on your imagery conveniently and repeatedly over a period of time*. Similar to editing a work of literature, the first edit might provide improvement over the initial draft, but not nearly as much as you'll gain from living with the work and refining it over time. The more you

do this, the closer the final product will be to perfectly communicating your intended message.

There are many methods of editing images from contact sheets. Like framing itself, editing is a process that decides what to leave in and what to leave out. I recommend editing first for technical quality; for example, immediately eliminate any poorly exposed or out-of-focus images. Commit to not trying to "fix" technical problems in the traditional or digital darkroom; instead, learn from your mistakes to avoid making the same ones again. With digital media, it's best to move technically poor images to the trash so they don't use space on your hard drive, they don't further slow your editing process, and so you don't spend money printing them in contact sheets. Next, edit for content and formal quality; ask yourself, of the technically sound frames, which ones best convey your ideas about your subject? Take notes on your contact sheets—circle frame numbers, make crop marks, and write critique responses on the back. These aren't intended to be pristine documents; they're intended to help you decide which images to make into pristine documents. After editing your contact sheets, I recommend enlarging the best images into *work prints—prints that you can hang up and live with* for a while in your studio or office. In a short time the best of those images, the ones with real communicative or emotive power, will emerge as successful final edits to enlarge onto good paper. Conversely, through the subtractive nature of editing, the less successful images will eliminate themselves. Work prints only need to be 5" × 7" to be effective, but many photographers (myself included) make them 8" × 10". Develop a habit of making contact sheets and work prints with good density, contrast, and color to help you to really know what you've got. To keep cost down, use inexpensive photo papers for contact sheets and work prints, and reserve your good paper for final enlargements.

Image Discussion 10: Contact Sheets

I came upon a controlled burn of bark beetle–infested forest on Colorado's Western Slope. The light was cycling rapidly in and out of clouds, which, combined with the smoke, intermittently made beautiful scenes of a tragic landscape. I edited my images down to around 80 that I believed best balanced the beauty and devastation, and then I printed contact sheets and lived with them for a while. Those that stayed with me from this contact sheet (circled) became work prints, and of those, two (the circled images on the second and fourth rows) made the cut to final prints. The vertical image of the tree I chose best shows the quality of light through the smoke, formally describes the scene, and metaphorically refers to the individuality of each the tree about to be destroyed and the bare landscape they leave behind. The final circled image shows a fireman walking toward a pyre, which dwarfs him because of its position in the foreground, referring to the scale of the natural disaster in relation to our ability to mitigate it.

IMAGES © ANGELA FARIS BELT, 2010.

nestled into adding to a sense of stability. The center image is, well, in between; it has a more standard composition but too little left side drop-off or right side wall to make a committed statement. Any of these crops could work, but each communicates differently.

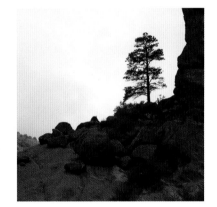

IMAGES © ANGELA FARIS BELT, 2009.

CHAPTER EXERCISES, PART 1: FRAMING YOUR SUBJECT IN CONSCIOUS WAYS

In Chapter 1, I recommended choosing a specific subject or genre to work with throughout the chapter exercises. Before commencing with the first exercise, clearly define your subject or concept and commit to conducting research about it. The more you know about your chosen subject, the more likely you are make informed decisions about content, and the better able you will be to use photography's technical elements to guide your creation of meaningful images. This subject should be one that engages you visually and intellectually throughout the exercises, a subject of interest to you and that is potentially

decide to leave out. Viewers are unaware of the content you subtract, so if cropping helps you communicate more successfully (and if you aren't philosophically opposed to it), then crop away!

To crop or not to crop: photographers decide which to do for different reasons. First, although the ideal time to make framing decisions is in-camera, it's not always practical. For example, when making images from the hip (not looking through the viewfinder), a photographer knows to some extent what will be captured in the frame but can't predict it with accuracy. Or in the rapidly evolving circumstances documentary photographers often face, capturing the moment's events might outweigh perfectly framed composition. In these cases the decision to crop extraneous content in the traditional or digital darkroom can help clarify the image or make it visually more powerful.

Although conscious cropping is a valid, and valuable, means of defining the frame's contents, many photographers choose never to crop an image in the printing stages. These photographers often print their images "full frame" with a fine black border denoting their conscious decision not to crop. (Part 2 of this chapter covers a variety of techniques used to control the appearance of a print's borders.)

Whereas this section of the element of framing discusses image capture, the next section moves into its presentation, dealing with the fact that while the world has no boundaries, the image does. Somehow we need to acknowledge those boundaries, and how we do it has a distinct effect on the image and the viewer's perception of it.

Image Discussion 12: Three Crops

I see square images in my mind's eye, so when I began shooting film in the 1980s I chose the 6cm × 6cm format, first using a Mamiya C330 twin-lens camera and then single-lens Hasselblad cameras. When I started using digital media in 2004 I discovered, much to my dismay, only rectangular sensor formats available. I knew I had to previsualize, excluding part of the sensor format,

and later crop the image to square. The top horizontal image is the original capture, with three different crops of that frame below. Each crop includes different content suggesting different meanings. For instance, the far left image feels most dramatic, with extreme offset compositional weight making the drop-off appear most precarious for the tree. The far right image feels more grounded with plenty of rock extending to the left side of the frame, no visible drop-off, and the solid wall the tree is

Image Discussion 11: Contact Sheets

Your contact sheets provide a means for editing images, but they also provide you with important insights about your own working processes that you can capitalize on during future shoots. This contact sheet contains images from three separate shoots, but all three demonstrate that even the slightest changes in vantage point can make a big difference in the image.

In the top and bottom shoots (the flowers and clovers), I change my own vantage point in relation to the image content to explore my subject through the framing process—looking up, down, horizontally, vertically, closer, and farther away. If I had settled with the first frame of each scene, I wouldn't have explored the potential for making a better image. In the top shoot, the flowers and stucco wall caught my eye from the road while I was driving past. I stopped and made some pictures, trying to bring out the vibrant color and organic form of the flowers against the rustic wall. The circled images are worthy of work prints, which would help me edit to the best one. In the

bottom shoot I noticed I had placed my tripod next to a four-leaf clover. I took a picture of it just before my traveling companion pulled the hapless plant out by its roots. I decided to take advantage of the situation and hold the clover up in an attempt to make it stand out from the background. In the first frame it's difficult to differentiate the clover's form from that of the foliage, so I moved it in front of the light bark of an aspen tree. From there I tried framing the clover against the sky by looking up at it. The two circled images are significantly different, but both are worthy of work prints for further consideration.

In the middle shoot, the subject moves more than I do. In this sequence the peacock moves slightly to make three different compositions (circled), each of which could be the best edit, depending on how I want the animal to be viewed. The other images document a process, that as the peacock moved his head I inched closer to him, creating a frame filled with, and completely defined by, my subject. This part of the contact sheet reveals the advantage of sticking with a subject until you know you have it.

CROPPING: A SECOND CHANCE TO FRAME IT RIGHT

Contact sheets and work prints also reveal that even the best attempts at in-camera framing sometimes fail to produce the desired formal arrangement; it's then you might decide to *crop—to exclude some portion of the frame's outer edges from the final print*. Essentially, cropping is your second chance to refine the frame's contents. Because the time to add content has passed, the subtractive nature of framing comes to the forefront; the final image becomes a product of what you

IMAGES © ANGELA FARIS BELT, 2010.

of interest to others. Throughout the course of these exercises, you'll learn as much about your subject as you will about the elements that constitute photographic language. I also recommend that outside of a classroom setting you form a small critique group. Through critique discussions you'll cultivate a fuller understanding of how to use the elements of photography, and you'll gain valuable feedback about which images succeed in communicating to others.

For all of these exercises you may shoot traditional or digital media, color or black and white, or you might shoot an alternative medium with an alternative camera. Media choices are completely up to you.

1. **Vantage Point and Juxtaposition**

 For this exercise, explore your subject in 10 frames—no more, no less—in order to improve your concentration on how the frame's contents interact as you move to horizontally, vertically, closer, and farther from your subject. Concentrate on foreground and background contents and on ways to juxtapose them (make them interact) meaningfully within the frame. This exercise is especially important for photographers shooting digital media. Because digital media frames are cost-free to expose, digital photographers tend to overshoot and underconcentrate, which is referred to as "the digital disease." This exercise will cultivate your awareness so you don't have so many poor frames to sift through

during the editing process, and will train you to recognize the best images as they present themselves.

Repeat this exercise as many times as you wish with as many different scenes as you find, but maintaining the frame restriction while trying to achieve meaningful relationships between content is key.

2. **Picture Planes**

 Consciously structuring content in the frame allows photographers to delineate the three-dimensional world's sense of space onto the two-dimensional picture plane. It also dictates the pace at which viewers read the image and the viewer's sense of spatial relationships among various content within the image.

 For this exercise you'll make three images of each scene you photograph. Consider the placement of your subject matter and the way that the sense of depth (or lack thereof) through the picture plane affects your viewers' attention to it, their pace at reading the image, and sense of relationship between objects within the pictorial space.

 First, choose a scene knowing that you can change vantage point and distance between each frame as you shoot:

 - Structure the content using a parallel picture plane, where all content is straight-on to the camera and the sense of depth in the image is minimized.

- Structure the content using a diagonal picture plane, where the contents of the image recede into space, diminishing in size as they do.

- Structure the content using overlapping planes, such that some objects literally overlap others from foreground to background.

3. **Macro to Micro** (5 sets) –10 pix

This exercise is used to define your subject both for yourself and for viewers, and it will assist you in maintaining awareness of your in-camera framing decisions. Concentrate on using the camera's imposed frame to define the content of your images. For each subject or scene, make two photographs:

- *Macro.* Step back from your subject matter. Provide an overall view of the primary subject matter within its larger context. Continue shooting as you move in to the micro view.

- *Micro.* Photograph the same subject matter so that it fills the frame. For this image, you'll move as close to your primary subject matter as you can. Try not to create an abstract image, but instead show us the textures and details of the subject.

- *Additional challenge.* Make macro images that contextualize the overall scene but confine your primary subject matter to a very small portion of the frame, say, 10% of it. Then, when you make the micro views, do the same. In this more advanced exercise, the challenge is to make the majority of the content within the frame refer to the small portion of the image that is your primary subject matter.

Understand that it will likely take several images per scene to achieve successful images for each. It's a process that relies on good exposure along with improving your ability to make that transition from seeing to seeing through the camera. Study your results and edit several images to enlarge. Discuss your results and the results of your peers in your critique group.

Optional Exercise

Review the chapter pages and make photographs based on looking up to looking down and outside in to inside out. Practice editing from contact sheets and make work prints to "live with" throughout the next chapter, by which time the best edits will have spoken to you.

PORTFOLIO PAGES

The Portfolio Pages throughout this text highlight a number of artists whose work I find engaging, meaningful, and who use specific elements of photography in a way that can educate photographers on the path of improving their practice. I also wanted to create a book with a marvelous collection of images that can be enjoyed on any coffee table. But perhaps more important, the Portfolio Pages are intended to spark discussion about the artist's work, to allow you the opportunity to analyze how artist statements contextualize visual work, and to introduce you to a wide range of photographic practice.

At the beginning of each artist's portfolio I have provided a brief Elements statement outlining how the work uses the chapter's element of photography. Some artists' work uses multiple elements particularly well, combining them to create additional meaning, and this will also be discussed. Because of this, as you proceed through the text you might refer back to previous Portfolio Pages to examine how and to what end the photographers combine the elements of photographic language to communicate meaning.

I encourage you to conduct additional research about these photographers and discuss their work in your critique group to add dimension to your understanding of the elements and the work itself.

ANGIE BUCKLEY

THE STAGES OF RESTORATION

ELEMENTS

I first saw Angie Buckley's work published as illustrations for a 2007 article in *Tricycle: The Buddhist Review* magazine. Although these are fine art images, like much fine art they are used editorially and commercially, which reflects the contemporary bridge between commercial and fine art practices. I immediately responded to her frame-within-a-frame approach and how well the images illustrated the article's concept about the duality of ego. By taking historic snapshots out of their original context and placing them in another, alternating between negative and positive cutouts, they lose content as well as gain it inside the same frame. By recontextualizing previously framed photographs, Buckley creates images with compounded meanings and explores framing as both an additive and subtractive boundary.

ARTIST STATEMENT

More often than not, we do not know the stories behind the family pictures we find in our attics, leaving us to project our own meaning and history. For me, the use of these vintage images connects the past as an important part of our present. Alongside projections, habits and psychological patterns are passed from one generation to the next. When the self-defeating habits rise to our consciousness, and more important when we act on changing these routines, we can break free from what confines us.

The cutout silhouettes imply the loss of a person who suffers from these blind spots. These silhouettes are the play of photography framing the repeated habits of people in new environments; it is a frame within a frame. Though we don't see the people whose bodies are removed, we see their gestures and absences. Not only do we naturally perform those gestures, we learn them.

Meanwhile, these newly isolated figures reenter the contemporary world in search of new contexts. These remote figures have accomplished a journey through their dark nights of the soul and now have the capacity to reveal their deeper, truer selves. Once we fully release our past and other collective memories, we can create a stronger sense of place. Dedicating oneself to venture through a vulnerable, lonely path leads to shedding light on the subconscious and conscious voices in our minds. Commitment—to personal growth and healing—is ultimate freedom.

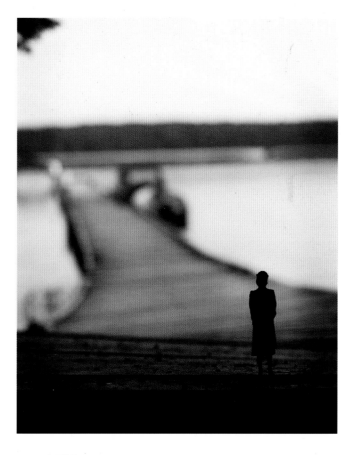

approval, 2010

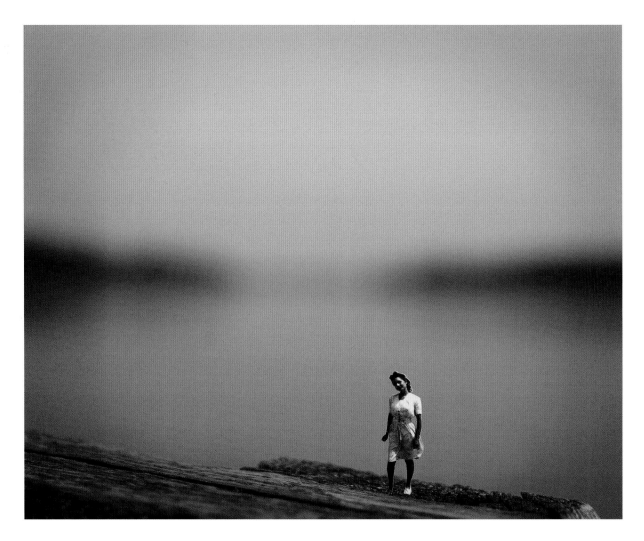

simultaneous, 2010

nest, 2010.

retrieval, 2010.

IMAGES © ANGIE BUCKLEY, FROM HER SERIES *THE STAGES OF RESTORATION*.

SAM WANG

CIRCULAR CAMERA IMAGES

ELEMENTS

In the beginning of this chapter, I explained that film format denotes the area of even illumination from within the lens's projected circular image. Essentially, the camera format crops into the inherently circular image before you even frame it. Photographer Sam Wang uses this circle of illumination to create unique imagery using the circular shape. The diagrams here display his cameras, the negative and positive images it produces, and the format that would normally crop into his images. The unique result provides a softer format frame encircling the content which speaks more eloquently to his feelings about his subject.

conventional cameras use only a rectangular portion of the image

the film negative and positive print showing the entire image

Self at Goblin Valley, 1992

a few of Sam Wang's cameras custom designed for round images

ARTIST STATEMENT

Much of my work is about discoveries through observation. Without observation there can be no perception, and without perception there can be no art. In my traditional black-and-white work, I built my cameras and have been using them to directly confront my subjects. I hope to give the viewer an intimate dialogue with what the camera captured, under an illusion of objectivity.

As digital tools become mature, I use them extensively also. Some of the methods and processes I use when I am outputting these digital images include very old photographic printing processes that require a great deal of time, labor, and patience. It is interesting to note that such extremely task- and skill-oriented processes seem to complement the fast and powerful hardware and software that we now have. Through my work I hope that the viewer can get a glimpse not at completed art but at the underlying creative process.

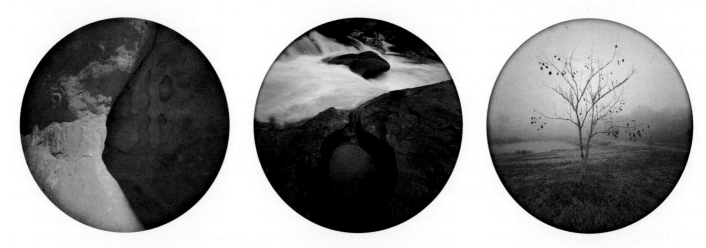

PHOTOGRAPHS © SAM WANG, PRINTS FROM TRADITIONAL 4" × 5" NEGATIVES; DIMENSIONS VARIABLE.

MICHEL LEROY

RALLY BIKERS

ELEMENTS

Austere, borderless frames that focus our concentration on solitary subjects help us understand this singular group of people who truly own who they are. There is no need for secondary content juxtapositions to inform us, to elevate them, or otherwise distract from their adorned, aging, tanned, and tattooed bodies. Michel LeRoy's conscious decision to isolate subjects in a frame celebrates the individual, while displaying them within a series refers to their collective identity. Through his direct approach to framing and vantage point, he offers us an open door to understanding people we otherwise might never encounter.

ARTIST STATEMENT

Rally Bikers comprise a spontaneous community of ordinary people defined by common interest. I attend motorcycle rallies and create portraits of riders ranging from 7-year-old kids on 90cc hill climbers, to middle-aged firemen on 1200cc road bikes, to sun-burned grandparents on 1800cc luxury touring marvels. The style is unrelenting black-and-white images that reveal texture and detail beyond the casual glance.

Meeting bikers on the street, in parking lots, or at a car wash, I photograph them in a portable studio to capture that initial moment, the point of simple truth while communal humanity remains in our eyes. The studio removes visual distractions and allows for a more intimate portrait, a brief shared moment to reveal the truth and the façade of identity.

Through portraits of Rally Bikers, I am looking for the significance of the individual in the community that defines them. Biker clichés, based on the notoriety of outlaw motorcycle clubs, do little to describe the other 99% of ordinary people who live for the freedom of open roads, camaraderie, and the love of bikes. The leather, the Kevlar, and the tattoos are trappings of a lifestyle that riders have chosen as an alternative to the everyday obligations of a 9-to-5 weekday existence.

My task was to create a portfolio of images representing the diversity of biker rallies through the people who keep the spirit and legacy of the community alive. The goal is to bring greater attention and understanding to the lifestyles of individuals and their surrogate communities through exhibitions and published books.

PHOTOGRAPHS © MICHEL LEROY, FROM HIS SERIES *RALLY BIKERS*.

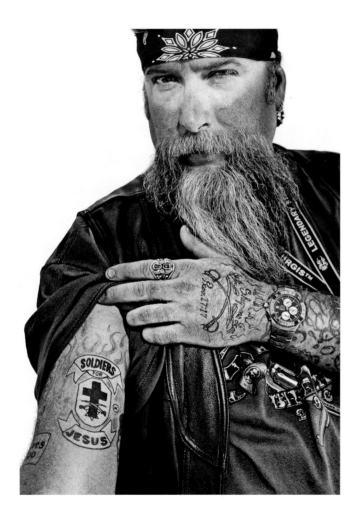

T. JOHN HUGHES

CITYSCAPE PANORAMA PROJECT

ELEMENTS

Photographer T. John Hughes merges two passions—documentary fine art and architecture—into projects that engage a range of audiences. In this project, Hughes specifically chose a panoramic camera format that captures a 90-degree angle of view onto a 2{1/4}″ × 9{1/2}″ negative. His initial choice for each scene's contents were based on intensive initial research and knowledge of the city, near-term and long-term plans for the spaces, and wanting places indicative of the built urban environment's changing landscape over time. He meticulously frames identical compositions by taping outtake transparencies to his camera's ground glass and using them to align the views every five years, creating a scientific kind of authenticity that unconsidered framing could not. The result is a fascinating study that urges us to thoughtfully consider the nature of change.

ARTIST STATEMENT

The Cityscape Panorama Project is a manifestation of my interests in the built environment, change, downtown Denver, panoramic viewing and the preservation of memory. In 1992 I walked throughout Denver, taking 160 snapshots with the intent to choose a specific number of views to define the city and set the stage to record its fabric and pace of change. These were edited to 40 views that I believed accurately represented the various looks of downtown from attractive to ugly, from humorous to sad, from boring to stimulating. I stepped away from my commercial sensibilities of glamorous light and planned to shoot at various times of day. I kept careful records of each shot, its location and the weather conditions, so that I could return in five years, repeat the shot under similar conditions, and allow for "apples and apples" comparisons.

This project has many facets and implications. Some are about form: lighting, composition, and timing. But the most significant aspects are definitely about content.

Watching the city change tells us about what works and what does not. It makes us think about what should remain and what could change. It is a visual record, in a society with so many organized written records and so few organized visual records.

Showing this work has made me realize that I enjoy projects that appeal not only to my fellow artists but also to people completely removed from the art world. Both seem to be engaged by the photos, spending long periods examining the prints. Finally, I want viewers to think about the value of the "preservation of memory." It is so easy for us to forget what was on a corner a short while after it has been replaced with something else. The Cityscape Panorama Project helps us retrieve those memories as individuals and as a society.

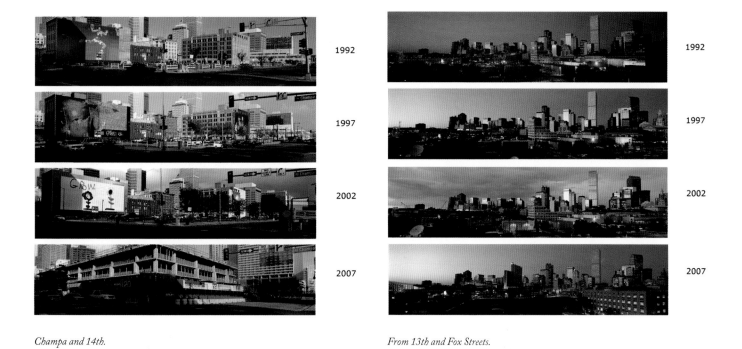

1992

1997

2002

2007

1992

1997

2002

2007

Champa and 14th.

From 13th and Fox Streets.

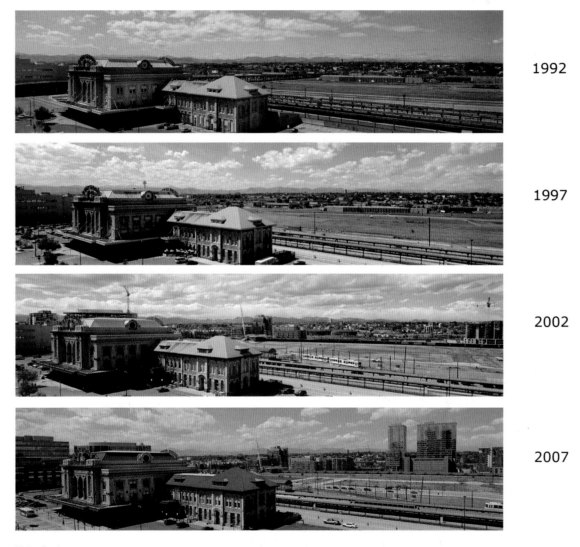

1992

1997

2002

2007

Union Station.

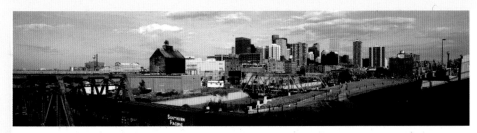

1992

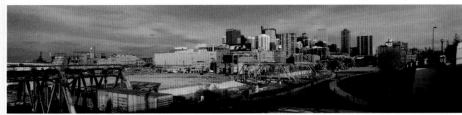

1997

2002

2007

Platte Valley.

PHOTOGRAPHS © T. JOHN HUGHES, FROM HIS SERIES *CITYSCAPE PANORAMA PROJECT*.

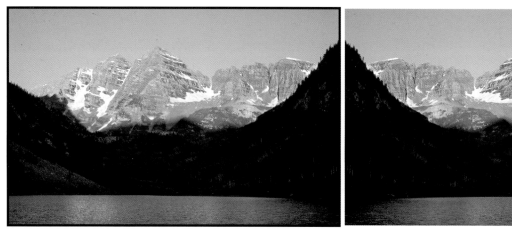

IMAGE © ANGELA FARIS BELT, *DAWN, MAROON BELLS*, 2010.

PART 2: BORDERS: THE EXTERIOR EDGES OF THE FRAME

Boundaries are actually the main factor in space, just as the present, another boundary, is the main factor in time. —Eduardo Chillida

INTRODUCTION: WHAT PURPOSE DOES A BORDER SERVE?

Even photographers with a practiced sense of framing and composition in-camera might be delayed in realizing that the *image border—the transitional space between the frame's content and its surroundings—*has its own significance. Perhaps because it is a boundary space, the image area's border carries with it all the weight and connotations of any other boundary. It is a demarcated line, whether it's specifically addressed or not. It's the point at which viewers enter, rather unconsciously most of the time, the pictorial space. Entering the frame is like opening a book; the quality and attention to the outside cover affect our ideas about its content, prior to our reading a word of it.

As an undergraduate darkroom photography student, I hadn't thought of a "carrier edge" (not adjusting the easel blades to within the image area) as being anything other than sloppy craftsmanship, until my professor Jack Teemer explained it in reference to his color photographs of children at play. When I asked about the colorful, jaggedly

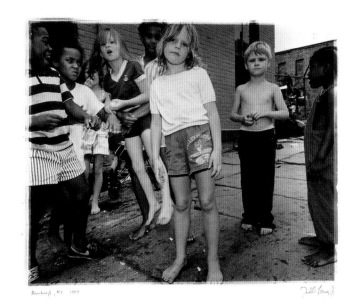

IMAGE © JACK TEEMER, FROM HIS SERIES *CHILDREN AT PLAY*.

Carrier-edge border. With a carrier-edge border, artist Jack Teemer suggested to viewers that the world captured inside the photograph extends beyond the frame. This carrier-edge was created using a standard negative carrier (not filed out) with the easel blades adjusted to outside the image area; the jagged edge is a natural outcome of light refracting between the negative and the interior edge of the negative carrier. (Learn how to control borders in the next section.)

inconsistent border area he said, "I wanted to suggest that this environment continues beyond the frame." And it did! At their outermost edges were "additional" hints of color and detail that extended each frame. Conceptually, the rough edges also set a tone referencing the underprivileged people and neighborhoods he captured within the frames. At that moment I realized the importance of image borders, and I began to experiment with a variety of darkroom border effects. I started to consider as part of my printmaking decisions the type of border to create (if any) to enhance my images of a particular subject.

TRADITIONAL DARKROOM BORDERS AND TECHNIQUES

In the traditional darkroom, negative carriers hold film flat between the light source and the paper so the image can be enlarged. The place where the carrier's inside edge meets the negative is also projected onto the paper and so produces a visual outcome. Because the interior opening of a standard negative carrier is slightly smaller than the image area on film, where they meet creates an inconsistent, jagged border due to light refracting from the inside edge of the carrier (hence, "carrier edge"). Because this printed effect generally isn't pleasing, photographers use easels (which hold the paper flat) and adjust the blades to crop just inside the visible carrier-edge to produce clean, borderless images. With borderless prints, the image simply ends where the paper's white space begins; it's the default method of printing both traditional and digital photographs. In fact it's so common that most viewers never think about it, which can make prints with borders all the more compelling.

If borderless images sound too plain and you prefer other options, help is on the way! With some simple customizing, your negative carrier allows you to create a wide range of striking image borders. The techniques outlined here are straightforward if you're familiar with traditional darkroom printing, but if not a little additional research and experimentation might help.

A note to digital photographers: the information in this section is still relevant to your practice because understanding how traditional darkroom borders look helps you replicate them in the digital darkroom. A digital darkroom borders discussion follows the traditional darkroom technical section.

Technical Discussion 2: How to Create Image Borders

This illustration outlines in red the interior dimension of a standard negative carrier in relation to the negative; as you can see, it ends just inside the image area. The larger blue outline shows a typical interior dimension of a "filed out" negative carrier, which allows you more freedom over the types of image borders you can print. You can file out negative carriers by hand, but the process is time consuming and the results aren't as precise as you might like. Also, hand filing often leaves residual metal burrs, and no matter how minute they are they will irreparably damage your negatives. Instead of going it alone, I recommend outlining the size that you want the carrier enlarged (remember it still must hold the negative on all four sides) and taking it to a local tool and die shop. These experts have the proper tools to modify your carrier to exact dimensions

without leaving any sharp edges. Once your carrier is filed out, experiment to see if light refraction bounces into the image area; if it does, then reduce it by using flat black spray paint or black Sharpie marker on the interior edge.

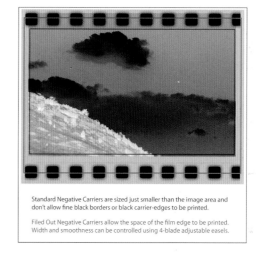

Standard Negative Carriers are sized just smaller than the image area and don't allow fine black borders or black carrier-edges to be printed.

Filed Out Negative Carriers allow the space of the film edge to be printed. Width and smoothness can be controlled using 4-blade adjustable easels.

Using a filed-out carrier, you can customize a range of print borders. To aid your endeavor, a four-bladed adjustable easel is an indispensable tool. There are many brands and types of easels, but exacting photographers use easels with four independently adjustable blades because they're designed to precisely control print sizing, cropping, and borders.

The most common border types are: *borderless, fine black line* (called a "stroke" in digital photography), *carrier edge*, and *vignetted*. I refer to these four borders as "organic" because they are a natural, albeit nurtured, outcome of the interrelationship among the tonal values at the edge of the frame, the interior edge of the carrier, and exposure to light. Think

of borders like the adverbs of framing—they modify the already existing frame edge for the purpose of enhancing it. I recommend making work prints with a variety of borders and living with them to help you determine how they reflect on the subject of your images. You can also use specialized glass negative carriers (discussed at the end of this section) to help you control borders, though image quality can be slightly reduced as a result of printing through the glass.

Basic Borders: Borderless and Fine Black Line

BORDERLESS

In the darkroom, the easiest and most common way to print is borderless. To make a borderless print, all you need to do is

Borderless. Printing with easel blades adjusted to just inside the image area eliminates carrier-edge refraction from the printed area. The resulting pristine border between the image and the paper is a somewhat default method of printing negatives and digital files. The borderless print's frame edge is inconsequential to the image meaning; since there is no border content, the edges go unconsidered by viewers.

adjust the easel blades (which hold the paper) to within the image area so that no light refraction from the carrier edge is printed. A borderless print has no demarcated boundary, only a clean transition from inside to outside the frame.

FINE BLACK LINE

The second basic border, and likely the second most popular choice for photographic printing, is a fine black border. It's made by using a filed-out negative carrier, which allows the film base + fog around the image area to be printed to maximum black. To make a fine black border, simply adjust your easel blades to include some of the clear film area around the image. You can adjust the blades for as wide a black border

Fine black border (stroke border). Using a filed-out negative carrier, the easel blades are adjusted to a position just outside image area to include the film base + fog. The width of the black border can be adjusted to any width inside the carrier edge. By creating a black border around the image area, the photographer tacitly points to the boundary of the image, and the viewer more consciously enters the pictorial space.

as you want within the boundary of the carrier edge. Even the finest black line serves to separate the image from the white of the paper, defines the frame edge firmly for viewers, and tacitly indicates an un-cropped image, whether or not it really is.

Carrier-Edge and Film-Edge Borders

Carrier-edge borders can have a smooth or rough edge, with rough edges ranging from slight to extreme. Just like fine black line borders, you can control the width of carrier-edge borders with a four-blade easel. Carrier-edge borders feel

handmade, but they walk a fine line between organic and overdone. Where they land depends on their width in relation to the image size, their presence (textural quality) in relation to the image content, and what aspects of the film edge they reveal. There is no standard for making carrier-edge borders, but the more of them you see and make, the better you'll become at determining whether they enhance or detract from an image.

Film-edge borders are printed using a negative carrier filed out extremely wide, or by using a glass carrier (covered in the

Rough carrier-edge border. Printed with a negative carrier filed out to the distance you see here. Adjusting easel blades ouside the carrier's projected light refraction creates an irregular border in the film base + fog area. A variation: Adjust easel blades to outside the area of light refraction of an unfiled carrier. This often creates visually unappealing results, but in cases like Jack Teemer's color *Children at Play* images, it can be very interesting.

Film-edge border. Printed with a negative carrier filed extremely wide or using a glass negative carrier. Using a four-blade adjustable easel you can easily print a wide area around the film edges and still make a smooth outside border by moving the blades inside the area of light refraction. This allows you to include film sprocket holes, frame numbers, and so on.

next section). Like carrier-edge borders, film-edge borders include film base + fog, but outside that area is a clean edge. Whereas you adjust easel blades to outside the area of light refraction to create a carrier edge, you adjust the easel blades to just inside that refraction to include film base + fog but still maintain a clean edge.

Vignetted Borders

In addition to any of the borders that negative carriers allow you to create, you might choose to *vignette—to darken or lighten the image gradually toward its edges*. Making vignetted borders in the traditional darkroom is easy (and is easily mimicked in the digital darkroom), but like carrier-edge the effect can range from organic to overdone. Where they land depends on the vignette's density, width, and degree of gradation in relation to the image size and content. To make a dark vignette, simply supplement the overall print exposure to darken the edges by *burning* them in. The degree of vignette is determined by the duration of the burn's added exposure as well as the contrast filter used. When a borderless print is vignetted very subtly, the effect is often referred to as a "psychological burn" because while viewers don't recognize the edges as vignetted, their vision tends to stay within the frame.

Most often, vignetted-edge manipulations carry with them connotations of memory, traveling back in time, or project-ing forward to the future. They can also allude to notions of ephemerality, ethereality, and other transitional states. The edges of a vignette should create a smooth visual easing into the pictorial space, encouraging viewers to linger within the image. Vignetting applied to the wrong image content can have an overly sentimental or clichéd feeling, but technique helps you avoid it.

As an alternative form of vignette, some photographers vignette their images to white by *dodging* them, by blocking some of the exposure to light that the paper receives during the initial exposure. The technique is rather uncommon but can be successful when working with some (in particular high-key) images.

A variation of these techniques is to vignette the border to dark edges while printing the entire sheet of paper to black. To do this, simply make an exposure set to maximum black to the area of photographic paper outside the image area, after the initial image exposure is made. Simply place an opaque board the size of the image on top of the image area, lift the easel blades, and expose the remainder of the paper surface. In the digital darkroom, simply make the canvas size around the image area the size of your printing paper and fill it with black. This technique is often used when you want the entire sheet of photographic printing paper to be regarded as part of the work itself. Often, these prints are displayed "floating" in a frame using spacers (with no window mat), or they are incorporated into a larger piece (this will be discussed in Chapter 6).

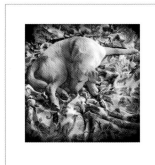
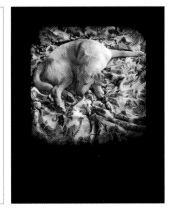

IMAGE © ANGELA FARIS BELT, *DHARMA IN A PAISLEY FIELD*, 2005.

Four border treatments. Clockwise from upper left: borderless, fade-to-white vignette, fade-to-black vignette with paper printed to black, and black vignette border. The various types of vignettes change the feeling and intensity of the image and affect how the viewer reads the image content. Notice that while the dark vignettes serve to keep your eye inside the frame, the white vignette leads your eye outside the frame.

Glass Negative Carriers for Special Film Formats

Standard film format negative carriers are filed out to allow greater control over the appearance of your image borders. But what if you shoot custom image formats or if you want to include the entire film base + fog area around 4" × 5" film (these carriers are hard to file out)? You can buy a *glass negative carrier—two sheets of Anti-Newton glass*, attached together, which accommodate a larger than 4" × 5" area. They can be expensive, but the special glass prevents the concentric circles that will appear in your prints if you try to use regular glass. When using glass negative carriers, simply place the negative inside and mask it off just outside the area you wish to print using *rubylith tape, which is opaque to photo paper but allows you to see through.* Then adjust the easel blades to create the borders you want.

Another alternative for nonstandard negative sizes is to make your own carrier out of four-ply black mat board. Measure and cut two pieces of black mat board to fit your enlarger, and cut interior openings that work with your image format. You can make very crisp edges with a mat cutter or make rough cutouts by distressing the interior edges of the mat.

IMAGE © TODD DOBBS, *BUILDINGS NO. 12*, 2002.

Glass negative carrier. In this example, fine art photographer Todd Dobbs created a traditional darkroom gelatin silver print from a long strip (multiple, overlapping Holga plastic camera exposures) of 120 film placed in a glass negative carrier and masked just inside the image edge with rubylith tape. The resulting clean, pristine border between the image area and the paper is a common way to print standard negative sizes, but it can be difficult to achieve with nonstandard negatives without a glass carrier.

THE DIGITAL REALM: BORDERS WITHOUT FILM

We've just looked at print borders produced organically in the traditional darkroom. But what about adding borders to digital prints? Whereas traditional darkroom borders are an organic outcome of the relationship of light to the media, in the digital darkroom no such relationship exists, but that makes the possibilities endless.

In photography's digital age, adding a film-edge image border necessarily references one or more key notions about the image and its subject (discounting borders made because the photographer "just likes them"). First, the border could be used to harken the viewer back to a particular period in photography's history. I'm not talking simple nostalgia here; since photography's existence its various media have produced physical edges that are recognizable when printed. In terms of interpreting photographs, without knowing the vintage of the image, viewers might refer to the time period during which its particular border was most commonly made. Digitally added film-edge borders can also imply that

a particular camera type and format was used. For instance, film borders from view camera images have distinct edges, as does Polaroid Type 55 film; and Hasselblad cameras leave small triangular notches of unexposed film at the edge that are visible when printed to a fine black border. All of these things could denote meaningful juxtapositions between the medium and the subject, but not always; the digital realm has undone many former assumptions about how the medium dictates form.

Technical Discussion 3: Digital Image Borders

With digital photographic capture, there is no physical medium extending beyond the frame, so nothing outside the image area to work with. This combined with the darkroom norm led digital photographers to carry on the borderless tradition. But if that's too limiting for you, the digital realm provides nearly infinite possibilities. Read on.

There are two invaluable online resources for adding image borders: *tutorials and templates. Tutorials show you step-by-step how to mimic photographic borders*, even those from the traditional realm not made with negatives, such as Polaroid lifts and transfers. These kinds of widely recognized borders are sought after in both fine art and commercial use, and they can be easily replicated by researching the vast number of on-line Adobe Photoshop tutorials in the subject. Just search something like "photo border Photoshop tutorial" in your browser, or use the specific border name, but don't settle on the first tutorial you find. Like anything else in photography, fabricating borders is a process, so try several tutorials to see which produce the most pleasing effect.

Templates are prefabricated borders that are often supplied with online Photoshop tutorials and are digitally loaded into the image document and set in place. Template borders are either scanned or digitally created and are often made to mimic traditional film borders and Polaroid Type-55 and transfer images. When looking for a download template border, find a large image size (in pixel dimensions) or vector-based options. Vector-based borders can be scaled to any size without a loss in quality and then rasterized (made pixel based, like photographs) once you have them incorporated into your image.

Many template borders are perfect for commercial imagery, but editorial, fine art, and decorative art photographers often want to create and control the appearance of their images, even to the borders. This is where customization comes in. For

instance, in the traditional darkroom the carrier edge is unique to each image, and the potential for that same unique-to-each-image character exists in the digital darkroom as well. Because borders in the digital realm are independent entities from the original image, they can be scaled, rotated, distorted, recolored, and so on, providing exponentially more options than are offered in the traditional darkroom. With some understanding and practice with image-editing software tools, you can turn a single template into unique but similar borders for several images in a series. You can scan your own borders from traditional images or even objects, or create them from scratch digitally. The farther from the ease of canned effects and closer to more organic and conceptually sound approaches you get, the more authentic your images become.

Image Discussion 13: A Hybrid Approach to Image Borders

Fine art and editorial portrait photographer Dan Snow was trying to come up with the perfect borders to surround his *Portraits* series, and he began by mixing traditional and digital techniques. As an expert in traditional darkroom printing, Snow already knew how to create a range of borders, and he knew the general look of the border he envisioned. Although he wanted a rough, organic feel similar to a carrier edge, he didn't want to simply copy a darkroom border. Because he was shooting digital media, however, he knew he'd have to experiment to come close to something achievable in the darkroom, so he began discussing with his critique group their perceptions of the variations he produced.

Far left: In his initial experiment, he began by painting black brushstrokes on paper. Once dry, he scanned them and using Adobe Photoshop he layered the painted border onto the photographs. In going through the process, he quickly determined that though he liked the uneven quality, the first border was overdone and distracted from the photographs.

Center: Undeterred he began a second experiment by buying some Adobe Photoshop brushes resembling the painterly

brushstrokes he was going for. The borders looked far closer to what he intended, but with two problems. First, they were still somewhat distracting from the subject, and, second, removing himself from the creative process by buying the brushes wasn't what he wanted to do. He tried making his own digital brushes and made prints to evaluate at each stage, but noting suited.

Far right: For his final experiment Snow went back into the darkroom. He used filed-out 4" × 5" negative holders with no negative inside and exposed the carrier-edge refractions onto RC paper; once processed, he made high-resolution scans. In Photoshop he turned the scanned borders into digital brushes and placed them around the images. He then edited the borders so that each was as unique as if it was printed in the darkroom with filed-out carriers—individual, handmade borders that support the images.

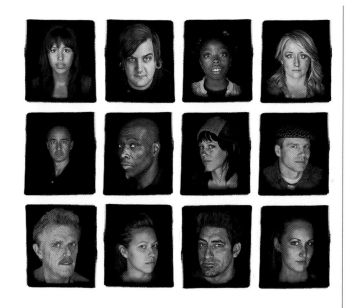

IMAGES © DAN SNOW FROM HIS ONGOING *PORTRAITS* PROJECT.

Borders are not an element of photography on their own, but they are an extension of framing and an aspect of presentation (which will be covered in Chapter 6). Not all photographs need borders; borderless prints are classic for a reason. The best image borders are the ones that feel inseparable from the image. The last thing you want is for viewers to notice overpowering image borders first and then see the image. Borders that distract from rather than enhance images fail in their purpose. From this perspective, less is more.

Research and experimentation are the best ways to determine the types of borders, if any, you want for your photographs. In addition, you can analyze borders you find in commercial and fine art work for aesthetics and potential meaning in reference to the subject or the era of traditional photography from which they came. The process of making a border, then looking at it, then making another, and so on is similar to the process of determining display methods (covered in Chapter 6). It's most beneficial to actually see

the prints with borders (as opposed to on screen or via small contact sheets). Making as many versions as necessary and living with them as work prints will reveal which border is right for your image both visually and conceptually.

CHAPTER EXERCISES, PART 2: EXPERIMENTING WITH BORDERS

1. Tear Sheet Discussions

In Chapter 1 I recommended collecting *tear sheets*. Whether you view images in magazines or online, saving a copy of the ones that really strike you in some way—intellectually, visually, emotionally, or on a gut level—enhances your understanding of photographic language and how to use it. This exercise is best done in the context of a critique group as well. Find two to three images whose borders refer to the form or subject of the images, and bring them in for discussion. Because we can learn as much from failures as we do from successes, you could also discuss images whose borders don't work, that are unnecessary, or that distract from the image. Be aware of images within series that have identical ("canned") borders versus those that have customized "variations on a border" throughout the series.

2. Borders Experimentation

Edit to your three best images from the previous chapter exercises. Using the medium of your choice, create two different border effects and apply them both to each of the three images. Critique these images and determine which border effect works best to support your subject and the style of your images, and if the effect needs to be revised in some way. Determine whether this border effect might be used throughout the series of images. You might decide that borderless is the way to go with your images, but it's difficult to know without looking at alternatives.

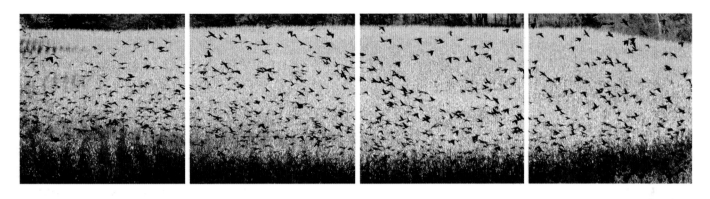

IMAGE © ANGELA FARIS BELT, *FLOCKING*, 2007.

PART 3: MULTIPLE FRAMES TO CREATE A SINGLE IMAGE

WORDS—SO INNOCENT AND POWERLESS AS THEY ARE STANDING IN A DICTIONARY, HOW POTENT THEY BECOME IN THE HANDS OF ONE WHO KNOWS HOW TO COMBINE THEM. —NATHANIEL HAWTHORNE

INTRODUCTION: EXTENDING THE FRAME

The most basic element of photographic image making is the frame, since it's the first element you encounter when you pick up a camera. The most basic way of using the frame is to make individual photographs, single captures of time and space. Since individual images have such potential for great and lasting communicative and emotive power, what more is there? Well, you can use two, three, or multiple frames to create a single image, which might help you expand your statement about your subject. And why would you choose multiple frames to make a single image? There are several reasons.

First, *using multiple frames challenges photographers to conceptualize new ways of creating images.* In addition to organizing the individual frames, you now have to organize several of those frames to cohere through *gestalt*. To successfully combine a group of images into a singular work forces us to previsualize each frame within the multiplicity of frames, their relationship to one another, and the interrelationship among image contents. Additionally, it challenges viewers

to understand our subject and the nature of photographic language in a more faceted way.

A second reason to use multiple frames is it allows photographers to extend a camera's frame format. It lets you include physical space beyond what a single frame can capture, in effect *capturing a wider angle of view than the camera's format could otherwise capture*. It also allows digital media users to effectively increase the sensor and megapixel size of the camera.

A third reason to use multiple frames is that it gives photographers the option of *representing the passing of time without blurring motion*—that is, since each frame is captured separately, there is the opportunity to add, move, and change contents from one frame to the next, affecting interconnection and evolution between frames.

Finally, using multiple frames in the form of *montage* allows photographers to incorporate historical and other images that expand on their subject, as in recent works by Mark Klett and Byron Wolfe (shown in this chapter's Portfolio Pages). For commercial photographers, it enables you to "shoot to a layout" provided by advertising art directors. If the director needs a panoramic or square image, you'll know how to combine frames to achieve it.

This part of the chapter isn't about multiple exposures or multiple printing techniques (those are more closely related to the element of time covered in Chapter 5). It's about using multiple frames to create a single image; it's about ways to extend and add complexity to the way you approach your subject. Think of multiple frames like individual stanzas in a poem: their proximity to one another within a single poem defines each as part of the larger whole; they may be read individually, but to get the full meaning of the poem you have to interpret all of its stanzas together. And like stanzaed poems, multiframe images have distinct "framed" content, each independent of the larger whole; however, only in relation to the other frames (other stanzas) is the image complete. Like stanzas, multiframe image components tend to be of equally measured size for the purpose of structural unity, but that's in no way a rule because adding frames allows for (and even encourages) creative variation. In this section we'll discuss some common types of multiframe images and ways to create them.

GESTALT IMAGES

Originally a term from the field of psychology, *gestalt refers to a unified whole*. Applied to visual art and perception, gestalt is necessary in making discrete, individual parts act as and be perceived as a single image. There is a great deal of information about gestalt visual principles, and I encourage you to do independent research as you proceed in making multiframe images. There are five basic aspects to gestalt design: similarity, continuation, closure, proximity, and figure/ground. Although they're all important, one is particularly relevant to making multipanel images work—proximity. *Proximity*

CHAPTER THREE

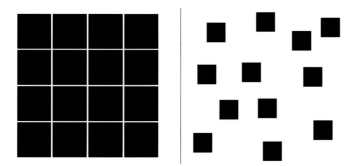

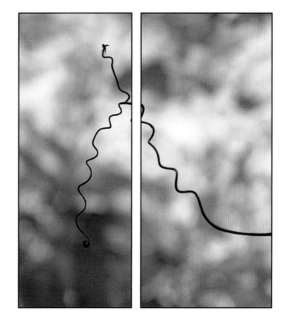

IMAGE © ANGELA FARIS BELT, *WISHBONE STICK*, FROM THE SERIES *TRACES*, 2007.

means that separate elements, placed close together spatially, will be perceived as one whole. For example, as viewers we can envision the squares to the left as one larger square, while we see the squares to the right as separate entities, even though the same number of individual squares are arranged in the same amount of space. We still acknowledge that the "single square" is made from distinct parts, which is what gives gestalt images unique communicative power!

Even more powerful, gestalt proximity allows you to construct images from multiple sources as well as from the same scene. The ways in which multiple frame images can expand your statement about your subject will become clear as we go and as you consider your subject within constructs such as multiframe panoramas, contact sheet images, diptychs, and triptychs. Not every technique will suit every subject, but the knowledge will expand your photographic vocabulary, and one technique might emerge as an incomparable way to express something important about your subject.

Gestalt. This simple image uses nearly all aspects of visual gestalt. The frames are in close *proximity* to one another, so your eye *continues* through the space between frames to *close* the wishbone and *complete* the contents of the scene. Because the strong foreground figure has a similar shape and size on both sides, we recognize it as a continuous entity. Extremely shallow depth of field also helps the figure stand out (more on this in the next chapter). In interpreting these multiple frames, the slightly asymmetrical panel width refers to one side coming out just that far ahead when wishbones are split. Although we visually acknowledge two panels, we mentally construct one image whose meaning relies on two distinct but interconnected images.

Stitched Panoramic Images

You run into them quite often, and they frustrate you every time: a perfect scene with too wide an angle of view to capture with the focal length lens you have. To your advantage you're shooting digital media. You think about it, and you proceed to make several consecutive exposures from left to right with a plan to put them seamlessly together later. The process can be exacting, and your success depends on how well each image aligns and overlaps. You're trying to make *a panorama—a continuous extensive view, whether composed of a single panoramic frame or several images seamlessly stitched together.* Although it was captured that way, the final image has no gestalt parts.

With respect to framing (remember, it's our first photographic element), individual frames seamlessly stitched are no different than a single panoramic frame made with a panoramic camera—in the end they are still read as a single frame. Stitched panoramas do, however, rely on gestalt principles while photographing in order to stitch together succcessfully.

Although it's helpful to know how to make digitally stitched panoramas, we'll not spend too much time on them because we really want to discuss methods of using several, clearly distinguishable frames to make gestalt images. The following Technical Discussion describes the process for anyone wanting to extend the width of your frames.

Technical Discussion 4: Stitched Panoramas

One advantage of the digital darkroom is the ease with which several images can be seamlessly "stitched together." Stitching digital panoramas can be valuable for two reasons: it lets you make wide format images without cropping, and it lets you effectively increase your megapixel capture size.

When you're capturing the frames to stitch, there are some general guidelines to help ensure success. First, choose a still subject and use a stable tripod. Align each image as carefully as possible and try to maintain a level horizon for each image; the more level the individual images, the more level your stitched image will be. There are tripod heads made specifically for

ILLUSTRATION © TOBY COCHRAN.

When making panoramas, be methodical in your approach. Your lens's angle of view will dictate the degree of rotation for each frame; wide-angle lenses will create more distortion, and normal focal length lenses (best for beginners) will yield a more natural looking result.

complex panoramic imagery, but with some attention a regular three-way head with bubble levels works perfectly well.

Second, maintain an overall exposure for middle gray. Meter the entire scene you wish to capture from side to side, and use a balanced exposure to minimize loss of highlight and shadow detail throughout. Use an aperture that will render adequate depth of field throughout the subject area, and lock in the exposure and focus so that neither one shifts between frames. The more consistent the exposures and focus, the more likely the frames will seamlessly stitch.

Finally, use vertical frame orientation (for horizontal panoramas), and overlap as close to 1/4 of the frame content as possible as you pan across the scene. This makes a more balanced aspect ratio for the resulting panorama, and gives the program enough information on which to base stitching decisions. I highly recommend making a second round of exposures for any panorama; in case of an unexpected exposure change or gap in content, you'll have the second try to fall back on.

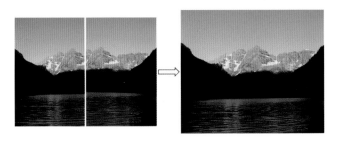

IMAGE © ANGELA FARIS BELT, *DAWN, MAROON BELLS,* 2010.

21 megapixels to 36 megapixels in less than 10 seconds. I captured these two images to make a square image with a large file. I didn't use a tripod; I just shot a frame to the left and another to the right, overlapping about one third of the image content (notice the peaks repeated in both frames). I also maintained the same focus distance and exposure. Although I didn't quite double my camera's megapixel size (because of overlapping content), the increase I did get was well worth it. I stitched them together using Adobe Photoshop's automated Photomerge function. The Help menu in Adobe Lightroom or Photoshop will easily guide you through the stitching process.

Multiframe Panoramas

Multiframe panoramas, what I call gestalt panoramas, are panoramic images with recognizable components. They're made in much the same way as stitched panoramas, but rather than negating the individual frames by stitching you use them in proximity to one another. This is where gestalt comes into play. If there is too much space between frames in the final image, they will be read as separate entities; if proximity or other gestalt principles bridge the individual frames, then the space between them can vary and there can even be repeated content in separate frames. But too much repeated content makes it difficult for the viewer's eye to continue from one frame to the next. Worse, gaps in content, even small ones, can stop viewers at the point where continuity ends. With any multiframe image I recommend making more than one attempt at capturing the scene (in other words, hedge your

bets), because you can't see the finished product until you construct it afterward.

When making gestalt panoramas, some of the same stitched panorama technical considerations still apply. They aren't always necessary, but they're an advisable starting point until you understand how gestalt works and become more adventurous in your constructions. Using a tripod still increases your likelihood of success by giving you time to align each frame as carefully as possible. Maintaining a level horizon for each image and maintaining similar content at the top and bottom of each frame also helps, but the advantage to

IMAGE © ANGELA FARIS BELT, *WYOMING PLATEAU*, JUNE 2006.

Multipanel panorama with horizontal camera orientation. This six-panel panorama was made on my first expedition into Wyoming. The view was so expansive and so foreign to me that I wanted to make a panoramic image of it. I placed my camera on a tripod and leveled it for each frame using the circular bubble level on the tripod head. I paid attention to what was in the far right edge of each frame, being careful to repeat that element only slightly in the far left side of the next frame as I panned across. The slight repetition of content from frame to frame provides visual continuity so the six images are easily read as one. Although panoramas tend to have a more pleasing height-to-width ratio when you orient the camera against the direction of panning, in this case the opposite approach best represented the feeling of the place.

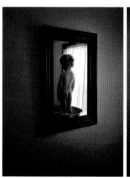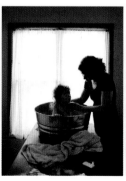

IMAGE © DAVID HILLIARD, *TEPID*, 2010.

Multiple frames and passing time. You don't have to stick to still subjects to make multipanel images. There is boundless potential for interpreting time's passage, as this image by David Hilliard demonstrates. In this scene, the image content changes from the far left image to the central image it references; we can experience a sense of time passing during the ritual bath because the child's reflection counters his position in the next frame. The close proximity between frames allows us to mentally construct a single panoramic scene.

gestalt is that you don't have to. Also, maintaining an overall exposure for middle gray to minimize loss of highlight and shadow detail throughout the scene gives you more latitude to "mix it up" in the traditional or digital darkroom. For standard multipanel panoramas, the more consistent the exposures, the more seamless the gestalt effect will be.

Multiframe Overlapped Panoramas

Another way to construct multiframe panoramas is to overlap frames wherever primary content intersects. You can collage separate prints onto another substrate, or you can montage overlapped frames printed on the same piece of paper (my preferred method) in the traditional or digital darkroom. *Overlapped content means there is no space between the images, yet they are still not seamlessly stitched.* Often small elements are repeated where the frames overlap. You can choose to make the top and bottom of the image align by cropping all frames evenly, or you can maintain the unevenness of the panorama. Both methods of frame alignment add texture and complexity. Remember, content doesn't have to align exactly (that's part of the appeal); it only has to *proximally* align.

Image Discussion 14: Two Panoramas

Multiframe Overlapped Panorama with Borders

This panorama is made from nine separate frames, captured from my deck on a particularly beautiful snowy Colorado morning. I wanted a high megapixel file that I could print very large, so I used multiple frames and stitched them together in Photoshop. I don't care for the telltale borders created by stitching programs—they tend to be very jagged and somewhat warped—but I did respond to how their unevenness related to the textures of the scene, so I modified each frame's height and left them uneven but with less jagged edges. I avoided aligning

IMAGE © ANGELA FARIS BELT, *DAWN LIGHT AFTER BLIZZARD, VIEW FROM MY DECK, COLORADO FRONT RANGE*, 2008.

the spacing between "frames" at the top and bottom to energize the borders. The effect adds interest to the panorama while maintaining a seamless interior frame.

Multiframe Overlapped Panorama with Seams

This panorama was made on the same snowy day as the previous one, after a storm hit full-force. I wanted to capture the avalanche conditions behind my home, so I decided to shoot a panorama flanked by hints of the house and shed. The center of the image had a dramatic arc that felt too empty, so I copied partial frames down to fill the space. It not only added content to balance the frame but also elongated the trees. This panorama

differs most from the previous one in that the individual frames are easily recognized within the larger frame, adding even more complexity to the image.

When you're working within a larger series of images, it helps to have several images that utilize the same (or similar) image constructions. This keeps them from being read as anomalies within the rest of the group and reinforces the use of the technique. Although these were personal images, I still wanted to use a similar approach to each because they each told a part of the same story.

IMAGE © ANGELA FARIS BELT, *AVALANCHE LOOMING, POST-BLIZZARD, VIEW FROM BACK ENTRYWAY, COLORADO FRONT RANGE, 2008.*

Dividing a Single Frame

You don't necessarily have to capture several frames in order to create a gestalt image; you can also divide a single capture into multiple frames and rearrange them. In this image, I saw hundreds of birds flocking, preparing for winter migration. The scene was loud and frenzied; I just had to make photographs. I edited to two images and cropped one into a wide horizontal to follow the flow of dense trees and shadows surrounding the bright cornfield.

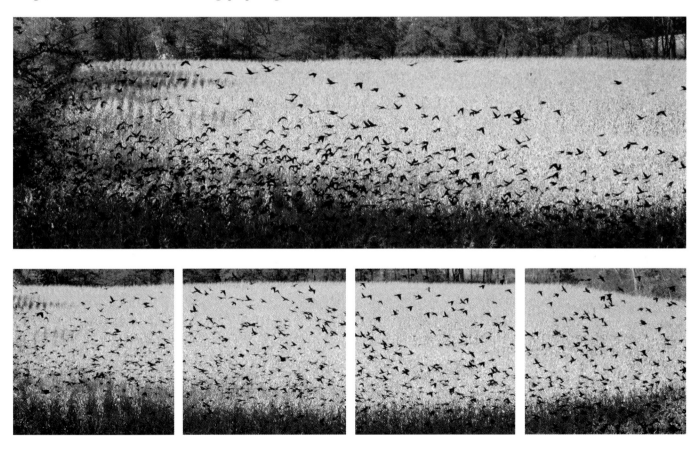

IMAGES © ANGELA FARIS BELT, FLOCKING, 2006–2007.

After evaluating the panoramic crop, I chose a slightly different edit with more birds and decided to crop it into four separate frames, symmetrically aligned. The multipanel image is the final version I made; I felt it best represented the scene by underscoring its organized chaos and reflecting the rhythm and energy of the migrating birds.

Contact Sheet Images

We've discussed contact sheets as invaluable editing tools that also allow us to analyze our shooting process, but what else could they offer? Well, as prints they have a life of their own, and their distinctive appearance (including media borders and the space between frames) has prompted some photographers to use the contact sheet's unique multiframe format to make gestalt images. *Contact sheets—prints with images the same size as the negatives—*originated from traditional darkroom practices as a means of editing tonally reversed exposures. They can be printed with as many frames as will fit onto larger sheets of photo paper. Since they allow us to see many positive images in close proximity to one another, they open the door for creative use of gestalt.

Like most other multiframe images, each frame comprising it is captured separately, allowing you to create relationships and construct images that are entirely different than a single image of the scene. For instance, you can shoot some content out of focus to mimic depth of field wherever you like, you can change vantage point between frames, you can blur some frames and not others, and you can add, move, and remove content between frames. The possibilities are almost limitless, and that makes the photographic challenge more exciting!

Because contact sheets allow us to see and compare the multiplicity of images within them, we can consciously engineer the organization of images to cohere through gestalt. Simply by knowing the number of frames a particular contact sheet will hold horizontally and vertically, as well as their printed orientation, you can preplan each frame as you shoot. Film needs to be shot in sequence, so the process is less forgiving than with digital media, but the appearance of the film-edge borders running throughout are worth it. (For examples, see Thomas Kellner's amazingly complex film-based contact sheet images in this chapter's Portfolio Pages.)

Although digital contact sheets lose the characteristic film-edge borders surrounding the images, they do offer one distinct advantage: they allow you to configure the sheet with as many or as few rows and columns as you like. You're not constrained to the length of a roll of film, and you can shoot more frames than necessary (like bracketing, to hedge your bets) and include only those that work well in the contact sheet. And if you want film-edge borders, you can always scan film strips to layer with the file or drop your digital frames into a scanned traditional contact sheet.

Technical Discussion 5: Making Contact Sheet Images

Gestalt contact sheet images are an interesting way to approach many subjects, and they also provide a direct reference to the history of the photographic medium. Making successful contact sheet images can be difficult, so it takes a good deal of planning prior to shooting. The following tips will help you along.

First, the medium. If you're using traditional film, be sure to know its orientation and the direction it advances inside the camera. Also, determine how the film fits into its designated sleeves (rows and columns, inserted vertically or horizontally), or plan to hand-place your negatives under glass in a specific configuration for printing. If you're using digital media, predetermine how many rows and columns of frames you want in the final piece, and shoot for that configuration. You can make contact sheets through Adobe Photoshop or Lightroom in a few simple steps through their automated functions (see the program's Help menu). Be sure to name your files such that they're placed in order when the automated function runs. Digitally you can make contact sheets with black, white, or color backgrounds and with or without file text identification. You can also use layers to manually place the images onto a separate digital canvas.

Second, the visuals. Making a preliminary sketch that matches general content to the number of rows and columns you want in the final piece will help you organize your thoughts and provide a reference while shooting. Contact sheet images work best when they're previsualized.

Third, the technical stuff. Before you begin shooting, determine proper exposure by metering an average (middle-gray) part of the scene or using an incident-light meter, and keep your exposure the same throughout the contact sheet regardless of your camera meter's changes between frames; otherwise your gestalt image won't have consistent density. Zone-focus and keep your focus point at the same distance (turn off auto-focus) if you want your image focus similar to a single capture.

Once you choose your subject and camera position, do a dry run by panning the camera sequentially from side to side, row by row. Consider your distance from your subject, because a common reason for failed contact sheet images is too much distance from the subject matter. You should only see a small part of the larger whole in each frame, so move in close or use a longer focal length lens.

Finally, remember that you can choose a fixed vantage point or you can vary it. For a fixed perspective use a tripod, for a varied perspective you might not need one. If you want to draw attention to content in specific frames, then change focus to capture other frames at varying degrees of soft focus (mimicking shallow depth of field). Also remember you can change your distance from your subject between each frame; what might those things help you to communicate about your subject? Above all, experiment and have fun!

Following is a great example of what can be done with a contact sheet or any grid-type configuration used to make a multiframe image. Be open to any means of combining images to make a unique statement about your subject.

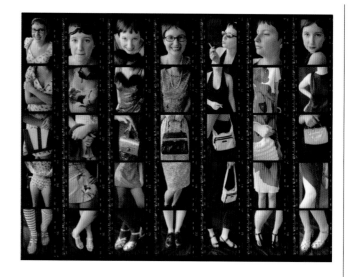

IMAGE © JASON LAVERIS, *STACEY PLOTT*, 2000.

Contact sheet image. This comparative image by Jason LaVeris was designed by envisioning the contact sheet divided into seven distinct scenes, and shooting to that format. This inventive concept allowed his friend and collaborator Stacey to show off the well-planned pieces of her extensive wardrobe in a unique way. To create the gestalt image, Jason captured five frames of Stacey from her head to her toes (*far left*). She then changed outfits, returned to the same spot, and they repeated the process six more times, taking care to maintain similar content across the rows. The result is a kind of typology and a whimsical look at an equally whimsical model.

Diptychs and Triptychs

As we discussed in the first part of the chapter, *juxtaposition creates meaning through the relationship and interaction among discrete contents.* To reference written language again, when juxtaposition occurs inside a frame, it's similar to a "complex sentence," rather than a "simple" one. You can take this complexity a step further by juxtaposing one frame's content across its borders and into another frame, like the interaction between two complex sentences. *Diptychs (two images arranged in proximity)* and *triptychs (three images arranged in proximity)* offer one way to do just that. A terrific example is fine art photographer Dan Estabrook's *Untitled Twins, Joined,* discussed in the beginning of Chapter 1. (I recommend taking a moment to reread Image Discussion 1, "Interpreting Subject by Examining Content and Form"). His use of the diptych format juxtaposed two men, one whose hand seems to be reaching out of his frame and into the other. Diptychs like these create connotative meanings beyond what can be accomplished in a single frame.

Diptychs and triptychs differ from other types of multiframe images in that their content does not connect panoramically. One frame's content isn't continued into the next; rather, two or three discrete frames of content are placed in proximity to one another to indicate that they create a combined meaning.

The creative and communicative advantage offered by these and all gestalt images is that *there are different frames,* each captured with individual exposures at individual times. Armed with this knowledge, you can create even more interesting images by conceptualizing simulated depth of field (shooting strategically placed frames of secondary content slightly out of focus); by changing the frame orientation or crop between each image (who says all the images have to be vertical or horizontal?); and by varying density, color, and

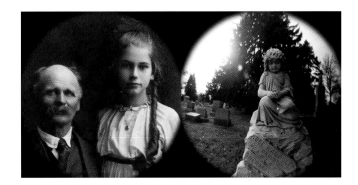

IMAGE © MELISSA MERCADO, #4 FROM HER SERIES *AT REST,* 2006.

Diptych with vignetted borders. Photographer Melissa Mercado encapsulates her diptychs from this series within heavily vignetted borders. Combining traditional and digital media, Mercado uses the vignette to simultaneously isolate and bind the disparate images, forcing us to consider each one prior to considering the larger meaning they suggest together. The opera glass–like feeling provides a tunnel through time and suggests a relationship between the people in the historic image and the tombstone image placed beside them.

IMAGE © JOE LAVINE, 2007.

Juxtaposition between frames in multiframe images. This dual-panel image operates as a diptych because of the dramatic difference in color from one panel to the next, even though at first glance one assumes the horizon is a continuous (panoramic) one. The approach allows photographer Joe Lavine to create a disjointed landscape, making the message of toxicity within "pristine" farmland more visceral.

contrast (who says they all have to match?) to make truly unique images that work as a whole. You can even incorporate images from other times and places into them.

There are innumerable ways to combine several images into a single piece; the idea is to think about *how multiple images might communicate about your subject specifically* and what using multiple frames will allow you to accomplish that using a single frame could not. Experiment, practice, be open to conceptual implications, and be sure to notice all of the multiple frames around you. We discussed several ways to make gestalt images with individual frames, but don't stop here. Expand your creative vocabulary and innovate with your own unique use of gestalt.

CHAPTER EXERCISES, PART 3: A FACETED APPROACH TO YOUR SUBJECT

These exercises will help you take your adventures in framing one step further by using multiple frames to communicate about your chosen subject. Take a no-holds-barred approach to conceptualizing and creating these images, in particular when it comes to unique ways to make several frames interact. Research and problem-solve to overcome any technical hurdles you might encounter so you can make your images exactly the way you want them.

1. **Multipanel Panoramic Images**

 Make a series of photographs in a row with the intention of printing them as a multipanel panorama. Determine how many frames will create the image you envision, and plan it from left to right or top to bottom. Remember to keep your focus distance and exposure consistent throughout all images in the panorama. You may or may not use a tripod, but you'll have more control with one. If you're shooting film, remember the size constraint of your enlarger; for instance, a 4 × 5 enlarger can accommodate a panoramic image of three horizontal 35 mm frames using a handmade or glass negative carrier. Or, you could print each frame individually and physically arrange them afterward by window matting or dry mounting.

2. Contact Sheet as Image

For this exercise, use the format of your contact sheet to create an image. Consider what the format—the number and configuration of frames and space between them—of a contact sheet can add to a viewer's perception of your subject.

Shoot each frame deliberately, so that when they are printed together as a contact sheet, the resulting gestalt image represents the unified whole that you had envisioned. Making a successful contact sheet image can be easier said than done, because everything has to be meticulously planned to be successful; one incorrect frame and the entire piece could fall apart. See the tips included earlier in this chapter for help. When using traditional film, be sure to cut your negatives in the right place, because once you cut them there's no reconnecting them.

3. Incorporating Other Images

In this exercise, think about using images you have previously made or found imagery of any kind (maps, snapshots, antique-store photos, magazine ads, etc.) and build on them to broaden your statement about your subject. You could rephotograph the images, or you could use an original, one-of-a-kind image. You may choose to collage or montage; you can tear, cut, slice, recolor, and resize. Anything goes, really.

Concentrate on combining any other imagery with your new imagery to expand on concepts surrounding your subject. You might look through this and other chapters' Portfolio Pages first to help you conceptualize. This exercise provides a unique take on multiple frames because many photographers don't want to appropriate someone else's imagery into their own. Suffice it to say that even if you don't emerge from this exercise with a portfolio piece, you will have expanded your vocabulary about recontextualizing images.

With each chapter, continue conducting independent research about your subject, and keep pushing your creative boundaries. You might even add to these exercises making diptychs or triptychs, or any other multiframe construct you can think of. Remember, not every image you make is going to be a masterpiece, but the journey you take in making it is where the lessons are.

PORTFOLIO PAGES

The photographer-artists represented in these Portfolio Pages all use more than one image to piece together a more faceted view of their subjects than any single image could provide. Their images defy the hold of time over single captures to create significant visual and conceptual references to their subjects. Their work isn't about multiple

frames; however, their meanings are intrinsic to the physical interrelationship or interconnectedness among the frames.

To create their images, these photographers use the range from film to digital and combined media to suit their specific needs. This is not a Photoshop textbook; it's a book about photographic language and using the camera as the means of interpreting the world. But using layers in the digital darkroom allows for mimicking certain camera effects, and as such it is a viable substitute (at times even a necessary substitute) to add historical and other types of imagery. The artists in these Portfolio Pages use all of these techniques and more. They should inspire ideas and discussion regarding the use of multiple frames and should whet your appetite for multiframe possibilities.

MARK KLETT AND BYRON WOLFE

YOSEMITE IN TIME

ELEMENTS

Through an intensive process of research, photography, exacting rephotography, and incorporation of historic images, Mark Klett and Byron Wolfe have broken through the temporal barrier separating past from present. By combining multiple frames in a single image, they juxtapose some of the first photographs of the American West with their own contemporary images of the same physical space. The result allows us to compare and contrast the effects of time while documenting change in specific environments.

ARTIST STATEMENT

We began our collaboration as a way of sharing ideas about time and change and to examine the ways we had developed personal relationships with place. Working together we began with 19th-century landscape photographs of the American West and made rephotographs from the same locations as the initial starting point for what became an extended form of visual research that combined historical images with scenes from the same location. By relocating the vantage points of historic photographs and embedding them into contemporary panoramas made of the contemporary view, the composite images revealed aesthetic decisions of photographers in both centuries.

The pictures also clarified how the basic physical reality of the world is often quite different from what is suggested within the borders of an original photograph. Such comparative techniques are especially complex in Yosemite National Park, a landscape filled with many iconic photographs that helped define photography as an art form. Assembled as single, all-encompassing views containing historic images by photographers such as Carleton Watkins, Eadweard Muybridge, Edward Weston, and Ansel Adams, these multidimensional composites led us to consider a form of stratigraphic layering of physical and cultural changes across time and space.

View from the handrail at Glacier Point overlook, connecting views from Ansel Adams to Carleton Watkins, 2003. *Left inset:* Ansel Adams, c. 1935. (Courtesy the Center for Creative Photography, University of Arizona.) *Right inset:* Carleton E. Watkins, 1861. (Courtesy the Center for Creative Photography, University of Arizona.)

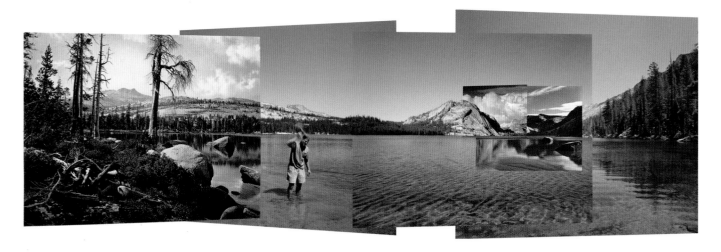

Four views from four times and one shoreline, Lake Tenaya, 2002. *Back panels:* Swatting high-country mosquitoes, 2002. *Left inset:* Eadweard Muybridge, 1872. (Courtesy the Bancroft Library, University of California, Berkeley.) *Center and right insets:* Ansel Adams, c. 1942; Edward Weston, 1937. (Both courtesy the Center for Creative Photography, University of Arizona.)

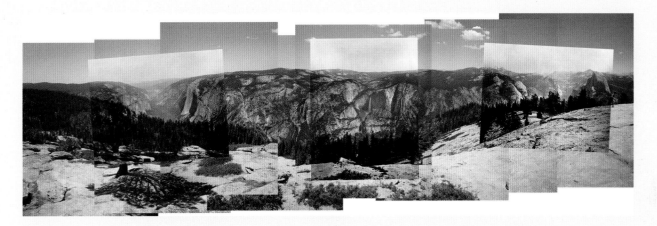

Panorama from Sentinel Dome connecting three views by Carleton Watkins, 2003. *Left to right insets: From the Sentinel Dome, Down the Valley, Yosemite,* 1865–1866; *Yosemite Falls from the Sentinel Dome,* 1865–1866; *The Domes, from the Sentinel Dome,* 1865–1866. (All courtesy Fraenkel Gallery.)

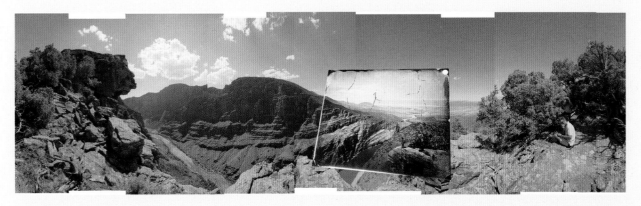

Panorama from Timothy O'Sullivan's 1872 *Canyons of Lodore,* Dinosaur National Monument, Colorado, 2000. *Inset:* Timothy O'Sullivan, 1868. (Courtesy U.S. Geological Survey.)

IMAGES © MARK KLETT AND BYRON WOLFE FROM *YOSEMITE IN TIME*; LARGE-FORMAT PIGMENT PRINTS.

Jane Alden Stevens

Seeking Perfection: *Traditional Apple Growing in Japan*

ELEMENTS

Jane Alden Stevens carefully composes square and panoramic format images, then juxtaposes them to create complex statements. The resulting layouts are as classically measured as the traditional Japanese apple growing practices she documents. Significantly, Stevens arranges images within the borders of each page with austerity, paying specific attention to sequencing within and between pages. Her methods tell the story in a style reflective of her subject, while beckoning us to consider the larger meanings created by the interrelationship among the images.

ARTIST STATEMENT

Growing apples in the traditional way is a laborious, hands-on process in Japan. At the moment of harvest, an apple raised in this manner has been touched by the farmer's hands at least ten times since its blossom was set. This includes picking off unwanted flower buds, hand-pollinating the blossoms, pruning the branches, covering individual fruit in colorful bags, hand-culling imperfect fruit, hand-turning them to ensure even coloring, and, in some cases, affixing stencils to the apples.

This approach to raising fruit is slowly disappearing. When asked why fewer apples are being bagged now than 15 years ago, the farmers will hold up their hands in front of them and say, "There are simply not enough hands!" This is a reflection of the lack of migrant workers in Japan, as well as the desire of young people to move off the farms and find work in the cities.

Over the course of two growing seasons, I photographed this process on the apple farms in Aomori Prefecture. The resulting body of work is a meditation on the time, care, and attention that farmers using this method lavish on their orchards. Speaking to a tradition that is becoming increasingly marginalized, these photographs preserve for future generations a memory of the agricultural past.

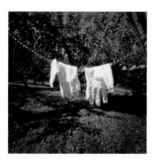
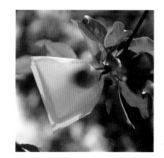

Bagging Apples in June, Aomori Prefecture.

Culled Apples, Aomori Prefecture.

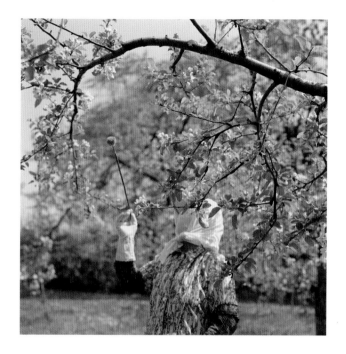

 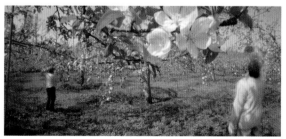

Hand-Pollination of Blossoms in Spring, Aomori Prefecture.

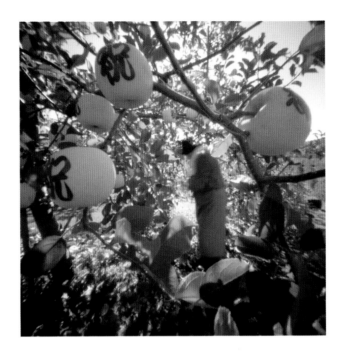

Stencils on Apples in Autumn, Aomori Prefecture.

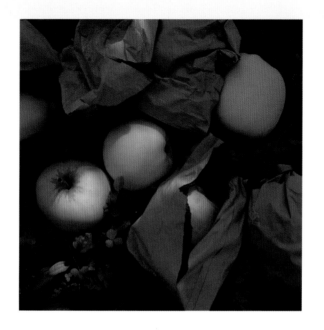

Apples After Inner Bags are Removed, Aomori Prefecture.

DAVID HILLIARD

PANORAMIC PHOTOGRAPHS

ELEMENTS

David Hilliard creates large-scale, multipanel color photographs based on his experiences and the lives of people around him. Although the contents of his images are personal and unique to his experience, his subject is universal—interpersonal relationships and simple, daily existence. His panoramas direct the viewer's gaze across the gestalt image, while allowing narrative, time, and space to unfold frame by frame.

ARTIST STATEMENT

For me, the construction of panoramic photographs, composed of various single images, acts as a visual language. Focal planes shift, panel by panel. This sequencing of photographs and shifting of depth of field allows me the luxury of guiding the viewers across the photograph, directing their eyes; an effect that could not be achieved through a single image. The idea of "time" is also called into question, as the single moment is fractured and perhaps sped up or slowed down. For years I have been actively documenting my life and the lives of those around me, recording events and attempting to create order in a sometimes chaotic world. While my photographs focus on the personal, the familiar, and the simply ordinary, the work strikes a balance between autobiography and fiction. Within the photographs physical distance is often manipulated to represent emotional distance. The casual glances people share can take on a deeper significance, and what initially appears subjective and intimate is quite often a commentary on the larger contours of life. I continually aspire to represent the spaces we inhabit, the relationships we create, and the objects with which we surround ourselves. I hope the messages the photographs deliver speak to the personal as well as the universal experience. I find the enduring power and the sheer ability of a photograph to express a thought, a moment, or an idea to be the most powerful expression of myself, both as an artist and as an individual.

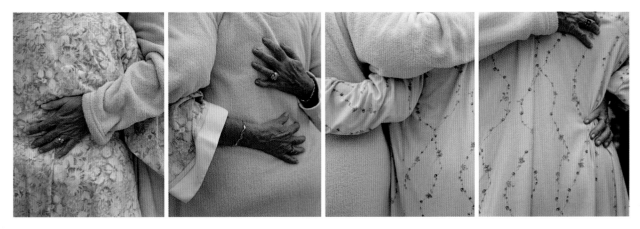

Rouse, 2008.

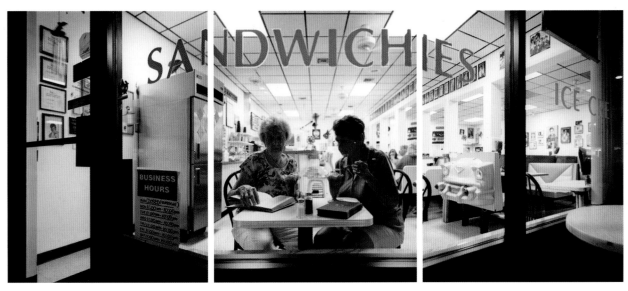

Lickety Split, 2008.

Boys Tethered, 2008.

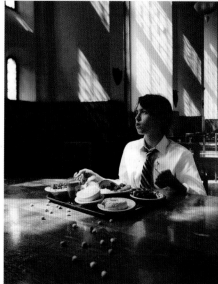

Bleeder, 2008.

IMAGES © DAVID HILLIARD; ARCHIVAL PIGMENT PRINTS, DIMENSIONS VARY.

Jason DeMarte

Utopic

ELEMENTS

Brilliant color, vertical framing, and ironic whimsy first caught my attention in Jason DeMarte's work. Each frame isolates its own contents, but only until juxtaposed with another frame; with no space separating them, their interconnection is unavoidable. Using both vertical and horizontal frame orientation and varying dimensions within each diptych, DeMarte converts banal and humorous scenes into complex and serious images about the environment, its nonhuman creatures, and our perceptions of them.

ARTIST STATEMENT

Utopic investigates how our modern-day interpretation of the natural world compares to the way we approach our immediate consumer environment. I am interested in modes of representing the natural world through events and objects that have been fabricated or taken out of context. This unnatural experience of the so-called natural world is reflected in the way we, as modern consumers, ingest products. What becomes clear is that the closer we come to mimicking the natural world, the farther away we separate ourselves from it.

I work digitally, combining images of fabricated and artificial flora and fauna with graphic elements and commercially produced products such as processed food, domestic goods, and pharmaceutical products. I look at how these seemingly unrelated and absurd groupings and composites begin to address attitudes and understandings of the contemporary experience. I represent the natural world through completely unnatural elements to speak metaphorically and symbolically of our mental separation from what is "real" and compare and contrast this with the consumer world we surround ourselves with as a consequence.

Cream Filled, 2007.

Forage, 2007.

Buck Shot, 2006.

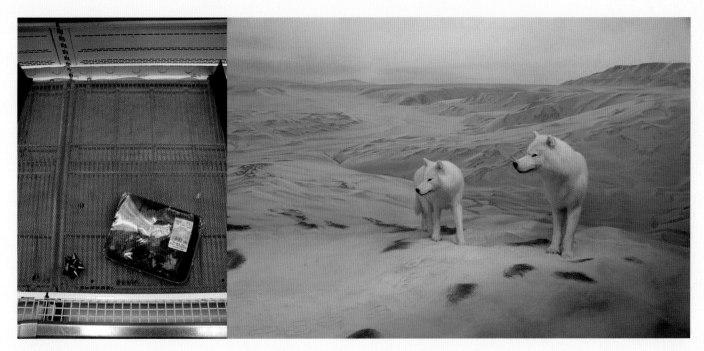

Shopping Season, 2007.

PRIYA KAMBLI

COLOR FALLS DOWN

ELEMENTS

Although my own cultural experience initially drew me to Priya Kambli's work, the intensity with which she saw and juxtaposed images drew me to consider her uniquely Indian cultural experience. By relating color, content and form across frame boundaries, she helps us understand the dilemmas facing nearly all immigrants trying to embrace the American way of life while simultaneously honoring their own cultural identity.

ARTIST STATEMENT

My photographs visually express the notion of transience and split cultural identity caused by the act of migration. Recently in my artwork I have been viewing this issue through the lens of my own personal history and cultural identity. My move from India to the United States 13 years ago left me feeling that I do not belong fully to either culture, leaving me unable to anchor myself in any particular cultural framework. This disconnection from both cultures has changed the way I perceive myself by forming a hybrid identity, a patching together of two cultures within one person. Photography has been a way of bridging the gap between the two cultures while coming to terms with my dual nature. Ironically, because photography appears to be true, it allows me to create convincing fictional depictions of my new identity. My digital photographs reflect the tension caused by the duality by piecing together fragmented images and by mingling family snapshots with carefully staged imagery.

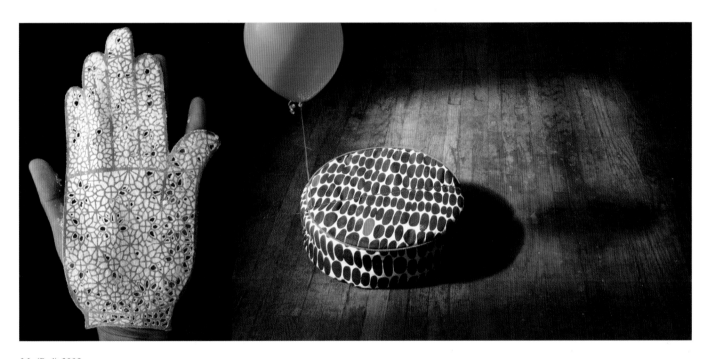

Me (Red), 2008.

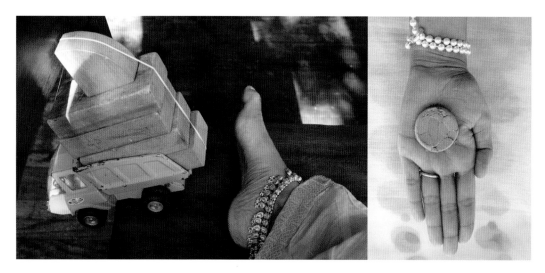

Me (Tonka and Turmeric), 2008.

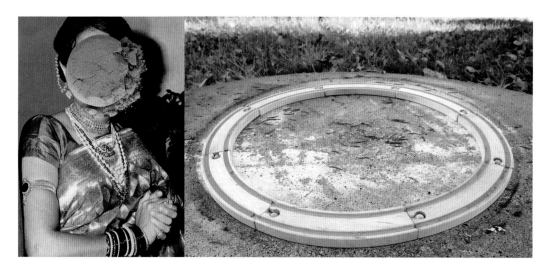

Muma (Turmeric), 2008.

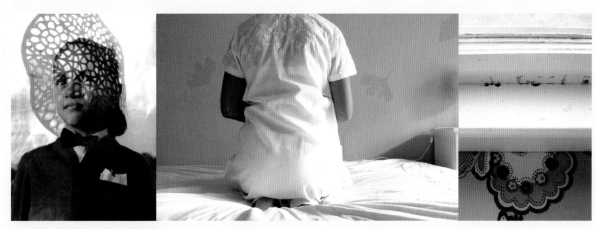

Muma and Me (Cast Shadows), 2008.

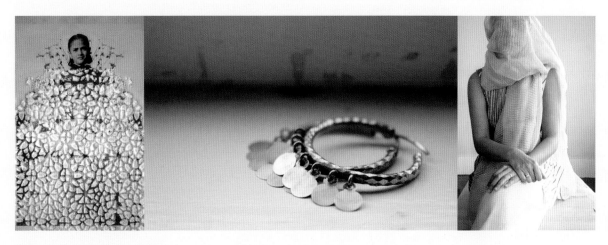

Muma and Me (Gold Earrings), 2008.

IMAGES © PRIYA KAMBLI, FROM HER SERIES *COLOR FALLS DOWN*; ARCHIVAL PIGMENT PRINTS.

THOMAS KELLNER

CONTACT SHEET IMAGES

ELEMENTS

I first saw one of Thomas Kellner's contact sheet images in a magazine in 1998; it made such an impression that I still remember it today—London's Big Ben clock tower. I was drawn to the relevance of the filmstrips printed in full, especially as the dawning of photography's digital age was at hand. And I was impressed by the degree of advance planning and on-location engineering needed to make these complex contact sheets work. The continuity of his images—their gestalt power—comes from two things: proximity and alignment of vertical contents throughout the image. Kellner can tilt the camera any number of ways between frames and the image will cohere because the vertical aspects provide continuity from the contact sheet's first row to its last. The images allow us to experience some of the world's most famous architecture in reference to the countless minute parts that combine to form their structures and aesthetics.

ARTIST STATEMENT

My work has been titled in very different ways in the past years. Usually I go back to its basic technical description: contact sheets. Some have called my work deconstructive, others collage, de-collage, or montage; some say it is architectural photography—no and yes; only the subject is architecture. In a time where everyone turns to digital photography (some have not even used film in their life at all), "index prints" might be the more contemporary description, but I still use film and I use every image on the roll. If I shoot on one frame, the final size of the print is 20 × 24 cm; if I use 36 frames, the print is 100 × 120 cm. And because the single frames are all shot in sequence, I simply cut the strips, mount them together, and make a contact print.

I began creating multiple image reconstructions using an 11-pinhole-camera and one with 19 pinholes made for the whole length of a 35 mm roll of film. I learned to collage on the negatives

by shooting different objects or moving the camera in between each shot. This I still do today when I shoot architecture—each frame is a single shot and each shot I tilt the camera differently.

But it all starts with choosing the object and finding the right time of day and weather (everything is shot with the same exposure time and aperture). Then I decide the final size of the image through the number of frames I am going to use. I already know how many frames there will be and I have to divide the images into this number of frames by finding the right focal length. I use a scale on my tripod to match all the vertical lines to line up precisely. Shooting can take anywhere between 30 minutes and five hours, depending on the size of the image.

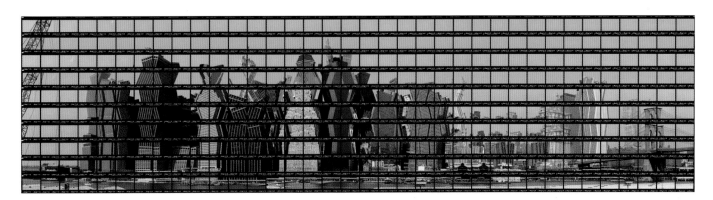

40#11 New York, Lower Manhattan Skyline. 2003.

IMAGES © THOMAS KELLNER; LIMITED EDITION C-PRINTS, DIMENSIONS VARY.

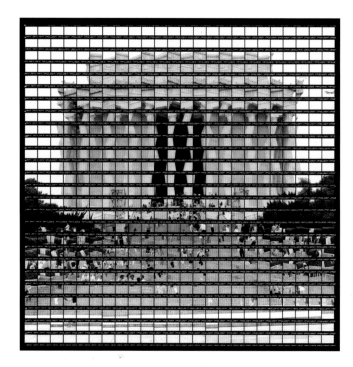

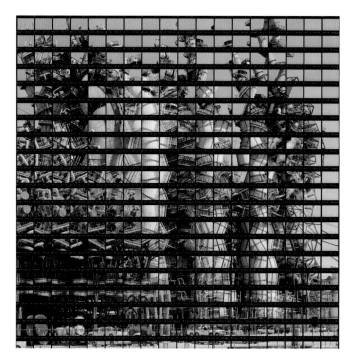

41#05 Washington, Lincoln Memorial, 2004.

51#01 Houston, Texas Refinery, 2006.

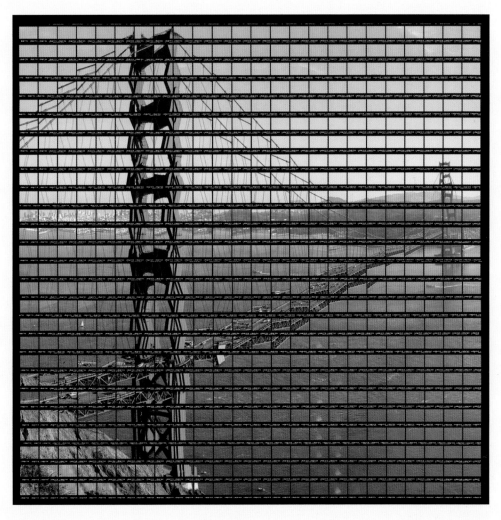

42#16 San Francisco, Afternoon at Golden Gate Bridge, 2004.

IMAGES © THOMAS KELLNER; LIMITED EDITION C-PRINTS, DIMENSIONS VARY.

MARK ESHBAUGH

DAY'S END

ELEMENTS

Mark Eshbaugh uses multiple frames in a wholly unique way. His method includes designing and constructing cameras that hold several rolls of stacked film so that exposure extends through the medium's edges. At these edges we see the slight curl of the film, light refraction, and other artifacts of how a single camera serves to frame multiple rolls simultaneously. Whereas one frame usually suggests an encapsulated piece of the world, these frames suggest that the world extends only as far as the camera format and film do. Alternately, while his diptych and triptych images suggest continuous scenes, in fact they are carefully arranged multiframe images of different scenes, which reflect his concepts and his process itself.

ARTIST STATEMENT

My continual experimentation with different cameras and different film formats has eventually led to the creation of my own unique camera that I use today, which shoots multiple rolls at once.

Through dedication to experimentation, my images are works of art that incorporate the medium they're composed in.

The fractured imagery reminds us of the limitations of the medium and the limitations of our own memories. We cannot capture a complete moment of time with a photograph, just as we can never remember a complete moment of time accurately. Humans can only remember bits and pieces of a moment, and as time moves on, biases and changed perspectives cloud that vision. Each fractured pane exists in a paradox of harmony and conflict. One moment the pieces are working together to create a whole image; the next moment the pieces are fighting one another, trying to capture your full attention.

Outside of Tahoe, From The Mural Series, 2007; 30″ × 46″.

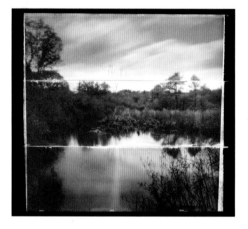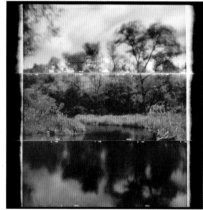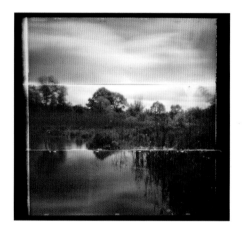

Triptych (Chelmsford, MA) from the series *Day's End*.

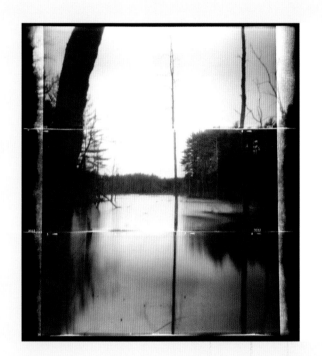 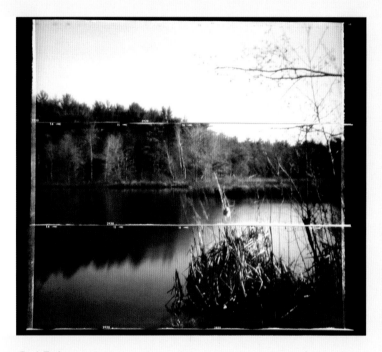

Diptych (*left:* Savannah, Georgia; *right:* Carlisle, Massachusetts) from the series *Day's End*.

IMAGES © MARK ESHBAUGH; CHROMOGENIC CONTACT SHEET IMAGE AND MULTIPLE SELECTIVE TONED SILVER PRINTS, DIMENSIONS VARY.

RODDY MacINNES

CELL PHONE MOSAICS IN THE PROJECT "JIM RIVER"

ELEMENTS

As one who always has a cell phone by my side, I can honestly say that I treasure its ability to capture photographs. The world-wide abundance of cell phones has ushered in a new era remarkable for its proliferation of pictures, although few photographers have embraced it as a mode of serious practice. But Roddy MacInnes has, and he not only uses the ease with which this technology allows a multiplicity of images, he counters and questions it through his choice of nontechnological subject matter. Employing the cell phone camera's ubiquity, he makes multiple images of the same or related subjects and combines them into elaborate multipanel grids. In doing so he blurs the line between the uniqueness of contents within individual frames, and broadens the way we think about this technology's resulting images.

ARTIST STATEMENT

I began using a cell phone camera while working on a project in North Dakota. The project was inspired by two albums of photographs I purchased at an antiques mall in Wheatridge, Colorado. It turned out that a North Dakota woman, Nina Weiste, made the photographs in 1917. The more I looked at the people and places in her pictures, the more I felt connected to Nina and to North Dakota. When I arrived in North Dakota for the first time, it felt as though I was coming home. Using a variety of photographic media, the project attempts to generate conversation on the relevance of photographs in the construction of identity. The introduction of roll film toward the end of the 19th century by George Eastman made photography accessible to Nina Weiste. In 1917, she represented the first generation of ordinary Americans to keep a photographic record of their lives. Celebrating the cell phone camera as representing a further paradigm shift in the evolution of photography offered a new medium through which I could connect with Nina's world. I also had a novel way to add variety to the project.

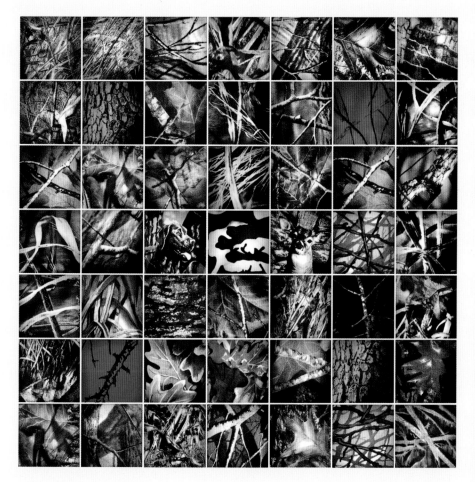

Camo', Aberdeen, South Dakota.

Hands, North Dakota and Colorado.

Hay Bales, Ellendale, North Dakota.

IMAGES © RODDY MACINNES, FROM HIS SERIES *CELL PHONE MOSAICS*, 2010; ARCHIVAL PIGMENT PRINTS, 30" × 30".

Dan Estabrook

Pathetica and Nine Symptoms

ELEMENTS

Usually associated with his combined use of historic photographic processes and drawing, Dan Estabrook also works on a higher level using photographic language. His process combines with form and content to create meaning, perhaps best illustrated in his diptychs and grid images. Estabrook's diptychs pair original paper negatives alongside their resulting positive prints, binding his subject and process, and providing a logical platform to mirror contrasting words as well. Like photographic processes themselves, Estabrook's images reflect the human condition as a chemical and physical process subject to the elements, time, and one another.

ARTIST STATEMENT

It is the alchemy that moves me. The first photographs, just baby steps from drawing, exist for me in an ideal transitional state between the rational world of the machine and the more human world of the hand. The base materials of these processes—paper, silver, and salt—are for me invitations to transform my photographs, to draw or paint or cut, acting willfully on the object in an attempt to cross the divide between the past and the present, and between the real and the absurd.

Early photographers even sought to correct by hand the technical limitations of their new art, and over time it is their handwork that seems to tell the real story: a rose-tinted cheek is now brighter than the faded face it once enlivened. In combining the handmade image with the magic of the machine, my "corrections" and reimaginings can begin to tell a tale of their own—a braid turns to rope, the shadows are false, and a painted sea doesn't quite hide what it should.

The old photographs that inspire me—especially those lost, without name or history—have a way of seeming less real yet more revealing, as though the passage of time could simultaneously obscure meaning and expose truth. Even the dust, decay, and stains of an old print appear almost legible: they are time's own language, written on the skin and bones of paper, tin, and glass.

Using 19th-century techniques and celebrating their flaws and failures, I make seemingly anonymous photographs in order to reimagine a more personal history of photography, seen from a 21st-century perspective. With these processes, I can create my own "found photos"—highly personal objects in which to hide my own secrets and stories. I am not interested simply in recreating the past; instead I wish to make contemporary work inspired by the ever-growing gap between what we know of the past and how we understand the present.

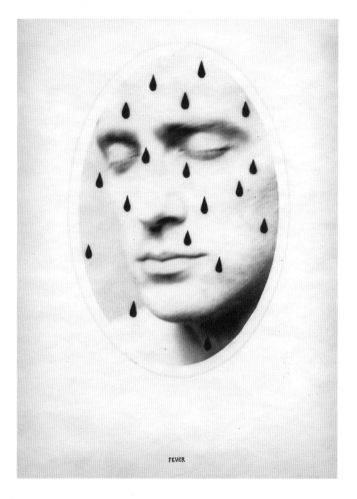

Nine Symptoms no. 5: Fever, 2004; salt print with ink, 14" × 11".

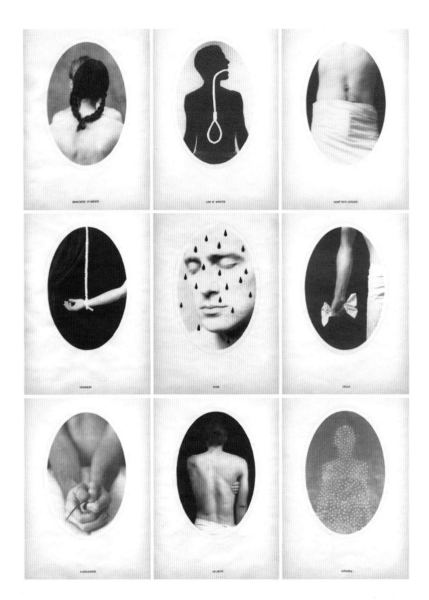

9 Symptoms; grid view.

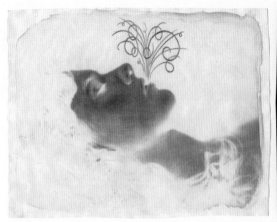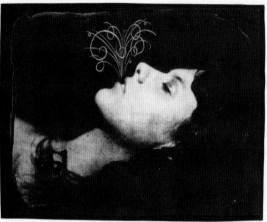

Breath (Lying), 2004; pencil on waxed calotype negative, and platinum-toned salt print (diptych), 8″ × 10″ each.

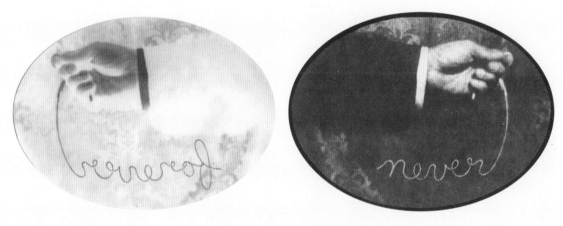

Forever & Never, 2003. Pencil on calotype negative, and salt print (diptych), 5″ × 7″ each.

IMAGES © DAN ESTABROOK, FROM HIS SERIES *PATHETICA*; MIXED MEDIA, DIMENSIONS VARIABLE.

KATHARINE KREISHER

CONTEMPLATING PEACE

ELEMENTS

Fine art photographer Katharine Kreisher's work has many of the elements I respond to in highly communicative photographs. Her pinhole camera images captured on darkroom photographic paper produce a soft and receptive negative canvas to which she adds painting and drawing. She scans the images to digitally create vertical diptychs, which at times include scanned objects referencing the original image. Between frames, comparisons can be made, narratives invented, real and psychological worlds linked. Her use of diptychs allows her to imply progression throughout various internal and external states of being.

ARTIST STATEMENT

All my images begin with photography. Over several decades of art making, I have altered photographs of myself and my personal environment by employing the distorting effects of handmade cameras, linking pictures through direct collage, painting on the surface of finished photographs, transforming them as photo etchings, and eventually feeding them to the computer.

Current images about one's unstable sense of self in an unpredictable world are driven by archetypal images derived from dreams. I begin with pinhole photographs, because they extend the serendipitous nature of the photographic medium, supplying me with pictures that seem to come directly from the unconscious, the source of dreams. The process is enhanced by the reinterpretation of everyday experience through meditation and disciplined yoga practice. For me, the images reflect our anxious experience of ongoing metamorphosis as elusive, fragile constructed identities shift throughout life. The contemplation of images emerging from the unconscious supports a search for peace, both an individual peace of mind and a shared universal peace.

Contemplating Peace: Corpse Pose, 2006.

Contemplating Peace: Sunspots, 2006.

Contemplating Peace: Waiting, 2006.

Contemplating Peace: Angels Near and Far, 2008.

IMAGES © KATHARINE KREISHER, FROM HER SERIES *CONTEMPLATING PEACE*; 16″ × 6″ DIPTYCHS CONSTRUCTED
DIGITALLY FROM PINHOLE PAPER NEGATIVES.

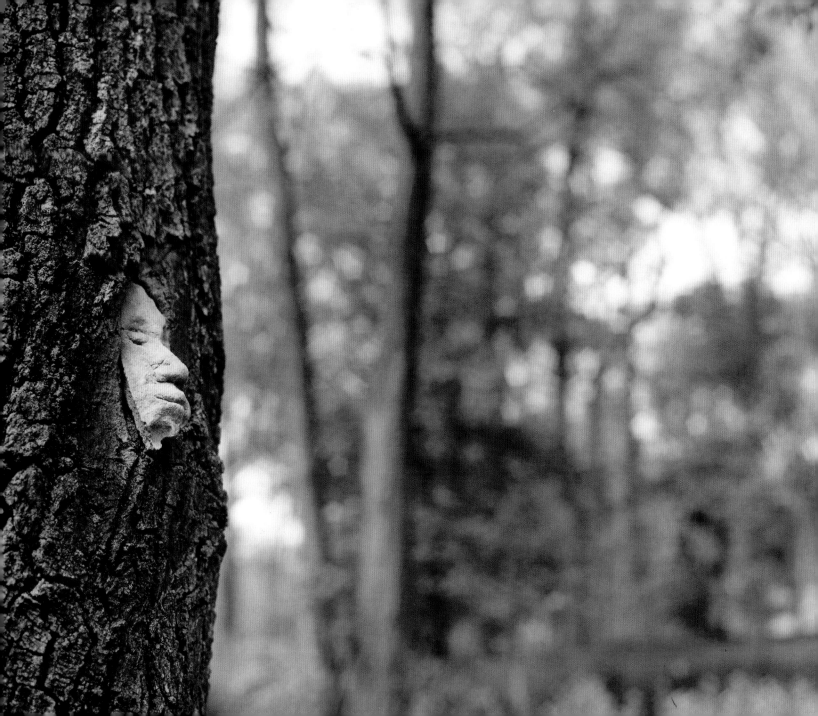

APERTURES:
FOCUS, LENSES,
AND CLARITY

MY PRIMARY PROJECT HAS ALWAYS BEEN IN FINDING WAYS
TO MAKE THE VIEWER AWARE OF THEIR OWN ACTIVITY OF
LOOKING AT SOMETHING. —UTA BARTH

INTRODUCTION: FOCUS, THE SECOND PHOTOGRAPHIC ELEMENT

Have you ever seen a painting you identified as "photorealistic"? What made it
look most like a photograph? A large part of the answer is the *quality of focus* it
depicts. Setting photorealistic paintings apart is that they depict a scene *the way a
camera sees it*, and photographs, no matter how closely they seem to approximate
human sight, never depict the world *as we see it*. Photorealism looks photographic
primarily because it reproduces a sense of the camera's monocular vision, which,
as discussed Chapter 3, differs from our binocular vision in the way it flattens
depth perspective onto the two-dimensional plane. The physical characteristics of
the camera's aperture and lens, along with its variable depth of focus, projects an

image onto the medium that looks altogether different from the one our eyes transmit to our brain. Second, photorealism reproduces the clarity and detail that has been a highly coveted attribute of photographs since the daguerreotype. It is these physical characteristics of camera vision that delineate the nature of focus in photographic images, and it is these characteristics that photorealistic painting explicitly acknowledges. I use this example to begin discussing the *element of apertures and focus* because it calls attention to attributes so inherent to photographs that they're often overlooked as communicative tools.

Images captured by the action of light, through apertures and lenses, exist on a sort of continuum whose center resembles the familiar depth and quality of focus of our binocular human vision. At the farthest ends of the continuum exist qualities of focus vastly different from our own. On one end are images that are clearer and more detailed, or that capture closer and farther views than human eyes can see; on the opposite end are images that lack the clarity and detail of human vision. Precisely where the focus in an image is fixed on the continuum affects the way viewers see and interpret it, as well as what and how it communicates about a subject.

The earliest camera, the camera obscura, greatly influenced the way artists and photographers regarded quality of focus, following scientists who used the device's ability to render the visible universe more objectively and more accurately than could the mind's eye. By 1850, only a few short years after photographs could hold the ephemeral image, daguerreotypes began replacing traditional forms of manual reproduction for any image that relied on fidelity and descriptive quality. Conversely, the pictorialists became photography's first practitioners to embrace and value the *lack of sharpness* that camera-made images could deliver, gravitating toward this quality as a more expressive use of the medium. Around the same time, the still point of the focus continuum was located with P.H. Emerson and the naturalists, many of whom consciously manipulated the monocular vision of the camera in an attempt to approximate human vision's quality of focus. Thus began undying waves of photographic practitioners' efforts to sharpen, dull, or accurately express *what we see and how we see it* through photography.

At the one side, sharply focused photographs carry connotations of specificity and, by extension, truth and reality. Viewers more readily equate sharp focus with what was present in front of the camera, and the more descriptive it is, the greater our degree of trust in the accuracy and factualness of image. Documentary, photojournalistic, scientific, and evidentiary images rely on sharp focus for this very reason. Photographs on the opposite end, those using

soft or distorted focus, remove this relationship between the image contents and the seen world. They connote a vague essence of things and an atmospheric or more overtly filtered image of reality. In addition, soft-focus images guide viewer attention more consciously to the act of seeing the image, reminding us that we're not merely looking through a window on the world. Throughout its history, the element of focus has given photographers control over these aspects of the appearance and meaning of images; today there are even more tools helping us control and manipulate focus, and in this chapter we'll explore the how's and why's of doing so.

APERTURES: A BRIEF TECHNICAL REVIEW

The following technical notes are only simple reminders about apertures. If you're still new to photography or just want a refresher, go to Chapter 2 and reread the information about apertures and exposure; be sure to do the chapter exercises at the end.

It's usually assumed that this element of photography is composed of two parts: the aperture and the lens. However, you don't need a lens in order to capture images from light. Apertures and lenses each have distinct technical attributes that contribute to the visual outcome, and therefore the meaning of photographic images, making discrete but inter-related study of each the most thorough approach.

An aperture of any kind is simply an opening. As it relates to the camera, the aperture (also called the f-stop) liter-ally refers to the opening through which light enters the camera to produce an exposure. This mechanism, normally located within the camera lens, controls the amount (or intensity) of light that will strike the photographic medium upon releasing the shutter mechanism. Full-stop aperture numbers *adjust to exactly half or two times the amount of light allowed by the number directly before or after it*, an important relationship to understand. Some lenses let you adjust the aperture in fluid, step-less increments, and others in solid one half– or one third–stop increments in between the full stops; both are a means of offering finer exposure control, though they make exposure seem more complicated. For that reason, I recommend memorizing only the "whole-stop" apertures, and knowing what your camera offers in between.

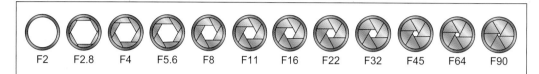

| F2 | F2.8 | F4 | F5.6 | F8 | F11 | F16 | F22 | F32 | F45 | F64 | F90 |

Opening the aperture increases exposure
Makes the image brighter
Shallow depth-of field
Requires a shorter/faster shutter speed

Closing the aperture decreases exposure
Makes the image darker
Greater depth-of-field
Requires a longer/slower shutter speed

ILLUSTRATION © TOBY COCHRAN, 2007.

The common whole-stop apertures: Each one doubles or halves the exposure from its adjacent numbers.

f/2

f/4

f/8

Technical Discussion 6: Depth of Field

An image projected through a camera aperture is only "in focus" at a specific distance, the focus point, and it gradually becomes less focused the farther you get from that specific distance. The fall-off of focus occurs both in front of and behind the focus distance. This important technical and visual attribute of the aperture and lens is called *Depth of Field*. *It describes the area of sharp focus from foreground to background in an image. The ratio of depth of field is always predictable; it is one third in front of the focus point and two thirds behind it.*

f/16

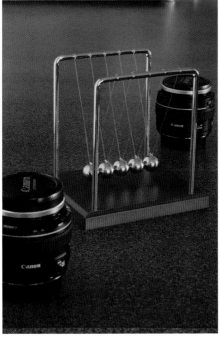

f/22

One third in front, two thirds behind. Depth of field increases both in front of and behind the focus point, but to different degrees. Here, the two lenses are equidistant from the focus point in the center of the image. Note as depth of field increases, the background sharpens faster than the foreground.

Because most aspects of this chapter affect depth of field, it's important to understand how it works before we get started. The three controllers of depth of field are the lens or camera aperture, the focal length of the lens, and the distance from the center of the lens to the subject.

- *Aperture.* The size of the aperture controls the depth of field. The smaller the aperture is, the greater the depth of field (the other two factors remaining the same).

- *Lens focal length.* The shorter (wider angle) the focal length, the greater the depth of field (the other two factors remaining the same).

- *Lens-to-subject distance.* Usually called camera-to-subject distance, this really refers to the distance from the center of the lens to the subject. The farther from the focus distance, the greater the depth of field (the other two factors remaining the same).

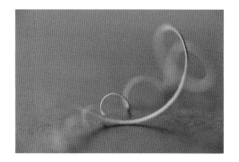 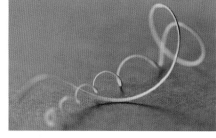 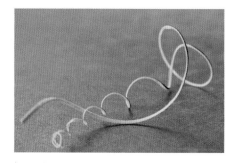

f/2.8 *f/8* *f/22*

Tiny paper squiggle, deep implications. This impromptu still life of a paper trimmer shaving was captured using a range of apertures (and equivalent exposures) to provide editing options. Notice that at *f/2* only a small part of the subject is in sharp focus and your attention lingers there, whereas at *f/22* nearly the entire subject is sharp, encouraging your eye to wander more. Part of the dramatic depth of field difference and the reason why the front of the paper isn't sharp, even at *f/22*, is because the camera-to-subject distance is extremely close, made possible with a 28 mm extension tube.

But with great depth of field comes great possibility of camera shake! This is because smaller apertures generally require longer shutter speeds. Camera shake happens when any movement of the camera itself blurs the image, and it can ruin an otherwise perfect photograph. Fortunately, most cameras offer ways to help you avoid it. First, self-timer and cable release options allow you to make exposures without touching the camera. But that doesn't always help, especially when camera shake is coupled with its equally problematic relative specific to SLR cameras—mirror vibration. In particular when using extension tubes or doing other extremely close-up work, and especially with an SLR camera, the best way to ensure a sharp exposure is if the camera has a "mirror-up" option. The mirror-up moves the SLR mirror out of the way before you release the shutter so it doesn't vibrate during the exposure. The difference can be dramatic, but it is only a viable option when doing still life photography with a tripod.

No self-timer, no mirror lock-up: camera shake.

Self-timer with mirror lock-up: sharp image.

Mirror up for sharp pictures. Both images were made at *f*/22 (for maximum depth of field) using a 28 mm close-up extension tube and a shutter speed of 1.5 seconds. On the left, the shutter mechanism was depressed with a finger, causing camera shake; worse, the DSLR camera's mirror caused vibrations that further reduced image sharpness. On the right, a self-timer and mirror lock-up feature were used to maintain fine, sharp details.

PHOTOGRAPH © ANGELA FARIS BELT, *SHE'S HURT*; FROM THE *TRACES* SERIES, 2006.

Shallow depth of field holding power. Shallow depth of field directs the viewer's attention to the primary content in the image; the lack of sharp focus on other areas in the frame indicate areas of secondary or supporting content. In this case, the spider and glass are sharp in contrast to the soft city in the background, which in its softness operates to add atmosphere to the image. The fine black border (made using a filed-out negative carrier or by adding a fine black stroke in the digital darkroom) explicitly indicates the edge of the pictorial space.

There are other things you can do to take advantage of depth of field: use your depth of field preview before you shoot. Most SLR cameras have this option, and view camera lenses allow you to do it as well. *Depth of field preview lets you close the aperture while you look through the viewfinder, so you can see the actual field at that aperture.* Its only drawback is that as you stop the aperture down, the image in the viewfinder gets increasingly darker and more difficult to see. But once you become accustomed to using it, you'll be able to "look past the darkness" and you'll find it a helpful tool when trying to choose the best aperture.

All this depth of field technique seems pretty complicated, but it's simpler in practice because of how we usually make photographs. Most photographers select a lens focal length and distance from subject first, because they control what will be inside the frame. It usually isn't until we have the image framed that we determine the depth of field we want. So if you want to maximize it, then select your smallest aperture, focus one third of the way into the scene, and shoot at an appropriate shutter speed for good exposure. Conversely, if you want narrow depth of field, use a larger aperture and focus on the precise distance of your primary subject matter.

So depth of field isn't only a technical attribute; like every other element of photographic language, it affects the way images look and how they communicate. For example, as depth of field increases, viewers are granted increased *depth of information*. We can see from foreground to background details throughout the picture plane with equal clarity. Limiting the depth of field limits viewers' depth of information by narrowing the range of clearly identifiable contents and details within the frame. Shallow depth of field constricts the contents that viewers can concretely or confidently interpret, and the rest of the image becomes a wash of progressively less recognizable information. Further, shallow depth of field permanently restricts our access to those details, creating a situation we do not encounter when viewing the world firsthand. Although human vision has relatively shallow depth of focus, we adjust our focus distance continuously to take in more information at varying depths around us, which gives us a clearer picture of the overall scene. This process of focusing and refocusing adds depth of information over time without adding true depth of field. Whereas the human eye varies focus on the fly according to where our attention is, the two-dimensional image can hold a range of depth from that most closely approximating human sight to more limited or expanded; however, it is fixed, never offering more or less information no matter how much we try to focus in on it.

As photographers, once we begin to analyze the significance of focus and depth as they refer to our subject, we can use them to control the specificity of information the image relays to viewers to make the most accurate visual statement we can.

CAMERAS WITHOUT LENSES

As we stated earlier, cameras don't need lenses to capture an image; all they need is an appropriately sized opening to allow light to enter. This opening—the aperture—its size, composition, and shape, dictate important aspects about the visual outcome of the image. The aperture size determines the intensity of light entering the camera, and it also determines the plane of focus for the "focal length" of the camera. That is, light entering an aperture is focused at a specific point in space; if you place light-sensitive media at that precise distance, a sharper image is rendered; any other distance will render less clearly focused images.

Photographers choose to make images with lens-less cameras for a variety of reasons. First, many photographers prefer to make cameras rather than buy them; they enjoy capturing images using simpler hand-made devices. Second, lens-less images captured through an aperture have unique characteristics (which we'll cover more in depth in a moment) that could better communicate about the photographer's

impressions of a subject than a lens-made image could. Still others like the experimental nature of alternative cameras or are interested only in the ephemeral image inside the camera obscura rather than in capturing it onto media to make it permanent.

The Camera Obscura

The first apparatus to use an aperture to transfer an image made from light was the camera obscura (Latin for "dark room"). Essentially, a camera obscura is a dark room, which can be of any size and dimension. It has a small hole in one side that, if sized properly, allows light to project the outside scene onto the interior opposite wall of the camera. Although the technology to record images onto light-sensitive media didn't exist until the 19th century, camera obscura optics were recognized by Arabian scientist Abu Ali al-Hasan Ibn al Haytham in the 10th century B.C.E., who described it as his tool for studying a solar eclipse. There were references to the camera obscura in China as early as the 5th century B.C.E. and by the Greek philosopher Aristotle in the 4th century B.C.E. It wasn't until the 15th century that European artists used them to trace images from nature, though many wouldn't admit to doing so. Recently, the camera obscura has made a comeback, notably by photographer-artist Abelardo Morell, who has created iconic documentary images in hotels, museums, and other interiors throughout the world by capturing the image inside.

Although the camera obscura has no lens, its aperture must be a specific diameter, and must be a specific distance from the far side of the "dark room" for the image to be rendered as sharply focused as possible. A couple of notes about both:

- Focal length equals the distance from the aperture to the far wall (focus plane) of the camera obscura. This distance dictates the aperture diameter needed to make the sharpest image as well as the angle of view of the camera.

- Aperture diameter determines the sharpness and brightness of the projected image. The formula for determining the best aperture diameter for a given focal length is complex, involving physics of light wavelengths and some more advanced mathematical calculations. Several reliable charts are available on the topic; through research you'll find the aperture diameter that works best for your needs.

Pinhole Cameras

A pinhole camera is essentially a camera obscura, but inside the "dark room" a piece of light-sensitive medium is placed at the plane of focus to record and preserve the projected image. As stated in the camera obscura section, for every focal length there is an "optimal" aperture diameter for maximum sharpness. Given that pinhole photographers don't necessarily want the greatest possible sharpness, the aperture size and shape are general guides, and deviating from them can

produce unique and beautiful results, particularly in terms of image clarity.

There are many excellent resources with extensive information about pinhole cameras, beginning with www.pinholeresource .com. Several places fabricate and sell custom pinholes in metal shim stock as well as in body caps to fit nearly any SLR camera, but if you enjoy experimenting and making things by hand, then you can construct the entire camera yourself. For SLR cameras, you can simply buy an extra body cap and drill about a 1-inch diameter hole in the center of it. The "ideal" aperture size for the camera is equal to the distance from the pinhole to the media plane. You can measure it or find your camera model's specifications on-line. On-line you will also find the correct needle size to drill your pinhole (usually a standard quilting needle found at a local craft store). Drill it through a thin piece of metal shim stock, and attach it to the inside of your camera's body cap. The size of the pinhole will also indicate it's aperture number, which you can use to calculate exposure. If you're using a digital camera body, you can simply check your histogram to hone in on proper exposure. This method of pinhole camera experimentation provides the convenience of a camera body with accurate, adjustable shutter speeds and a ready-made tripod mount, as well as the comfort of familiarity with the equipment.

Pinhole body cap. Prefabricated pinholes (like this one) use a laser to drill a perfectly round aperture with sharp edges at a precise diameter optimized for the local length. This renders a sharper image while still having the other attributes of a pinhole camera. However, many photographers prefer to make their own pinholes, because the lack of precision adds welcome softness and unexpected attributes to its images.

Beyond the basics, there are a few technical considerations that lead to more successful pinhole photography:

- Because of their minute apertures (for example, *f/295*), pinhole cameras capture nearly infinite depth of field. A given camera structure has a corresponding, optimum aperture (pinhole) size that will produce the sharpest focus. The same formulas for focal length (the measurement from the pinhole to the media plane), aperture size (f-stop), and aperture diameter used for camera obscuras apply to pinhole cameras.

- Optimal pinhole diameters (apertures) vary depending on the camera's focal length, although other sizes can be used. Generally, a smaller pinhole will result in better image resolution (a sharper picture) because the projected circle of confusion is smaller. Also, the extensive depth of field means that the fall-off in focus in front of and beyond the focus point has little visible effect. Any softness produced by the aperture is far less a factor of "lens-less-ness" than it is of light diffraction resulting from the minute aperture size (or rough-edged pinholes).

- The rounder and smoother the pinhole, the sharper the image; distorting the shape of the pinhole softens the image and has potential as a creative and communicative tool. Industrially made pinholes are generally laser etched to perfection, producing sharper images.

- The thinner the material in which the pinhole is made, the sharper the image. As the diameter of the aperture approaches the thickness of the material, a greater degree of edge vignetting occurs due to light entering at other than a 90-degree angle. Materials too thin to remain rigid are not useful either. Materials such as brass shim stock or metallic shim stock (painted black) work quite well.

- The smaller the pinhole, the longer the required exposure time. This makes a tripod necessary in most situations.

- The distance from the pinhole to the media plane determines the angle of view. A shorter focal length decreases the exposure time and results in a wider-angle image; a longer focal length increases the exposure time and results in a more telephoto image.

IMAGE © DENNIE EAGLESON, *SPRAY BOOTH*. SEE MORE OF HER WORK IN THIS CHAPTER'S PORTFOLIO PAGES.

Loose-film pinhole cameras make great light leaks. Photographer Dennie Eagleson made this image on 35 mm film in a "Yip Yap Dog Breath Freshener" tin that's 2″ × 3″ × 3/4″ in dimension, converted to a pinhole camera. The camera has an attached 35 mm film feeder cassette and a light-tight takeup cassette, and it has an aperture of *f*/62. The remarkable distortion is due to the extremely wide angle of view provided by the shallow tin. The sample image reveals that exposure extends beyond the film's sprocket holes, which adds very unique borders, and the pinhole creates visually interesting light-leaks, too!

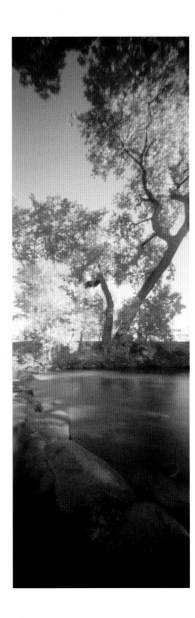
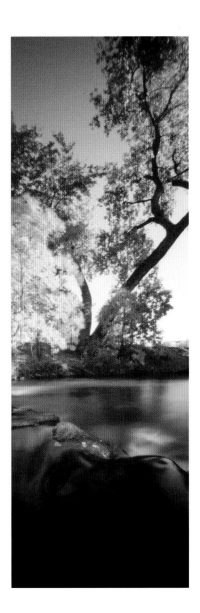

Going with the pinhole's flow. These two images are made minutes apart with a large-format pinhole camera. With some pinhole view cameras you can swap aperture sizes (pinhole plates) to match different bellows extensions. In these two images, different shutter speeds (exposure times) have very different effects in the water's appearance; however, the depth of field stays the same because of the minute aperture size. In the right-hand image the artist used an extremely long shutter speed (24 seconds) to extrude the water's flow over the rocks, softening the feel of that image to resonate with the pinhole aperture's quality of focus. Equivalent exposures with varying aperture/shutter speed combinations allows you to experiment with depth of field and motion, and provides you with more editing options later on.

AFFECTING VISUAL QUALITY AND MEANING WITH APERTURES AND LENSES

Although we don't need lenses to make photographs, their addition dramatically affects the way light strikes the media, and creates a wide range of visual results. There are significant advantages to using lenses; first, photographers can vary the point of focus precisely, projecting light rays sharply onto the media plane. Second, most lenses allow photographers to vary the aperture size, which is a benefit in terms of exposure and depth of field. Third, some lenses (called zoom lenses) provide a range of focal lengths in a single lens, so you don't have to frame images within a fixed angle of view. Finally, the majority of lenses have dramatic optical advantages over a lens-less aperture: they provide more even sharpness, reduce distortion and vignetting, have optical coatings reducing chromatic aberrations for more accurate color, and reduce flare and reflections.

On a practical level, it isn't necessary to understand the inner workings of camera lenses. But it is important to understand three attributes of lens-made images that significantly affect the visual character of the image: they are the *lens focal length, plane of focus,* and *lens quality.*

Lens Focal Length

Quite simply, lens focal length is equal to the distance from the center of the lens to the media plane, when the lens is focused at infinity. Even though we usually turn a lens to focus it, the lens elements are actually moving closer or farther from the media plane. There are three basic categories of lens focal length: normal, wide angle, and telephoto. If you measure a lens from front to back, it is the length indicated, usually in millimeters. There are some instances where lenses are referred to in inches (especially in large-format photography), and the conversion is that 1 inch = 25 mm. A 100 mm lens is a 4-inch lens.

The primary difference between focal lengths is the angle of view they capture; the wider the lens, the wider the angle of view in front of you that will be captured in the image, and the longer the lens the narrower the angle of view. There are also visual attributes to the different focal lengths that we'll cover as we go. Lenses are more complex than just focal length: they differ in their maximum aperture (the widest aperture available, which dictates light-gathering ability), weight and size, cost, and quality. *Prime lenses are lenses with a fixed focal length.* The advantage to prime lenses is that they usually capture sharper images than zoom lenses. *Zoom lenses are lenses with a range of focal lengths.* Their primary advantage is that you can change your focal length on the fly. Zoom lenses often have a *variable maximum aperture,* meaning that zoomed out to a wider angle the maximum aperture is larger (say, *f*/2.8), and zoomed in more telephoto the maximum aperture is smaller (say, *f*/5.6). Variable aperture

keeps the size and cost of the lens down but provides less exposure and depth of field flexibility when zoomed in. Generally speaking, the larger the maximum available aperture, the more expensive the lens will be. The wider the range of apertures available on the lens, the more creative and exposure latitude you will have.

Normal Focal Length Lenses

The normal focal length for any given media format is the same as the diagonal measurement of the media plane. For instance, if you measure the image size of a 35 mm SLR camera, you arrive at a normal focal length of approximately 50 mm.

Normal focal length lenses give photographers one particular visual advantage that is often (unfortunately) overlooked. *Normal focal length lenses most closely approximate human sight*

ILLUSTRATION © SHAWN MARIE CURTIS, 2007.

and project an image with the least distortion and compression of space from foreground to background.

The approximate normal focal length size for the common film formats are as follows. *Note: As of this printing, some digital SLR sensors are still a bit smaller than the 35 mm film camera image area, although you can often use the same lenses. If this is the case, then you should know that the normal focal length for the camera is shorter than 50 mm, so a 50 mm lens will be somewhat telephoto. Consult your DSLR manual for specific sensor measurements and focal lengths.*

Camera Format	Normal Focal Length in mm
35 mm	50 mm lens
6 × 6 cm	80 mm lens
6 × 7 cm	90 mm lens
6 × 9 cm	105 mm lens
4 × 5 inches	150 mm lens

For darkroom practitioners, these are also the minimum focal length lenses required to make an enlargement with an even spread of light across the picture plane, as well as the largest projection possible. Using a shorter focal length than required for the negative size vignettes the image to white.

Normal focal length lenses are the standard when you want to represent a subject in a relatively noninflected way, by maintaining normal perspective within the visual field and

keeping the distance and size relationships from foreground to background relatively unchanged. Although their visual advantages are often underrated, normal lenses are excellent general-purpose lenses.

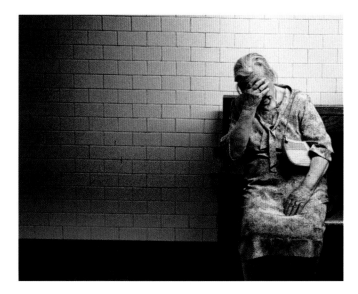

PHOTO © DAVID BECKERMAN, *HEAD IN HANDS, NEW YORK SUBWAY*, 2005.

The way we see it. Using a normal focal length lens brings to this documentary-style photograph a balance of intimacy and distance. We as viewers feel we're at the distance the camera is to the tired woman. It creates an image that feels more like natural human vision and in so doing places us easily into the scene, allowing us to empathize with the subject more intimately.

WIDE-ANGLE LENSES
Technical

Also called *short lenses*, the wide-angle lens for a given format is any lens that is literally shorter than the normal focal length. For a standard 35 mm SLR camera, this is any lens shorter than 50 mm. *Wide-angle lenses provide a wider angle of view than the format's normal focal length lens* (that's how they got their name), which means they include more of the scene than their longer counterparts. At the extreme are "fisheye" lenses, which cover a 180-degree angle of view. They come in two varieties: circular fisheyes cover 180 degrees in all directions resulting in an image with black borders; full-frame fisheye lenses capture 180 degrees along their diagonal only, so the image covers the full frame. Circular fisheye lenses range from 8 mm to 10 mm, whereas the full-frame types are usually 16 mm. Fisheye converters can be purchased to go on top of your lens like a filter, but they can dramatically reduce image quality.

Visual

In addition to providing a wider angle of view, short lenses exaggerate size relationships by making foreground elements larger than they would appear naturally in relation to background elements. Wide-angle lenses distort the perspective (and image contents) progressively more toward their edges and make elements in the background feel comparatively tiny. This is why portrait photographers who don't want to distort peoples' features use moderate telephoto

lenses (generally 85 to 105 mm for a 35 mm format). At the extreme, ultra-wide and fisheye lenses distort image contents into a circular form with the center bulging toward the viewer and the edges receding.

PHOTO © DAVID BECKERMAN, *METROPOLITAN MUSEUM, NEW YORK*, **1999.**

Taking in the wide view. Using a 16 mm wide-angle lens on a 35 mm SLR camera provides a much wider than normal angle of view. In this scene the distortion of the building and people, as well as the inclusion of the traffic light dangling from the top of the frame, all result from the wide angle of view combined with adopting a low vantage point looking up.

PHOTOGRAPH © TONY SWEET.

A true 180-degree view. This image has about as wide an angle as you can get. It was made with a Lensbaby and Fisheye Optic attachment (we'll cover Lensbabies in a moment). Circular fisheye lenses provide a telltale circular image on their intended camera format.

TELEPHOTO LENSES
Technical

Also called *long lenses*, the telephoto lens for a given format is any lens that is literally longer than the normal focal length. *Telephoto lenses provide a narrower angle of view than the format's normal length*, which means that they include less of the scene than their shorter counterparts. The longer the lens you use, the more the subject is magnified, making a faster shutter speed necessary to prevent camera shake.

Visual

In addition to providing a narrower angle of view, telephoto lenses compress perceived space between foreground and background in the scene, bringing objects in the background into heightened juxtaposition with objects in the foreground. Telephoto lenses allow you to capture images that are too far away for you to get to, such as a ball field while the game is going on.

PHOTOGRAPH © DAVID BECKERMAN, *WALL STREET SHAPES*, NEW YORK, 2000.

Telephoto depth compression. A long telephoto lens (200 mm on a 35 mm SLR format) dramatically compressed the wide space from foreground to background and merged the buildings and the light post into a single almost abstract composition. The compression caused by telephoto lenses can help you create a static picture plane.

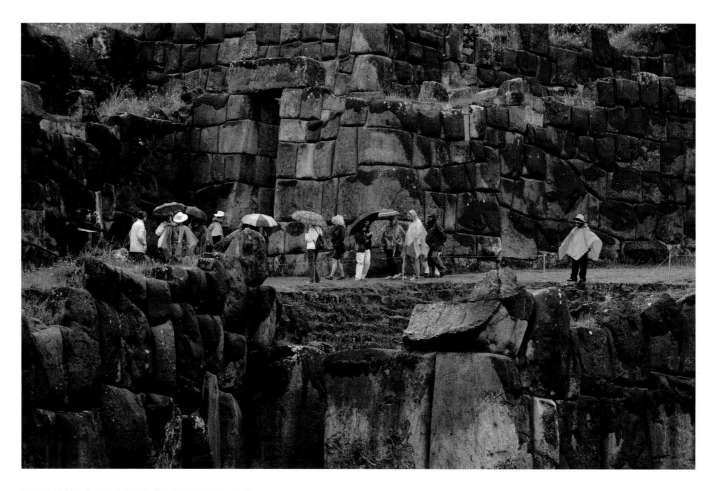

PHOTOGRAPH © JILL P. MOTT, *MACHU PICCHU*, 2009.

Get where you need to go. This image was made with a 200 mm telephoto lens by documentary photographer Jill P. Mott as she explored Machu Picchu. Aside from compressing space, it more importantly allowed her to capture an image from across a wide canyon, bringing the landscape's details and touristy color contrast close into view.

85 mm
Narrow angle of view.

50 mm
Normal angle of view.

28 mm
Wide angle of view.

What do you see? These images were made from the same distance and perspective; nothing moved. As the lens focal length changes the contents of the frame change too, as do their relationships to one another. In this makeshift "studio" the 85 mm lens isolates the subject, the 50 mm lens provides a view that approximates human sight, and the 28 mm lens reveals the entire scene (including the entire environment around the subject). You can use focal lengths to extend or compress the perceived relationship between objects, to provide accurate or distorted perspective, and to increase or decrease the contents within the frame at its edges.

Image Discussion 15: Visual Variety and Macro to Micro with Focal Lengths

Jill P. Mott; Police force at the Democratic National Convention in Denver, Colorado, 2008.

As we move through the text, remember that the Image Discussions are here to get you thinking about how these elements build on one another to create meaningful images. The elements of photography are technical tools in your toolbox that, when used thoughtfully, help you make a statement about your subject, rather than just taking a picture of it.

Take, for example, documentary photographer Jill P. Mott. She was living in the right city at the right time, and she took her cameras to the fevered Democratic National Convention protests as the city's police, in a show of force, used tear gas to disperse the crowds. I edited these two images from several hundred images she captured during the week of events because they demonstrate how lens focal length operates in the real world. By shooting the image on the left with a wide-angle 24 mm lens, Mott was able to capture an overall environmental view that operates as a scene setter, showing us what it was

like to be there. With help from intense mixed-lighting colorcasts and her low vantage point looking up at police, making them look even more intimidating, this image communicates to viewers the feeling of the moment.

Once protesters and police engaged, Mott made the image on the right to place us in the position of a protester literally looking down the barrel of a gun (it fires tear gas). As we discussed in Chapter 3, adding visual variety can mean looking from the outside in or the inside out, from the police toward the protesters or vise versa. It's all a means of surrounding your subject. The 200 mm focal length gets viewers up close, adding intensity to a scene we were a bit more comfortable with through the wide-angle view.

As you continue to study and practice the elements of photography, remember to analyze how the technical attributes of the medium affect and create meaning in your images and in other images you see.

Plane of Focus

After focal length, the second attribute of lens-made images affecting their visual outcomes and is plane of focus. *The plane of focus is the precise distance where light entering the aperture or lens projects an image onto the medium, which is usually parallel to the lens plane.* Any camera with the lens plane in a fixed, parallel relationship to the media plane will render everything at the focus distance in the same degree of sharp focus. But some cameras and accessories give photographers extensive creative control over the plane of focus by changing that parallel relationship. Read on.

BELLOWS OPTIONS

One common way to alter the fixed relationship between the lens and film planes occurs in direct view cameras, where a flexible bellows is placed between the lens and the media plane, allowing you to manipulate each plane independently. View cameras locate the lens on what is called the "front standard" and the media plane is on the "rear standard." View cameras provide two movements that alter the lens plane to media plane relationship; they are tilt (in which the front or rear standard is tilted downward or upward) and swing (in which the front or rear standard is pivoted horizontally). Tilt allows you to confine the plane of focus to a horizontal strip across the media plane, and shift allows you to confine the plane of focus to a strip vertically through the film plane.

In addition to view cameras, certain medium-format camera systems, such as the Hasselblad ArcBody, offer a lens mount

that will allow the same, albeit a bit more limited, plane of focus adjustments. Many SLR camera systems also have what are referred to as "tilt/shift" lenses. These options are smaller and less cumbersome than view cameras and offer the added benefit of being able to look through the viewfinder while making the photograph.

Unfortunately, both of those bellows options (view cameras and tilt/shift prime lenses) are cost prohibitive for most photographers wanting to experiment with plane of focus. Fortunately, a solution came in the form of a relatively inexpensive lens designed for most common SLR and DSLR camera bodies: the Lensbaby.

PHOTOGRAPH © ANGELA FARIS BELT, *SNOW ROLLER*; FROM THE SERIES *TRACES*, 2010.

Bend it with bellows. Snow Rollers just make me smile, and when I photograph them I want people to scratch their heads and smile too. I do it by using a camera with flexible bellows and adjusting the bellows so that the plane of focus creates the path I want your eye to follow; then I adjust the aperture to restrict depth of field to where I want it. The result is a puzzling perspective on a rare phenomenon.

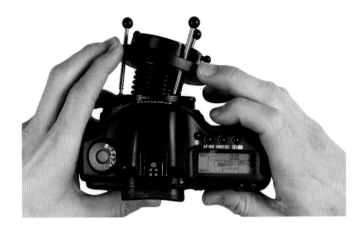

Lensbaby Muse.

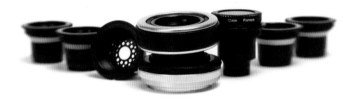

Lensbaby Composer and Optics accessories.

Lensbabies are flexible selective focus SLR camera lenses made with multicoated glass to provide good optical quality. Using a Lensbaby, photographers can capture images with one plane in sharp focus at an angle to the media plane. You can adjust the area of sharp focus anywhere in the image area by bending the flexible lens. There are several versions of the Lensbaby, each with different advantages, and there are Lensbabies made for medium-format cameras. There are several versions of the Lensbaby and Optics to take your focus experimentation to the next level. Go to www.lansbaby.com to learn more.

Bellows cameras and adjustable plane prime lenses (including the Lensbaby) allow you to manipulate the plane of focus to direct viewers' attention in nontraditional ways. Skewing plane of focus "out of parallel" with the media plane alters the way viewers normally see, with the fixed plane of focus afforded by human vision. It replaces the expected with seeing in a way that only the camera can, making viewers ponder the image a bit longer. This lack of familiarity forces viewers to literally see the image contents in a new and different way, opening their mind's eye to clues about potential meanings.

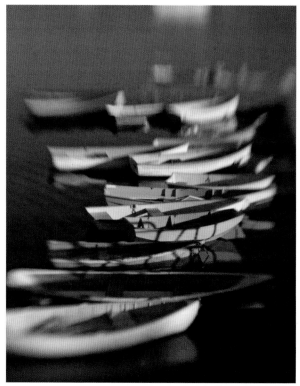

LEFT IMAGE © KATHLEEN CLEMONS; RIGHT IMAGE © TONY SWEET.

Another kind of fisheye. We discussed taking a fisheye view to vantage point, as in going underwater if that's where the shot is. But even if the shot is on land or in the sky, you can use a fisheye lens or attachment. These maritime scenes were both shot with Lensbaby, the left image with a fisheye optic added for an ultrawide view, and the image on the right with a double glass optic for a more spot-diffusion effect. It's not only the wide warped perspective and nonlinear depth of field that give these images their charm; it's that the photographers used vantage point and framing within the angle of view to construct engaging compositions that describe unique views reflective of their subjects.

FLEXING IN THE TRADITIONAL DARKROOM

Using a flexible bellows is the most common way to break free of the rigid relationship between lens plane and media plane, but based on understanding these aspects of photographic language you can conceptualize and experiment with other ideas. Think about the relationship of the lens plane to the media plane, and at what other points in your process you might adjust it. You cannot "bend" a digital sensor, but *you can bend, bow or otherwise alter the flat plane of traditional media, both film and paper, often in traditional film and pinhole cameras and nearly always in the traditional darkroom.* You can alter the flat plane of the negative in the enlarger housing, or you can print onto paper that is not parallel to the negative carrier by bowing it at its ends or placing it and the easel at a 10- to 20-degree angle to the enlarger. The attributes of focus extend any time a lens is used to project images, so the sky's the limit. The communicative and visual potential of manipulating plane of focus isn't limited to practices that have been widely used. Also, remember that if you're a digital photographer and are willing to combine traditional media as well, then you can scan in one-of-a-kind traditional images to further process and print from your digital darkroom. The idea is to understand the elements of photographic language, and use their characteristics to make your own unique visual statements.

Image Discussion 16: A View from Above

Olivo Barbieri, *Site Specific, New York City,* 2007.

Ariel views of cityscapes don't often tread new photographic ground (so to speak). That's because they're generally shot with a camera that has a fixed parallel relationship between the lens and media planes. But Olivo Barbieri breaks from convention to make images of the great city of New York (and other places) in such a way as to visually reduce it to the scale of a minuscule tabletop model. He accomplishes his unique style of imagery through tilt-shift photography using a large bellows camera and going against the plane of focus, distorting the size-scale relationships of the buildings and their surroundings.

Connotatively, Barbieri's vantage point provides us with a "god's-eye view," which, combined with his control of the element of focus, seems to indicate that even the largest constructions of human engineering and habitation are reduced to mere shiny miniatures against the scale of earth itself. When viewed from above looking down, even our highest towers are diminished below us.

These images provide an excellent example that *the elements of photographic language are never used in isolation*; they combine with your vision to make more complex statements in a style that's as unique as your perceptions.

OUT-OF-FOCUS OR SOFT FOCUS SLR

Whereas the bellows option allows the lens plane and media plane to be manipulated independently, even SLR cameras with a fixed parallel lens-to-media plane relationship also offer unique opportunities for focus control. Although their plane of focus might remain parallel, in most cases cameras let photographers decide *where to place the plane of focus.* When an image is out of focus that only means that the lens is focusing the image at some place in space other then the media plane. If you're using a manually focusing camera, *to make an out-of-focus image you choose to capture the image out of focus by placing the plane of focus in front of or behind the media plane.* While capturing images in sharp focus is an obvious default, choosing to focus outside the sharp depth of field range can lend a great deal of feeling and meaning to your images.

The only real tip to making good out-of-focus images (I know, that sounds sound like an oxymoron) is to *shoot using the widest aperture on the lens.* When you view through the lens as you do with most SLR cameras (called TTL viewing), you are seeing through the viewfinder at the lens's widest aperture, because the aperture only closes down to record the image or for depth of field preview. Shooting at the camera's maximum aperture gives you an accurate view of how the final image will look. Simply look at your subject through the

PHOTOGRAPH © SEAN WILKINSON, UNTITLED; FROM HIS SERIES *TRACES*,
1999, LONDON.

(Un)Focused attention. The pictorialists were on to something when they rejected the sharp nature of photographic images, but they didn't explore all the potential surrounding lack of focus. Fine art photographer Sean Wilkinson uses a medium-format SLR camera, carefully regarding the degree of focus through the lens. He adjusts the focus until the image in the viewfinder is intriguing on its own, without relying on sharpness to carry the subject. View more of Sean Wilkinson's work in this chapter's Portfolio Pages.

viewfinder, and watch the image as though it were projected on a small screen; when the contents of the image take a form that you respond to, then shoot.

So the question becomes "Why on earth would I *want* to take a picture out of focus?" The answer, as always, is you would do it for emotive or communicative value. Out-of-focus imagery can express a range of conceptual and visual meanings. Because soft focus is indistinct, you might use it to give viewers only a vague or mysterious sense of something, rather than a concrete picture of it. A lack of focus refers to memory, connotes the past, and can become completely abstract. Not all subjects will benefit from techniques like this. All you can do is consider what it might indicate about your particular subject and use it if it's appropriate. If nothing else, the practice will help you to engage in another way of seeing and expand on your understanding of the camera's vision.

Lens Quality

In addition to focal length and plane of focus, the third attribute of lens-made images affecting the visual outcomes and meaning of the images is the quality of the lens. *Lens quality includes its optics, the clarity of its glass and coatings, and other factors; they can be plastic or diffused in a number of ways.* Lens quality is a significant factor in both clarity and perceived sharpness of the image.

Image clarity and perceived sharpness include, most importantly, resolution and acutance. Without getting too far into the technical aspects of lenses, resolution is defined as the ability of the lens to render fine detail; the lack thereof creates an image that feels soft or unsharp. Acutance is the ability of the lens to render fine edge crispness and sharp transitions between contrasting tonal values. Media and materials also

affect clarity, resolution, and acutance, but lens quality plays significantly in terms of camera capture. In short, the better the lens construction and higher quality the glass and coatings, the clearer and sharper your images will be. You can test resolution and acutance of any lens by purchasing a printed "resolution test chart" and shooting it according to its specified instructions. If the test chart is sharp and clear, you have a high-quality lens; if it is somewhat fuzzy compared to the original test chart, then your lens quality is lower. Keep in mind that all photographs are the second generation from the original, and no photograph will be equally sharp or sharper than the chart itself printed at equal size.

But not all photographers want to produce images that are perfectly or even reasonably clear. Many photographers recognize the value in lack of clarity for its unique relationship to the frame's contents. In effect, decreasing lens quality can increase expressive potential. One way to produce images of diminished clarity is to use a plastic lens camera, and another is to diffuse your SLR camera's sharp lens.

Plastic Lens Cameras

There are many types of plastic lens cameras, but the two most common are the Diana, originally introduced in the 1960s and no longer in production, and the Holga, introduced in the 1980s and still in production. Both cameras capture images that are highly regarded by some for their low-fidelity aesthetic; they maximize the serendipity of capture, producing images with light leaks, vignetted at the edges, and a reduced degree of clarity. These are all positive aesthetic advantages for practitioners who wish to use the camera's ability to represent a subject less concretely or in this particularly stylized way. Remember that if you're a digital photographer, then you can always shoot with these film cameras and scan in the negatives, or you could retrofit a digital camera with a plastic lens. It's all about "the Lomo" effect (a particular brand of plastic camera—the Lomo Kompakt Automat—and urban slang for any plastic camera photography). If you're really interested in exploring the depth and breadth of plastic camera photography, read *Plastic Cameras: Toying with Creativity* by Michelle Bates. It provides a detailed history and extensive technical information about plastic cameras (even retrofitting them).

Plastic camera images have distinct characteristics that make them appealing to a wide range of photographers from commercial to fine art. Because they generally don't hold the film taut, the media plane is rather loose, resulting in an unsharp overall image. The exposure is usually slightly to extremely vignetted, darkening toward the edges, and often the lack of quality in camera construction leads to random light leaks. The plastic lens skews colors, causing them to be more intensely saturated than they would normally be. All of these are welcome advantages to plastic camera shooters who embrace the quirks to make truly singular images.

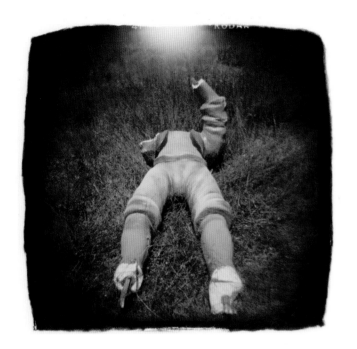

Body, from the *Exquisite Decay* series, 2008. *Gold Guard, Bangkok,* 2007.

PHOTOGRAPHS © MICHELLE BATES; HOLGAMODS MODIFIED HOLGA PLASTIC CAMERA IMAGES.

Cheap cameras, rich images. This plastic camera phenomenon is evidenced no more strongly than in Michelle Bates's photography. She is so passionate about plastic cameras that she literally wrote the book on them. And passion is contagious, because photographers across the spectrum use plastic cameras for fun and profit. She hopes for serendipitous lens flares and adds her own unique film-edge borders to the images using a handmade negative carrier as well. These images speak to how quirky, garish, bizarre, or just out-of-the-ordinary subjects spring to life when seen through a plastic lens. See more of her work in this chapter's Portfolio Pages.

PHOTOGRAPH © ANGELA FARIS BELT, *RAIN LEAVES*, 2007.

Cheap cameras, intense images. This plastic camera image was made with a Holga camera with insert in place to make a horizontal frame. Characteristic of plastic cameras, the image edges are vignetted, and the entire image has a soft feel to it. Plastic camera images aren't usually confused with documentary photography; they are generally used for more subjective forms of photographic expression.

DIFFUSION

Diffusion is another aspect of lens quality that should be discussed independently because of its specific, unique attributes. *Diffusion shouldn't be confused with lack of focus; diffusion softens specular light without reducing focus.* It's a fine line, I know, but even subtle differences in visual quality matter in photographic language, just as subtle differences

in connotations between similar words matter. Diffusion can be accomplished in a number of ways, but most commonly it's done with simple diffusion filters.

Essentially, diffusion filters affect bright lights by causing them to flare, thus creating a soft halo around the bright area. When shooting with diffusion filters, the highlight areas are affected most. However, the opposite happens when you take the same filter and use it to print in the darkroom; that's because the shadow areas in a negative are the "thinnest" part of the film (less density), so they allow brighter enlarger light through. Therefore, diffusion used in the darkroom creates soft halos around shadow areas of the image. Diffusion shouldn't affect sharp focus or image contrast.

There are spot diffusion filters with stronger diffusion at the edges and less toward the filter's center, and there are graduated ones with stronger diffusion at one end that gradually gets less intense across the filter. Like any filters, you should limit the number you stack atop one another to three, because more than that will vignette the edges and reduce the image quality.

You don't necessarily have to buy a diffusion filter; you can also make custom diffusion materials in a number of ways. You can find a piece of clear acetate to place in front of the lens; you can even scratch it if you like. Some people recommend spreading petroleum jelly onto an inexpensive UV filter, but I find that's

 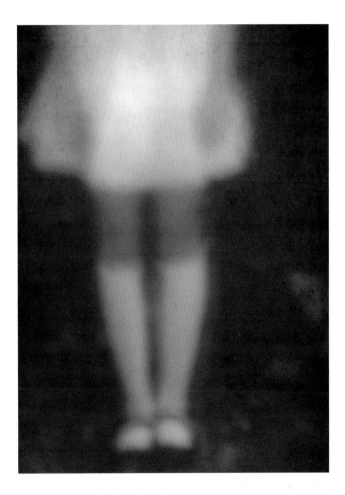

PHOTOGRAPHS © TINA LOUISE.

Lenses lacking quality. For these images the photographer used a Lensbaby (which has good optical quality when used alone) to skew the parallel plane of focus, but she added to it a single glass optic (*left*) to soften the image to a more vintage look. On the right, she added a pinhole optic to distort the smoothness of the image. Anything you do to the lens or place in front of it will affect the image quality; knowing how allows you to control its effects.

Enlarger Diffusion Effect

Original Effect

In-Camera Diffusion Effect

IMAGE © LINDSAY GENRY, 2007.

Diffuse now or diffuse later. Once you understand the nature of diffusion, its effects can help you to create a mood in your images whether in the camera or in the darkroom (traditional or digital). You can add visual weight to an image by diffusing the shadow areas into the highlight areas; conversely, you can create a more ephemeral feeling by diffusing the highlights into the shadows.

too messy; instead, spray hairspray onto the UV filter (this isn't a filter you'd use for anything else) and you can wash and respray it at will. You can also add things like cellophane, thin nylon stockings, or any other translucent material in front of your lens. There's no rule here, only methods that bring your images closer to your vision.

Diffusion carries connotations from dreamy and ethereal to sappy and romantic; very slight diffusion is often used in portraiture, in part to subtly smooth skin imperfections. The following images illustrate the diffusion effect; although they are digitally created, they compare to the effect you achieve using diffusion filters in-camera versus in the darkroom. Remember, half of being able to re-create a camera effect digitally is to know how it looks traditionally.

Lens Flare

Beyond the attributes of lenses, there's one aspect of using them that, when it occurs, tends to vex photographers. It's called *lens flare—any non-image-forming light that strikes the lens and causes exposure to the medium.* Lens flares can take the appearance of polygonal shapes (mimicking the aperture) and streaks of light that are either white or appear like a rainbow spectrum. Those kinds of lens flares are often welcome if they don't interfere with the primary image contents. It is often an effect added in the digital darkroom as well. But another kind of lens flare is called "veiling flare," and it's almost always unwelcome; it appears as a very washed-out, low-contrast look across the image.

Lens flare, like every aspect of photographic language, can either add to or detract from your image, but knowing how it happens allows you to control it or avoid it. Lens flare most often occurs when you shoot "into the sun" or frame a bright light source inside the lens's angle of view, but it can also happen when you don't see the light source in the frame if the light is striking the front of the lens. If you want to try for lens flare in the image, then make several attempts varying your position slightly while keeping the light on your lens. If you want to avoid it, the first option is to recrop—that is, move. But if you have the image framed the way you want it, you can also add a lens hood or shade (or even use your free hand) to help shield the front of the lens. If a lens shade is too long for the focal length for which it is intended, it will cause edge vignetting (as will your hand if you're not careful). You can avoid or embrace the vignetting too, knowing that you don't have to shield the entire lens, only the glass in the front of it.

As an element of photographic grammar, apertures, lenses, and focus act as image quality control more than any other element. From wide views to narrow ones, from deep to compressed space, from crisp sharpness to soft diffusion—these are all attributes of the same element. Focus and depth of field direct the viewer's eye in a controlled and meaningful path throughout the frame and emphasize the aspects of the frame that are central to communicating the meaning of the image. Radical manipulation of lens attributes such as plane

of focus and diffusion are prevalent in contemporary fine art and advertising photography, pointing to this element's significance as a sophisticated tool for visual and communicative expression to a wide range of viewers. Conceptual use allows you to utilize focus on its continuum from concrete imagery whose authority and specificity feel indisputable, to seductively ethereal imagery that only hints at its content as it highlights form and color.

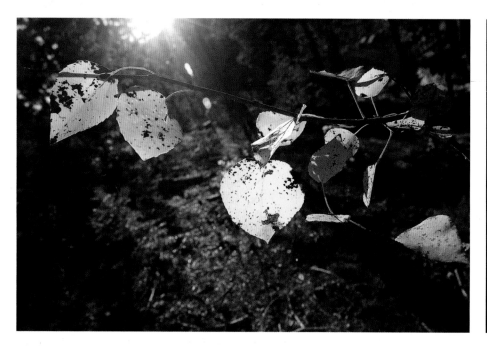

PHOTOGRAPHS © ANGELA FARIS BELT, 2009.

Happy accident rainbow flare. Walking through my backyard woods I turned a corner into the sun and was struck by the light and the color of the aspen leaves just in front of me. I decided to take a snapshot study (*left*) hoping that if I didn't shade my lens I would get some lens flare. Exploring different angles and distances, I finally made the image on the right, complete with a huge half-moon rainbow lens flare. It worked so well—the halo edge of light surrounding the aspen leaf, and the rainbow cradling the leaf in a similar shape came together to make a photograph that expresses both the intensity of the light and the beauty of the leaf that struck me to begin with.

CHAPTER EXERCISES: USING APERTURES AND FOCUS TO COMMUNICATE

These exercises will help you "focus on" (I couldn't resist) camera focus and how to manipulate it. It will also help you answer questions about elements like clarity, depth of field, plane of focus, and softness that are important aspects of photographic image making. Can an out-of-focus image enlighten us about a subject? Can a pinhole camera image, with its lack of sharpness but infinite depth of field, offer new perspective about a specific topic? As you proceed, remember to stick with the chosen subject or concept you've been shooting for the previous exercises. For these exercises concentrate on what the notion of "focus" has to say about your subject or what your subject has to say about focus. As another challenge, try to work in a "series"—that is, a group of images that all work together. If you find a technique that really works for your subject, then continue shooting that way until you have perhaps four successful images.

1. **Depth of Field Series**

 Make a series of photographs with your camera set at its closest focusing distance.

 Look through the lens and compose your images based only on the sharply focused aspects of the frame in relation to light and shadow rendered in the rapidly diminishing depth of field that you see. *Use close to the widest aperture (f/2, 2.8, 4) available on your lens in order to limit your depth of field to what you see through the lens.*

 Next, with your camera on a tripod, compose an image with content in the foreground, middle ground, and background. Focus in the middle and, using equivalent exposures, make a range of images in one-stop increments from your largest to smallest aperture.

 For added complexity, you could create limited depth of field images to be printed as diptychs, triptychs, or multipanel panoramas. As in the previous chapter exercises, plan the gestalt images in advance so that the results are more predictable. Still, work in a series, and edit four to six successful multipanel images to print.

2. **Out-of-Focus Series**

 For this exercise, make a series of photographs with your camera set to a focusing distance that renders the scene out of focus. Don't change your distance from your subject until it's in focus! Look through the lens and compose based only on the light and shadow that you see. Use close to the widest aperture (f/2, 2.8) available on your lens in order to limit your depth of field to what you see through the lens. Print a series of three to five of them, being sure to consider how their subject matter relates as a group.

3. Plane of Focus Manipulation

For this exercise, you'll need access to a Hasselblad Arc Body or Flex Body, a Lensbaby, a large-format view camera, or even a vintage camera with an adjustable bellows. View the scene through the lens, and begin adjusting the bellows or lens plane until the plane of focus looks interesting to you. Don't over-analyze it—make intuitive decisions based on the appearance of the image in the viewfinder or ground glass.

Approach this exercise as a series as well, and try to produce four to six images where the plane of focus manipulation adds to visual quality or meaning.

4. Convert Your SLR Camera into a Pinhole Camera

For this exercise, you'll want to do some independent research (beginning with Pinhole Resource, www.pinholeresource.com). Purchase a ready-made pinhole body cap, or buy an extra camera body cap and follow the chapter instructions about how to make one. Use it to make photographs of your chosen subject, topic, or genre. Think conceptually about how the extremely wide depth of field against the softness of the image can affect your viewers' perception of your subject.

PORTFOLIO PAGES

The artists represented in this chapter's Portfolio Pages engage in a wide range of photographic practices. They use traditional, digital, and hybrid media, and they consciously (visually as well as conceptually) address how the depth and clarity of focus affect the appearance and meaning of their photographs. The work in these pages is not *about* apertures or focus per se; rather, it uses the guiding principles of these technical devices as visual strategies to support or address their subject.

These images are intended to inspire creative thinking and critical debate about the content and subject of the work, as well as the use of apertures and lenses in relation to them. Additionally, think of other instances where still images use the depth and clarity of focus consciously, or reference them in the work in order to comment on their subject. How might increasingly conscious use of the attributes of apertures and lenses add dimension and meaning to your images?

CYNTHIA GREIG

LIFE-SIZE

ELEMENTS

Cynthia Greig's work straddles a strange line between humorous irony and serious theoretical photographic study. She consistently uses photographic language to carry her messages in intelligent and visually interesting ways. In this series she juxtaposes miniature objects in the frame with their actual-size human users, forcing us at first to laugh, then to question our eyes, and finally to think about the nature of perception in general.

ARTIST STATEMENT

I'm fascinated by the fact that almost anything—whether sunglasses, a hypodermic needle, or a condom—can be found in miniature. I'm equally intrigued by the desire to collect such tiny replicas of normal-size objects. As a smaller-scale surrogate of the original, the miniature implies the existence of some kind of alternative universe where we—as larger bodies—are like gods, omnipotent and in control. For my series Life-Size, I use a 35 mm SLR camera with a macro lens to photograph my friends and family interacting with miniature dollhouse objects in their own homes and backyards. By exploiting extremely shallow depth of field I make the surrounding environment fall out of focus, drawing attention to the surface details of the tiny objects as well as the wrinkles, scars, and pores of my larger human subjects. In the darkroom I enlarge the negative so that the previously small appears to approximate the "life-size" in the final photograph. This dramatic shift in scale and narrow range of focus emphasize the resemblance of the miniature to its larger-size referent and at the same time upset our usual sense of order and proportion.

The resulting photographs show gigantic adult figures invading a claustrophobic world of Lilliputian proportions, awkwardly attempting to make these undersized objects function as if they were actual working possessions or tools. This intersection of scales disturbs the imagined perfection of a mini-sized fantasy world, eliciting humorous and absurd narratives that explore our desire to control and contain the unpredictable and sometimes overwhelming circumstances of life. By inviting the viewer to look beyond the surface and confront the

betrayal of appearances, the photographs explore the relationship between how we see, interpret, and experience the world we live in. By making images that challenge our expectations, I'm exploring how perceptual experience shapes our understanding of the world around us and our concepts of what is real or an illusion.

Sunglasses, 2001.

Life preserver, 2003.

Gun (evidence), 2003.

MICHELLE BATES

PLASTIC CAMERA IMAGES

ELEMENTS

When you get down to it, plastic cameras really are fun. Combine that with the subject matter in Michelle Bates's images, and you have a perfect combination. With subjects ranging from ironic to tragi-comic to humorous, she capitalizes on the serendipitous happenings that go along with using plastic cameras, such as the lens flare surrounding her *Holy Cow*. Her rough-hewn but rounded borders made with her own handmade negative carrier speak to the content of her images and give them a signature style.

ARTIST STATEMENT

The Holga is my camera of choice. It's a super-simple plastic box with a spring shutter and almost no way to adjust your exposure. It doesn't roll the film on tightly, sometimes the back falls off, and the negatives are usually way overexposed or underexposed. On the plus side, they're cheap and light, and the images they make have a look and feel wonderfully different from what you get with a "normal" camera.

With my first successful Holga image made in 1991, I discovered that the square-ish negative was a bit bigger than the standard size for its format (6 cm × 6 cm on medium-format 120 film). In response, I cut a negative carrier out of cardboard that follows the Holga negative's natural edges, and I've been using that carrier ever since.

I've always loved the inherent characteristics of Holga images. They bulge outward like an old TV screen, leaving straight lines out of the picture completely. They vignette, drawing the eye into the center of the frame. The focus likewise falls off toward the edges, mimicking how we see the world through our eyes.

The themes I've made the subjects of my Holga images have changed over the years, but my Holgas always seem to like photographing quirky subjects. I have many images of carnivals rides, animals, fake animals, sculptures, parades, and other funky subjects that make people smile. Over time, though, I've pulled the Holga away from its traditional milieu to try to tease great photographs out of other subjects. These series include many city and nature photos, both scenic and abstract, and photos that focus on graphic qualities in structures.

The hit-or-miss aspect of this type of shooting keeps the intrigue in the act of photographing, breaking the expectation of predictability, and leaving room for unanticipated surprises.

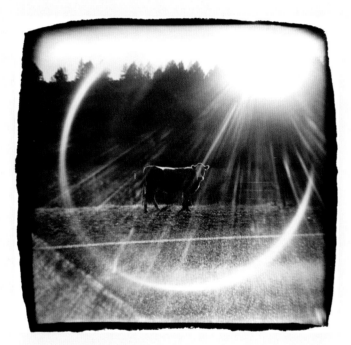

Holy Cow, Eastern Washington.

Lakeview Cemetery, Seattle.

PHOTOGRAPHS © MICHELLE BATES.

CHIP SIMONS

BUNNY

ELEMENTS

Black-stroke borders and darkened vignettes draw you into another world inside Chip Simons's photographs. This world's odd, saturated color and strangely delineated quality of focus gives it the feeling of a fairytale, but the odd happenings occurring in *Bunny* might not only refer to the realm of fairytales. We could interpret them as a reference to the human condition—always chasing that carrot, the psychological weight of age, and the work and play we engage in as we pass the time in our lives. Either way, the framing, focus, and content of the images make for fascinating stories.

ARTIST STATEMENT

I love to run around with a shift/tilt lens adapter on my Mamiya RZ 67, especially with a 75 mm lens and 85b filter, and the auto prism. Though it is the world's heaviest point-and-shoot camera, it frees me to be spontaneous with both exposure and focus. This led to a "shoot before I think" way of shooting; I let my body and my stomach feel what to do … then I snap the shutter before I let my brain compose or focus. This is how the *Bunny* series came about. It is a bit macabre, and melancholy, but it is also playful and innocent and fantastical. The soft focus, the vignette, and tonality add to their nostalgic and timeless impressionism. I think that selective focus is a bit like selective attention spans; sometimes my mind and I just like to wander and not focus on details … but rather take in the whole image and feel. Through these images, the viewer can do the same.

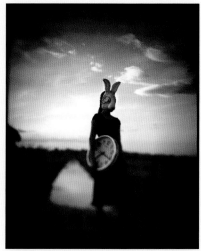

Clock Bunny.

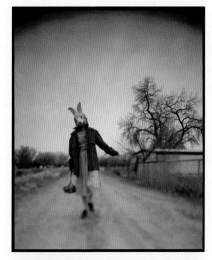

Penelope.

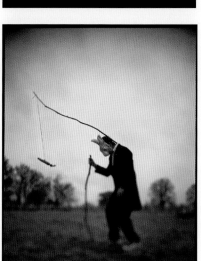

Follow the Carrot.

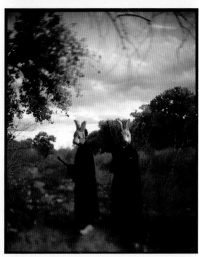

Bunny Hunters.

POLLY CHANDLER

PHOTOGRAPHS

ELEMENTS

Polly Chandler's images have a true dreamlike quality created by the tilt and shift of view camera movements, but they don't stop there. These quiet, ethereal worlds are encapsulated by rough edges of the world outside, signified by her full-frame printing of the Polaroid Type-55 film borders.

ARTIST STATEMENT

I have always been drawn to expressing myself through an artistic medium, whether it is with drawing, printmaking, or photography. My images are not portraits, but narratives of my inner self. In searching for my life's purpose, my work documents the exploration of my own identity. By combining figures with backgrounds, costumes, and props, I create works that are spiritual and allegorical. Seeking insight to who I will eventually become, I look for resolutions to unanswerable questions.

It's important to me that my decisions in my image making are done in the field. Nothing is an afterthought; everything is done in-camera. My photographs represent, among other things, my experience and interpretation of a particular place and moment in time. To manipulate the image later takes something away from that for me; it's a sort of detachment from staying in the moment. It's also a part of challenging myself as a photographer to create the image I'm looking for in the field and on the negative rather than "fixing" it later. I also print full frame to show that I pay close attention to everything in my frame, including the very edges; nothing is an accident. Shooting this way slows everything down and the subject has to pay close attention to the process of making the photograph along with me, making it a very collaborative effort.

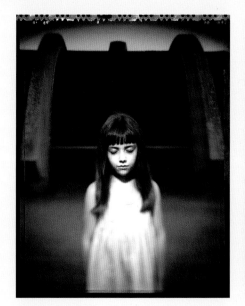

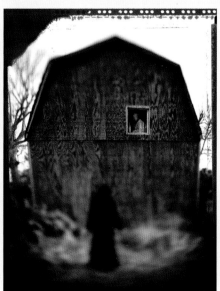

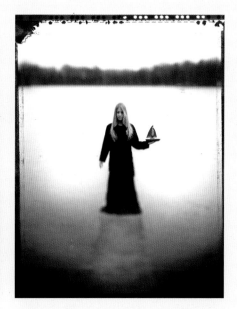

Chloe.

He Has No Friends of His Own.

Along an Icy Pond.

PHOTOGRAPHS © POLLY CHANDLER.

OLIVO BARBIERI

THE WATERFALL PROJECT

ELEMENTS

Like he does with his photographs of New York City, Olivo Barbieri makes these huge waterfalls and coastlines seem like small models. His understanding of how plane of focus affects the appearance of depth of field enables him to transform our size-scale perception and look at things anew, in particular our own rather insignificant scale in relation to the natural world.

ARTIST STATEMENT

By means of aerial perspective and fading effects, I ask how much reality exists in our living system, or again, how far our perspective is able to comprehend what surrounds us. Probably these are questions without an exact answer, but they allow calling into question the logical relation that should subsist between human beings and our activities. In the end, the sense of living that we detect in the pictures becomes the topic of a critical assessment, of a philosophical approach where the human view negates its subjectivity and seeks for a painful, deep, desperate cynical objectivity.

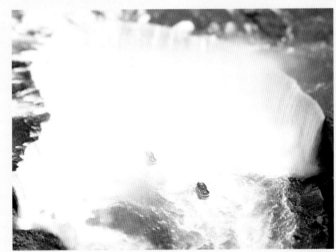

PHOTOGRAPHS © OLIVO BARBIERI; FROM HIS SERIES *THE WATERFALL PROJECT; CANADA-USA*, 2007.

SEAN WILKINSON

TRACES

ELEMENTS

Sharpness and detail have traditionally been the goal for photographers, and making images out of focus most often accidental. But unintended outcomes, studied carefully, can lead to great discovery. Sean Wilkinson understands the nature of photographic language and knows that making beautiful, meaningful, successful photographs is done through seeing intensely rather than following tradition.

ARTIST STATEMENT

In making these pictures, I was interested in the suggestion of a thing rather than its description. Objects merge with their backgrounds, and light dissolves edges. I have deliberately sacrificed precision and detail in order to emphasize allusion and evocation. At the same time, I want the viewer to identify the subject matter sufficiently to discern, simultaneously, both its substance and its essence.

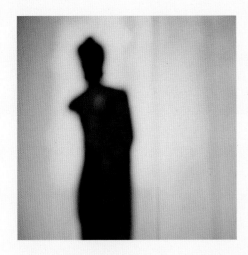

Untitled, Boston,
1999.

Untitled, Lyon,
1999.

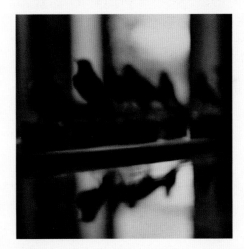

Untitled, Florence,
1999.

Untitled, Rome,
1999.

PHOTOGRAPHS © SEAN WILKINSON; FROM HIS SERIES *TRACES*; 18″ × 18″ CHROMOGENIC COLOR PRINTS.

TODD DOBBS

DITCHES

ELEMENTS

Todd Dobbs makes landscape photographs outside the typical landscape genre. His 6 × 18 cm pinhole photographs are unique in their vertical orientation and that he includes within their frames all the evidence of human presence that most photographers would exclude. Although softened by the use of a pinhole, the images offer far more meaning than the expected river walk.

ARTIST STATEMENT

As a transplant from the Midwest, the Colorado Front Range is a fascinating foreign landscape to me, and much like the explorers before me, I am drawn to discovering new places and gaining a better understanding of my surroundings. In the process of this exploration, I became very interested in how early settlers to the region had a significant and lasting impact on the scenery of the area in the process of making it more habitable. Namely, in the creation and maintenance of the irrigation and reservoir system, which is essentially a complex network of man-made ditches.

The ditches were often dug by hand or mule-pulled plow; not until many years into the process would the steam engine help ease the intense labor, but only marginally. The goal was simple: provide year-round irrigation for farmers and protection from spring floods. Before the ditch system, the Front Range flooded every spring and remained relatively dry the rest of the year. As part of the ditch system, reservoirs were established to both save water for drier months and protect newly developing communities from the threat of a devastating flood. The water was diverted far into the eastern plains of Colorado using ditches to establish a large network of farming communities; to this day agriculture is one of the primary revenue sources for Colorado, just behind tourism.

While the goals of early settlers were a simple task of survival, the result visible more than 170 years later is one of immense beauty. Many Colorado "natives," as they prefer to be called, take for granted this vital and necessary part of our ecosystem. With this project I am attempting to reacquaint the viewer with the beauty possible in the everyday utilitarian systems that we have created. The subjects I use are the ditches and the control mechanisms for Colorado's

most valuable natural resource—water. The camera I use is a simple box with a small hole, much like the crude tools of the settlers who first broke ground on the ditch system. As many scientists predict, our state will face an almost certain water shortage within the next 30 years; I hope to do my small part in recognizing and preserving these spaces before they again evolve, as humans continue to alter the ecology of our landscape.

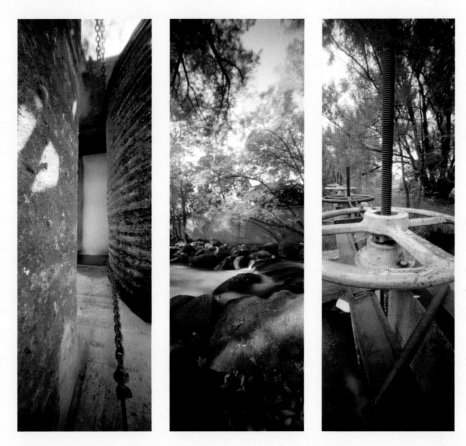

PHOTOGRAPHS © TODD DOBBS; FROM HIS SERIES *DITCHES*; 3' × 1' OR 1' × 3' ARCHIVAL PIGMENT PRINTS ON CANVAS WITH VARNISH, GALLERY STRETCHED.

VIRGILIO FERREIRA

UNCANNY PLACES

ELEMENTS

As a means of exploring our world and interpreting its visible realities, photography is a powerful form of empirical research. In exploring very ordinary places, Virgilio Ferreira references lack of focus metaphorically through a different element of photography—time. Through multiple exposures he actually softens the line between discrete moments to allude to the magic of the photographic process and our individual experience of the world.

ARTIST STATEMENT

The *Uncanny Places* project is settled on the expressive ambiguity of certain images, which are both familiar and foreign at the same time. In my view, these images evoke fragments of the contemporary world—a world of strangeness and similarity, hallucinatory, made of blurred and ever changing boundaries. My pictures aim to get away from that regulated world, without leaving it, but inspecting it.

The project deals with binaries such as the logic versus the magical, the rational and the irrational. Poetic experiments are created through an intuitive passage through apparently common places, with no compass; this deliberate aimlessness paves the way for moments of serendipity. Shot on various locations in Europe, the United States, China, and Russia, *Uncanny Places* meets with different trajectories combining several frameworks to include feelings of awe and fear, provoking memory and illusion, and giving off a sense of myth and fantasy—all of which I try to recreate visually.

A double-exposure is intentionally used, in a very short time span, in the same image, for the same occurrence. This is to create a notion of continuity between "there" and "here," where two points in time overlap in the same place. The presence of the two physical and chronological layers in the same image contradicts the ordinary flow of perception. These images were taken in medium format with the use of color reversal film, without resorting to digital manipulation, the analogical adding to the mystery of these images.

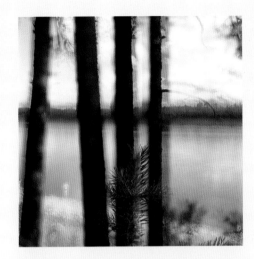

Untitled, 2010.

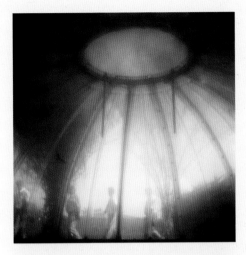

Untitled, 2009.

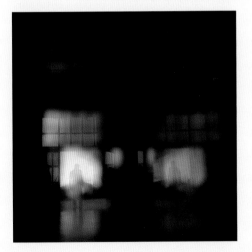

Untitled, 2009.

Untitled, 2007.

VICTOR SCHRAGER

THE WHITE ROOM

ELEMENTS

The selectively out-of-focus images by Victor Schrager might seem at first glance to be paintings. Indeed, in their lack of sharp focus throughout, they counter the usual still-life photography style, but they offer something new instead. They provide a fresh way of seeing, tied to unusual subject matter that transcends its own materiality to embody the form and shape that are these images.

ARTIST STATEMENT

Still life mines the inexhaustible plastic volume of space always available to me; the objects in the pictures are semiconductors of light: light as, light through, light in, and light on.

Light lubricates the interaction of objects in front of the camera with interstitial joy.

Focus sharp and soft, thick and lean, allows the visuality of the photograph to construct as well as describe.

The White Room is a Clean Room. Dark and darkness are no longer the underlying metaphors for photography.

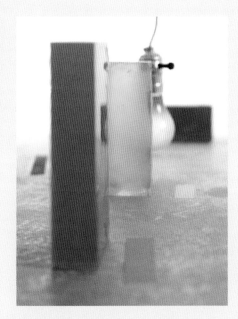 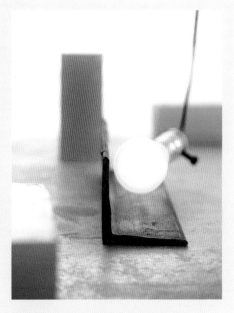

The White Room, Untitled No. 53, 2008. *The White Room*, Untitled No. 83, 2008. *The White Room*, Untitled No. 271, 2008.

IMAGES © VICTOR SCHRAGER; FROM HIS SERIES *THE WHITE ROOM*; ARCHIVAL PIGMENT PRINTS, 35″ × 44″, 2008.

SHUTTER SPEEDS: TIME AND MOTION

PART 1: SHUTTER SPEEDS, THE THIRD PHOTOGRAPHIC ELEMENT

We've covered framing (the first element beginning with the camera's viewfinder, continuing to print borders, and extending into multiple frames) and apertures (which control the intensity of exposure to light and are tied to quality of focus). Now we'll move into another important element of photographic language affecting exposure as well as visual quality and meaning—*shutter speeds*.

Since the first photographs, images recording blur (movement extruded across the picture plane) have vexed and fascinated photographers and viewers alike. Blurring motion was not a creative discovery; in fact, throughout photography's early years the available media's extremely slow light sensitivity meant that photographers

PHOTOGRAPH © NICOLE KULINSKI, 2006.

The freeze-blur continuum. In this photograph of a traditional Mexican dancer, editorial photographer Nicole Kulinski used a relatively *slow shutter speed* of 1/4 second with a relatively long 170 mm *focal length* lens. The dancer is moving the edges of her dress *quickly* while her face and body stay relatively *still*, and she is *moving toward the camera.* These factors (in italics), along with Kulinski's *distance from the subject*, combine beautifully to capture simultaneously a graceful frozen moment surrounded by the fluidity of soft blur.

(and their subjects) had to go to great lengths to avoid it. But to many, blurred motion in an image was a welcome occurrence, visually interesting and ripe with meaningful potential. And as media sensitivity increased, the degree of freezing to blurring motion could be controlled, and photographers could better use shutter speeds as an aesthetic and communicative tool. As they did, they and visually literate viewers began to recognize how time's transcription onto photographic media affected visual character and meaning of the image. Like degree of focus, motion in a photograph can be recorded on a continuum of nearly innumerable points ranging from frozen to unrecognizable blur, among other things; and it's important for photographers to understand how their content's placement along that continuum creates specific, unique photographic meaning. To start, it takes some technical knowledge.

SHUTTER SPEEDS: A BRIEF TECHNICAL REVIEW

The following technical notes are only basic reminders about shutter speeds. If you're still new to photography or just want a refresher, go to Chapter 2. Reread the information about shutter speeds and exposure, and be sure to do the chapter exercises at the end.

The shutter speed controls the length of time that the medium receives exposure to light, or how long the aperture is open. When you activate the shutter release mechanism, a curtain within the camera opens, leaving nothing between the open

lens aperture and the medium (the sensor or film) so that light may enter to create the exposure. There are two basic types of shutter mechanisms, leaf and curtain.

The common whole-stop shutter speeds are:

1/2000, 1/1000, 1/500, 1/150, 1/125, 1/60, 1/30, 1/15, 1/8, 1/4, 1/2, 1", 2"

While going through this chapter, remember that *camera shake—creating a blurry picture from using too slow a shutter speed while handholding the camera*—is beyond your control with shutter speeds below the number of the lens focal length. Aside from using a tripod you can avoid it by using a shutter speed number that is at or higher than the focal length of the lens you're using (i.e., with a 200 mm lens, use a shutter speed of at least 1/250). Understanding shutter speeds and their relationship to the other factors we'll go over in this chapter lets you control the representation of time and motion in your images. Only practice and experimentation provide enough guidance to control this

☐ = Time

Faster shutter speeds let in less light
Faster shutter speeds = shorter time
Faster shutter speeds decrease exposure
Faster shutter speeds begin to freeze motion

Slower shutter speeds let in more light
Slower shutter speeds = longer time
Slower shutter speeds increase exposure
Slower shutter speeds begin to blur motion

element of photography to make it effective as a communicative tool. Review these principles in Chapter 2.

Students often question why they should learn these techniques when it's easy enough to create blur effects in Photoshop. My response is as usual—as photographers we use light to translate the world of motion through the camera and onto static media. You might decide to create freezing or blurring effects in the digital darkroom, but to do it with credence requires understanding how movement, suspended or drawn out against static light-sensitive media, actually looks. We live in an age where many viewers know how movement "should look" in a photograph, so this knowledge helps you create digital effects in which the movement is wholly believable (or incredible, whichever you're going for) by drawing on the viewer's suspension of disbelief.

AFFECTING VISUAL QUALITY AND PHOTOGRAPHIC MEANING WITH TIME

We use photography's technical attributes to communicate with viewers, and as one of those attributes time is no exception. Time is a constant in the realm of photography but is not so in terms of our relationship to it. For instance, imagine a father, just home from work, tired and preoccupied, who goes to the park with his young daughter to push her on a swing. They stay for 20 minutes. For the father it may feel like an eternity; but for the daughter the time has flown by. They both experience the same amount of time passing.

Some years later, the memory of that timeline has reversed—the daughter remembers that her father took her to the park to swing *for hours*; while the father, tired and preoccupied at the time, remembers it as only a few moments.

So it is with time, or rather, with our experience of it. Every moment is the present fleeting into past, and the future is just ahead. We simply cannot arrest time in order to contemplate it firsthand. But photography has the unique and outstanding ability to change that for us. *It captures a direct, objective perspective on time.* I call it objective because photographs are captured through the physics of light and time, and the image is of something that was actually there in front of the camera throughout the exact moments of exposure. *But for photographers, that objective translation of time onto photographic media creates opportunities for highly subjective expression.* By understanding the physical laws governing time's translation onto static photographic media, we can orchestrate it into different configurations that reflect our own perception of it. So when we capture a photograph, it not only reveals another way of perceiving time (an objective photographic way), but it enables us to *express* our own perception of how time relates to our given subject. All it takes is technical knowledge, and applying that knowledge to communicate photographically.

Movement recorded in a photograph is dictated by three factors: the shutter speed (duration of the exposure), the static nature of the medium (the flat, stationary, light-sensitive

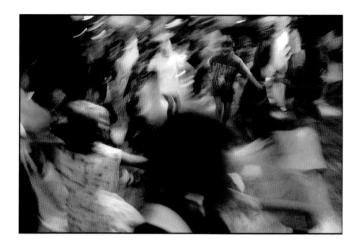

PHOTOGRAPH © JILL P. MOTT, *BIRTHDAY PARTY*.

Motion and energy. Knowing where to place movement along the freeze-blur continuum helps you to define the energy of a subject or scene. Here, slight blur transfers the excitement of dancing children to viewers.

material inside the camera), and the movement in front of the camera or of the camera itself (affected by speed, direction, distance, and magnification/focal length). Photographers use shutter speeds to communicate by controlling the interrelationship among the three factors.

Explained by photographer Steven Shore, "while photographic media is static, the world flows in time." Movement captured onto static media for a particular duration of time—30 seconds, or 3 hours, or 1/250 of a second, or 1/8000 of a second (what theorist John Szarkowski calls "a discrete

parcel of time")—creates a range of meanings completely different from those derived by watching the event unfold. These meanings are communicated in part through framing because the photographer determines the specific contents of motion to be recorded in the image (remembering that viewers see and interpret only the motion within the frame's borders), as well as how the motion itself is registered.

Just as shutter speeds create a broad range of visual effects from freezing to blurring motion, the range of meanings created by those shutter speeds is so great that at polar ends they might have the connotative effect of contradicting one another (depending on the subject matter). While freezing motion in the creation of a sharp, crisp image carries with it connotations of truth, accuracy, and clarity (rightly or not), blurring motion necessarily calls into question the relationship between clarity and truth and forces the viewer to confront the indistinct nature of the blurred content as well as its place in time and space.

A photograph that freezes a moment creates concrete juxtapositions among clearly seen subject matter, allowing viewers to contemplate the moment in time as they imagine it took place. The clarity of frozen time often offers viewers the borrowed confidence of one who sees a thing firsthand, a great service to credence for photojournalists and documentary photographers. It also allows us to carry that moment through time, to view it again and again, and to share with others that same moment of which none of us were a part. Conversely,

a photograph containing blurred motion allows a viewer to contemplate a less usual reality, one that is unique because our sense of vision doesn't transfer blurred motion to the brain. In so doing blurred images offer the possibility of understanding truth of a different order than a frozen moment can reveal. Using slow shutter speeds in relation to particular subject matter can reveal a transitional state of being; it can literally record passing time as it relates to a process, a "discrete parcel of time" on earth, and the very traces left by its movement through time and space. Imagine you are making photographs whose subject is "time" and you decide to use a Newton's Cradle as your primary content. The object itself indicates energy displacement, and that displacement is evidenced through time (which is what your image is about). You could simply make a photograph of the Newton's Cradle, with everything in the frame crisply frozen. Or you could place the camera on

a tripod, set the object into motion, and using a slow shutter speed capture the device and its surroundings in a static state while blurring the rhythmically clicking ball bearings such that viewers can see the motion extruded into the image. This type of comparison can be applied to a vast range of subjects and makes a significant difference in both the appearance and meaning of your images.

Time's continuum. Sir Isaac Newton's cradle demonstrates the conservation of momentum and energy through a simple temporal device. When the cradle is at rest, time seems to be standing still; when its motion is arrested onto photographic media, time seems to be frozen (as in the chaos of the balls in the process of tangling); and when the cradle's motion is blurred across the media, there is a sense of tracing time.

Static time: ISO 100, *f*/5.6 @ 1/3 sec. Frozen time: ISO 1600, *f*/1.8, @ 1/1250 sec. Blurred time: ISO 100, *f*/2.8 @ 1/15 sec.

THE DECISIVE MOMENT: THREE INTERSECTING FACTORS

As we stated earlier, time is translated onto photographic media resulting from three interacting factors. But what a random result they make without the intervention of the most important factor of all—the photographer's attention to where they intersect. As photographers, armed with the knowledge that we're exposing static media to time, we can choose when and how long to release the shutter so we can create meaningful images.

One of the most significant aspects of the intersection of shutter speed, static media, and motion is how we frame it. Photographer Henri Cartier-Bresson dubbed our ability to extract meaning by framing a precise moment in time "the decisive moment." He embraced a way of making photographs in which the photographer mentally recognizes and captures a moment in time when the frame's visual elements take on enriched psychological meanings. He believed photography's strength to be "the simultaneous recognition, in a fraction of a second, of the significance of an event as well as of a precise organization of forms which give the event its proper expression."

To this day, this "decisive moment" is the very thing that draws many people into photographic practice. It epitomizes the significance of image making for countless photographers from commercial to fine art to documentary work.

PHOTOGRAPH © NICOLE KULINSKI, UNTITLED, 2006.

Decisive moments in time. This photograph was made in the San Luis Valley with a 300 mm lens using *f*/8 at 1/500 second shutter speed. It represents a perfect moment of tenderness between a mother horse and her foal that existed only in the fraction of a second that the image was made. The shutter speed Kulinski used was fast enough to freeze the movement of the subject and prevent camera shake from the telephoto lens. But beyond that, her attention to the scene unfolding allowed her to capture this specific moment—not the ones preceding it or after it—but the very moment of connection that makes the image meaningful.

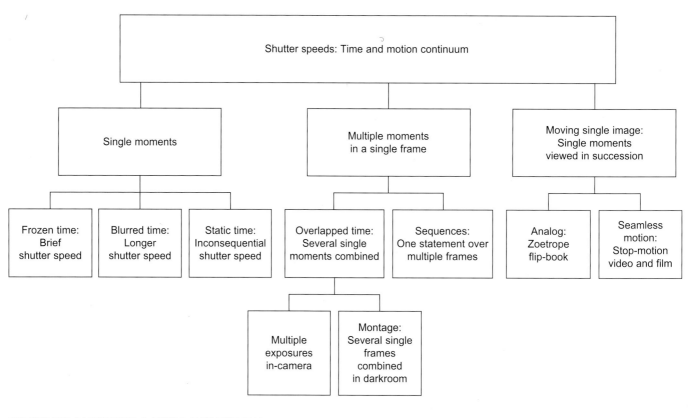

CONCEPT AND ILLUSTRATION © ANGELA FARIS BELT, 2010.

TRANSCRIBING TIME ONTO A PHOTOGRAPH

The three factors that control time in a photograph (shutter speed, static media, and movement) can be combined in several ways to create meaning. There are innumerable degrees between arresting and extruding time, and some images can contain both simultaneously; however, all photographic images delineate time in either single or multiple exposures. In this section of the chapter, we'll discuss these two manifestations of time and motion in photographs, and in the second section, we'll touch on bringing these manifestations back into the world of time.

The "Shutter Speeds Time and Motion Continuum" flowchart outlines broad categories for the delineation of time in a photograph. *Single moments include three types of time: frozen, blurred, and static.* All three are created by single captures (one release of the shutter, no matter how long or short) per single frame and offer a wide range of communicative possibility. Many photographers never move beyond these means of single-moment capture because they offer such rich potential in themselves. The second kind of capturing of time I call *multiple moments—a means through which we can overlap exposures onto a single frame*

or sequence them to make a single statement. These images require a bit more technical know-how, but can expand your visual vocabulary, allowing you to communicate about your subject in ways you might not have considered. Beyond these two means of framing time, we can string together discrete frames in order to make *moving single images—images in which single frames create the illusion of motion when the viewer looks at them sequentially through time.* This method of delineating time moves a bit beyond the scope of this text but holds potential for anyone wanting to explore analog or video means of creating moving images.

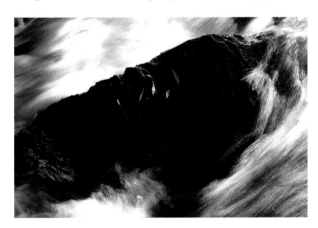

Blurring time: ISO 100, *f*/22 @ 1/2 sec.

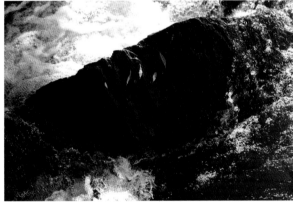

Freezing time: ISO 1600, *f*/4 @ 1/1000 sec.

It's a continuum. These two images were captured using a tripod with the most extreme exposure range the camera afforded to blur and freeze the movement of the rushing water. Notice that the when the ISO changed, the shutter speed and aperture also had to change to maintain equivalent exposures. The blurred image began with 100 ISO and the smallest aperture, and to freeze the ISO changed to 1600 with the largest aperture. These decisions were made to maximize the desired effect. But the visual relationship between the moving water and the still rock with leaves (as opposed to the frozen water image) is dramatically different and therefore has very different connotative meanings. When the water's movement is juxtaposed with the leaves, their stillness stands out, whereas in the frozen moment everything exists on equal temporal ground and as such the leaves don't hold attention to the same degree. We'll expand on these images later in this chapter when we discuss ways of controlling blur that lie beyond the camera's exposure capabilities.

Frozen Time

The first kind of single-moment capture in a photograph freezes time. When time is frozen in a photograph, two things are at play: movement is occurring (in front of the camera, the camera itself, or both) and that movement is arrested. Here, a "discrete parcel" of fluid time is stopped because the exposure was of a brief enough duration to do so. Frozen time often brings to mind midair fast-action sports photography, but this is not usually the case. In fact, to some degree or another the majority of photographs capture frozen time, because cameras are most often handheld and their own motion during exposure must be arrested. A frozen image shows us the world of motion not visible to our eye, allowing us to pause and consider its contents and what they might mean.

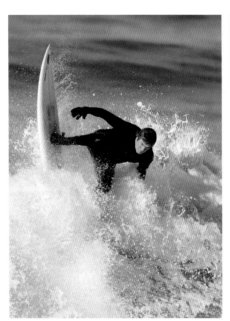 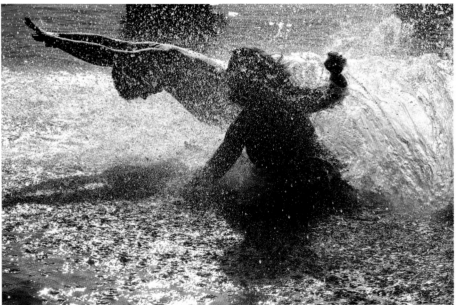

PHOTOGRAPHS © JILL P. MOTT.

Freezing for sport. These two images show how fast action can really be frozen in time. A necessity of sports photographers and photojournalists, freezing time is a skill that takes knowledge of several factors affecting time against static media. In these images all five factors are controlled such that even the rushing water creates solid forms within the picture plane.

Frozen time is used in any photograph where the significance of the image relies on a moving subject suspended in time, as well as in specialty areas such as scientific photography. For whatever reason you want to freeze motion, there are several technical factors to consider, and only practice will enable you to know how to achieve your desired result. Understanding these factors prevents you from capturing an image "that would have been great" if only the motion was completely frozen. *Five factors determine the degree of frozen time in a photograph: shutter speed, speed of motion, direction of motion, camera-to-subject distance, and focal length or magnification.* Here's how they work:

1. *Shutter speed.* All other factors being equal, the faster the shutter speed, the more frozen the motion will be. *Remember that shutter speed freezes camera shake as well.*

2. *Speed of motion.* All other factors being equal, the faster the subject or camera is moving, the faster the shutter speed must be in order to freeze the movement.

3. *Direction of motion.* All other factors being equal, the more parallel to the lens axis the motion, the more frozen it will be. So a subject moving toward or away from the camera will be rendered frozen at a slower shutter speed than a subject moving across (perpendicular to) the camera's field of vision.

4. *Distance from subject.* All other factors being equal, the greater the camera-to-subject distance, the more frozen the motion will be. The closer the subject, the faster the shutter speed needs to be to freeze it.

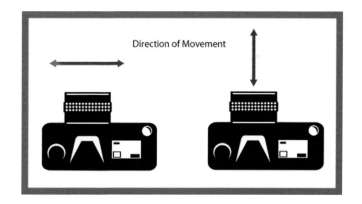

ILLUSTRATION © SHAWN MARIE CURTIS, 2007.

If movement is perpendicular to the lens axis (across your field of view) a faster shutter speed is needed to freeze it. If movement is parallel to the lens axis (toward or away from the camera) a slower shutter speed can freeze it.

5. *Focal length/magnification.* All other factors being equal, the shorter the focal length of the lens, the more frozen the motion will be; shorter focal lengths (wider-angle lenses) provide less magnification. Conversely, telephoto, micro, extension tubes, and close-up lenses need a faster shutter speed to freeze motion because they magnify the subject. (This aspect of freezing motion is covered in Chapter 4.)

Here is a little something you should know about flash/strobe: As we said, most of the images in the world depict frozen time, but getting extremely fast motion to actually be frozen

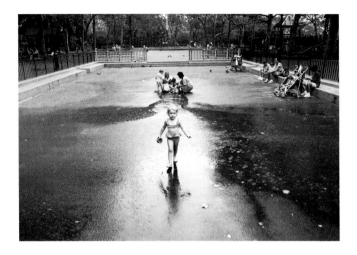

PHOTOGRAPH © DAVID BECKERMAN, *GIRL WITH PAIL*, NEW YORK, 2003.

Frozen in space. Action doesn't have to be moving fast to create a powerful frozen moment. Freezing time also has to do with knowing when to freeze it, and choosing the right vantage point to do so. This photograph captures a young child in midstride, freezing her motion (and the motion of others around her) in such a way as to draw connotative meaning between her outstretched arms and the light that seems to emanate from her amid surrounding darkness. The 21 mm wide-angle lens adds to the feeling of space engulfing the girl because of the size-space relationship exaggeration and edge distortion.

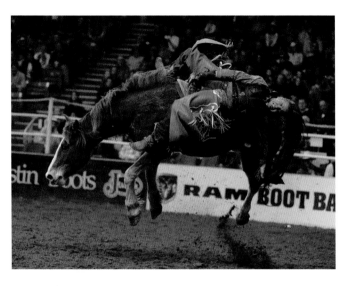

PHOTOGRAPH © JILL P. MOTT.

Fast action freeze. This photograph demonstrates the power of frozen time. The image was shot with a 120 mm lens, 3200 ISO, *f*/2.8 at 1/500 of a second. The distance from the subject helps maximize depth of field even with the large aperture, and the high ISO gives a shutter speed fast enough to freeze the fast action. A blurred image wouldn't allow us to connect with the emotional intensity of the scene—the rider's expression, the bronco's four legs off the ground, the perilous moment before the rider's fall.

in a photograph can be tricky. Many of the studio photography images you see (wine being poured, a berry splashing into a glass of some fizzy liquid with even the fizz stopped, dancers doing somersaults in midair) as well as other images of very fast-moving subjects (a hummingbird's wings frozen in midflight, a racecar speeding past) can only be accomplished through the use of flash or strobe. That's because the speed of the motion can only be frozen relative to the shutter speed you use. For example, a hummingbird's wings flap at an average rate of 40 to 60 times per second; I don't know of

a shutter speed fast enough to capture that in the presence of ambient light. But a flash is very intense light; it can be made to overpower the amount of ambient light in a scene and can illuminate the subject in one quick burst averaging 1/2000 of a second. Many cameras shutter speeds go higher than this, but it's the ambient light that allows blur, so if you remove it from the equation, the flash is better able to freeze. Several strobe units easily accomplish 1/20,000 of a second bursts, making them capable of freezing extremely fast motion. Because this book is about photographic language created through the use of the camera's technical attributes, the use of flash and strobe is beyond its scope, but research on artificial lighting can only enrich your practice and expand your elements of photography capabilities.

Blurred Time

The second, and perhaps the most intriguing, way of transcribing time in a single capture is blurred time, where the movement in front of the camera or the movement of the camera itself is traced, drawn out across the picture plane. Blurred time opposes frozen time on a continuum; the farther away from frozen time you move any of the factors controlling it, the more blurred the image becomes. There are nearly unlimited ways to delineate blurred time in a photograph; practice and experimentation help you predict and control the effects of time and motion on static photographic media.

There are two particularly useful tools for helping you blur motion—*tripods* and *neutral density filters*. (And in the

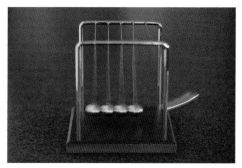

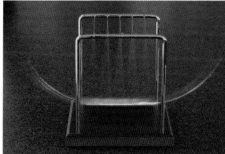

ISO 100, *f*/2.8 @ 1/15 sec. ISO 100, *f*/22 @ 6 sec.

How blurred can you go? An interesting outcome of extreme blur is that if the camera is stationary too long and the blurred motion moves across the picture plane too quickly, the moving objects are "absorbed" into the surrounding contents and can disappear without leaving a trace.

previous chapter we discussed the "mirror-up" function available in many SLR cameras.) When you want to use a long shutter speed to blur only the motion in front of the camera (not the camera itself), it's best to place the camera on a tripod. If it's practical for the shooting situation, using a cable release or self-timer is also helpful. These actions will result in an image that places the viewers in a stationary position, looking at time drawing out in front of them. Conversely, when you move the camera around a stationary subject, the image places the viewers "in motion."

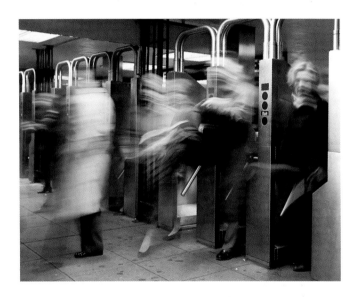

PHOTOGRAPH © DAVID BECKERMAN, *TURNSTILE*, NEW YORK, 1994.

Tracing human transit. Here, New York photographer David Beckerman placed his camera on a tripod and used a slow shutter speed (1 second) in order to capture with clarity the environment of the subway turnstiles and simultaneously blur the motion of the fast-moving commuters moving through them. Only one face is somewhat distinguishable, and our attention is drawn to her. Notice also that feet and legs that were "planted" throughout the duration of the exposure are clearly seen.

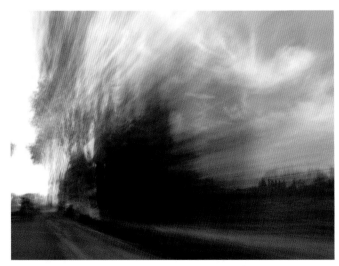

PHOTOGRAPH © JOHN DANEHY, FROM HIS SERIES *FRANCE IN PASSING (TREES, LIGHT, SKY)*, 2007.

Behind the curtain. In this scene of rural France, a slow exposure time combined with the motion of the car determine the degree of blur. Notice that at the same rate of speed, the foreground contents are considerably more blurred than those in the background. Notice, too, that the closer and more blurred the foreground trees are, the more "transparent" they become.

NEUTRAL DENSITY FILTERS

There are times when you want to blur motion beyond the capabilities of your camera's exposure settings. For instance, you want to blur a waterfall to make it look extremely silky. You set your digital camera to the slowest ISO or buy slow ISO film, and you set your aperture to the smallest setting your lens offers so that you automatically get the slowest shutter speed you can while maintaining good exposure. But if the lighting conditions are very bright, you still might not have a shutter speed sufficiently slow to blur motion to the extent you want. This is where neutral density filters come in; they help by effectively extending your shutter speed range.

Neutral density filters are designed to absorb light before it hits the medium. They are sold in increments that absorb varying amounts of light according to the stop-factor chart (covered in Chapter 2). An ND 2 filter absorbs one stop of light; an ND 4 filter absorbs two stops of light; an ND 8 absorbs three stops, and so on. Neutral density filters can be

Singh-Ray Double Ring Vari-ND Duo Filter with polarizing capabilities.

Singh-Ray Variable Neutral Density Filter, 2 to 10 stops.

stacked one on top of the other, but the maximum number of filters you should use at any time is three to avoid a loss of image quality (more layers of glass for the light to transmit through) and edge vignetting.

These unique neutral density filters made by Singh-Ray, are a new kind of neutral density filter. They're called the Vari-ND and they allow you to "dial in" the exact amount of neutral density you want between two and eight stops (that's 256 times light absorption!). The advantage is that you only need one filter for a truly remarkable range of control. The company also has a polarizing neutral density filter called the Vari-ND Duo with two independently adjustable rings that control polarization to minimize reflections, and neutral density between 2{2/3} and 8 stops.

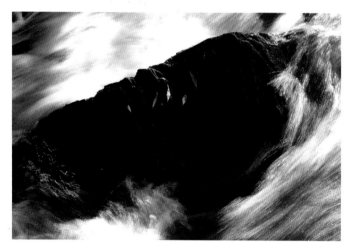 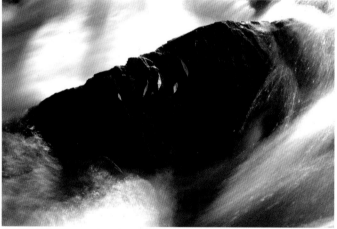

Blurred: ISO 100, *f/22* @ 1/2 sec.

Blurred more: ISO 100, *f/22* @ 2 sec. with an ND 4 filter.

Neutral density slows shutter speeds. The image on the left was captured using a tripod with the slowest ISO and smallest aperture available on the camera to allow for maximum blurring of the water. But the blur was not quite dramatic enough, so the addition of an ND 4 filter, which absorbed two stops of light, allowed for an even slower shutter speed and increased motion beyond the camera's exposure capabilities. The more neutral density you add, the slower the shutter speed and the smoother the movement becomes.

Image Discussion 17: Spirit Photographs

In the 1860s, William H. Mumler (1832–1884) used double exposures and people moving through photographs while the primary subject sat still in a practice dubbed "spirit photography." But what originated from a hoax now adds a significant level of meaning for artists who reference spirit, ephemerality, or many other subjects that are not nouns (see "Selecting a Subject" in Chapter 1). That's just what fine art photographer Susan Lirakis does in her series *Finding Voice*. She gives her images a historic feeling owing to her choice of timeless content and her technical approach referencing the medium's history and our collective memory. The subject's direct gaze, expression, and attire are as technically practical as they are meaningful—the white clothing allows her subject to stand out against the black background (with multiple or long exposures dark clothing would be entirely lost, tracing only a face). This image might look like multiple exposures (covered in the next section) because of the more distinct figures, but in reality, the portrait is made with a long shutter speed during which time the subject moves, then stays still, then moves, then stays still. Her image is recorded more clearly and intensely onto the medium when she is still; when she moves she is blurred.

The artist's control over the technical element of shutter speeds and time allows her to translate meaning through photographic

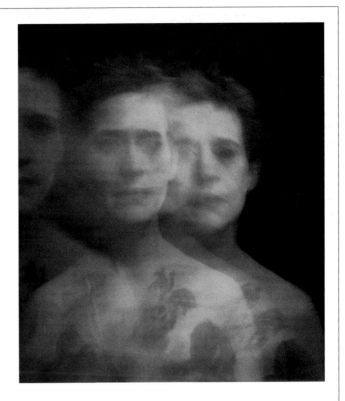

SUSAN LIRAKIS, *COVENANT*, FROM HER SERIES *FINDING VOICE*.

language. Remember that meaning is still interpretive much of the time, but *articulate* use of photographic language allows you to lead your viewer down a more specific path.

Neutral density filters are indispensable tools for photographers who want control over the degree of motion in their images, and a high-quality glass screw-mount filter will provide that control.

PAINTING WITH LIGHT

A uniquely beautiful way to use blurred time is called *painting with light—moving the light source (rather than the content or camera) throughout a long exposure time.* In addition to a long exposure it requires a darkened environment, allowing you to literally "paint in" areas of the scene using a flashlight or any small, controllable light source. The effect somewhat softens the overall image by creating a soft, diffuse, and often colorcast glow around painted areas. Because you control the direction and intensity of the light source, you can decide which aspects of the image content to illuminate and to what degree. The image content emerges from a fluid rather than single, fixed light source.

Photographers who paint with light often use colored filters or "gels" (larger, flexible colored filters) over the light source to control the color of light in particular areas of the scene,

PHOTOGRAPHS © ANNA ZOROMSKI, *BONE-YARD* SERIES, PHOENIX MINE, IDAHO SPRINGS, COLORADO, 2007.

Only the light moves. In these images, editorial photographer Anna Zoromski "paints with light" to add a sense of dark mystery and weight to her images of this automobile graveyard through shifting illumination. Arriving on location at dusk, she places her camera on a sturdy tripod and makes her long exposures using two flashlights, which she directs through the scene. Her exposure setting is ISO 100 at *f/22* to allow a 30-second long shutter speed.

as well as diffusion filters over the lens during the exposure. Remember, images made by painting with light aren't blurred in the traditional sense—neither the camera nor the content is moving—but the effect relies on blurred time and can add a sense of mystery to your images.

PANNING

Another means of registering blurred time in a photograph is commonly known as *panning—using a long shutter speed while tracking with the motion in front of the camera*. The technique is often used by sports photographers; it's relatively difficult to master but lends itself to a unique combination of motion against frozen elements within the frame. In order to pan, you use a longish shutter speed (say, 1/8 to 1/2 of a second), handhold the camera, and literally move the camera the direction and speed of the subject's motion across your field of vision. If you can keep the moving subject in the same place in the frame throughout the exposure, then a successful pan is created, rendering the moving subject frozen and all other content blurred because of the motion of the camera. The key is to move the camera *at the same rate of speed* as the subject's motion; to accomplish this I recommend that you keep both eyes open before, during, and after the exposure; track the motion with your body for a few seconds before depressing the shutter; and continue tracking at the same pace until the shutter closes again. Keep in mind that the subject has to be moving *across your field of vision* (perpendicular to the lens) either horizontally or vertically; movement at an angle to the media plane will nearly always be blurred.

Panning creates a tremendous sense of motion depending on how blurred the background is. Because the background motion interacts with the frozen subject, the more blurred it is, the faster the subject is perceived to be moving. Panning technique takes a long time to perfect but is an alternative worth exploring.

PHOTOGRAPH © KATHY LIPPERT, 2007.

Fast-action panning. Western lifestyle and outdoor recreation photographer Kathy Lippert made this image during the National Western Stock Show and Rodeo in Denver, Colorado. Lippert trained her camera on the horse and rider, tracked their motion as they grew closer, and followed them throughout the exposure. The subject is not tack sharp because they were not moving exactly perpendicular to the lens, but the technique still yielded a visually successful result. Panning captured not only the power and speed of barrel racing but also the simultaneous fluidity of the horse and rider's motion.

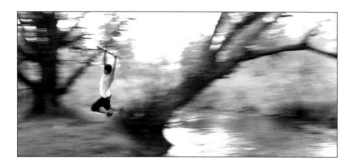

PHOTOGRAPH © JILL P. MOTT.

Panning even moderate-speed action. Like freezing and blurring, panning isn't only good for very fast moving subjects. You can increase the illusion of speed by panning slow-moving subjects, as long as you have the exposure capabilities to do it. In this image the boy wasn't swinging very quickly, but the pan tracking him for 1/15 of a second makes it feels as though he is.

Static Time

The final method of translating time in a single capture might be confused with frozen time, but there are distinct characteristics. I call this type of time in a photograph *static—a form of stasis in which neither the camera nor the subject moves for the duration of the exposure.* With static time, the length of the exposure onto the already static photographic medium becomes nearly irrelevant. I say "nearly" because in mixed lighting conditions ambient light sources affect the look of the image by "burning in" (increasing exposure) to a greater or lesser extent. Still, the uniform stillness of the camera and subject give the image a quality unique among the other aspects of time.

In the world of temporally static photographs, time literally stands still. Static time is really a case of frozen time taken to the extreme, as eventually everything in the universe moves or changes. But in a photograph, static time appears quite different from frozen time in that *the contents of the image seem at rest, as opposed to seeming arrested in time as they move;* as such, these images hold different connotative meanings in relation to their subject.

PHOTO © DAVID BECKERMAN, *BETHESDA PASSAGE,* **CENTRAL PARK, 1994.**

Static time has an architectural stability. This image captures the true nature of static time; there is nothing moving in the scene, and the camera itself is still, so the scene carries with it a feeling of solitude, calm, and quiet. The lights at the top draw viewers diagonally into the picture plane where we find only the intense light illuminating the interior space. The image was made with a 4 × 5 view camera on a tripod with a normal focal length lens (150 mm), a small aperture, and 1/2 second shutter speed.

An indispensable tool for creating images of static time is the simple tripod. With it, images can be made to have maximum depth of field and still be static, because the smaller the aperture gets, the longer the shutter speed needs to be, and the more often blur occurs. If the subject is still (a still life, an interior/architectural space, or anything else that isn't moving or changing) and the camera is on a tripod, then the length of time the exposure takes is completely inconsequential; so with respect to motion, a slow shutter speed can be used to the same visual effect as a fast one.

AMBIENT LIGHT BUILDUP

As previously stated, a subject can be captured in static time using a long shutter speed, if nothing in the image moves. However, one major factor in relation to long shutter speeds and static time is the buildup of ambient light that occurs in the scene. For example, in architectural photography it's desirable most of the time to produce sharp, clear images of a place using a small aperture for maximum depth of field. When doing so, a sturdy tripod is essential, as is the ability to meter the difference between flash and the various ambient

PHOTOGRAPHS © PAUL WEINRAUCH, 2006.

Ambient light building throughout static time. Even if neither the camera nor the content moves during a static time exposure, if there is ambient light in the scene it will build over time. It's the same principle behind painting with light—the longer the light is allowed to expose the medium, the more intense it will get. In this example, architectural photographer Paul Weinrauch produces static time images that use the color and buildup of ambient light. Using a slow shutter speed, he is able to build upon dusk or dawn light, juxtaposing it with interior lighting, to produce a beautiful visual effect in conjunction with the Victorian architecture that he loves. The slight movement of clouds is the only subtle evidence of blurred time here, underscoring that more than one aspect of time can be captured in a single photograph.

light sources in the scene. When using flash or strobe in combination with ambient light sources, it's also necessary to understand "light balancing" techniques (which are beyond the scope of this book; research lighting resources for additional information) to adjust your flash output in relation to the ambient light to produce your desired results.

Because the speed of light is constant, time and motion, arrested or traced over static media, are somehow predictably written into light-sensitive photographs. Through the confluence of time, motion, and the duration of the exposure, we translate image content into a fixed position on a continuum from frozen to blurred. In translating time and motion onto a two-dimensional plane, new meanings about a photograph's subject are created; conceptual ties bind the content to the way it was recorded in time, one of the medium's most valuable gifts.

As photographic processes continue to evolve, the ways in which time is delineated in images will also evolve. The potential for heightened understanding of any subject that can be rendered through the action of light in a photograph is extensive, and by uniting the photographic process with other time-related processes that potential is exponentially increased. From cinema's evolving time to image projection, film stills, scanner-as-camera, and animation through photographic sequencing, the medium is rich with possibility. But to capitalize on that possibility, practitioners need to understand how the medium's grammar operates with respect to the physical laws of time and light, and how our static

medium relates to a moving world. By exploring your subject through a range of temporal approaches, you expand your own knowledge of photographic practice, your subject, and how the camera translates time into photographic language.

CHAPTER EXERCISES, PART 1: USING SHUTTER SPEEDS WITH YOUR SUBJECT

In these exercises, you want to consider in what ways time and motion relate to your chosen subject or concept. How might freezing, blurring, panning, or a combination of these techniques help a viewer to understand your subject and your point of view about it? These exercises are designed to help you explore your subject and practice your effective use of shutter speeds in relation to the world of motion.

1. **Blurring Time and Motion from the Camera's Perspective**

 This exercise is intended to familiarize you with how your own movement or the movement of the camera itself can be used for communicative effect. In other words, you are locating the movement as emanating from your own perspective, and therefore the perspective of the viewer. Approach your subject using a range of slow shutter speeds, and, while moving around your subject or through the content of your images, make photographs. Don't worry about the results yet; just make photographs.

 In the editing process really look at the resulting images on your contact sheets; this is where you'll discover the unique possibilities that moving the camera in relation to

the subject can create. Being open to the images you did capture in addition to the one you tried to capture is where real discovery happens. How do your own movement and the movement of the camera during the exposure create images and meanings that differ from those images in which the camera is stationary and the subject is moving?

2. Freezing Time

The use of frozen time can lend a great deal of insight about a given subject, in that it gives the viewer the opportunity to pause over an event that has been sliced from and held in time. In this exercise, you should consider your subject in relation to Henri Cartier-Bresson's "decisive moment." Use a sufficiently fast shutter speed to freeze the motion of your camera if it is handheld and to freeze any activity in the frame's content, or you might choose to freeze motion using a flash or strobe in a darkened interior, as the duration of many strobe units is faster than the shortest shutter speed on most cameras. Be aware of the juxtaposition of stationary contents within the frame and how they interact with frozen contents.

How does a frozen moment relate to your subject, or how could some secondary contents frozen in midmovement relate to your subject? Consider the natural moving aspects of the content surrounding your subject or the meanings that might be conveyed about the movement of your subject itself. Also consider putting your subject into motion, interacting with it in such a way as to animate it for your viewers.

3. Personal Direction

Experiment with your own ideas about how to communicate about your chosen subject, genre, or concept as it relates to time and motion. You might choose to use a flash (to freeze motion) coupled with long exposure (to add faint blur) or rear-curtain flash coupled with long exposure. The idea is to use your knowledge about the nature of time and motion as it relates to your particular subject. Create a sequence (covered in the next section) of motion or produce a gestalt image that varies motion within the image. Be inventive, be creative, and think conceptually!

PORTFOLIO PAGES

The photographers represented in this chapter's Portfolio Pages use a wide range of techniques in which the shutter speed and the world of motion are intertwined to produce images with specific meaning and unique visual character. As opposed to being images *about* time, their various concepts are expressed through the use of *the camera's ability to capture time.*

Like all of the Portfolio Pages in this text, these images are intended not as exhaustive examples of this element's possibilities but as a source of inspiration from artist-photographers who have successfully employed it in the service of making images that more accurately communicate their meanings. Enjoy the images, read and understand the statements about them, and keep looking for more unique ways to render time in a single frame.

ADAM JAHIEL

THE LAST COWBOY

ELEMENTS

Documentary photographers have to be quick to respond in rapidly changing situations, and the daily work of cowboys and herds is no exception. Through frozen time, Adam Jahiel describes the details, texture, light, and atmosphere that epitomize cowboy life. Using a medium-format rangefinder camera, he is able to shoot in very low light conditions with slower shutter speeds, because there is no mirror to vibrate the media as there is with an SLR format. Also, the camera allows him to observe the action and determine the decisive moment to release the shutter without his view being blocked by the mirror. He tells his story through peak moments that can never be repeated, and so carries perfect instances through time.

ARTIST STATEMENT

I like to look and I like to share what I see. But I like to do that sharing wordlessly. Over the years, some of my peers have accused me of being mostly interested in the "fringe" people. Maybe so.

But I like to think I am drawn to those who seem to exist outside of time in forgotten corners and cultures. They seem somehow more in touch with, or part of, the human condition.

The FSA photographers of the Depression have always been my role models. They documented people and life in a difficult period of our history, in an honest, straightforward, respectful, and intimate way, and they did so beautifully. And they preserved it forever.

I work in black and white because it allows me to boil elements down to their very essence—shape, lines, and light. Light can be indescribably beautiful and fascinating. I love to watch it completely transform something. The same scene can go from being unremarkable, to extraordinary, and back to unremarkable in a heartbeat. Even after all these years of working, the ability to freeze a moment in time and preserve it forever, although mostly science, to me is really more like magic.

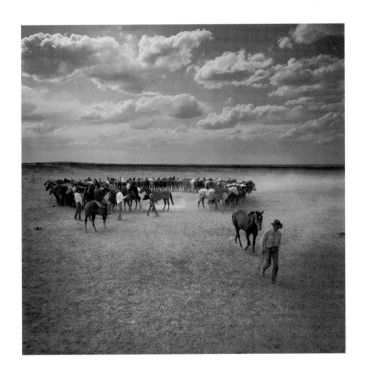

Part of his *String,* 1993, YP Ranch, Nevada.

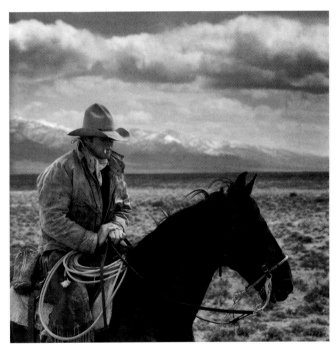

Fish Creek, 1990, Fish Creek Ranch, Nevada.

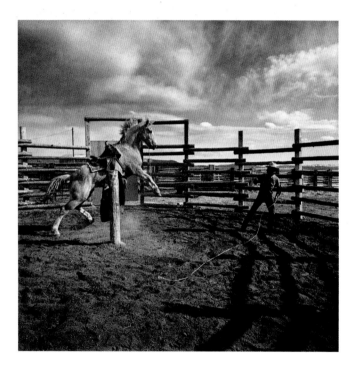

Rancho Grande, 1990, Nevada.

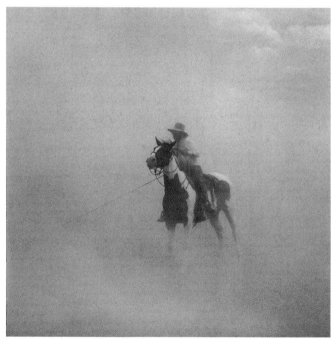

Dust Storm, 1993, YP Ranch, Nevada.

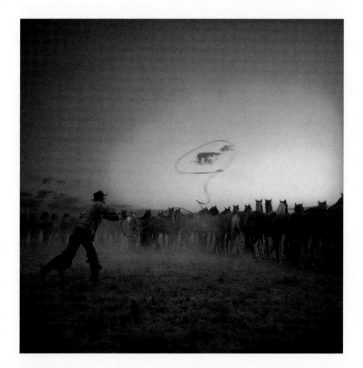

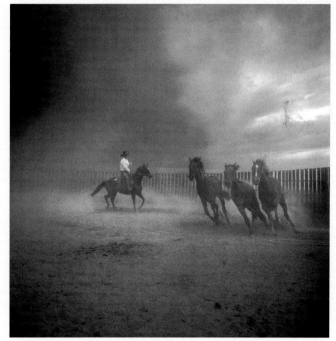

Roping a Cloud, 1994, Winters Camp, IL Ranch, Nevada.

Three Horses of the Apocalypse, 1994, Idaho.

ALEXANDRE ORION

METABIOTICS

ELEMENTS

What happens when a camera is placed in the hands of a graffiti artist? In the case of Alexandre Orion's photographs, the relationship between an intentional painting and a random event is frozen in time through the use of the Decisive Moment, allowing for continued contemplation of the moment's implications. Ranging from humorous to tragic to outright odd, the images set the stage for a juxtaposition that will carry with it the very meaning of the images.

ARTIST STATEMENT

Alexandre Orion grew up on some of the busiest streets in Brazil. As a child in São Paulo, he became accustomed to sidewalks thronged all day and the din of traffic at night. Orion was quick to respond to the street's appeal, and his first graffiti was done at the age of 14. While driven by adolescent instinct, the hard reality of the streets called for new ideals. Now he draws inspiration from multitudes, silence and thought, experiences and memories, happiness and suffering. Humanity lives in Orion: his time unique, his universe collective space.

Discovering photography in 2000 coincided with his interest in the image theories of Barthes, Dubois, and Aumont. A year later, his *Metabiotics* project involved finding a place in the city where he would paint the wall and with his camera at the ready, await the decisive moment when people interacted spontaneously with his paintings. Framing the precise situation promoted a joining of painting and real life, encouraging an encounter (or confrontation) between reality and fiction within the field of photography.

This decisive moment of interaction between people and painted image led to *Metabiotics*, opposing traditional photography's false idea that all that is photographic is real (in the documentary sense). *Metabiotics* questions truthfulness: the paintings were actually done in the walls, people really did pass by and act spontaneously, but what we see suggests a type of montage that did not exist. Everything is both true and false.

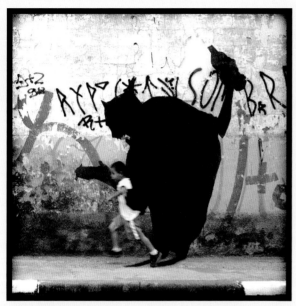

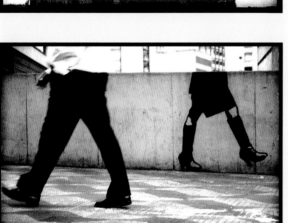

IMAGES © ALEXANDRE ORION; FROM HIS SERIES *METABIOTICS*.

ANDREW DAVIDHAZY

STRING THEORY IMAGES

ELEMENTS

Concept and technique merge in these images by Andrew Davidhazy. They result from the following process: when confronted with a concept, first thinking about its connotations, then researching those connotations, then using photographic language to communicate it. As discussed in Chapter 1, interdisciplinary research is key to making meaningful images about any subject. These images demonstrate the conceptual/intellectual side of making photographs, and that the technical attributes of the medium are invaluable in helping you to articulate your visual meanings.

STATEMENT OF CONCEPT AND PROCESS

Some time ago I received an email message from an editor who had been exploring my website and who thought I might have some photographs that could be applicable to an article about a theory that has the world of science abuzz—string theory. The truth was I had no photographs of strings in any shape or form but the inquiry started me previsualizing what these images might look like and how to make them.

The request was for an image that would show strings moving and vibrating in odd ways. This reminded me that when held taut, strings in musical instruments plucked in the middle produce sound waves. I also remembered that one could simply hold one end and make the other end move up and down; if done properly this would induce a wavelike motion on the string that under some conditions would be a "standing wave." So I built a setup to induce waves by attaching the string on one end to the edge of a rotating disk driven by a small electric motor whose speed could be varied. I then attached a small weight to the other, free end and let gravity pull the string down.

Contrary to convention, instead of making a sharp record of the string I purposefully chose an exposure time long enough for the string to make several rotations. This, now, revealed the rotating string not as a single line in space with a wave in it but rather as a "volume," something that seemed to have a three-dimensional quality. This was a bit more interesting than the plain string picture, but then something unexpected happened. While adjusting the voltage to the motor, it went so high as to cause the rotating string to assume a changing wave pattern, as the weighted-down string

PHOTOGRAPHS © ANDREW DAVIDHAZY, *STRING THEORY*.

could not keep up with the speed of the disk powering it. The string pulled the weight upward, causing the string to perform rather erratic motions.

I continued photographing and when these images were displayed on the camera's LCD screen it became clear that as far as an interpretation of a vibrating string that might accompany an article about the string theory, these photographs seemed to hold much more promise than a simple image of a plain string with a wave pattern on it.

BETH EGGLESTON

TYPOLOGIES

ELEMENTS

Beth Eggleston is a studio and conceptual photographer (and she created the cover image for this edition of *The Elements of Photography*!). In this series, *Typologies*, her direct, uninflected approach intentionally speaks to the banal mass-produced and consumed items she studies. She underscores her approach by using parallel picture planes and adhering to static time. Her methods stage a contemplative space of typological image groups—multiple images that compare and contrast similar objects. The individual images feel like mug shots, their austere arrangement drawing attention to both ubiquity and individuality, reality and fakery, in an almost humorous way.

ARTIST STATEMENT

TP Typology

In a saturated market, the most banal products have the fewest opportunities for differentiation. Toilet paper brands fight for every bit of distinction they can, from special lotions to animal mascots. Someone out there gets paid to design toilet paper patterns. Charmin Ultra Strong is geometric and masculine; Ultra Soft is feminine butterflies. Cottonelle has a subtle boring pattern, but a fancy website with a downloadable puppy app.

It's easy to see some absurdity and to resent having to choose from too many almost-same options. But after you've made that choice, a grocery store that doesn't stock your brand might seem lacking.

Brand, price (cents/square foot)

1. 365, 2.04

2. Angel Soft, 1.56

3. Bright Green, 2.07

4. Charmin Ultra Soft, 3.97

5. Charmin Ultra Strong, 3.98

6. Cottonelle Ultra, 2.67

7. Kroger Value, 0.94

8. Quilted Northern Ultra Plush, 5.01

9. Scott, 1.08

10. Scott Extra Soft, 1.36

11. Seventh Generation, 2.82

12. Ultra Softly, 2.80

13. Up Premium, 1.88

14. Up Ultra Premium, 2.36

15. Value Red, 0.98

Blue

Blue roses don't exist. They are the Holy Grail of flower breeding. The quest to genetically engineer (and patent and trademark) a true-blue rose has so far only given a lukewarm lilac color.

But fake blue roses are everywhere. They're the blue raspberries of home décor, the fake that has no original. Individually, their frayed edges and cheesy plastic stems are forlorn, but oddly attractive.

The Closest Shave Yet

Disposable razor manufacturers are locked in an arms race. The battle for the most blades seems to have reached a truce … at five, so the war moves on to dueling handle ergonomics and lubricating strips. Men get "an improved blade suspension system." Women get "the indulgent powers of the pomegranate fruit."

Each new model is designed and mass-produced with the knowledge that it is disposable and will quickly become obsolete. But each, individually, is a marvel of shiny symmetry and compound curves.

PHOTOGRAPHS © BETH EGGLESTON; FROM HER *TYPOLOGIES* SERIES.

COLE THOMPSON

THE GHOSTS OF AUSCHWITZ AND BIRKENAU

ELEMENTS

These images made in former Nazi concentration camps speak of a specific genocide, but Cole Thompson's approach really speaks to the ghosts of all genocides. They were created using 10- to 30-second long exposures during daylight hours using a tripod and stacked Singh-Ray ND filters totaling 13 stops of light reduction. The challenge of making images reflective of the enormity of his subject was made all the more difficult by casually dressed tourists sporting cell phones moving all around, and that's where Thompson's understanding of photographic language came in. He solved two visual problems at once using shutter speeds and time. By adding neutral density, he was able to negate the rather irreverent scenes of tourism, changing them to scenes of ghosted figures haunting the history of these places.

ARTIST STATEMENT

What can be said about Auschwitz and Birkenau that hasn't already been said? What photographs can be made in these sacred places that haven't already been made?

As I thought about what had occurred there, I wondered how any human could do such inhumane things, and then I recalled "The Mysterious Stranger" by Mark Twain. In this story a young boy named Seppi is talking to Satan about a man who had brutally beaten his dog. Seppi declared that this man's actions were inhumane and Satan responded: "No, it wasn't Seppi; it was human—quite distinctly human." Satan points out that no other creature on the planet would treat another this way—except humans.

I had not intended to photograph during my tour of the camps, but after being there a few minutes, I felt compelled. With every step I wondered about the people whose feet had walked in exactly the same footsteps. I wondered if their spirits still lingered there today.

And so I photographed ghosts.

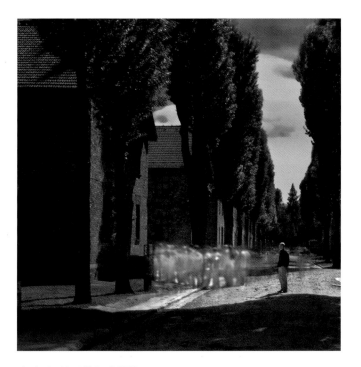

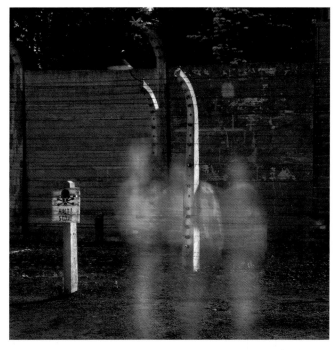

Auschwitz No. 4; Poland, 2008.

Auschwitz No. 9; Poland, 2008.

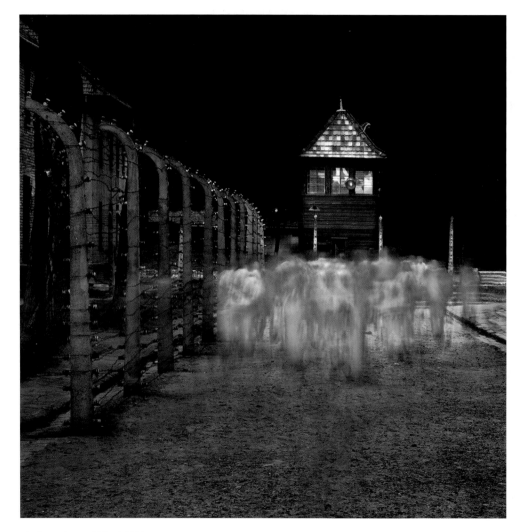

Auschwitz No. 14; Poland, 2008.

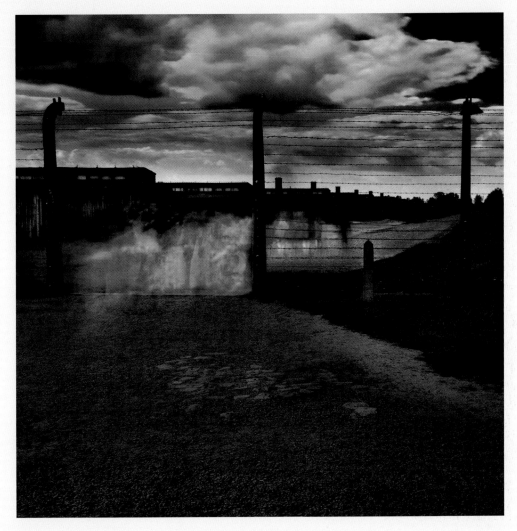

Birkenau No. 2; Poland, 2008.

PHOTOGRAPHS © COLE THOMPSON; FROM HIS SERIES *THE GHOSTS OF AUSCHWITZ AND BIRKENAU*; ARCHIVAL DIGITAL PRINTS, 12" × 12".

SUSAN LIRAKIS

FINDING VOICE

ELEMENTS

In this series, Susan Lirakis uses long shutter speeds and moving subjects to create images that are less about a specific person and more about something universal. That the person is burred across the picture plane indicates that she is not the primary subject of the image, but rather the transition she goes through.

ARTIST STATEMENT

Although we are ultimately connected, we must make choices about our own pathways, at the crossroads and on the thresholds. We do have comparable life experiences. We undergo similar stages of life, in childhood, adolescence, early adulthood, middle and old age. Common events bind us together; we are connected by the bonds of relationship and of experiences.

These experiences are frequently represented in the telling of myths and stories, the characters of which become examples for us collectively. I began making self-portraits in an attempt to explore voice and the manifestation of spirit. I have progressed to working with the broader vision of the process of becoming. I have been working with both literal and figurative imagery illustrative of these various life stages and personal quests.

We are all involved in our own process of becoming, yet our quests contain common archetypal elements. Myths are mirrors in which we see our own faces. They speak to us in symbol and paradox. These photographs show us on the threshold of our choices. During periods of passage from one life stage to another, we experience the tumult of making those decisions and the dilemma of choosing. The images illustrate feelings of times of passage, a time when we most frequently access our own soul.

Like myths, these images are filled with feeling and the language of dreaming. They confront the human conditions of our limitations, our process of becoming and transcendence, the sense of who we are in relation to others and our connection with one another and the universe. The images celebrate our wholeness, our value and

purpose. Whether or not we question or doubt the existence of greater realities, we tend to wish to see the numinous at work in our objective world. These images chronicle journeys and passages of the soul.

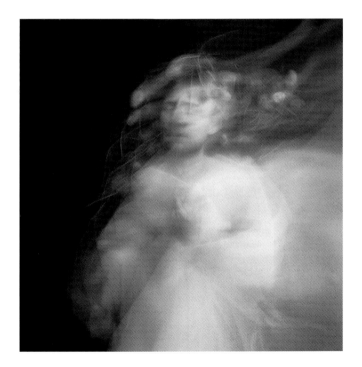

Personal Mythology.

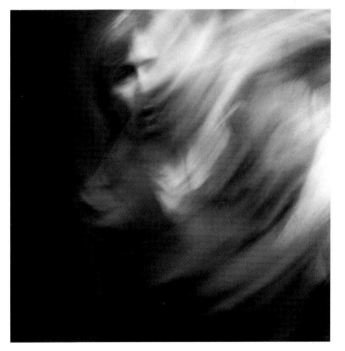

Threshold.

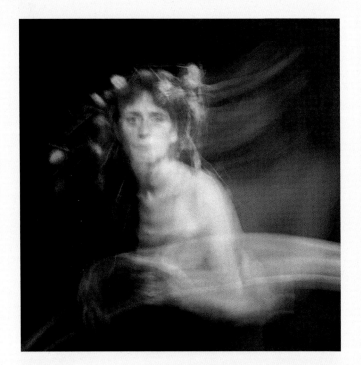

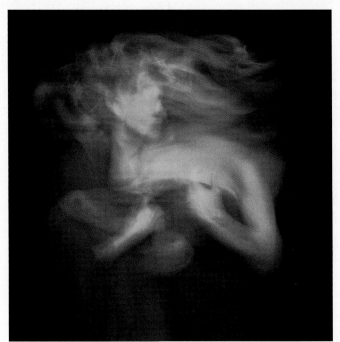

Pilgrim's Quest.

Tempest.

PHOTOGRAPHS © SUSAN LIRAKIS; FROM HER SERIES *FINDING VOICE*.

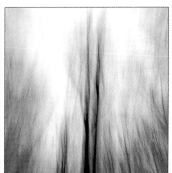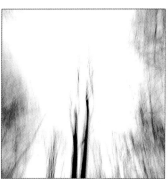

IMAGE © ANGELA FARIS BELT, *TREES FOR MY FATHER, DYING*, 1997–2009.

PART 2: MULTIPLE MOMENTS IN TIME

BECAUSE PHOTOGRAPHY IS TECHNICALLY … SUCH A PRECISE MEDIUM, ABERRANT EFFECTS, WHICH ONCE OCCURRED QUITE UNPREDICTABLY, CAN BE CONTROLLED AND SKILLFULLY EXPLOITED IN SERVICE OF GREATER EXPRESSION. —MARTIN FREEMAN

INTRODUCTION: COMBINING SHUTTER SPEEDS TO EXPAND MEANING

Combining multiple moments in a single frame can expand meaning and say things about your subject that a single exposure can't say. *This section adds to the three types of time in a photographic capture by combining them with the use of multiple frames.* In this section we'll cover the four basic ways that *multiple moments in time* combine to make a single image or communicate about a single subject. The first is *overlapped time,* which includes multiple exposures both in-camera and montage in the traditional or digital darkroom. The second is *sequences* (a single narrative or temporal statement viewed over several static images). I have also included the use of *scanner as camera* and finally *moving single images,* including

tactile images (such as flipbooks and zoetropes) and perceived seamless motion images (such as stop-motion/time-lapse and video). We'll only touch on the aspects of image making that go beyond the camera's grammar, but these things are an extension of photographic practice and so should be considered.

The frontispiece for this chapter section came from images I made just after my father died in 1997. I went to our woods and made blurred exposures of a particular favorite tree with my square format Hasselblad camera, and spent varying amounts of time shooting toward the ground and the sky. I shot an entire roll. When I looked at the contact prints, there were four that, when viewed in sequence, visually reflected the feeling of something tangible and heavy passing into weightless ethereal light. Any meaning derived from the images is made possible only through placing the single moments in (blurred) time into a temporal sequence. And that's where the power of *multiple moments* lies.

OVERLAPPED TIME: MULTIPLE MOMENTS IN A SINGLE FRAME

Because our medium is static, time can be overlapped onto it. Overlapping time consists of combining separate exposures of discrete instances in time layered onto one media plane. They are capable of creating complex visual interest and meaning, and show us another kind of image that cannot be seen with human vision. There are a number of ways to create multiple exposures; further, each separate exposure is itself created through time capture (frozen, blurred, or static), giving you the opportunity to combine the two attributes in countless ways. Awareness of these kinds of image making techniques opens many doors to communication about your particular subject, making overlapped time an important temporal tool in any photographer's toolbox. Overlapped time comes in two forms: in-camera multiple exposure and montage in the traditional or digital darkroom. But before you can make images using these techniques successfully, it's necessary to understand the basic principle of combining exposures to achieve proper density. The following Technical Discussion is primary, but it also might help to reread the Advanced Exposure section toward the end of chapter 2.

Multiple Exposures

The first variety of overlapped time is multiple exposures. These can be done in two ways: in-camera or in the darkroom (traditional or digital). There is another type of multiple exposure we'll cover as well—sequences—but they operate a bit differently in that although they are interdependent they do not exist the same media plane.

Technical Discussion 7: Using Stops and Factors to Overlap Time

One of the difficulties of getting good results with overlapping time in the camera (or in the traditional darkroom) is determining the correct exposure for each frame that will combine into the final image. Well, help is on the way! This simple *stop-factor chart indicates the reduction to each exposure depending on the total number of exposures that make up a single frame*, and it works in capture and in the darkroom.

Stops	0	1	2	3	4	5	6
Factor	1	2	4	8	16	32	64

Here's how the chart works: We know that for each *one stop* change, the medium receives *two times or half* the amount of exposure to light—that's an exposure factor of 2. Each additional one-stop change entails applying a simple multiplication factor, and the chart provides it for you. So, as a starting point, if you want to overlap two images onto a single frame, underexpose each image by one stop; to overlap four images underexpose each by two stops, and so on, making a final image close to a good overall density. Many cameras do the math for you if you program in the number of exposures you want to overlap, but knowing the math lets you control your results when your camera doesn't offer this capability. Memorizing the chart will help you to think on your feet while you shoot so you have confidence in the results you'll get.

The stop-factor chart is handy for more than just multiple exposures. It is the standard way to describe filter factor (how much light a filter absorbs); and in studio photography it determines the number of multiple flash or strobe "pops" that are needed to build up exposure when your lights lack the power to provide proper density to an extremely small aperture. Finally, it's used to describe ratios (the difference between the amounts of light in the highlight versus shadow areas of a scene).

Image Discussion 18: Multiple Exposures In-Camera

Doug Keyes's approach to and creation of multiple exposures reference Bernd and Hilla Becher's practice of creating typologies of industrial buildings and structures. The Bechers' work adopts the most objective view and matching vantage points throughout each thematically related series of images; Keyes's work also takes an austere vantage point, directly above the books, and does not alter that position throughout the series of overlapped exposures. The difference is that in a typology the frames are presented next to or in relation to one another, and in these images the frames are presented on top of one another.

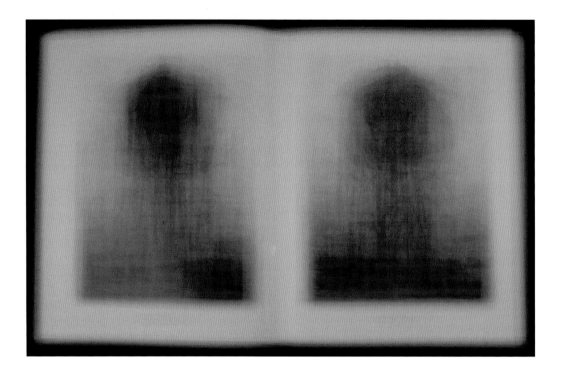

IMAGE © DOUG KEYES, *BECHER-WATER TOWERS*, 1997.

Although typologies and these multiple exposures use several images of similar content, the multiple exposures add another dimension—that of overlapped time, which alters the way we see, compare, and distinguish the individual images. We view them superimposed onto one another as a new kind of photographic image, one whose juxtapositions overlap to create a reality broader than one in front of the camera at any particular time. The images resulting from overlapped time are an interesting comment not only on the traditional notion of typology but also on our own ability to reference or carry in our minds one image to another over time. View more of Doug Keyes's work in the Portfolio Pages presented later in this chapter.

In-Camera Multiple Exposures

In-camera multiple exposures are the result of *exposing a single media frame to light more than once.* The exposures can be frozen, blurred, or static time, but they should all add up to proper exposure in the final image. This is achieved using the stop-factor chart discussed; remember that manual cameras force you to do this simple math yourself (not a problem once you memorize the whole-stop apertures and shutter speeds!), but more advanced electronic cameras allow you to program how many exposures you want to layer and the camera meters and adjusts for you.

In-camera multiple exposures carry with them compounded degrees of chance and serendipity, technical skill and decisive moments. As opposed to making multiple exposures in the darkroom, the images are not as predictable as you'd expect them to be, and that's part of the excitement and potential of making them.

Traditional Darkroom Multiple Exposures

Also called montage, traditional darkroom multiple exposures are the result of layering separate exposures from individual media frames. Whereas in-camera techniques control the translation of the world in front of the camera onto the capture medium, darkroom techniques using the element of time translate the captured images onto the output medium (the print). The printing aspect of this element of photography only comes into play in a real sense in the traditional (wet) darkroom, because in the digital darkroom the passing of time doesn't directly affect the visual outcome of the print.

In the traditional darkroom, the enlarger's timer operates as the equivalent to the camera's shutter speed; this aspect of photographic image making happens in real time and is the aspect of print exposure that allows the opportunity to dodge and burn and to manipulate the print through movement of the printing paper, the negative, or additional elements during the exposure. It also allows the creation of combination prints, the addition of motion onto the print by moving the paper or objects positioned between the paper and the enlarger light during exposure, and it enables photographers to make multiple exposures onto the printing paper.

Technically, exposure works the same way in the darkroom as it does in the camera, though the longer exposure times allow a greater degree of creative control. The stop-factor chart works the same way in the darkroom, so that if you need a 20-second exposure for proper density in the print, then you can split that time into any number of increments in order to manipulate the element of time to your advantage. You might make two 10-second long exposures; you could place text printed onto acetate in the light path during one of those exposures; you could move the image or paper during one of the exposures; and so on. You might

Image Discussion 19: Traditional Darkroom Mixed Multiple Exposures

CAROL GOLEMBOSKI, *SKINNING BIRD*; TONED GELATIN SILVER PRINT, 2003.

Carol Golemboski uses the element of time to combine images during her printing process; she states, "All manipulations occur in the printing process … I incorporate photograms into the pictures by laying objects on the paper during exposure to achieve a reverse (white) silhouette of the object, or a dark (black or gray) silhouette if I am using an Ortho-Litho template." The resulting images are complex and would be unattainable if the artist limited her creative process to in-camera capture and direct printing of a single negative. Not only is *time* central to her work's concept (the objects depicted had previous lives in the world, with meanings of their own, and are now resurrected into a completely different context) but it's also the primary physical means through which she creates it. Darkroom printing allows her to split exposure times and add objects to make final images that couldn't be accomplished without understanding and manipulating the element of time. View more of Carol Golemboski's work in this chapter's Portfolio Pages.

make one 10-second exposure; and two 5-second exposures, and move the negative slightly in between. There are countless ways to use the element of time during the printing process; the key is to do so in such a way that it makes sense for the subject of your images. Photographers also use these practices when making photograms (camera-less images). Perhaps the most significant (and at times frustrating) aspect of manipulating contents during the print

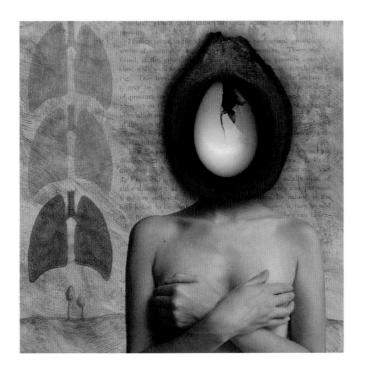

IMAGES © AMY HOLMES GEORGE; FROM HER SERIES *AWAKENING TO A DREAM*; 9" × 9" ARCHIVAL INKJET PRINTS.

Trading time for layers. In the digital darkroom the passing of time plays no role in the creation of overlapping time images, but "photomontage" derives from traditional photographic practices, including in-camera multiple exposures, and is a natural outcome of technological advancement. In these images, Amy Holmes George uses digital layers to overlap separate photographic exposures and scans, altering the opacity of each layer to control overall density. In the digital realm, your multiple exposures can include scanned (another way of using time) objects and documents, thereby expanding on the use of multiple frames. Essentially, Photoshop's layering, opacity, and blend mode abilities supplement or replace our traditional use of time in terms of multiple exposures. The layers represent discrete captures, made in time, then combined later on much as one would in the traditional darkroom. Be open, enjoy your digital process, and begin interpreting digitally combined photographic images through the principles you learn as you explore the elements of photography.

exposure is that each print will be unique, as it is difficult to impossible to reproduce the exact degree of movement throughout an edition of prints.

DIGITAL DARKROOM MULTI-IMAGE MONTAGE

The digital darkroom equivalent to multiple exposures is something I call "multi-image montage" because it results from "layering" individual frames. In the traditional darkroom, the stop-factor rules of exposure apply; the separate exposures have to add up to the amount of light and density you wish to achieve. But if you're creating "multiple exposures" from separate captures in the digital darkroom, these rules do not apply, because the element of time is removed. It doesn't matter how much time it takes you to add and adjust layers; what matters are the opacity (density) and method of blending of those layers. In the digital darkroom, adjusting the opacity of each separate layer is like increasing or decreasing the exposure of each capture, and changing the blend modes (the parameters by which each layer's tones are combined) expands on your ability to give specific image densities priority over others.

This is an aspect of the "fine art versus commercial" debate that I have too often heard, which I'd like to address here: that traditional darkroom prints can be counted as "Art" (with a capital A) because they're "hand-made", while digital prints can't be counted in the same class because they're

not. Well making prints, whether traditional or digital, primarily entails all of the decisions that lead up to the processing step (things like density, contrast, color, dodging, burning, etc.), not the processing itself. Traditional darkroom processing is, in effect, just "tipping a tray", which takes no more skill or art than hitting "print" on a keyboard in the digital darkroom. Indeed many traditional darkroom photographers, unbeknownst to viewers, pay skilled printers to process for them, and we nonetheless call their work art. Media is media; as my graduate school professor Joseph Grigely said, "You can't be dependent on any one technology to make your art." The art is in the concept, vision, and execution of craft. Period.

This isn't a Photoshop textbook; it's a book about photographic language and using the camera as the means of interpreting and communicating about the world. But mimicking certain camera effects digitally is a viable, and in some cases necessary, substitute (for things like adding historical and other types of imagery). In this respect, and combined with in-camera techniques, the digital darkroom actually offers a wider range of possibilities for delineating time. The bottom line is, the medium doesn't matter, but understanding how time looks when captured through traditional means helps you to create more believable (or fantastical) photographic effects in other ways.

PHOTOGRAPHS © ANGELA FARIS BELT, *STORM*, JACKSON LAKE, WYOMING, 2007.

Tell me a story. A cloudy day at Jackson Lake gave way to a stormy evening that resulted in a snow-covered morning. The end. A sequence of images can tell a story as complex as *War and Peace*, but it doesn't have to. In fact, most sequences expand on the notion of a single moment in time through only a few moments in time. The challenge is to consider what several frames in sequence might say about a subject that a single frame couldn't.

SEQUENCES: SPACING MULTIPLE FRAMES

Another means of using multiple frames that I categorize under "multiple exposures" is the sequence. *Sequences are several discrete images that must be read in a specific order to communicate.* They can be broken down into two categories, narrative and temporal, and they have no set number of images. I place sequences with time and motion (as opposed to multiple frames, covered in Chapter 2) because they don't operate on the same principles of gestalt. Multiframe and gestalt images (such as diptychs, panel panoramas, and contact sheet images) are not viewed temporally; their meanings derive from the combination of all images at once. Sequences, on the other hand, are temporally based, read

one at a time; their meaning is derived from seeing the individual images in specific succession.

Like other multiple-frame images, sequences are held together through gestalt, but not through the visual gestalt that allows a multiframe panorama to read as a continuous view made from separate parts. Sequences are held together through a conceptual gestalt; for the sequence to be read and understood, narratives need to cohere and time should progress in some sort of logical manner. If the order of images in the sequence leaves gaps that are too wide for the viewer to bridge, then the meaning is lost because the piece as a whole can't communicate. Sequences also hold together visually in that images generally cohere better if they are related in appearance

(density, contrast, color, etc.). Because they are made from multiple discrete frames, however, there are no strict rules about aesthetic appearance—only more and less successful ways of relating the images to make a visual statement.

A narrative sequence tells a story with a beginning, middle, and end. Is your subject, say, about children at water parks? What

if you photographed a child climbing to the top of a high dive platform, struggling to keep his nerve, going back toward the ladder, turning back around to face his fear, back and forth again, jumping—and finally emerging from the water with an exuberant show of pride and personal victory? This story could be told in as few as six images, but it just can't be told the same

Image Discussion 20: Sequence Documenting a Performance

Robin Rhode is a performance artist, street graffiti artist, painter, and photographer from South Africa. His photographic sequences document his conceptual performances, and through

ROBIN RHODE, *PAN'S OPTICON*, 2008; 15 DIGITAL PIGMENT PRINTS MOUNTED ON FOUR-PLY MUSEUM BOARD, EACH 20{7/8}" × 31{1/8 }" × 1{9/16 }".

them he can share the work with a wider range of viewers than could witness it firsthand, as well as conceptualize and make another piece of art in a different medium.

In this piece, *Pan's Opticon*, Rhode illustrates a highly conceptual double-entendre. The "panopticon" describes a space where everything is visible; specifically it refers to a space where the observer has a vantage point of power over the observed. In contrast, the title of the sequence, "Pan's Opticon," also suggests our protagonist is Pan, the Greek God who oversees shepherds and flocks.

The image is immediately strange. A man, dressed as the *Everyman*, stands anonymously facing a corner with no escape from his field of vision, and which he paints using his eyes. The act is documented and presented through a sequence of

15 frames and might be interpreted to refer to the inescapable position of anyone held inside the panopticon, cornered within a dominant outside gaze.

In describing the image content, our protagonist appears to be painting a blank wall with brushes protruding from his eyes, and as the story unfolds he then absorbs that paint from the wall back into the brushes. Only in the end they seep from their tips like mascara teardrops, down the wall without the prior control Pan's gaze had. It's a narrative sequence that seems to indicate that a view from a position of power has a life of its own, uncontrolled, capable of staining the one who looks as much as those blotted by their vision. View more of Robin Rhode's work in this chapter's Portfolio Pages.

way without a sequence. It relies on more than one photograph to contextualize the others, and sequences do just that.

The second type of sequence is *temporal, one that shows a passing of time or the evolution (or devolution) of some process.* How might this aspect of *the element of time* relate to your specific subject? Does your subject display a process that unfolds over time? For example, your subject is botanicals or flowers. What experience of these plants might a viewer gain by seeing a sequence from seed to sprout through full bloom and death? Or, what if you place your camera on a tripod and shoot every 30 minutes from dawn to dusk

a plant in a windowsill following the arc of the sun; it's interesting to view in sequence because it's something we rarely see. Who has the time? Say your subject is "ice." Let's watch it melt. Say your subject is "birth." Let's see a hatchling break through and emerge from its eggshell. Whatever your subject is, although it might not "tell a story" it is likely still influenced by time, which opens up potential for communicative power through sequences.

To summarize this unique type of multiple moments in time, sequences all have one thing in common—they freeze, blur, or capture static individual moments in time and

place them in a particular order. While you might think that the video medium "does it better" (an argument I hear quite often from video artists), they are really two very different things. We'll discuss video later in this section. But with respect to sequences, they rely on viewer participation in reading the images more so than video. In effect, video fills in all temporal gaps through rapidity, whereas sequences leave intentional gaps for viewers to ponder and fill in for themselves. Like framing itself, the success of a sequence is as much about what we as photographers leave out as what we leave in. The most successful sequences engage viewers in the aspects of the piece that aren't there, making the space between frames as relevant as the images themselves.

SCANNER AS CAMERA: WHEN THE MEDIUM MOVES

At the beginning of this chapter we said that the photographic medium is static, but the world flows in time, and that the duration of the exposure dictates the visual appearance (and contributes to the meaning) of images, ranging from motion to blur. But what if the medium were, *in effect, not static*—that is, what if exposing a single frame took thousands of sequential exposures in a particular direction across the picture plane? How would the world of time and motion translate in relation to a medium that is itself *exposed through its own time and motion*? These are interesting questions whose answers can be found in current technology. It's a camera that anyone with ingenuity,

and research and fabrication skills, can make—a flatbed scanner camera. *Scanner cameras are made of flatbed scanner parts attached to a camera body* (preferably large format) with a secondary medium that holds the resulting images. Making one (and making it work) can be very involved, and the methods vary widely depending on the scanner you choose to disassemble; for this reason we won't cover the process here, but if you're interested, you can easily find helpful tutorials online. I do, however, want to discuss this kind of technology's relationship to time and motion, show some images made with it, and consider its aesthetic and communicative potential.

Scanner camera images have distinct characteristics evident even to nonphotographers. These characteristics are a direct outcome of the way the scanner captures an image—its response to time and motion both in front of the camera and of the sequential exposure across the medium itself. Whereas conventional cameras (relatively speaking) expose the entire static media plane simultaneously, scanner cameras expose the media plane sequentially across its plane. Each scan happens line by line, a pixel width at a time, in minute fractions of a second, and the number of lines dictates exposure time. Depending on the scanner resolution (the higher the resolution, the slower the scan), an image can take from 30 seconds to 10 minutes to expose.

Perhaps the most unique attribute of scanners and scanner cameras is their relationship to time and motion. Like conventional cameras, if nothing in front of the camera moves and the

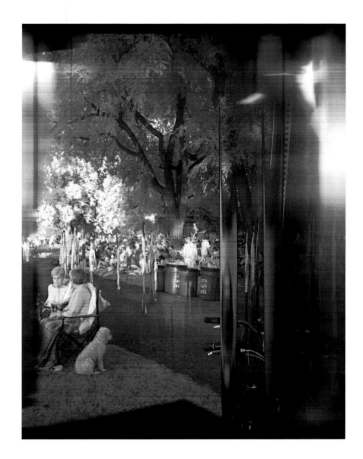

PHOTOGRAPHS © ANDREW GROTE, 2010.

Scanning the scene. Using his homemade flatbed scanner 4 × 5 view camera, photographer Andrew Grote examined the goings-on of city life. Because of the scanner's orientation, the speed of its exposure, and the movement in front of the camera, his images contain forms that are alien to us, juxtaposed with identifiable frozen moments. Grote retained the borders, which are an organic outcome of his process, consciously not cropping because of how they visually engage with the image content and because they serve as a vignette to hold the viewer's eye inside the frame. See more scanner camera images in this chapter's portfolio pages.

camera itself doesn't move, then the effect is static time. But here, blurred time is different; anything that moves during the exposure is subject to stretching, compression, and other kinds of distortion. Although scanner camera distortion may seem random at first, when you begin to analyze it you find a method to the madness that you can control. Affecting how movement translates in a scanner image are the following factors:

- *The resolution of the scanner.* The speed of the exposure depends on the number of lines scanned; the greater the number of lines, the greater the resolution (a larger image is produced).

- *The direction and orientation of the scan relative to the direction and speed of the movement.* The scanner can be oriented to expose horizontally or vertically from left to right or right to left, or to expose vertically from top to bottom or bottom to top.

- *The precise position of the scan line relative to the position of the subject.* If throughout the scan nothing moves, the result is static time. If the subject moves against the direction of the scan, then only parts of it are recorded. If the subject moves in the direction of the scan, then it is extruded across the picture plane.

Images from scanner cameras reveal the world of time and motion in ways we cannot see in frozen, blurred, or panned photographs. In fact, because the media exposure moves sequentially, the images act as a sort of timeline that starts reading from where the scan began and ends where the scan ends. We can watch time unfold across the media plane when movement occurs in the same relative direction and speed as the scan, or we only see slivers of contents that moved against the scan direction. Contents in the scanned image can "disappear" into the medium in much the same way as subjects moving fast during a very long exposure (discussed in the section "Blurred Time"). Engaging the way a scanner sees has as much potential as engaging the way a camera sees; it's a tool of the digital age that adds to our visual vocabulary and our ability to communicate photographically.

MOVING SINGLE IMAGE FRAMES

As photographers, we are moved by the power and dedicated to the lasting validity of the still image. We look at a single photograph and recognize it as a miraculous confluence of time, focused light, and attention onto photosensitive materials. Photographs are worth countless words, able to communicate volumes of a kind very different from written language. But as practitioners we're also curious about the limits of the medium and our own ability to use it, and so we experiment along its edges. And then we come to an edge where multiple frames begin to move closer and closer to time—multipanel panoramas, multiple exposures, sequences, and scanner cameras—all push our ides about what constitutes a single photographic image.

But what happens when multiple photographic images move beyond that edge and the "whole picture" cannot be read *until it is brought back into a temporal space*—until it is read through time? What if *a single photographic statement* is made not by combining multiple frames into one, but through viewing them one after the other in quick succession? We

ZOETROPE © CYNTHIA GREIG; FROM *HIDDEN FROM VIEW*, 1995, COLOR
PHOTOGRAPHS, ALUMINUM, WOOD AND LIGHT, 48" × 48".

Still and spinning. These installation views of Cynthia Greig's zoetrope, *Hidden from View*, shows the scale of the object (*left*) and demonstrates that you see the images through it as it spins (*right*). In this zoetrope, we see a human figure in front of a horse rearing back. Because the slits pass by your eye quickly when the drum is spun, illuminated sequential images create the illusion of motion. Notice that even to clearly explain how zoetropes work, two different types of time and motion capture were used! See more of her work in the Portfolio Pages of Chapter 6.

have images like these, images that create *perceived seamless motion; although the images' contents aren't moving, they create the illusion of motion when viewed temporally.* The illusion of motion produced by sequenced single frames (particularly in film and video) is as real, or perhaps even more so, as the illusion of depth in a two-dimensional photograph. There is no moving content within the picture planes, but the sequencing and placement of content relative to our viewing it in time make it look as though it does. This allows such works of photography to communicate about a subject in a way that a single image and nearly all gestalt images cannot.

Tactile Images: Flipbooks and Zoetropes

I refer to the first type of perceived motion images as *tactile— images intended to be read through direct physical interaction with a viewer* (generally an individual or a small group). "Moving" tactile images assume an interactive relationship between the method of viewing and the viewer, with the viewer's interaction dictating the pace at which the extruded images evolve. This interaction also determines much of the visual quality of the image, those qualities that come from viewing the images in time. Tactile motion images include such things as flipbooks and zoetropes. Although they're very different objects, they operate on similar principles of time and motion.

Flipbooks—yes, the same ones we played with as children— have to be handled, their pages "flipped" through our fingers to reveal a sequence of images playing out through time. If the images are sequenced properly, having very small gaps in content from one image to the next, then through rapid

succession we see their content appear to move. The size and scale of most flipbooks are small, the size of a personal object or snapshot. I recommend embracing your inner child and buying one from your local bookseller; they can be enormously fun and can provide inspirational food for thought about making your images move.

Zoetropes (Greek, roughly translated "turn of life") are another kind of tactile device that create the illusion of motion from multiple still frames. Although earlier versions existed, the modern zoetrope was invented in the early to middle 1800s. They create perceived motion by allowing pictures sequenced inside a hollow drum to be viewed through slits cut opposite them. The drum is mounted on a spindle to allow the images to spin past your view through the slits; the faster it spins, the smoother the perceived motion of the image.

Perceived Seamless Motion: Forward Through to Video

Other kinds of perceived seamless motion—film and video—images provide viewers with even more believable illusions of seeing actual movement. We can do this because the timing between the frames passing before our eyes (frame rate) can be precisely controlled to sync with human vision, creating slow, normal, or fast motion sequences. This illusion is as powerful as a two-dimensional picture plane creating the illusion of depth; we look at a two-dimensional plane, but we mentally construct a three-dimensional space;

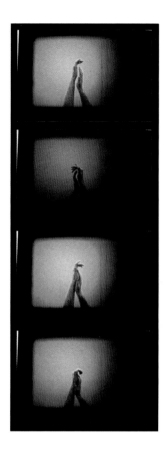

IMAGES © KRISTINE GRANGER FROM HER VIDEO "JOUISSANCE."

A temporal sequence of film stills. Video frames are viewed over the same spatial plane rapidly over time, like these four frames are supposed to be viewed. But here they exist as individual frames edited from a longer video piece sequenced in proximity to one another. We have the sense that time is passing, but we don't actually see it seamlessly, making it a very different experience for us as viewers. See more of her work in this chapter's Portfolio pages.

we look at a movie and know that the image isn't really moving, but our eyes allow us to accept it.

Too, there are some advantages to capturing video that, if we "pull them apart," we can utilize in still photography. Think about it; narrative and temporal sequences allow viewers a different level of interaction with the entire image sequence because of gaps between the images being read simultaneous to the images themselves. Although video fills in those gaps, it only does so when viewed in rapid succession. As photographers we can capture video for the purpose of bringing select images back into the still realm. Like viewing a contact sheet, a sequence of video stills can be edited to make a singe statement different from or beyond what the video seen in time could make. The potential in pulling apart individual image frames, which can be cropped, toned, adjusted to the look you want, and resequenced, is a photographic gold mine; we create a new form of gestalt experience for viewers.

In the digital age, the potential for mining video for its individual frames offers another benefit—it gives us a second chance to "capture" the decisive moment—only it's done after the fact, during editing. This generation of digital cameras capture film-quality video in individual, sequenced frames, and photographers are discovering that they can find the "perfect" frame by capturing many of them. Video allows them to slow down time, to look at the event again in time, and to capture the moment after the fact. With respect to photographic language, video gives the option of leaving no temporal gaps in the narrative or temporal sequence by showing it in the rapid succession that was intended or adding the temporal gaps by recontextualizing selected image stills into a single gestalt image.

Like the scanner cameras, the digital age has made readily available this dynamic way of using multiple frames in time. Video is within the grasp of any photographer; many DSLR cameras have HD video capability (as do some cell phones!), and there are several software programs for video editing in what we might someday call the "video darkroom." The potential is limitless for any photographer interested in pursuing image making on the edges of time. And although video is its own art, the principles of photographic language can be applied to it to more meaningfully explore your subject. The potential lies in keeping an eye toward both ends of the medium's time continuum, and embracing the ever-expanding practices which add to our knowledge and abilities as photographers.

CHAPTER EXERCISES, PART 2: EXPERIMENTING WITH MULTIPLE MOMENTS

This section of the Chapter Exercises pushes your ability to use photographic language. These exercises capitalize on combining multiple frames with time related to your subject. Consider choosing just one of the exercises and producing several pieces using the methods so that you can concentrate on a particular kind of image construct more intensely.

STOP-MOTION SEQUENCE © ANGELA FARIS BELT, *THE CAT WANTS OUT*, **2011. VIEW IT AND OTHER STOP-MOTION ANIMATIONS ON MY WEBSITE, WWW.ANGELAFARISBELT.COM.**

Stop-motion animation: the cat wants out. As I was photographing a simple shadow falling inside my screen door and onto a broom, I noticed my cat Luna(tic) walk into the frame. Rather than stop shooting, I waited to see what she would do, and since my digital camera has rapid-fire capabilities, I depressed the shutter and kept shooting using continuous mode. While the frame rate is not fast enough to provide seamless motion quality, when the images are stacked and play by rapidly in time they provide a unique, fluttering sense of motion that adds comedy to the way we view the scene. You can also move your eyes across these images sequentially and have an understanding of the movement that was happening, because your mind fills in the gaps. If when viewing my contact sheets I had ignored the images, I would have missed the potential of this stop-motion sequence. It doesn't "read" properly as a contact sheet or printed sequence, so placing them back into the temporal realm for viewing provides the proper context for viewing the whole picture.

Remember to discuss your results with a community of peers in the classroom, in a critique group, or online.

1. **Multiple Exposure or Montage**

 Do you enjoy pushing your camera and exposure skills? How about your ability to conceptualize what will be in a frame? Using your camera of choice, decide upon several scenes that you believe would make a statement about your subject if combined into one frame. Use the stop-factor chart to help you expose the frames properly.

 Do you enjoy working in the darkroom, building images in addition to capturing them? This exercise might be for you. Decide upon several images that you would like to combine using separate time exposures in the traditional darkroom or layers in the digital darkroom. Use your technical skills to arrange the images with the density you wish to have.

 Whichever you choose to do, make several attempts at each image, varying the densities of the montaged frames in order to change the contents that take priority. Remember, when there are two or more exposures on a single frame, then natural hierarchies will be created depending on the balance of exposures.

2. **Sequencing Photographs**

 Construct a narrative or temporal sequence of images that allow viewers to experience something about your subject through several frames in close proximity to one another but that also rely on one another to communicate meaning. Arrange your sequence vertically, horizontally, or in whatever way makes the most sense for your piece.

3. **Optional Exercise**

 This exercise is for any of you who want to push the limits of your knowledge and skill in digital media. While remaining on track with your chosen subject, consider shooting with a flat-bed scanner converted to a camera, or consider shooting video and editing specific frames to sequence or build into a multiframe gestalt image. Notice the unique character and quality of the images you get using these media as opposed to a conventional camera.

PORTFOLIO PAGES

These Portfolio Pages contain such a wide range of photographic practices that it might not be apparent at first how they fit together into one collection. To help clarify (as in all the Portfolio Pages), I have provided some thoughts about why I chose each artist's work, and how it fits within the elements of photography.

The artists here represent their subjects through separate exposures of discrete instances in time layered onto one media plane, or separate exposures that must be read sequentially to communicate their meaning. Their images broaden our understanding of a subject and how photographic language can encapsulate it. In addition to the range of practices and technical approaches, the range of subjects and complexity provides a good basis for critical discussion.

CAROL GOLEMBOSKI

PSYCHOMETRY

ELEMENTS

Who says traditional darkroom photography is dead? These images by artist Carol Golemboski demonstrate the unique forms of imagery that can be created through the element of time and its relationship to positive and negative densities. Understanding this relationship allows her to combine exposures from negatives as well as add drawings and other marks on a range of translucent to transparent materials for specific exposure and density effects. She also uses Ortho-Litho film to create templates for black marks, drawings, and text. In this way her images are one of a kind, using "mixed media" art techniques.

ARTIST STATEMENT

Psychometry is a series of black and white photographs exploring issues relating to anxiety, loss, and existential doubt. The term refers to the pseudo-science of "object reading," the purported psychic ability to divine the history of objects through physical contact.

Like amateur psychometrists, viewers are invited to interpret arrangements of tarnished and weathered objects, relying on the talismanic powers inherent in the vestiges of human presence. These images suggest a world in which ordinary belongings transcend their material nature to evoke the elusive presence of the past.

Through an examination of fortune telling and clairvoyance, many of the images confront the desperate human desire to know the unknowable, historically referencing the Victorian interest in spiritualism as well as the look of the 19th-century photographic image. Illegible text and arcane symbols in pictures with themes like palm reading, spoon bending, and phrenology force the viewer to consider man's insatiable need to anticipate his own fate.

The success of these images relies on the viewer's expectation of truth in the photograph, expanding on age-old darkroom "trickery" to suspend belief between fact and fiction. The romantic ideas suggested by these photographs are enhanced by the nostalgia that accompanies historic photographic imagery, the process of traditional printmaking, and the magic of the darkroom.

Blind Bird, 2005.

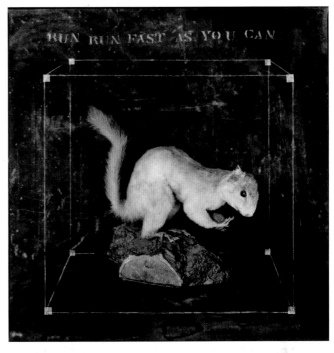

Run, Run, Fast as You Can.

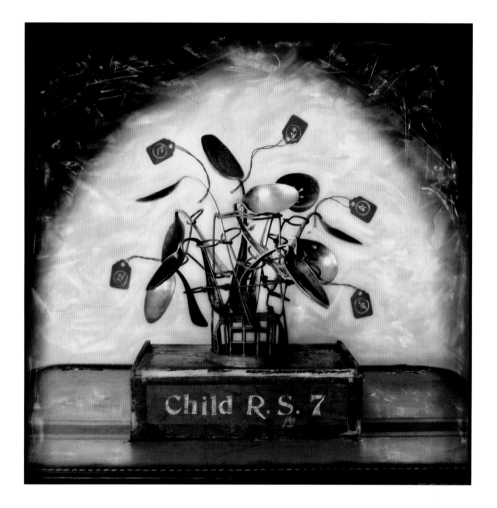

Bending Spoons, 2004.

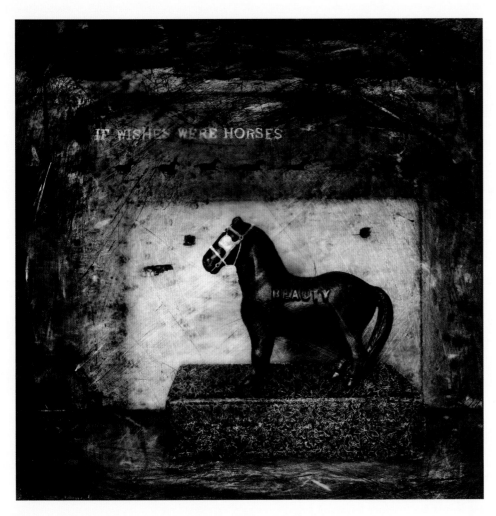

If Wishes Were Horses, 2006.

IMAGES © CAROL GOLEMBOSKI; FROM HER *PSYCHOMETRY* SERIES; TONED GELATIN SILVER PRINTS, 17.5" × 17.5".

ROBIN RHODE

PHOTOGRAPHS

ELEMENTS

I first became aware of Robin Rhode's work when I saw it on the cover of *Art in America* in 2009. I'm always intrigued by how performance artists and others whose works are temporary use photography to not only document but also to contextualize and share their work with a larger audience. These photographic constructs become new artistic statements, disconnected from the original work, but able to communicate in direct reference to the performance and its subject.

ARTIST STATEMENT

Embracing a variety of media—principally photography, but also drawing, animation, performance, and sculpture—the work of Robin Rhode uses simple, ephemeral devices (soap, charcoal, paint, and chalk) to comment on urban youth culture, colonialism, and socioeconomic issues in a simple, witty, and subtly effective way. His work often uses the street as his canvas or his backdrop, alluding to hip-hop and the role of the graffiti artist, and he often operates within the gritty aesthetic associated with that culture.

Rhode's work, however transient it may seem, involves creating a kind of narrative that contains several stages of erasure and redrawing with the trace of his actions remaining visible throughout. There is also a pervasive mood of failure, while his persistent gestures toward ludicrous and apparently unachievable goals are as poignant as they are humorous. Rhode draws a skipping rope and cajoles a room of people to engage in a game of Double-Dutch with him, or he plays an upside-down game of snooker that only he can win—the challenger is absent and the game defies logic and gravity. For another work, Rhode fashioned a bike out of soap, rendering the object comically futile. While his work calls to mind early silent film, stop-start animation, and flip books, Rhode's alter ego—a recurring feature—evokes a character from 19th- and early 20th-century American minstrel shows and the exploits of Buster Keaton. Rhode's practice straddles both the recent past, when one only needed a ball or a yo-yo in your pocket for amusement, and the constant, overwhelming stimuli of the present day. —*By Michele Leight*

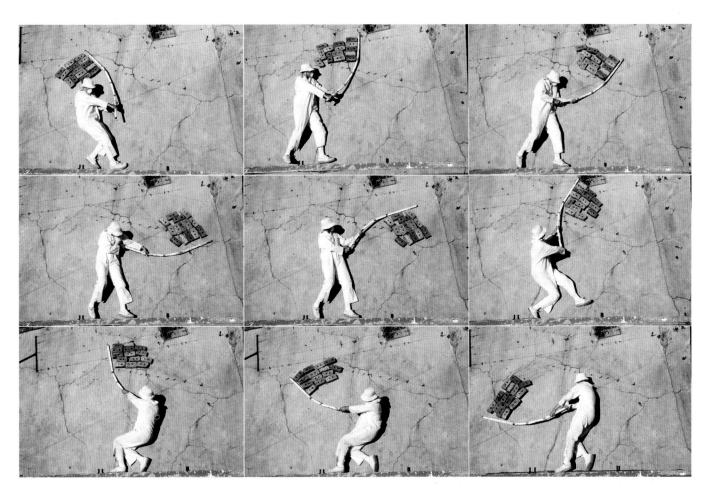

Stone Flag.

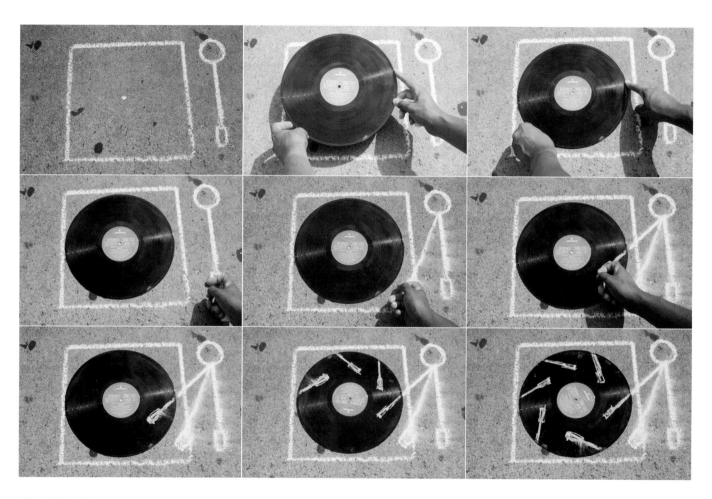

Wheel of Steel, 2006.

Ballad to Ballet, 2008.

PHOTOGRAPHS © ROBIN RHODE; FROM VARIOUS WORKS.

Jean Miele

The Vintage Series: Scientific Inquiries

ELEMENTS

There is no right or wrong photographic medium, only those that bring you closer or farther from articulating your meaning. Artist Jean Miele fuses all things photographic, from traditional to digital. He carries historic images through time, scanning aspects of them to recontextualize in digital montage. He adds borders and embosses his printing paper to reference his sources and inspiration, in addition to layering scans of historical artifacts such as ancient manuscripts, maps, star charts, and ships' logs. By merging process with image content, he creates unique and beautiful images that reference the medium's history while articulating his subject—the timeless universal questions surrounding who we are and why we're here.

ARTIST STATEMENT

The Vintage Series: Scientific Inquiries is a portfolio of photomontages relating to the history of science, mysticism, theology, cartography, cosmology, and photography. The work explores the idea that these are intertwined disciplines and all arise from the fundamental human need to ask, "Who are we, and what is our place in the universe?"

To that end, the deliberately small scale of these images, deceptively ambiguous navigational aids, and barely legible text reflect the way answers to the questions that are most important to us are always just slightly beyond our grasp. No matter how advanced the methods or technology we bring to bear, "facts," scientific and otherwise, inevitably change over time. Ironically, counterintuitively, the seeming outward precision of these images hides an underlying, and perhaps greater, exploratory—or divinational—function. Defining the seen, the known, the possible, implies a line of demarcation. By delineating terra firma, we provide access to terra incognita.

Terra Incognita.

For Frank Hurley.

Hc Svnt Dracones.

Projection.

PHOTOGRAPHS © JEAN MIELE; FROM *THE VINTAGE SERIES: SCIENTIFIC INQUIRIES*; 8" × 10" ON HAND-EMBOSSED 16" × 20" WATERCOLOR PAPER.

DAVID STEPHENSON

STARS

ELEMENTS

When I first saw David Stephenson's images in the Cleveland Museum of art, I was drawn to them from a distance because of the graphic arcs alone. When I realized the "designs" were made from his interaction with star trails over time, I also realized that Stephenson had taken standard blurred-time image of stars and coupled it with another way of recording time—the multiple exposure. The resulting images are a fascinating study of both the star trails and the way their light relates to time itself.

ARTIST STATEMENT

My photographs of star-filled night skies in 1995 and 1996 looked to the celestial realm for a sublime space in nature. Any photograph records a specific moment when light strikes film or paper—and in this sense it is always a document of time itself. In my photographs of the night sky, the light of distant stars may take tens of thousands of years to reach us, and so my camera was recording the present moment but also looking back into time, using light originating from distant prehistory, and the movement of the earth, to "draw" on the film. The Stars series evolved from an initial exploration of black and white silver prints in 1995 to the color images of 1996. By rotating the camera while overlaying as many as 72 multiple exposures, I was able to build up complex patterns that have affinities with the geometric structures of cupolas and mandalas, as well as system-based minimalist art. Extending Talbot's metaphor of photography as the pencil of nature, the stars are drawings whose marks result from the movement of the earth and a stationary camera that is periodically moved through a sequence of predetermined positions.

Stars No. 1211.

Stars No. 1004.

Stars No. 706.

Stars No. 1207.

T. JOHN HUGHES

ARCHITECTURAL APPARITIONS

ELEMENTS

The ghostly apparitions emerging from T. John Hughes's color photographs are made possible through the digital darkroom's ability to layer discrete moments in time captured decades apart. Using layers to control density in the same way that traditional photographers use the stop-factor chart for multiple exposures, Hughes approaches media as a means to make a comparative statement about the nature of change in the built environment.

ARTIST STATEMENT

Architectural Apparitions calls on me to be a photographer, a researcher, and a bit of a detective. My fascination with change and the built environments of cities is apparent within this work. These ghosted images are not uniformly architectural jewels whose passing is to be mourned, as I choose to use a wide array of structures to place within what would be their current locations. I prefer to show a variety of subjects and stimulate a discussion about what should stay and what should or could go. I comb through books, library photo collections, Internet sites, and government databases to see which older images are interesting and available.

As much as anything I have the intention generating a feeling in the viewer about change over time. My idea for *Architectural Apparitions* actually predated the availability of digital technology that made the images practical to produce. I would often spend time thinking about how earlier lives had occupied various spaces.

The detective work comes in as I search to find the right spot where some earlier subjects existed. It can be both frustrating and exhilarating. Streets change, peoples' memories are not always accurate, historical maps conflict, and whole areas can be completely transformed. And so when I find a distant hill, an almost hidden roof, or some other clue that orients my older image to the current setting, I experience one of the most rewarding aspects of the whole process.

Denver Club.

Detroit City Hall.

Madison, FL; Wright Boat House.

Pittsburgh Bridge.

Historical images: Denver (William Henry Jackson/Western History Collection, Denver Public Library); Pittsburgh (Charles W. Shane/Historic American Engineering Survey); Madison (Stanley Charles Hanks/Wisconsin Historical Society); and Detroit (Allen Stross/Historic American Building Survey).

ANNA NORTON

THE ROAD TO STILLMORE

ELEMENTS

What constitutes the decisive moment in a digital age? Would Cartier-Bresson have allowed himself a second chance at capturing that moment, or let it disappear into memory? We can't answer for him, but we can look to contemporary photographers like Anna Norton who use video to capture several minutes of seamless motion, only to edit the individual frames down to the one that best represents her subject. These images are notably less resolved than conventional photographs resulting from video quality capture, though the technique is primarily visible only when the images are enlarged to her choice in size—30" × 30". That's part of the point, and eventually photographers will have to decide whether to maintain or manipulate the improved quality to make their statements. But here we are treated to images that feel like memory through their indistinct quality, color, and slight movement.

ARTIST STATEMENT

Photographs from the series *The Road to Stillmore* begin my current exploration into the medium of digital photography, in particular video capture. Iconic stills are collected from video recorded while passing briefly through the landscape of my childhood home in Southern Georgia. The resulting image quality creates photographs that speak to Impressionistic landscape painting when viewed from a distance; however, from close range the forms of the landscape break apart into digital texture. Although the images are captured in a particular place, the scenes of apparent rural simplicity combined with pixilation leave the viewer with a mixed sense of past and present.

 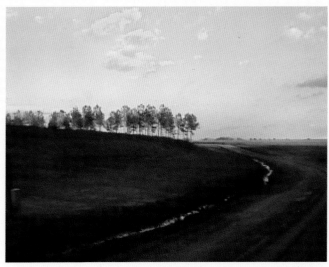

Untitled, 2006.

PHOTOGRAPHS © ANNA NORTON, FROM HER SERIES *THE ROAD TO STILLMORE*, 2006; 24" × 30" ARCHIVAL INKJET PRINTS FROM VIDEO STILLS.

DOUG KEYES

COLLECTIVE MEMORY

ELEMENTS

We walk through museums viewing one image at a time; we page through books taking in one spread at a time. But how do those images and pages accumulate in our psyche, intellect and experience? It's hard to imagine making photographs that adequately address that question, but Doug Keyes uses the *temporal element of photographic language* to overlap time into a single frame, capturing each page of the book once it's turned. The 10 to 40 multiple exposures transcend time, allowing us to see something that human vision and our own existence in time won't allow—an entire book at once.

ARTIST STATEMENT

Working under the premise that all things in our universe are connected, Keyes's work investigates the interconnectedness of ideas. As an artist and graphic designer, Doug Keyes is hyperaware of the ways in which information and images are conveyed to the public. He is equally aware of the way knowledge stacks upon itself over time, leaving an impression or collective memory.

Using books and documents from Keyes's own collection as well as friends and relatives' personal favorites, the topics cover a broad spectrum of inquiry, invention, and expression. Produced with multiple exposures of all the pertinent pages of each book, Keyes's luminous color photographs reveal (or conceal) the entire contents in a single image. The result is a condensed document of the ideas contained within as well as the physical identity of the book itself.

The Cat in the Hat Comes Back, Dr. Seuss, 2001.

Ishihara's Tests for Colour-Blindness, 2001.

Eadweard Muybridge, 2004.

Sugimoto, 2001.

PHOTOGRAPHS © DOUG KEYES, FROM HIS SERIES *COLLECTIVE MEMORY*; DYE COUPLER PRINTS MOUNTED TO ACRYLIC, WOOD FRAME; DIMENSIONS VARIABLE.

ANDREW GROTE

SCANNER PORTRAITS

ELEMENTS

Digital technology has changed, and will continue to change, the way photographic images are made and perceived. This change allows us to see and experience in new ways, to expand our thinking about what constitutes a photograph, and allows photographic images to show us realities previously beyond our grasp. The scanner camera is one of the newest devices in the arsenal of photographic equipment, and Andrew Grote is one of the pioneers embracing it. His images demonstrate the nature of time on the medium and use that medium to help him comment on our existence in time.

ARTIST STATEMENT

I have always loved mixing graphic and photographic art, from old techniques to hybrid workflows. I am searching for a new way to capture images while simultaneously embracing a romantic connection to old world techniques. To achieve this vision I have taken digital technology, a flatbed scanner, and retrofitted it to the back of a large-format view camera.

I am attracted to the extremely high resolution and fine detail of the scanner camera. The speed of the camera is controlled by its resolution—the higher the dpi, the slower it reads and the longer the exposure. Images from this capture device are stretched or compressed, depending on the scanner's orientation on the camera, the direction of the scan, and the motion in front of the camera during the exposure. I effect and manipulate the effects while shooting by choosing scanner orientation or by instructing subjects to change position during the scan.

I have always believed that the camera captures people's spirits or personalities; this is a study of how technology perceives humans. The human body is made of cells and every image is made of pixels. Every piece of the image is unique just as people are unique. By connecting threads of technique and a passion for people within my work, I have found a different way to capture the similarities. My photographic practice attempts to bridge gaps between modern and postmodern processes by combining characteristics of each.

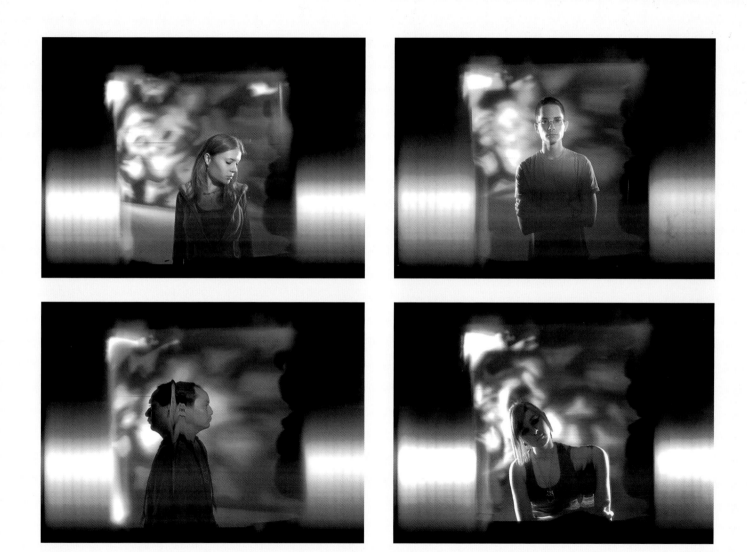

PHOTOGRAPHS © ANDREW GROTE, FROM HIS SCANNER PORTRAITS.

KRISTINE GRANGER

STILLS

ELEMENTS

When I viewed Kristine Granger's *Jouissance* video I was mesmerized, taken aback by the still-frame nature of the moving images, and I knew that from now on there is an inseparable connection between still photography and its rapidly sequenced counterpart. The simple beauty of the movement combined with the vertical lines, flicker, and pacing of the images themselves lends the piece a feeling of primal familiarity, of the home movies of the past, and of something universal that continues beyond the video loop. As a sequenced grid of stills removed from their original context, the images you see here are very different from the original experience that was intended; I recommend going online to see the video in motion on hers or another video website.

ARTIST STATEMENT

I am interested in the psychological and physiological imprints that memory carries. The elasticity of our beings: when one has been stretched so far, what are the effects, or if there is a repeated pattern, can it be broken by perseverance of self? My work communicates my personal and emotional state in relation with the surrounding world as I have experienced it. I investigate what makes a person, the moments in one's life lives where events or individuals have made an imprint, handprint, or shadow. These pivotal moments change you for the rest of your life; they are moments where personal decisions are made and their effects felt. My work derives from very personal events, but I believe the work's strength is that there is the shared experience enacted by the viewer. The continuation of the experience that is created at that moment then becomes a memory for the viewer.

Haunting explores the structure of an affective social experience and the unconscious, but it also explores the exchange between the defined and the inarticulate, the seen and the invisible, the known and the unknown. This installation included the zoetrope with its interior walls replaced with 13 digital solarized photographic self-portraits. The self-portraits are against a black background, and the figure is nude. The figure begins curled in a fetal position; the next images move from the curled position to a standing position, and then back to a curled position. The figure appears to have a

wet metallic sheen like mercury; there is a white electric-like halo that surrounds her (typical to the treatment of solarization in photography).

The history of the zoetrope device intrigued me. Its original use was to sequence still images and spin the device to animate them. It is only until the viewer chooses to no longer engage that the zoetrope stops. The use of the zoetrope acts as a metaphor for the illumination of the interior of our being. My intention in using it was to show that once it is put into motion, the life-size interior existence of self is illuminated, including the events or moments of struggle that stay with us throughout our lives. The events that shape us are brought to the foreground and explain the layers necessary for the creation of who we are or become.

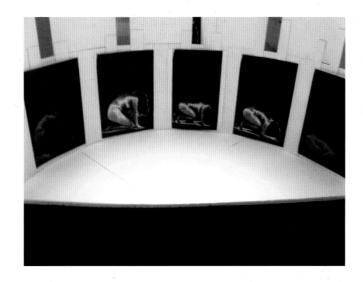

This is the body multiple. The focus of this work is the area between subject/object and the blur of the existence: interior-exterior relation. With the viewer's participation the interior becomes enacted.

Jouissance is a super 8 film that runs in a continual loop. For me the choice of color and gesture speak of the "ecstatic" in this film. My preference is to have the piece loop on a film projector; it is to be viewed small, approximately projected 6 × 6 inches visually encouraging an intimate interaction with the work. Reading Marcel Proust and my interactions with Julia Kristeva directly inspired the film. Julia Kristeva writes, "Proust can give us in a glimpse of the way a psychic life can possess and expose its own unprecedented complexity: a life is at once painful and ecstatic, sensual and spiritual, erotic and pensive." The ability to find the ecstatic for me is directly related to understanding oneself and one's connection to all. The expression of this in written form is difficult for me; the piece *Jouissance* is important because through it I found the ecstatic.

To film *Jouissance*, I painted the wall of my studio robin's egg blue, a color representing the divine, the color of the robe that the statuettes of Madonna are swathed in from my childhood. The film is of my two hands, palms facing one another. My hands start out slowly moving up and down with a small amount of space between them. The pace increases, and as it does the space between the hands disappears and they become one; the pace then begins to slow down and the hands begin to move slightly away from one another; and the film's loop repeats. At first it is the tension or the existence of the space that is illuminated, but once the hands touch it is the ecstatic that is illuminated.

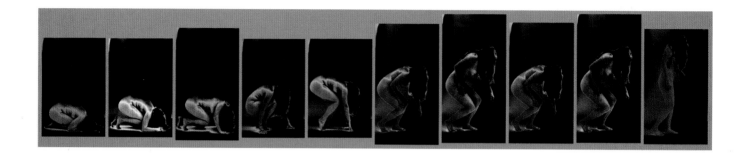

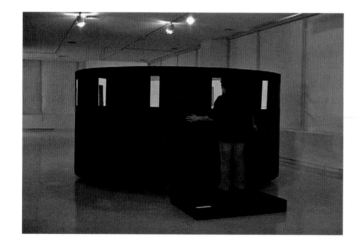

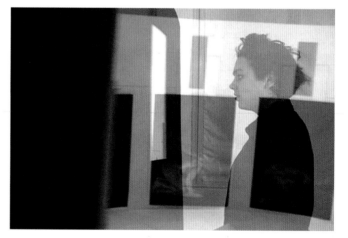

PHOTOGRAPHS © KRISTINE GRANGER; FROM HER ZOETROPE INSTALLATION *HAUNTING*.

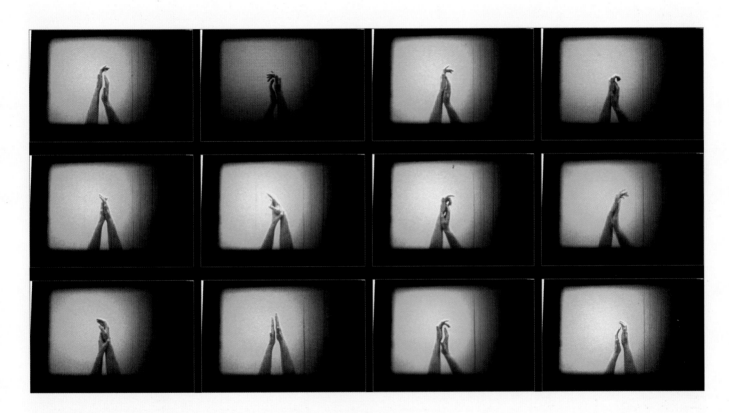

PHOTOGRAPHS © KRISTINE GRANGER; STILLS FROM VIDEO WORK *JOUISSANCE*.

Materials, Processes, and Presentation: The Aggregate Image

PART 1: GOING BACK TO THE BEGINNING

We start with a concept, from our mind's eye or by exploring the world through sight. We see something that intrigues us, that inspires or moves us, that makes us question, entertains or simply pleases us. We want to capture it in a photograph. We frame the scene in our camera's viewfinder; we meter the light and set the ISO, aperture, and shutter speed for good exposure density. We carefully consider all contents inside the frame, choose the right focal length lens, and find just the right vantage point to describe it, arranging juxtapositions and defining depth within the picture plane. We choose an aperture to produce the ideal depth of field, and

balance that with a shutter speed to place any movement precisely where we want it on the continuum of time. We've left the realm of just taking pictures and engaged in the process of making photographs. We're using the grammar of photographic language to articulate our vision to the world. Like combining parts of speech, we've synthesized all the necessary components to *make an image whose appearance reflects our intended meaning.* But then what? We've come full circle, and now we realize that even though we've captured a successful image, it exists only as a latent projection onto some form of photographic media.

Although this is where all photographs begin, it's not where most of them end. We generally bring them beyond the film or CF card to exist in the world in some form or another. That's where the *materials and processes* from which photographs are made become important. They affect how our images look and communicate as much as the other elements of photography, because *in their ability to gather light or hold a picture plane they contribute a grammar of their own*—that is, in the end, because most photographs exist as three-dimensional objects again, we need to consider what those objects are made of. I recognize that an increasing number of images are intended to be viewed on-screen, to exist only in the digital realm, and although that won't be the focus of this discussion, you can apply some of the information here to those images (things like perceived texture, color and tone, size and scale, etc.).

This is the fourth element of photography—the materials and processes that constitute the aggregate photographic object. The materials and processes from which they're made affect all photographic images. However, some images, such as photojournalistic and documentary images, surveillance photographs, x-rays, ID photos, and the like, rely on materials and processes only as a means to an end, not as an aesthetic attribute. Although materials and processes affect how these images look, they generally aren't intended to hold sway over interpretation of meaning. The communicative effectiveness of other images, however, relies heavily on the visual effects accorded by the specific materials and processes used to create them. These are the images we'll address most specifically in this chapter, helping you to interpret images you encounter, as well as inform your photographic practice.

THE AGGREGATE IMAGE: STRUCTURE AND SCALE

As stated in the introduction, this book is about what I call the grammar of photographic language—the four elements that comprise the technical foundations, as well as dictate the visual outcomes, of all photographic images. Framing, focus, and how time and motion are rendered are all associated with post-capture image production, but first they are camera and capture controls. The final element, *materials and processes*, is different from the first three in that it isn't related to camera controls; this element is significant because it's the physical stuff of which images are made. It's what literally records and holds photographic images, thereby contributing to their appearance and meaning.

The aggregate image consists of two broad categories: image structure and image size/scale, each of which has several qualities and considerations. The first of those, *image structure, consists of light, tone, tint, and texture.* We'll discuss those attributes first and then move on to the physical space of the image, its size and scale. Afterward we'll touch on how images exist in the world and a few of the considerations you might take into account when you put them out there, in particular in a gallery or exhibition setting.

Light

The majority of traditional and digital, black and white, and color images captured are made from *panchromatic materials—photographic media sensitive to all colors in the visible spectrum.* Within that spectrum lies our control over *the intrinsic appearance of images: density, contrast, and color.* These attributes must exist for us to see images at all; as such they're often intellectually transparent when we interpret images, because we tend to look at contents and composition first. But the seamlessness with which they affect images makes density, contrast, and color invaluable in communicating to a viewer's emotions and subconscious.

Density and contrast refer to the *tonal values* of the image; they result from the quantity and quality of light striking the medium. *Density refers to the relative lightness or darkness of an image.* Increased density (as we know from Chapter 2) means a darker image and decreased density means a

lighter image. *Contrast refers to the difference between the darkest shadows and lightest highlights in an image.* Increased contrast means greater difference between the image's shadows and highlights and decreased contrast means less difference between them. Density and contrast each work on a separate continuum and dramatically affect the mood of an image. Density's light extreme is a "high-key image," and its dark extreme is a "low-key image" (also discussed in Chapter 2); the high contrast extreme has no gray tones and the low contrast extreme has no black or white tones. None of these is right or wrong, they are aesthetic decisions that move closer to or farther from supporting the image subject. Think about the style of images you're attracted to (look over your tear sheets, discussed in Chapter 1). Are they dark and brooding with very few highlights and detail-less shadows? Thinking connotatively and emotively, would this type of look (density and contrast) work with the subjects you shoot? Why or why not? If so, learn how to make your images reflect your vision, and if not then define what type of look would reflect it. Either way, help comes in the form of understanding light.

It's not only the amount of light in the scene and reflectance value that affect density and contrast, but it's *the color of light* as well. Therefore, the color of light affects even tonal aspects of image appearance, and how it does so isn't as difficult to understand as you might think. The premise lies in the primary colors of light; all you need to know is how

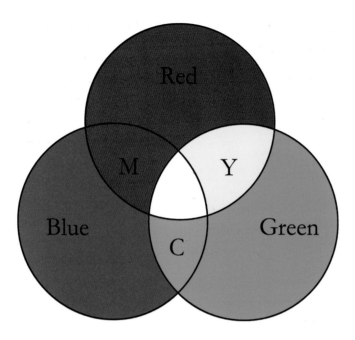

The light color star. The first thing you'll notice is that it's not the same as the pigment color star (ROYGBIV, which refers to printed color). The light color star is a simple way to understand how light affects not only color but also density and contrast. The primary (additive) colors are red, green, and blue. The secondary (subtractive) colors are yellow, cyan, and magenta. By combining equal amounts of two adjacent primary colors, you form a secondary color. You know this works only for light (and not pigment), because while combining red and green light will make yellow light, combining red and green paint will not. The colors opposite other colors are called complementary colors, they are red-cyan, green-magenta, and blue-yellow. Complementary colors absorb one another, and the degree of absorption depends on their saturation and value.

your media responds to them in order to control them. *The primary colors of light are red, green, and blue (RGB); traveling in wavelengths they combine to varying degrees to create all the colors we see. These colors affect density, contrast, and color based on the degree to which they reflect off of objects in the scene and are recorded onto the medium.* An object is red because it reflects red spectrum light more than the other colors, whereas a cyan object reflects both green and blue light (see the light color star illustration and description). There's no need to get into its physics; a basic understanding of panchromatic sensitivity allows you to adjust the appearance of your images.

An important aspect of the color star is *complementary color contrast—whereas like colors transmit, opposite colors (complements) absorb one another.* That the colors work on a continuum of hue, saturation, and value allows them to affect the image density, contrast, and color in endless configurations.

Color is inseparable from light, and light is inseparable from exposure. Even pure white is made of equal amounts of all three primary colors, and black is the absence of all light. And because increased light leads to increased exposure, increasing light of a certain color increases exposure to that specific color. These principles hold true for any panchromatic photographic process, from historic ones to digital

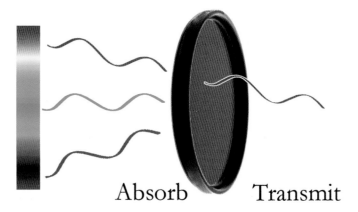

Absorb Transmit

Absorption and transmission. There are five ways to affect light: you can transmit it, absorb it, reflect it, refract it, or diffuse it. In terms of surface appearance, absorption and transmission are the two to understand. They dictate the density, contrast, and color of all images. The visible light spectrum (the amount of light in the scene) reflects to varying degrees from the scene toward the photographic media. If, say, a red filter were placed between the world and the camera, then there will be more exposure to red light than to green and blue. Color materials will look redder, but black-and-white materials will be affected in contrast—red objects in the scene will become lighter (because of the increased exposure from transmitted red light) and complementary colors in the scene will become darker (because of absorption). You can use this knowledge when shooting traditional black-and-white materials or when converting digital color images to black and white.

ones. That's what makes understanding the color of light so powerful. Because it works across the range of photographic media, perhaps the easiest way to demonstrate how it affects density and contrast is to look at a color image broken into

its component parts, as in the following images of red chili peppers hanging out to dry.

In the digital darkroom when you set the individual RGB color channels to 100% of any color and 0% the others, it's like shooting with color contrast filters for black-and-white film; the red filter transmits more red light to the medium and absorbs the others, making red objects lighter in the scene and opposing colors darker. Note the dramatic difference in contrast among the three images, while their overall density remains the same. The digital darkroom offers nearly unlimited potential for altering density, contrast, and color, far beyond that which can be achieved with traditional materials. There are many outstanding resources available to improve technical skills and expand your creativity; just research topics like "digital image management" and you'll find plenty out there.

Tone

Although the two terms are often used interchangeably, for this discussion I'll use *tint* to reference a substrate's color characteristics (the paper, fabric, etc. on which the image is printed) and I'll use *tone* to reference the image material's color characteristics (the emulsions, inks, etc. that form the image). They are separate aspects of image structure.

The second characteristic of image surface structure is its tone—the color characteristics of the image material,

PHOTOGRAPH © ANGELA FARIS BELT.

Black and white comes from color. A digital color image looks much the same as a traditional color image because both processes use panchromatic light sensitivity. Panchromatic materials capture red, green, and blue light to create full-color images, and even traditional black-and-white negative film does so. Both of these images contain density, contrast, and color. All panchromatic black-and-white images can be separated into their component primary colors (called "channels" in the digital realm). This black and white is how the image would be rendered when converted to grayscale using Photoshop's default settings or when captured, processed, and printed without manipulation in the traditional darkroom. In Photoshop, the default grayscale settings are red 40%, green 40%, and blue 20%, which gives you a decent looking black-and-white image. But knowing that all three-color channels make up the image, you can mix them to customize density and contrast. There are similar controls with traditional materials, including filtration for capture and printing. We'll touch on these things in this chapter, but part of the process is researching how to use your materials so you can apply the elements of photography.

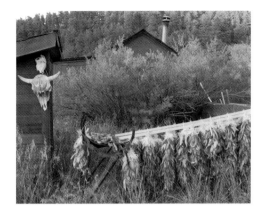

Red channel 100%.

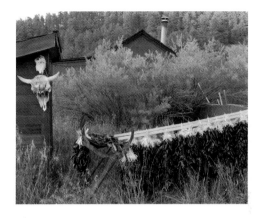

Green channel 100%.

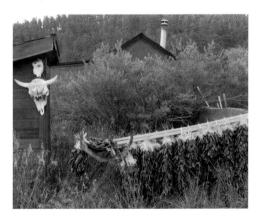

Blue channel 100%.

Three separate color channels as seen in black and white. Panchromatic images are made of red, green and blue colors. When combined they make a full-color image; but when they're separated into individual "channels" in the digital realm, you can use them to control image contrast to minute degrees. Here, the red chili peppers are brightest in the red channel, because they reflect red light and therefore increase red exposure (increased exposure to a color means that color becomes brighter). The same peppers are nearly black in the green channel, because green is nearly opposite of red, and the red light reflecting from the peppers is absorbed, causing less exposure. It might sound complicated, but you can be a color pro with just a little research and time spent using Photoshop's color channels.

the emulsions, dyes, inks, etc. that form the image on the substrate. When referring to tone we have to think of the attributes of color that compose it. Color has three qualities—hue, saturation, and value—and each affects the look and feel of the image differently. These qualities can be adjusted separately or in combination with one another to make your images look the way you want them to look. Read on.

HUE: THE ACTUAL COLOR AS IT APPEARS WITHIN THE VISIBLE SPECTRUM

Hue is a powerful communicator of feeling and emotion, and as we look at color in the world we have subconscious emotional responses. Warm colors (reds, oranges, yellows) evoke warm emotions; these emotions range from literal feelings of warmth or comfort to more harsh feelings from anger to hostility. On the opposite side of the spectrum, cool colors (greens, blues, purples) evoke cool emotions such as calm but can also associate with more depressed feelings from sadness to indifference. Photographers can choose the colors in staged scenes (like still life), but most scenes have their own colors (their own hues), and our response to it is what attracted us in the first place.

This photograph's hues are dramatic; the warm orange flowers starkly contrast the cool green foliage. The colors in the photograph are those reflected from the objects themselves,

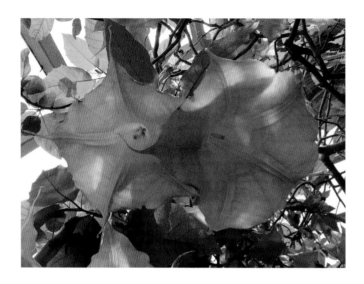

and exist along the visible light spectrum. You'll see that we can change specific hues in the image without affecting the other two attributes of color (saturation and value).

SATURATION: THE PURITY OF A COLOR

Saturation affects the intensity of color in an image and by extension affects the intensity of the viewer's experience. Desaturating an image in effect removes color, whereas saturating it adds color. We have emotional responses to saturation just as we do to hue and value: desaturated color is quiet, and saturated color is loud. These connotations are important considerations when printing images to view. Extreme desaturation is a grayscale image.

Lowered Saturation (more gray) Normal Saturation Increased Saturation (more vibrant)

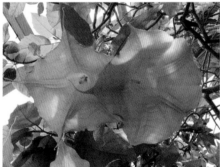

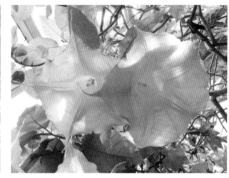

Darker Value Normal Value/Brightness Brighter Value

VALUE: THE RELATIVE DEGREE OF LIGHTNESS OR DARKNESS OF A COLOR

Value (also called brightness) is the third aspect of color; it is like adding white or black to a particular color of paint—the color is there, but it becomes either lighter or darker. Darker values range from feelings of stability or concreteness to oppression and foreboding, whereas lighter values range from feelings of ethereality to ephemerality and even youth.

Traditional Darkroom Tone Considerations

The first thing to recognize is that color exists in the traditional black-and-white darkroom as well. There are two aspects of all darkroom prints that affect their color tone: the chemical processes used in developing and the paper's emulsion formulation. Of primary importance is the paper's emulsion. *Chloride emulsions* are generally used for contact printing, as they have slow sensitivity to light and will often fog before an enlargement can be made; they tend to produce extremely warm tone prints. *Bromide emulsions* are generally used for making enlargements, as they are more sensitive to light; they tend to produce colder tone prints. *Chloro-bromide emulsions* are (as you might suspect) a mixture of the two and can produce exposure and color qualities anywhere in between, depending on the ratio of chloride to bromide. This describes the way typical over-the-counter emulsions respond, but it also illustrates that all light-sensitive chemical emulsions have distinct tonal properties.

Because darkroom processes are chemical, you can alter the tone of prints by using other chemicals. There are two common means of altering the tone of traditional darkroom grayscale images: sepia toning and split toning. Sepia-toned prints come in a range of rich, warm brown colors, whereas split-toned prints have warm highlights and cool shadows (generally made by submerging a warm-toned paper in a

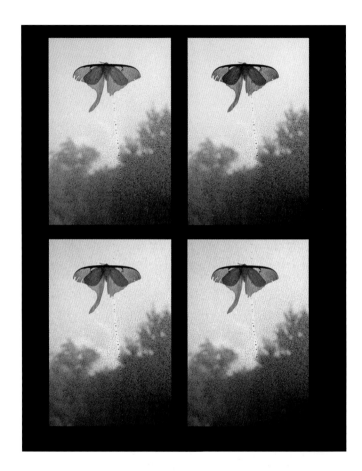

PHOTOGRAPH © ANGELA FARIS BELT, *LUNA MOTH.*

So many tones. The color and tone of an image greatly affect the way it is perceived, and the choices are limitless. Clockwise from upper left: the original digital color image, a grayscale version, a split-toned version, and a sepia-toned version.

concentrated selenium bath). Many other types of toners are available as well, and with a little research you can discover the tones you like. Each toning process requires special chemicals widely available through photographic chemistry suppliers, and each must be handled and disposed of appropriately based on their toxicity. There are other ways to tone prints; some photographers even submerge their processed prints in tea (yes, the kind you drink) to "stain" the print to a particular tone. As is the case with so many aspects of photography, these and other toning effects can be replicated in the digital darkroom; all it takes is some research into using the RGB channels to create the tones you want.

The second important darkroom consideration is that whereas traditional black-and-white film is panchromatic, *black-and-white darkroom printing paper is orthochromatic; it is only sensitive to green and blue light* (which is why you can use it under red safelights). But multigrade or variable-contrast papers operate on the same principles as digital channels to allow you to control contrast. The emulsion is sensitive to green and blue light. Green-sensitive silvers provide lower contrast, whereas blue-sensitive silvers provide higher contrast. When the contrast filter is lowered from the baseline (usually #2 to #2½ filter), it gets increasingly yellow in color, blocking blue light from exposing the paper and thereby lowering the image contrast. When the contrast filter is raised above the baseline, it gets increasingly magenta in color, blocking green light from exposing the paper and thereby increasing the image contrast.

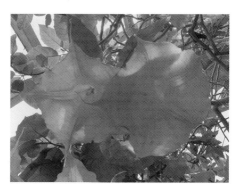
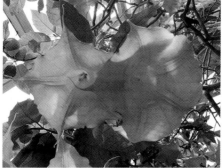
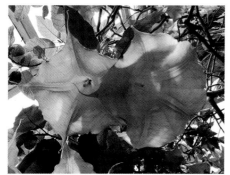

Lowered Contrast Normal Contrast Raised Contrast

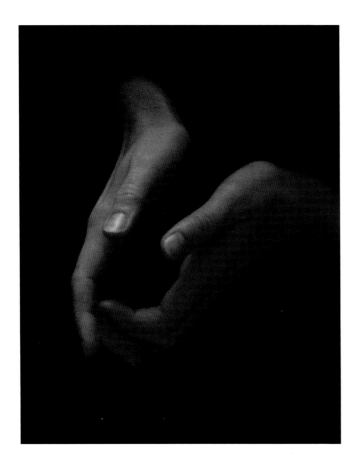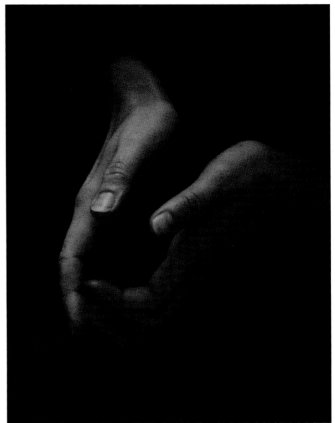

PHOTOGRAPH © JENNIFER HARDMAN, *HANDS***, 2007.**

Digital tint, tone and texture. Understanding how toning and special effects work (even things like infrared film) in the traditional darkroom enables you to create similar effects in the digital darkroom. To sepia tone a digital image, it helps to know how sepia toning actually looks; to create grain structure in a digital image, it helps to know how the grain structures for various films look. Both of these images are lovely on their own: on the left is the original digital color image captured under warm tungsten light, and on the right is the same image converted to black and white with a grain and sepia effect applied.

Tint

An often-overlooked attribute of image structure, *tint refers to the substrate's color characteristics.* Substrates are generally papers; some papers look warm, some neutral, and others cold. Some papers look bright white, some natural white, and others dingy white. There are less common printing materials as well, such as linen, canvas, and other fabrics as well as metallic substrates. Alternative substrates to which photosensitive emulsions can be added range from fine art papers to clear glass.

The substrate's tint is a factor in both traditional and digital imagery. While presensitized traditional darkroom substrates are becoming more limited, precoated inkjet substrates are becoming more varied. In addition to using coated substrates, some artists use traditional watercolor papers and other materials to coat with their own emulsions or to print using pigment or dye inks. Other artists transfer traditional or digital images from one substrate onto another, similar to traditional Polaroid transfer techniques. The results of these printing methods vary as widely as substrates themselves; once you find a look you like, you can apply it to your images through a little research and experimentation.

Texture

The final aspect of image structure is its *texture—the visual and tactile quality of an image surface.* Image texture comes in two varieties: perceived and physical. Perceived texture refers to the way the light-sensitive medium's configuration (what it's made of) affects the "embedded" visual texture of the image. Perceived texture isn't texture you can feel, but it is texture you can see, which makes it a potentially powerful communicator. Physical texture refers to the substrate material's tactile qualities, to how it actually feels and how its surface affects image appearance.

PERCEIVED TEXTURE: GRAIN AND NOISE

The first kind of image texture results from the capture media, in particular after it is enlarged. It's usually difficult to discern a particular medium's texture at actual size, but as it's enlarged it becomes increasingly apparent. Because light-sensitive media is itself a physical object, perceived texture comes from its composition becoming embedded within the image itself.

Traditional film is made of millions of tiny light-gathering particles (usually silver) called "grain," and digital sensors are made up of millions of light-gathering cells called "pixels." While both types of media have similar attributes regarding light-gathering ability, their textures are vastly different. Film grain tends to have a random pattern that is often visually appealing, but digital pixels are identically sized and spaced, making their appearance rather homogenous and visually unappealing. This explains why many photographers manipulate perceived texture in the digital darkroom, to bring a more unique and organic look to their images.

The light-gathering ability of photosensitive media is rated by the International Standards Organization; the lower the ISO rating, the slower the media responds to light to record an image. (ISO is explained in Chapter 2.) As a general rule, slower ISOs produce images with finer grain or noise; faster ISOs produce images with larger or more apparent grain or noise. The reason is that with traditional film, the faster the ISO, the larger the actual grains of silver have to be to provide a larger surface area so light renders an adequate exposure faster. With digital media, the effect is similar—increased noise with increased ISO—but the reason is different; digital sensors are optimized at their slowest ISO, and the electrical signal created upon exposure to light is amplified when you move to higher ISOs, thus rendering faster exposure but with noisier image quality.

The following example represents a digital image captured at both 100 ISO and 3200 ISO sensor speed ratings. The blown-up versions show the increased noise caused when a faster ISO is used.

Generally speaking, photographers choose the ISO rating to best suit the lighting condition and exposure needed, but often the decision about ISO can be made for purely aesthetic or connotative reasons. For example, consider that because a slower ISO medium creates a finer image, it might communicate more seamlessly or transparently about a subject, whereas a faster ISO medium might draw the viewer's attention to itself through added texture. In addition to the capture material's ISO characteristics, the processes used in the traditional or digital darkroom can emphasize either extreme, so mixing the materials and processes together enhances your ability to communicate to your viewer.

Perceived texture sets a sort of backdrop for the image; it's the subtle, underlying "background noise" created by the way the light-sensitive medium looks. Consider for what subjects you might navigate toward a particular quality of perceived texture. For instance, imagery about difficult subjects (poverty, war, disease, social injustice, violence, etc.)

PHOTOGRAPH © ANGELA FARIS BELT, 2007.
Original full-frame capture.

100 ISO: Increased Clarity and Detail Less Noise or Grain

3200 ISO: Less Clarity and Detail Increased Noise or Grain

created with enhanced grainy, gritty texture, when used right, can deliver an edgier, more visceral experience for a viewer than the same imagery using the finest grain structure. The potential impact of emphasizing the light-sensitive material's structure for emotive quality is apparent most famously (or notoriously) in Robert Frank's *The Americans*, as well as in his contemporary William Klein's work. (If you don't know these two photographers, conducting some independent research will prove rewarding.) Smooth, silky imagery minimizing the light-sensitive material's structure is in many ways at odds with the types of intellectual and emotional responses these subjects are intended to evoke.

Physical Texture: The Substrate Material

The second kind of texture, *physical texture refers to the tactile qualities of the substrate the image is printed on—how it feels, its smoothness, sheen, and so on.* Substrates have several levels of texture that imprint themselves onto the final image; they

range from smooth to coarse, soft to rough, high gloss to matte, patterned to random textured surface, heavy to lightweight, and thick to thin material. These textural qualities affect how the image tone is applied to (and accepted by) the material, how the image emerges from the substrate, and provide another level to engage with the work. They also affect how materials should be handled (i.e., many high-gloss materials must be handled with extreme care because they are prone to surface scratches, and many watercolor papers need to be brushed off with a drafting brush prior to printing in order to dislodge cotton particles, which will flake off when printed and dried).

Controlling your image texture is challenging and rewarding, and once you really look at the full range of substrates out there you can start to use it conceptually. Even darkroom photo paper can be used to add perceived texture in that a unique texture comes from printing through it. To do this, place photo paper into a 4" × 5" film holder or at the film plane in any film camera and expose it to light (depending on the paper, your ISO will range from 4 to 200, so testing is required). Once you've exposed each sheet, process and dry the paper as you normally would in the darkroom (you'll have a negative image). Then place the paper into a negative carrier or contact print it (if the negative size is what you want the positive to be) using a long exposure time (the light has to go through the paper) to make a positive image. You can still focus the images using a grain magnifier, and you

can still manipulate them (dodge, burn, tone, etc.) just like their film negative counterparts. Images from paper negatives feel "soft" because the substrate (paper pulp or cotton fibers) diffuses the enlarger light, and the substrate's textural patterns can be become evident as well. In addition, the degree of enlargement affects the softness and texture of the projected image—the larger the print, the more pronounced the perceived texture. Digital photographers can achieve the look of paper negative images by scanning the processed image to process and print digitally.

Above, a single video frame edit; on the following page, a greatly enlarged detail. Image (C) Anna Norton.

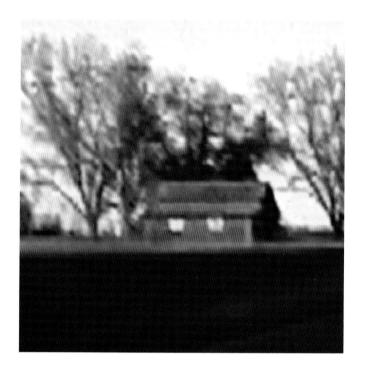

PHOTOGRAPHS © ANNA NORTON, FROM *THE ROAD TO STILLMORE*, 2006.

The texture of video. Photographer Anna Norton found a way to make her images match her concept for them. Using a video camera, she captures multiple, rapidly sequenced frames and later edits them to a single frame, which she enlarges considerably to 24" × 30". The resulting image quality creates painterly, impressionistic photographs when viewed from a distance; however, from close range the forms within the landscape break apart into almost pointillistic digital textures. Although the video is captured moving through a particular place, the edited scenes leave the viewer with a generic sense of it and a blurred sense of materials, past and present. See more of her work from this series in Chapter 5 Portfolio Pages.

Light, tint, tone, and texture are material aspects we use to create photographic objects with their own lives in the world, objects that are created and characterized by their physical nature. Through their materials and processes photographic images take on unique appearance, and combined with their content and form they affect viewers' interpretations of a subject. Decisions regarding all aspects of image making are important throughout the process, and research and experimentation are invaluable guides to give you the experience you need to make images communicate the way you envision.

IMAGE SIZE AND SCALE

In addition to surface structure, consider that because they are objects, the size and scale of images (relative to their environment as well as our own size) also contribute to their meaning. Just as materials and processes allow us to see photographic objects, their size and scale allow us to physically relate to them. And just as focus and time swing along continuum, size and scale provide a range, too. As is too often the case, *the determining factor for the size of your printed images* shouldn't depend on current trend; rather, it *should depend on what its size says about your subject*, as well as practicality (what's the end use of the image, and what's an appropriate size for this use). So if size and scale contribute to image meaning, how do you choose what size to print them so they best represent your particular subject?

In her critical text *On Longing*, Susan Stewart astutely recognizes that "The body is our mode of perceiving scale." Our perception of size and scale outside ourselves is relative to our own (human) size. Stewart says that "The miniature is … a metaphor for the interior space." This is why small things feel personal, secretive, sensual, precious, private as a family snapshot, or at times sentimental. On the other hand, she says that "The gigantic is considered as a metaphor for the abstract authority of the collective state and the collective, public life." Large things are engulfing, overpowering, and can be seen by many viewers simultaneously, making experiencing them rather impersonal; they are the shopping mall to the mom-and-pop store of small things.

Two contemporary artist-photographers come to mind when I think of size and scale. First, the team of Mark Klett and Byron Wolfe (see their work in the Chapter 3 Portfolio Pages), whose prints can engulf a space as large as 4' high × 12' wide. The contents of their images directly refer to their subject—the western landscape and its history of change—both of which are decidedly expansive (the grand landscapes themselves, and the space of time separating their montaged images). Their views are wide enough to visually overwhelm us, dwarfing our own physical size; and they are often taken in by crowds of visitors who flock to these remote locations, making them public spectacles. Even in the largest gallery space, Klett and Wolfe's prints are also as overwhelming as the landscapes they depict, allowing crowds of people to view them at once. Experiencing them feels public and collective through their size and scale relative to the space and our own size.

On the opposite side of the size-scale continuum exist Japanese artist Yamamoto Masao's series *A Box of Ku*, *Nakazora*, and *KAWA = Flow*, in which each unique image is small enough to fit in the palm of a hand. In his work, not only does scale feel intensely personal, but his traditional darkroom print surfaces feel as though each image has had its own life in the world, outside of the gallery. Their borders and edges are uneven, the physical picture planes interrupted by creases and stains, making them feel as though they have lived in a pocket. Their scale within the gallery space makes them feel simultaneously universal and personal, and speaks to the understated beauty of their varied and quietly framed content.

Image Discussion 21: In the Gallery

How did you get interested in the dynamic between the individual image and its relation to the whole? What is the nature and meaning of that relationship as it helps the viewer better understand your photography?

My earlier series of A Box of Ku and Nakazora are small photographs that are both individual works and elements of installations. The sizes of these prints are anywhere between 2 inches and 6 inches.

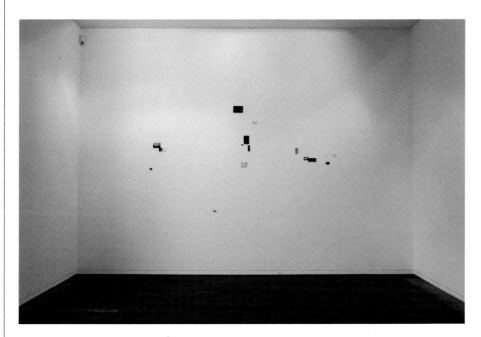
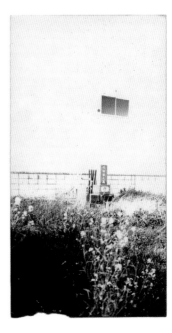

Yamamoto Masao; installation view and reference image for size and scale. (*left*) Installation at Forum Fotografie, Kolon, 2009. Unframed, small prints are the artist's installation styles for *A Box of Ku* and *Nakazora* series.

IMAGES © YAMAMOTO MASAO, NO. 103 FROM HIS *KAWA* = *FLOW* SERIES.

Vast landscapes, societies, countries, and space are all made from smaller parts. These small things do not only exist as elements that make up the whole; they each have their own story, as everyone has their own life. Under the rock there are thousands of baby ants being born, caterpillars are eating leaves, birds are being attacked by cats—small events are taking place in the continuous flow of time. Searching for beauty within these easily overlooked small events.

Why did you exhibit these images as unframed, snapshot-sized prints?

Unframed, small prints are all from my earlier A Box of Ku and Nakazora series taken before 2008. In 2008, I started KAWA = Flow series, which are singular images and larger in size. The following passage explains how I moved from "dispersion" to "concentration." Up to now I have been working in the form of installation. What overflows from one photograph would flow into the next piece, and in twos and threes, the groups would create a combined effect, like the layered notes of an orchestra. But recently my thoughts are more focused on the individual incident—the urge to dwell deeper into each element is rising slowly.

This text from an earlier interview offers us insight into Yamamoto Masao's choices in image content as it relates to

their very small scale. Too, he reminds us that a series doesn't have to consist of repetitive variations on a theme; rather, it is held together by the artist's vision of an overarching subject all its images share.

The small scale of these images makes looking at them an intimate experience, like holding a personal snapshot. There is no way to engage them without physically moving close to them, and the experience cannot be shared simultaneously with many viewers. Additionally, precious images we hold over time begin to show signs of wear, signs that exist in Yamamoto Masao's images before he places them on the gallery wall. Though he looks at universal things, he does so in a highly personal way, and through his approach extends an equally personal experience to viewers.

The final aspect of the images as they exist in the gallery is the configuration they take within the viewing space. In his earlier works he "scatters" the images, establishing a rather sporadic flow to our viewing experience, which, like life itself, offers treasures and transcendent experiences unpredictably spaced. His newer series, however, are displayed as evenly spaced (a more traditional gallery-style installation), as he says, "moving from dispersion to concentration," focusing viewers more on individual image content than the experience.

PART 2: HOW IMAGES EXIST IN THE WORLD

How many Americans, in particular those interested in U.S. history, have read the Declaration of Independence (or the Bill of Rights or the Constitution) in a textbook or online? If the influential document's words move you, how much more so would they if you read the original, hand-written on parchment document in the National Archives? What makes being in the presence of the physical document imbue its words and their message with more power? Perhaps it allows us to connect, through time and space, with its authors. Perhaps we recognize that the object itself bridges time and space, its physical presence a testament to the enduring nature of the things we create. The central component of a work that loses impact in a reproduction is its *form*, or at least part of it. The subject (or theme) and the content (in this case words) are reproduced, but the physical object (the color of ink, quality and tone of parchment, style of handwriting, etc.) are lost. As are its size and scale in relation to our own physical selves, which is central to communicating its nature.

A discussion of the Declaration of Independence might seem misplaced in a book about photography, but it isn't. Like this document, every aspect of a photographic object holds significant meaning. When photographers intend our images to take a particular physical form beyond the camera's latent image, it's important for viewers to experience them that way. And although reproduction in various forms lets us share them with a wider (even global) audience, copies will always fall short of transmitting an experience of the thing itself.

We've discussed *what* images are made from, and what their size might convey, but what about *where* and *how* they exist in the world? We all know that photographs are ubiquitous—they exist in matte low-fidelity newsprint, high-gloss magazines, on-screen—we see them in family albums, museums and galleries, on billboards and in books. Where they're to be seen and how they're perceived in various contexts is far too large a topic to fully address here, but it helps to consider a few aspects specific to gallery exhibition to get you thinking about this particular context.

FINAL PRESENTATION IN THE GALLERY

Much like carrier-edge borders can imply a world extending beyond the frame's boundary, presentation methods act as extensions of the work, and gallery spaces (or alternative means of sharing images) operate to contextualize the image. It does so in that everything we see before and after the image, everything adjacent to the image, and the conditions of the gallery environment impose themselves to a certain degree onto the images, affecting viewers' interpretations. This principle is further examined in the Image Discussion of Susan Kae Grant's work.

Image Discussion 22: Experiencing Images

After a long day of looking at images behind glass on gallery walls, I walked into Susan Kae Grant's *Night Journeys* exhibition and was given an experience that I had not gotten from any of the previous exhibitions. I am a strong advocate of the lasting validity of traditionally framed photographs; single images set inside window mats and behind glass will always communicate powerful insights and create intense emotional connection with viewers. But in this case, the way the images existed as objects, their scale, and the way they were displayed all spoke to Grant's subject in a eerily visceral way which brought them to life within our physical realm.

The humans, animals, and objects are shadows printed on extremely fine fabric which offers only hints of things behind them. Their large scale frames make these larger than life-size figures, and creates ghosted walls throughout the

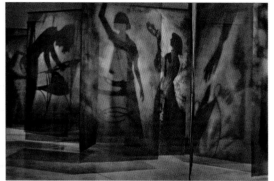

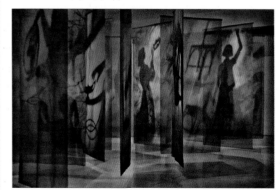

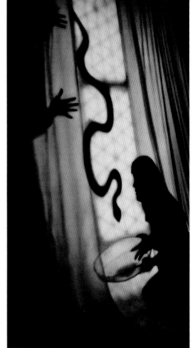

Photographic panels are 4' × 8' heat transfers on chiffon fabric, installed in 36' × 40' gallery space with sound track.

SUSAN KAE GRANT, FROM *NIGHT JOURNEY*; GICLÉE PRINTS (*RIGHT*), ARE 32" × 43.75".

room. Displayed loosely hanging, they move with the slightest breeze of passers-by, who can follow dimly lit paths among the tapestries. These images, their materials, processes, scale, and installation undeniably communicate the mysteries that exist in the night. No one aspect of the images is sufficient to communicate all that they as objects do. Through their combined content and form, their effect is at once quiet and disquieting, much like dreams that wake us in the midst of night.

Framing behind Glass

Photographs are most often displayed behind glass with a window mat extending beyond the image area, ending with a frame that holds the whole thing together. Window mats provide breathing room around images to help isolate them within our field of view, but they also prevent prints from resting against the glass (never a good idea because it deteriorates their surface). *Frames separate the matted space from the wall, and provide a final border outside of which the photographic object does not exist.* When your images are surrounded by the right mats inside the right frames, the combination works very well; when they're not it can really detract. In this section I'll offer some information about framing and presentation to give you a basis for getting started. Like everything else, additional research into materials and services is the only real way to choose the perfect way to present your work.

Your first consideration is "to glass or not to glass." And if you choose to put prints behind glass, it's important to know the available options, and which are best suited for your needs. This consideration is like choosing the right eyeglass lenses; it affects the way anything you see through it will look. The higher quality the glass, the better your images will look, but like for an athlete in a contact sport, maybe plastic lenses are safer even if they're not quite as clear.

There are several types of glass and Plexiglas made specifically for framing purposes, and both have benefits and drawbacks to consider that range from clarity to UV protection and from stability to weight. The best way to understand how the various kinds of glass look is to go to a high-end local frame shop and ask to see them.

The first consideration is clarity, and glass is king, but most glass is also highly reflective, and nothing is worse than wanting to see photographs on a gallery wall and more clearly seeing the room behind you and reflections of spotlights everywhere. The problem of reflectivity is solved with nonglare glass, which reduces reflections but can have a

foggy appearance. The second consideration is that ultraviolet light passing through it can destroy photographs; while glass manufacturers make UV-coated products, they can be distinctly hazy when they are thick enough to be effective (the thicker the material, the more UV they absorb). So how to provide a clear view to prints, avoid reflections, and simultaneously protect them? Though it's quite costly (up to five times more expensive than regular glass), the best option is to frame behind "museum glass," anti-reflective coated and UV protected glass that's so clear it's virtually invisible. For valuable or collectible photographs that will hang in your home, as well as your own artwork for display in high-end galleries, museum glass highlights your work the best while protecting it at the same time.

Whenever possible, the choice for framing two-dimensional work should be glass, but its drawback is its fragility—it's highly breakable, especially when shipped, and when it breaks it usually irreparably scratches and punctures the print (and that's never good). If you're going to ship framed work, then Plexiglas is the best choice; it's shatter-resistant and comes in clear grades for framing. It can also be purchased UV coated. However, the drawbacks of Plexiglas are that it scratches easily and adding UV protection makes it look foggy. Handling all framed artwork with care and shipping it in soft sleeves intended for that purpose can help alleviate scratching. And clarity is a check and balance

really; what's your priority and how can you meet it? If your work won't hang in direct light for long periods of time you can go without UV coating.

Another method of framing is to "float" the work behind glass without a window mat. This method is a bit more austere than window matting in that there is nothing present but the print inside the frame. It's done by adhering the print to a backing board on the rear of a deep frame (1 inch is often sufficient) and running spacers along the frame-edge channels to prevent it from moving forward inside the frame. This way the print is protected from contact with the glass, and you still have it framed.

Avoiding Glass Altogether

If you want to avoid putting your images behind glass there are several ways to do it. The methods I'll discuss are often better done by professionals, because they rely on specialty materials, and even the smallest speck of dirt can ruin an entire image. For about the last decade the trend in galleries has been to liberate the photographic object from behind glass, giving it presence like a painting by eliminating the barrier between it and the viewer. There are two basic alternatives to traditional framing, though they can be used in conjunction with frames if you prefer. Like the materials and processes you choose, the way you want your images to look is the deciding factor in framing decisions.

FLUSH MOUNT

The back of a flush-mounted print is adhered to a rigid substrate, commonly gatorboard, aluminum, Sintra, or Dibond, so it's ready to display and protected from crimping and bubbling. Because the print's surface is exposed, it is then sprayed with a matte, luster, or gloss protective UV coating that also helps prevent scratches. The advantage to flush mounting is that, like printing on canvas, there is nothing between the print surface and the viewer. Also, flush mounting provides two options: you can choose to mount the image "full-bleed" so that the backing material ends at the print edge, or you can allow some of the backing material to show around the image area, separating it from the surrounding environment like a mat (substrates like brushed aluminum look beautiful around the right images). Flush-mounted images can also be recessed into a frame of any depth, which helps to give the piece dimension.

FACE MOUNT

Face-mounted prints are adhered to an ultra-clear sheet of Plexiglas using ultra-clear adhesive, a process definitely best performed by a professional. Face mounted prints don't look much different from having glass in front of them in that there is a clear barrier between the viewer and the image. However, the Plexi becomes part of the image surface, and allows for no mat and no frame so the image "floats" on the wall and can be regarded all the way to its edges. This method can be particularly good for images shown in grids because they can interact with one another without a frame border between them.

OTHER MOUNTING ALTERNATIVES

Some photographs just don't look right behind glass, flush mounted, or face mounted, and some photographic processes won't even allow for it. Depending on the materials and processes you use, you might have to be inventive in your means of display. For instance, if your photographs are integrated into 3-dimensional sculptural forms, you might need appropriate pedestals to to place them on; if your images are on glass plates, then you might need small shelves with light behind them, and so on. The possibilities are endless. Photographs and their objecthood will suggest appropriate methods of presentation, and looking at a lot of work in galleries, online, and in your tear sheets will expand your knowledge of the range of possibilities and provide food for thought.

BACKING CHANNELS

Backing channels are made from lightweight aluminum channel material and are configured in a rectangle or square on the back of the finished/mounted image. They're like smaller frames adhered to the back of a face- or flush-mounted image that allow for easy hanging and hold the image parallel to the wall. Backing channels may provide the only hanging solution for some flush-mounted images if you want the hanging mechanism to be invisible, and they allow

PHOTOGRAPHS © TRACY LONGLEY-COOK, FROM HER SERIES *BEARING STILL*, 2006. DIGITAL PIGMENT PRINTS MOUNTED ON BIRCH PANEL WITH CLEAR ENCAUSTIC OVERLAY. (*LEFT*) *CAT'S CLAW*, 28" × 24" × 3"; (*RIGHT*) *RIPENING*, 22" × 18" × 3".

A process presents itself. Tracy Longley-Cook avoids glass because her nontraditional process seems at odds with traditional framing conventions. Through her tactile process of layering encaustic medium over her prints, the images glow and become seductively textured objects. She then floats them just inside wooden frames, which contain them while allowing viewers to directly experience the image surface.

the print to float in front of the wall. To hang pictures parallel to the wall without backing channels, glue "bumpers" to the bottom corners just inside the edges of the frame.

SPACING

In addition to display considerations, a significant factor in experiencing images as objects in the world is the spacing between them. In the gallery, almost by default, spacing is usually set to equal increments, creating a predictable, steady stream of images as you pass. Sometimes this is the kind of spacing you want, but often it doesn't utilize the fact that *the space between images helps to set the pace and rhythm for viewing them.* When you're spacing images in a gallery, the first consideration is what kind of spacing would best reflect the pace of the images. If there are several distinct groups

within the series, like stanzas in a poem, then maybe there are images that should act as punctuation and stand out from the others by having more space on either side of them. Second, consider how to arrange them in relation to the amount and configuration of the space they're in (how many prints versus how much space). You don't want your images too crammed or too sparse within a space; ideally you want the two to complement each other. When you're installing work in a gallery, map out the space and the images first, and then lay them out along the walls prior to hanging them so you can get a feeling for how the images and spacing work. Nothing is more satisfying than seeing your vision realized in a gallery space, from image to print, presented to its scale within the space.

Working with materials, processes, and presentation is similar to using (or making) borders for your images; anything you add to your images affects the way they're perceived, so it helps to experiment with several variations in order to actually see which work best, to see which combination of materials, processes, and presentation feels like an organic part of the images themselves.

Although the material in this chapter might seem to be beyond the scope of photographic language, it's quite similar to *style* in written language. Writers have written about the same subjects a multitude of times, but one author's poem about dreams is different from another's and is different from a novel about the same subject or a research paper about it, and so on. Their uniqueness might not be found in the subject but in how it's presented. These are the considerations that turn photographs into experiences for viewers, and when you enhance their experience without overpowering the imagery, you've created a successful aggregate image.

CHAPTER EXERCISES: EXPERIMENTING WITH THE AGGREGATE IMAGE

This final chapter's exercises are designed to get you carefully considering the materials and processes you use to make your photographs and to determine if those materials and processes help your images communicate what you want them to. Try a variety of capture and output methods, and consider the ways in which the materials and processes you use imprint themselves on your images.

1. **Changing Media**

 This exercise gives you the reason you need to experiment with some photographic processes you've always wanted to try but never had the time. We're all attached to some photographic material and processes, and sometimes we're so attached that we can't even think of anything better. But there are other processes with visually attractive aspects to you—maybe it's the texture of paper negatives, maybe it's the surface aberrations that occur when Polaroid Type-55 film processes too long, maybe it's a plastic lens, or maybe it's the way digital print transfers look. Whatever it is, think about ways to incorporate it

into making some images about your subject. Don't let traditional versus digital boundaries stop you; traditional media can be scanned and digital media can be output as enlarged negatives onto transparency film so that the images can be printed in the darkroom. The key is not to switch processes, but to find ways to bring the visual attributes you like about another process into your own.

2. Presentation

Whether you want to enter it in a gallery show, give it as a gift, or hang it in your own home, by this time you've made at least one image that you really connect with and that you know works well on visual and communicative levels because of your use of photographic language. That's the image you should choose to finish for display (you can finish several images for display, but depending on cost you might start with one).

Process and print several versions of the image—in color, black and white, or some other tone you're considering. Print the toned image you like best in a variety of sizes to see which you respond to most. Then print it on glossy and matte substrates also to see which looks best. Discuss you results with your critique group to see which they respond to as well. If you don't have the equipment to do what you want to do, choose a good photo lab to work with. Then, using the same image, try a couple of versions of display—window mat it with a variety of sizes and tones of mat board, face or flush mount it, whatever methods you think would work best. Once you've gone through the process, get prices and go for it! Complete the image and make it an object in the world. If you're planning a gallery show of several works in a series, you might work up all of the images in similar fashion.

PORTFOLIO PAGES

The artists represented in the following Portfolio Pages engage in a wide range of photographic practices. To create their work they use traditional, digital and hybrid media, and they are conscious of (visually as well as conceptually) how their materials and processes affect the appearance and meaning of their photographs.

Like the previous chapter portfolios, the work in these pages is not *about* the processes used; rather, it consciously uses the visual outcomes of specific processes to address the subject of their images. These artists push the envelope in terms of combining and hybridizing media; they use image size and framing to affect how viewers experience the work; some use scanners and alternative means of capturing images; some consciously draw attention to processes and methods; and all of them customize the process to the meaning they wish to infuse in their images.

These Portfolio Pages are intended to inspire creative thinking and critical debate about materials and processes as they relate to the subject of the work. And I encourage you to continue looking for new photographers whose work can expand your scope of appreciation and, through practice, to find your own unique voice.

ALIDA FISH

FROM THE CABINET OF CURIOSITIES

ELEMENTS

Moving from film to digital, then to digital negatives, and finally to a contemporary version of the historic Civil War era process, Alida Fish's tintypes are their own curiosities. Like the objects she photographs, each tintype is unique. Her process allows her to create new marvels that simultaneously reflect and embody the remarkable content of her photographs, making viewers relate to her images and their contents in similar ways.

ARTIST STATEMENT

During the 17th century in Europe, some privileged individuals assembled collections known as "cabinets of curiosities." These cabinets displayed marvels that were rare, foreign, or exotic. Sometimes they contained the bizarre, the unusually large, the unusually small, triumphs of technical skill, the remarkable, and the unexpected.

I have been frequenting small museum collections looking for and photographing, in situ, objects that might have been part of a cabinet collection. In addition, I have been taking objects from my own shelves and borrowing pieces from friends to photograph in the more controlled environment of my studio.

The final prints are 8" × 10" tintypes. There is a pearly, rich patina to the surface that enhances the images' straightforward presentation. The prints have a tendency to be dark, suggesting the way one might discover the objects cloistered in a cabinet.

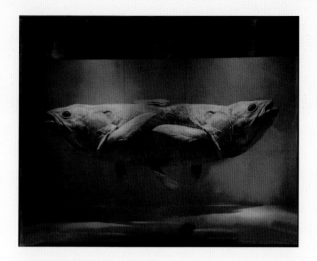

Conjoined Fish, 2006.

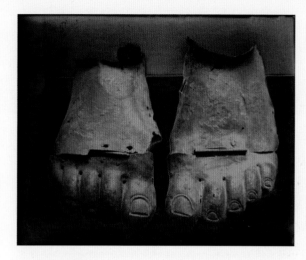

Hinged Feet, 2006.

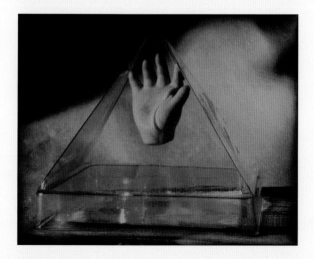

Pyramid Hand, 2007.

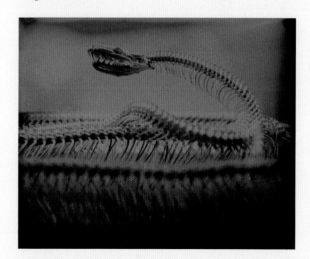

Snake, 2006.

PHOTOGRAPHS © ALIDA FISH, FROM HER SERIES *FROM THE CABINET OF CURIOSITIES*; 8" × 10" TINTYPES.

MYRA GREENE

CHARACTER RECOGNITION

ELEMENTS

Glass-plate ambrotypes are the deepest black, and hold their contents such that they beckon from deep inside. Myra Greene uses this unique historic process to refer her own cultural historic roots through the features of race. Indeed, her subject is deeply embedded in the psyche of nearly all African Americans and runs throughout our collective American heritage. That she chose a process that ran concurrent with and documented the visual history of the American enslavement of blacks connects viewers to her subject in immediate and conceptually relevant ways.

ARTIST STATEMENT

Throughout my artistic practice, I have returned to the body to explore a variety of issues. Issues of difference, beauty, melancholy sentiment, and physical and emotional recollections have played out on the surface of the skin.

Confronted with an upswell of bigotry both personal and public (the rhetoric surrounding Katrina), I was forced to ask myself, what do people see when they look at me? Am I nothing but black? Is that skin tone enough to describe my nature and expectation in life? Do my strong teeth make me a strong worker? Does my character resonate louder than my skin tone? Using a process linked to the times of ethnographic classification, I repeatedly explore my ethnic features.

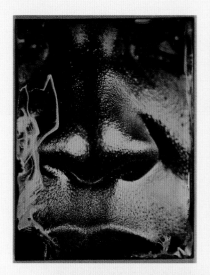
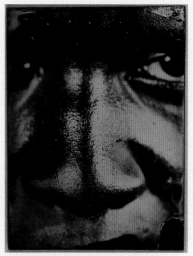
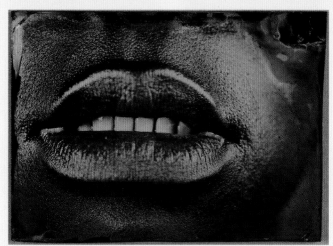

PHOTOGRAPHS © MYRA GREENE, FROM HER SERIES *CHARACTER RECOGNITION*, 2006; 3" × 4" BLACK GLASS PLATE AMBROTYPES.

CYNTHIA GREIG

REPRESENTATIONS

ELEMENTS

By removing common objects from their environments and reducing them lines and tones, Cynthia Greig calls into question our own ability to perceive the content of the photographs. *Are we seeing drawings or photographs?* becomes the question in our minds, and the answer that they're *both* makes the images all the more engaging and significant to puzzle over.

ARTIST STATEMENT

As a kind of playful homage to Henry Fox Talbot's 19th-century treatise, *The Pencil of Nature,* my series *Representations* combines color photography and drawing to create what I like to call photographic documents of three-dimensional drawings. Choosing objects from the recent past, I first whitewash them with ordinary house paint and then draw directly onto their surfaces with charcoal so that they appear to be simply sketched outlines when viewed through the camera. No digital manipulation is involved; however, the angle of view is imperative as the monocular vision of the camera's lens helps produce the illusion. The resulting images present visual hybrids that vacillate between drawing and photography, black and white and color, signifier and signified, and explore the concept of photographic truth and its correspondence to perceived reality. Examining the conventions for representing, identifying, and categorizing the world around us, the series draws attention to how we see, and it considers to what degree human vision is learned or innate. I'm interested in creating images that unite what appear to be opposites, to throw perceptual expectations off guard and subvert passive viewing. Ultimately, my photographs examine the camera's role in negotiating what we consider to be real, as well as those assumptions we might have about photography and its relationship to what we believe to be true.

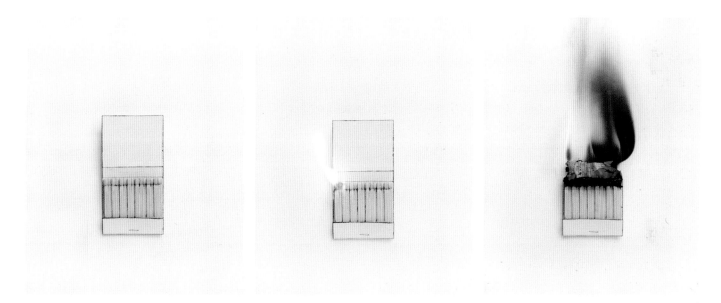

Representations # 16-18, matchbook; 10" × 28" sequence.

Representation # 65 (fan).

Representation # 38 (telephone).

Representation # 22 (black-and-white TV), 2002.

Representation # 31 (still life #1), 2003.

CARA LEE WADE

INSIDIOUS CHARMS

ELEMENTS

Through seductive textures and saturated colors that *just feel* rich and unreal, we see glimpses of coveted, yet ultimately unattainable glamour and beauty. Cara Lee Wade's combined Mordancage, oil painting, and digital media process integrates perfectly with her subject matter. Through it she makes these images as unique as they are, and able to communicate powerfully the muddied waters that divide the reality of women and our projected ideal.

ARTIST STATEMENT

Throughout history, women have put their bodies and, thusly, their psyches through torturous measures trying to live up to the elusive thing that is beauty. We have constricted our breathing and injected ourselves with poison. We have teetered precariously, balancing on minuscule pedestals. We have crafted our flesh into acceptable contours. But we have not been forced into doing so. We have consensually, if not violently, subjected ourselves to these dangerous tribulations.

This is a condition that I not only detest but also welcome and embrace. It has left me in a love/hate relationship with the idea of beauty and the quest to attain it. These images have emerged from this dichotomy. Through a combination of technical processes, I am able to merge representations of the accepted and established beautiful with those of my own manufactured grotesque. In this manner I am able to create imagery that manages to at once glorify and chastise, ultimately giving way to a different definition of beauty, one of engaging oddity and lush ambiguity.

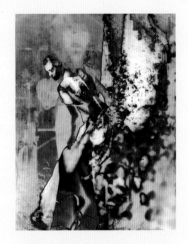

Life in the Sunless Garden.

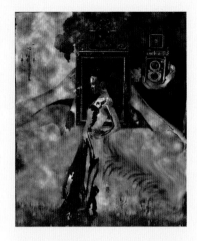

The Lie that Leads to the Truth.

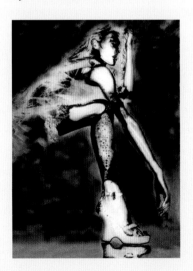

Beauty and Pain Are Constant Companions.

Twisted Illusion.

IMAGES © CARA LEE WADE, 2004, FROM HER SERIES *INSIDIOUS CHARMS*; MIXED MEDIA MORDANCAGE AND DIGITAL COLLAGE, 24" × 36" ON CANVAS.

MICHAL MACKU

UNTITLED, FIGURES

ELEMENTS

Tension is added to otherwise peaceful meditative figures in glowing light through edgy perceived and tactile texture. These textures, provided by his gellage process, help Michal Macku communicate certain dualities, the nature of choice and chance, and the simultaneous value and immateriality of the individual. The three-dimensional glass gellage pieces expand on these themes while allowing viewers to see the figures from all sides and through them, underscoring the "objecthood" of photographs as they exist in the world.

ARTIST STATEMENT

I use the nude human body (mostly my own) in my pictures. Through the photographic process [of gellage], this concrete human body is compelled to meet with abstract surroundings and distortions. This connection is most exciting for me and helps me to find new levels of humanness in the resulting work.

I am always seeking new means of expression and, step by step, I am discovering almost unlimited possibilities through my work with loosened gelatin. Photographic pictures mean specific touch with concrete reality for me, one captured level of real time. The technique of gellage that I use helps me to take one of these "time sheets" and release a figure, a human body, from it, causing it to depend on time again. Its charm is similar to that of cartoon animation, but it is not a trick. It is very important for me to be aware of the history of a picture and to have a sense of direct contact with its reality. My work places "body pictures" in new situations, new contexts, new realities, causing their "authentic" reality to become relative. I am interested in questions of moral and inner freedom. I do what I feel, and only then do I begin to meditate on what the result is. I am often surprised by the new connections I find in it. Naturally, I start out with a concrete intention, but the result is often very different. And there, I believe, lies a hitch. One creates to communicate what cannot be expressed in any other way. Then comes the need to describe, to define.

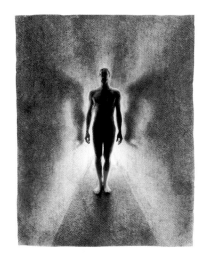

Gellage #116, 2000.

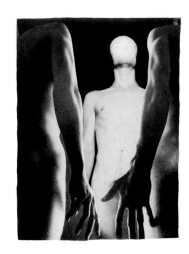

Gellage #92, 1996.

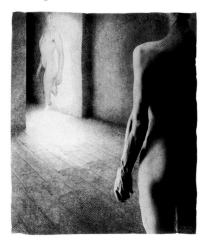

Gellage #111, 2000.

Gellage #93, 1999.

IMAGES © MICHAL MACKU, UNTITLED *GELLAGE* PRINTS.

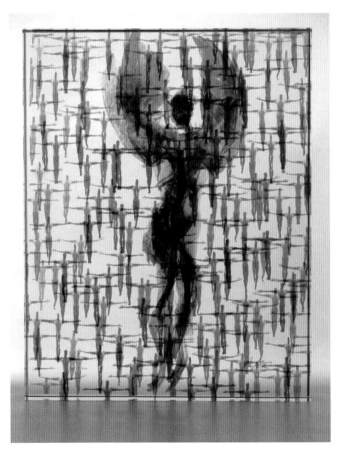

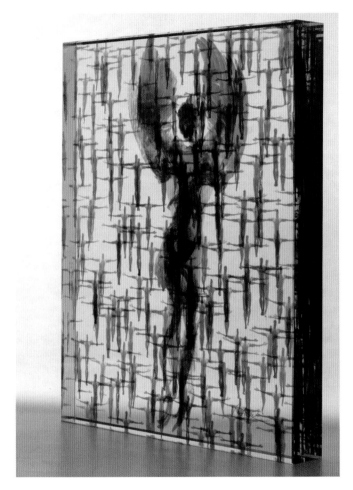

Glass Gellage #VII, 2006.

Glass Gellage #VII, 2006, three-quarter view.

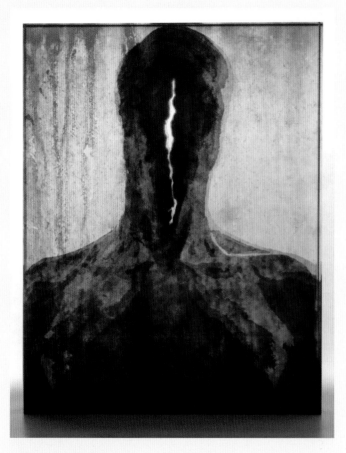

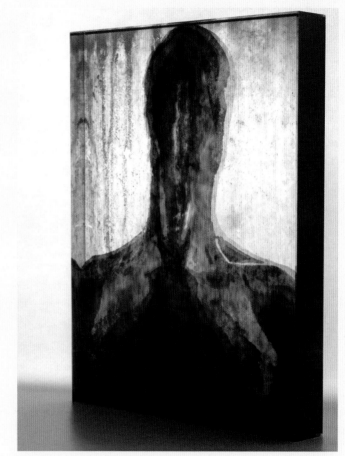

Glass Gellage #IX, 2006.

Glass Gellage #IV, 2006, three-quarter view.

IMAGES © MICHAL MACKU, UNTITLED GLASS GELLAGE.

DAVID T. HANSON

"THE TREASURE STATE": MONTANA 1889–1989

ELEMENTS

Some photographers, like David T. Hanson, make images about the shadow that human beings have cast on the landscape. But Hanson goes a step further by making the shadow literally fall on his devastated aerial views. By etching the names of Montana's endangered species onto frame glass and setting it in front of his prints, viewers can better understand Hanson's entire subject, an integral aspect of which is not present in the image contents. The images are inseparably tied to their presentation method, allowing them to communicate in a way that images alone could not.

ARTIST STATEMENT

During the past 25 years, my photographic work and mixed media installations have investigated the contemporary American landscape as it reflects our culture and its most constructive and destructive energies. These works explore a broad range of American environments, from mines and power plants to military installations, hazardous waste sites, and industrial and agricultural landscapes, examining the relationship of humans with their environment in the late 20th century. Collectively these works begin to reveal an entire pattern of terrain transformed by human beings to serve their needs.

"The Treasure State": Montana 1889–1989 is a personal response to the state's centennial celebrations, "100 Years of Progress in Montana." This series (1991–1993) is a study of land use in Montana, examining the primary economic and industrial forces that have shaped and radically altered the state's environment. I photographed farms and cattle feed lots, timber clear-cuts and paper mills, mines and smelters, military bases, oil and gas industries, industrial waste sites, railroads and airports, hydroelectric dams, urban and suburban environments, and tourist recreation areas. Each site is paired with one of Montana's imperiled wildlife species that have been impacted by it. The Latin and common names of the species have been etched onto the glass covering the print. Under a gallery spotlight, the etched text is projected onto the recessed print below, casting a kind of "ghost shadow" of the name onto the photograph.

The works are sequenced by the species' name, alphabetically within taxonomic class. The correspondences between sites and species are in most cases direct and documented: for example, the siltation and contamination of streams by logging and paper mills have severely impacted the bull trout, and the damming of major regional rivers like the Missouri and Big Horn has destroyed the breeding habitat for several bird species and disrupted the spawning of pallid sturgeon and other native fish. In some cases the correspondences are more broadly representative of the toll taken on native wildlife and habitat by increasing agriculture, industry, human population, and tourism. All of the animals included in this series have been heavily impacted by human activities; their numbers have declined significantly, and they are now vulnerable to extinction. Most of them are officially listed as endangered or threatened, or are candidates for listing; some of them are already extirpated. All that remains are their names, faint traces evoking those that have disappeared.

In November 1995, a flock of snow geese migrating from the Arctic to California stopped over in Butte. They landed in the Berkeley Pit, the world's largest toxic pond, which is filled with 28 billion gallons of highly poisonous mine wastes. Within the next two days, 342 snow geese were found dead in the lake, all of them poisoned and internally burned. Surrounded by one of the largest open-pit copper mines in the world, Butte is a part of the biggest Superfund hazardous waste site in the United States. Wastes from 130 years of gold and copper mining and smelting have heavily polluted the neighboring hillsides, grasslands, and 100 miles of the Clark Fork River. Lush mountain valleys, pristine creeks and rivers, and abundant wetlands have been replaced by a barren wasteland of frequent fish kills, toxic dust storms, and the carcasses of snow geese floating in a sulfurous, poisoned pit.

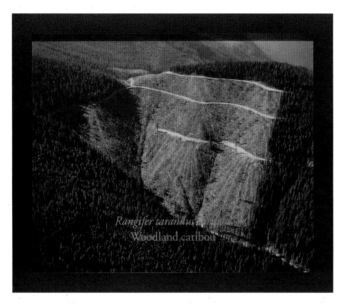

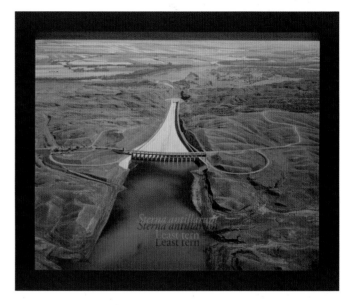

Kootenai River Valley timber clear-cut, Kootenai National Forest, Lincoln County.

Fort Peck Dam spillway, Missouri River and irrigated cropland, Valley County.

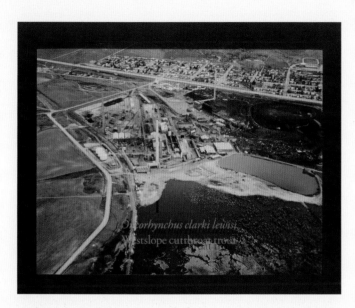

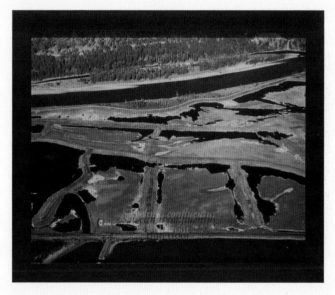

ASARCO East Helena Lead Smelter and waste ponds [EPA Superfund Hazardous Waste Site] and town of East Helena, Lewis and Clark County.

Stone Container Co. Pulp Mill and settling ponds along Clark Fork River, Frenchtown, Missoula County.

PHOTOGRAPHS © DAVID T. HANSON, FROM HIS SERIES *"THE TREASURE STATE": MONTANA 1889–1989*; INSTALLATION VIEWS OF FRAMED EKTACOLOR PRINTS WITH ETCHED GLASS, 20" × 23.5", 1991–1993.

TRACY LONGLEY-COOK

BEARING STILL

ELEMENTS

With the right presentation techniques, it's possible to make larger images feel intimate. Tracy Longley-Cook does this by applying layers of encaustic medium over her prints, simultaneously encasing them and allowing them to glow. Some of the images she hangs like tapestries with light to illuminate them from behind. She also uses the tilts and swings of view camera movements to concentrate focus to the most important areas of image content, even when they aren't parallel to the picture plane. The organic feeling works well with her subject, enticing viewers to move close in to see through the veil of literal and perceived softness.

ARTIST STATEMENT

The parameter of a box formed by the camera's viewfinder encourages the act of looking, framing, and piecing the world together. Observing the integrated visual relationships within a particular environment permits me to navigate further into the meaning of things, becoming an important tool for examining my surroundings.

These images represent a psychological investigation where an elusive threshold between what is perceptible and what is unknown exists. Acting as both participant and examiner in these obscure settings, I reflect on themes of memory, desire, personal inquiry, and transformation. I am interested in how we perceive and process experience, both consciously and subconsciously. Similar to the ever-present evolutions within our natural environment, cycles of physical and psychological change exist as a continuous undercurrent in our lives. Observing the symbolic relationships between the two becomes a form of navigation toward understanding the literal and figurative spaces we occupy.

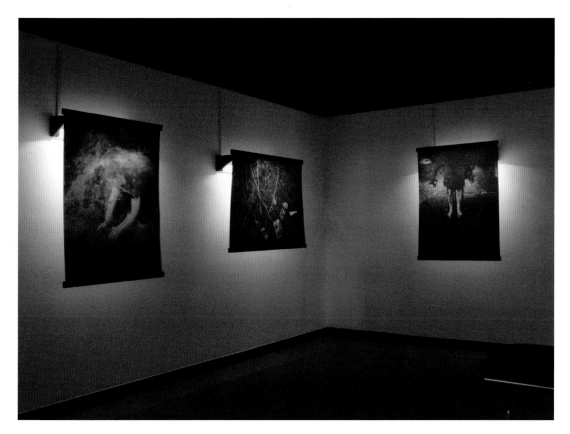

Installation view: Backlit digital pigment prints with clear encaustic overlay.

Extended Branch, 2006.

Fruit Tree, 2005.

Unearthed, 2006.

IMAGES © TRACY LONGLEY-COOK, FROM HER SERIES *BEARING STILL*; BACKLIT DIGITAL PIGMENT PRINTS WITH CLEAR
ENCAUSTIC OVERLAY.

FRANK HAMRICK

WALLET BOOK AND SCARS

ELEMENTS

I first met Frank Hamrick at a portfolio review session. The beauty of his images took me aback, especially after seeing so many other photographers' great concepts fall flat owing to poor technical quality. Hamrick's images merge content and style along with presentation methods suited to the work. The intensity with which he sees even the quietest things is powerfully conveyed through his use of photographic language, absolute technical control throughout his process, researched understanding of his traditional black and white materials, and uncompromising craft.

ARTIST STATEMENT

I have found the artist's book to be a favorable alternative to the traditional method of exhibiting photographs on the wall. Artist's books do not require costly matting and framing to be presentable. The artist's book can convey ideas in ways other media cannot. The viewer has an intimate relationship with the book by holding it, feeling its textures, and turning its pages, instead of just standing across the room staring at it. Additionally, the artist's book is its own piece of work and is not to be confused with a monograph, a book that often reproduces two- or three-dimensional works of art that should be seen in person.

If you were to think of a photograph in the same way you consider a single song, then an artist's book is similar to an entire album of music complete with cover art and liner notes. The artist's book allows me to combine imagery and text and incorporate materials, like handmade paper, and processes, such as staining and letterpress printing, to create unique or limited works of art.

The pieces I make have particular meaning to me, but I understand other people will see them in their own way. My photographs are not necessarily created to illustrate or provide answers. If anything, I would like for my images to generate more questions. I do not see them as end points, but rather starting places where I give viewers ideas to ponder and allow room for their imagination to create the rest of the story.

The *Wallet Book* is a one-of-a-kind piece where the materials relate to the content. It is a twist on the notion of a pocketbook containing things we want to protect from other people, such as our identification and financial information. Slots that normally hold a driver's license or a social security card now contain credit card–size photographs with stories typed on the back confessing personal traits and incidents I have had with friends and family members.

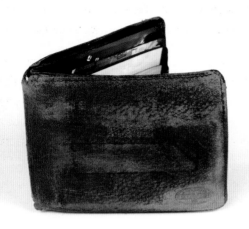

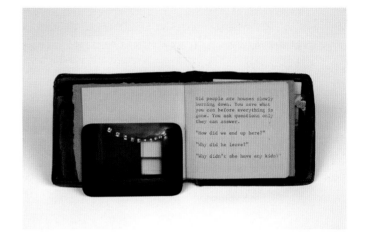

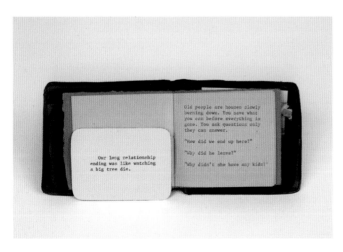

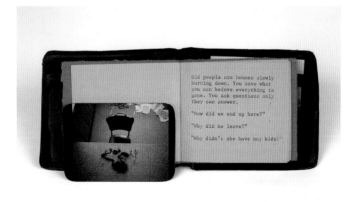

IMAGES © FRANK HAMRICK, FROM *THE WALLET BOOK*.

Scars is a limited edition book featuring six photographs of scarred people, plants, and places. A scar is strong subject matter to photograph. It is not just an image *of* something. It is, on multiple levels, an image *about* something. A scar is an effect, which inspires us to ask what the cause was. A scar can also be a metaphor. So while viewers may wonder what created the scar, they might also think about moments that have left impressions in their lives.

The photograph *Mom's Scar* shows marks remaining from the surgery my mom had after falling and breaking her wrist. But it goes beyond simply showing a healing wound to also suggesting a larger symbolism for both weakness and survival. The relationship I have with my parents has evolved over time. I am now able to understand they are human beings just like everyone else and should not be expected to have all the answers just because they are parents.

Every copy in the edition of *Scars* is made unique by the coffee-stained paper used for the front and back covers. The stain on one cover may be straight across and resemble the high water mark from a flood, whereas the stain on another cover may rise and fall and suggest the distant horizon of a wide-open desert. Stains are like scars in that they are seen as blemishes and people want to know the story behind a stain just as they would ask about the cause of a scar.

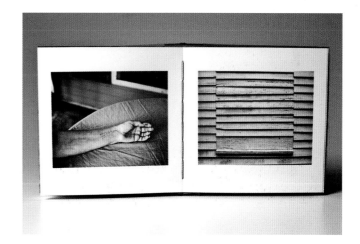

IMAGES © FRANK HAMRICK, FROM *SCARS*. IMAGES PRINTED IN A LIMITED EDITION ARTIST BOOK.

YAMAMOTO MASAO

A BOX OF KU, NAKAZORA, AND KAWA = FLOW

ELEMENTS

Have you ever been to a museum or gallery and immediately been attracted to the smallest image on the wall? Sometimes it's the smallest things that make the most profound statements, and when these images speak to you, you're able to internalize their message through a kind of interpersonal bond. This describes the experience of walking into an exhibition of Yamamoto Masao's work. The scale of such small objects surrounded by so much space makes them feel precious, and walking closer to them like some act of reverence, both of which are highly personal acts that seem to reflect his personal experience in making them.

ARTIST STATEMENT: NOTES OF REFLECTION IN REFERENCES TO THE SERIES *KAWA*

KAWA = Flow reminds me of "this world and that world," "previous life and current life," "this world and afterlife," "human world and the world of the gods," and life itself.

I hope the *KAWA = Flow* series will awaken a sense of relaxation and purification in the viewers' minds. I would be happy if my work somehow gives support and encouragement to the viewers as they move through their life. We should not hurry, but not stop. An ideal life for us is one of harmony and contentment.

I enjoy watching transitions in nature.

Clouds in the sky are all different from each other. While watching the clouds, I realize I am seeing beyond the clouds. I may be focusing on the clouds, but my mind is immersed in something else.

There is a haiku Ryokan (1758–1831), a Zen monk, wrote. It goes like this:

A Japanese maple leaf
It turns to show its back
It turns to show its front
Before it is time to fall

This haiku has made a great impact on me. I believe Ryokan wrote about life through using the metaphor of falling leaves.

Life is an accumulation of moments. There are moments when leaves show the sunny front, and there are moments when they show the dark backside. But at the end, all leaves fall and decay.

Ryokan's attention to nature and realization of how humans are but a part of nature made it possible for him to write this poem. I imagine how Ryokan led his life enriching, soothing, and purifying people's mind.

"Active passiveness," a teaching of Zen, influenced me, too. It is necessary to acquire the sense of active passiveness to reach a steady mind and body. When you achieve a calm feeling by finding yourself integrated into nature, you will develop a respect and humbleness toward the whole universe. You will be enveloped in a deep sensibility of the universe and the earth you are placed on.

This thinking is widely known in Budo (martial arts). I try to sharpen my sensibility to reach this state of mind when I photograph.

ADDITIONAL REFLECTIONS

Drips of water seep out of the mountain and form a flow known as a KAWA. A KAWA can also be seen as a pond on the top of a mountain, overflowing, creating small streams that grow into great rivers. KAWA changes its face, sometimes seen as a rapid stream and other times as a quiet flow of almost still water. All rivers eventually flow into an ocean, and then into vast expanse of chaotic sea, reemerging as the majestic cloud.

Buddha taught that a person starts living toward death on the day he or she is born, and there is nothing more obvious than that.

Ryokan's last Haiku poem:

Cherry Blossoms petals falling
Even the ones remained
Will soon be falling

No. 1167.

No. 209.

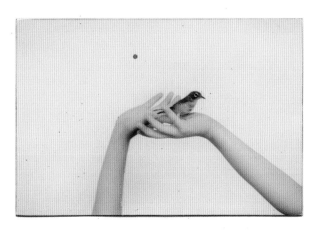

No. 955.

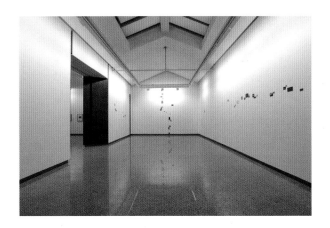

No. 1141.

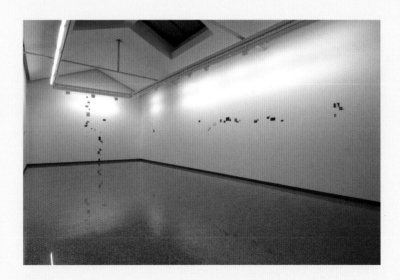

IMAGES © YAMAMOTO MASAO FROM *KAWA = FLOW*. COURTESY OF JACKSON
FINE ART, ATLANTA. INSTALLATION VIEWS FROM WOOLRICH WOOLEN MILLS AT
LORENZELLI ARTE, MILANO, 2010.

SUZANNE E. SZUCS

JOURNAL, IN PROGRESS

ELEMENTS

Suzanne Szucs's photographic practice is woven into her life. Through copious numbers of exposures made throughout many years, she demonstrates to viewers the significance of each moment in our lives—the comedic ones, tragic ones, the banal and quiet ones. She adds text to each image documenting its date and time, as well as some of her thoughts at the moment. How we relate the words to the images is our own personal contribution to interpreting them. Her installation method engulfs viewers with thousands of intimate moments captured on Polaroid instant film to exist in the world almost immediately. Time is part of this thematic portrait; as the images occurred sequentially but viewing them does not; it documents more than a decade of the artist's life, but goes beyond that to reflect photography's ability to carry moments into new temporal realms.

ARTIST STATEMENT

Journal, In Progress, is the accumulation of an instant Polaroid self-portrait made every day since January 1994. Started as a visual diary, the project soon evolved its own set of guidelines. Not quite snapshots, the images seem at first to catch random moments. Together the unassuming and approachable images present a narrative timeline measuring growth, change, and regression. Individually they address issues of the body and identity in a direct and nonglamorous way.

The simplicity of an instant image undermines fine art photography, at the same time belying the complexity of meaning the photographs hold as a group. The randomness of the moments depicted and their equal treatment subvert the importance of any single portrait. Their diaristic candor breaks down personal boundaries and presents a series of surrogate selves for the viewer. Together the photographs depict universal experience; their raw, personal, and sometimes frivolous nature demythologizes the self with humor and vulnerability. The text written on them—at the least recording the time and date—ranges from the factual to the absurd, becoming more about mark making than dialogue.

The images document, yet remain elusive. Viewed close up, they suggest individual transformations, recording momentary changes. Seen

from a distance, the figures evaporate, the ritual becomes more apparent, and the measurement of time emerges. Whereas the regularity of the image making imposes structure, the formal qualities of the piece as a whole—color, shape, light—are determined by chance. The images will fade and change over time, like memory, imprecise and shifting, an imperfect memorial to the everyday. Their deliberate presentation—like a figure traveling across the wall—contradicts the immediacy with which the individual images are made.

As an installation piece, *Journal, In Progress*, grows around the viewer. The 4" × 4" Polaroids are arranged chronologically as vertical strips of 17 images, equaling the artist's height of 5'6" and growing an average of 7 feet a year. The strips are each put up individually; therefore they can wrap around and turn corners. For this reason, the project transforms to whatever space it is displayed in, mimicking our own tendencies to transform to ever-changing situations. When installed, new images are constantly added, the piece literally accumulates itself, even as we accumulate experience and memory. Through its process, *Journal, In Progress*, becomes a constantly changing piece of art—different each time it is displayed, its parameters of height and chronology allow for flexibility in its presentation, keeping the piece lively and engaging.

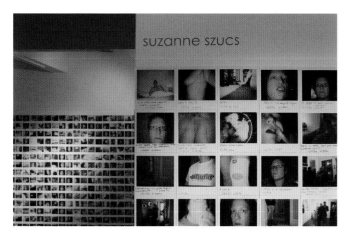 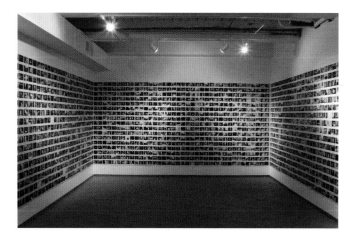

Journal, In Progress, installation views.

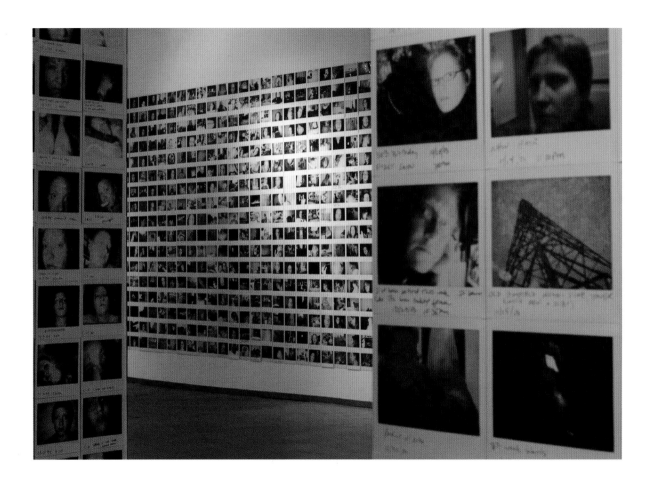

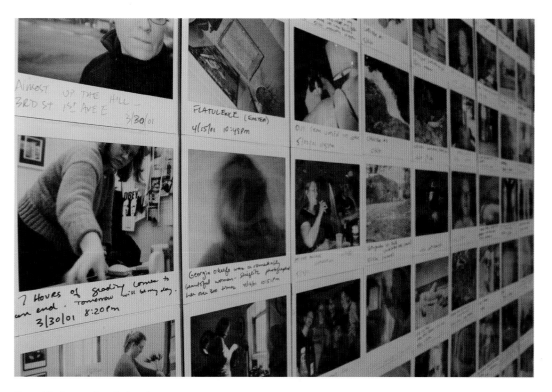

Journal, In Progress; installation views.

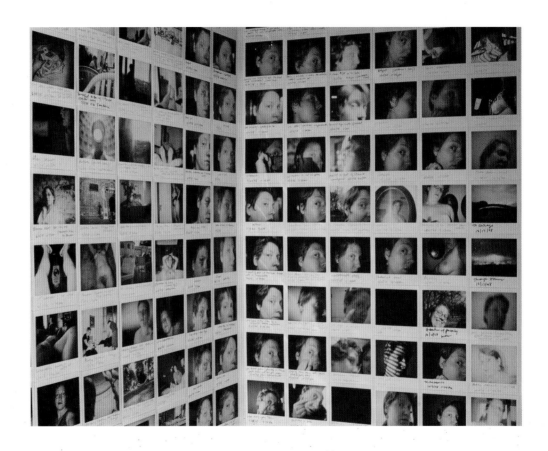

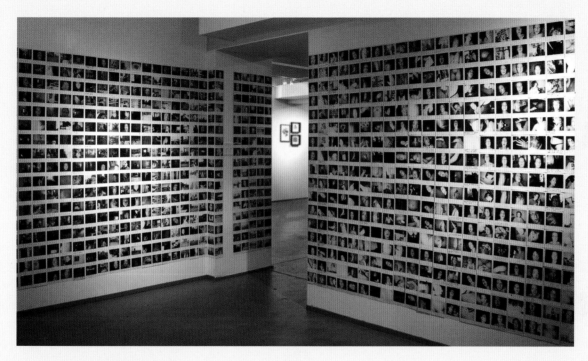

Journal, In Progress; installation view.

IMAGES © SUZANNE E. SZUCS, FROM HER SERIES *JOURNAL, IN PROGRESS*. INSTALLATION VIEWS FROM FLATFILE GALLERY CHICAGO, 2004; INDIVIDUAL 4" × 4" POLAROID SPECTRA PHOTOGRAPHS, 5'6" × APPROXIMATELY 80' INSTALLATION PHOTOGRAPHS BY CYNTHIA LAPP AND SUZANNE E. SZUCS, 2004.

Susan Kae Grant

Night Journey

ELEMENTS

How do your dreams feel? Do they feel real but fleeting? Do you feel you're really there but it's too dark to fully see? Are they pleasant but never quite comforting? These and other aspects of dreams can not only be *seen* in Susan Kae Grant's photographs, but they can be *experienced* through her highly conceptualized means of printing and displaying them. The experience of the installed photographs allows us to have a waking experience by placing us as close inside their depicted dreams as we can be.

ARTIST STATEMENT

Night Journey embodies the collaboration of artistic creativity and sleep laboratory methodology in the exploration of REM sleep, memory, and the unconscious. The work is composed of a series of intriguingly haunting large-scale images that re-create the fragmented and multisensorial experience of dreaming. The inspiration for the project came from the artist's desire to conduct an inquiry into the subconscious, which led to her experiences sleeping as a subject in a sleep laboratory. The series now takes two complementary forms: a suite of lushly printed 35" × 47" black-and-white giclée prints and a room-size installation consisting of 24 4' × 8' digital murals printed and heat transferred onto sheer chiffon fabric juxtaposed with a sound track of whispered phrases.

To produce the work for both versions, Grant collaborated with John Herman, Ph.D., at the sleep research laboratory of the University of Texas Southwestern Medical Center at Dallas. To access unconscious visual memory, Grant used herself as subject and was digitally monitored and awakened from REM sleep and then interrogated by trained technicians. The tapes of these narrative interviews were then used as inspiration to create the imagery for the series.

The shadow gestures depicted in the images suggest a fragmented narrative as they shift in and out of focus, signifying the impermanent quality of the dream state. To create the gestures and narratives inspired by the dream recordings, Grant photographs shadows of models and props in her studio using a high-resolution digital back and employs digital technologies to manipulate and print the

images on 100% rag paper. The mural prints were printed digitally as CYMK murals on paper and then heat transferred onto chiffon.

The *Night Journey* series examines the perceptual and psychological aspects of the dream state and provides a pictorial access to the unconscious. It raises universal questions among viewers and re-creates an unexplainable experience all humans share.

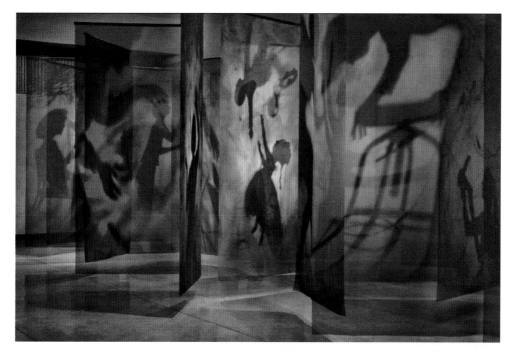

Installation view from *Night Journey*. Installation size: 36' × 40' with sound track and 4' × 8' photographic panels; heat transfers on chiffon fabric.

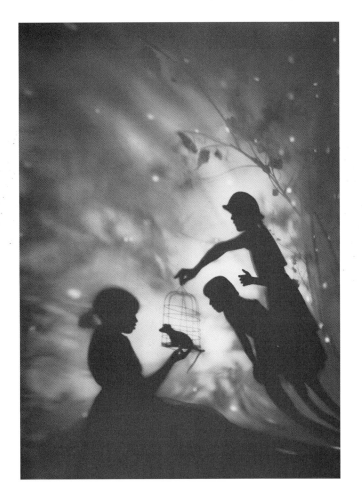

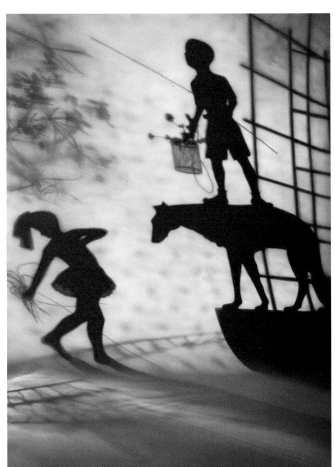

What's Being Offered? 2002.

Dancing Girl, 2007.

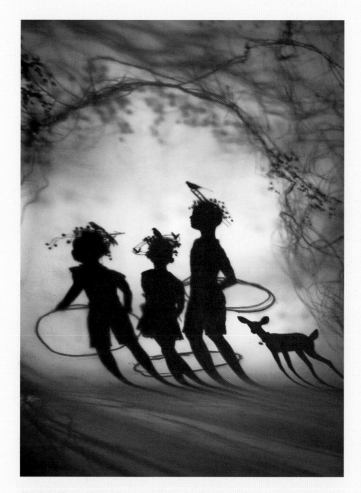

Far from Home, 2007.

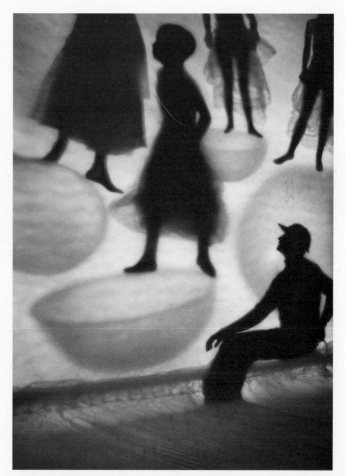

Idle Curiosity, 2005.

IMAGES © SUSAN KAE GRANT FROM *NIGHT JOURNEY*; GICLÉE PRINTS 32" × 43.75".

Conclusion

PHOTOGRAPHY'S POTENTIAL AS A GREAT IMAGE-MAKER AND COMMUNICATOR IS REALLY NO DIFFERENT FROM THE POTENTIAL IN THE BEST POETRY WHERE FAMILIAR, EVERYDAY WORDS, PLACED WITHIN A SPECIAL CONTEXT, CAN SOAR ABOVE THE INTELLECT AND TOUCH SUBTLE REALITY IN A UNIQUE WAY. —PAUL CAPONIGRO

IN THE END, THE ELEMENTS COMBINE

"They say of vision that it is a deliberate gift," observes nature writer Annie Dillard in *A Pilgrim at Tinker Creek*. I agree, although most people navigate the world by merely looking, without consciously *seeing,* and they miss potential gifts and richness afforded by connecting with the sense of sight. But not photographers. Photographers recognize that the gift of vision carries with it enriched meaning for our lives, and we use that awareness to translate those meanings into photographs. In truth, in order to take pictures all one needs is a camera; even looking through it is optional. *Taking pictures* is like *looking;* it's a passive act requiring little attention to what is seen. But *making photographs* is an active engagement that combines our own perception of the world with how cameras translate it.

There are so many photographers with an outstanding ability to do just that—to visually communicate their conception of something "out there" through their use of photographic language. You've been introduced to a lot of them through the Portfolio Pages of this book. For the conclusion, I chose to focus on a single photographer's work that's approachable in its style and deals with an issue in the forefront of current American consciousness and politics, but whose underlying issues have affected nearly all cultures in all times. David Taylor's *Working the Line* does

IMAGE © ANGELA FARIS BELT, *SNOW SHADOW*, 2009.

that, presenting viewers with a visual record of a complex story involving people, our sense of place, the land itself, and the boundaries that simultaneously bind and divide us.

I have selected only a few images from a considerably larger body of work, throughout which the *technical elements of photographic language* emerge as the aesthetic and communicative backbone supporting his subject. Like we did for all of the Image Discussions in this text, we'll examine how photographic grammar combines with content to interpret what they might mean. Taylor's work is not about the elements of photography, but he incorporates them seamlessly and skillfully to make a powerful statement about the politics and human aspects of the contemporary border between the United States and Mexico.

DAVID TAYLOR

WORKING THE LINE

ARTIST STATEMENT

For the past three years I have been photographing along the U.S-Mexico border between El Paso/Juarez and Tijuana/San Diego. My project is organized around an effort to document all of the monuments that mark the international boundary west of the Rio Grande. The rigorous effort to reach all of the 276 obelisks, most of which were installed between the years 1891 and 1895, has inevitably led to encounters with migrants, smugglers, the Border Patrol, minutemen, and residents of the borderlands.

During the period of my work, the United States Border Patrol has doubled in size and the federal government has constructed more than 600 miles of pedestrian fencing and vehicle barrier. With apparatuses that range from simple tire drags (that erase footprints, allowing fresh evidence of crossing to be more readily identified) to seismic sensors (that detect the passage of people on foot or in a vehicle), the border is under constant surveillance. To date the Border Patrol has attained "operational control" in many areas; however, people and drugs continue to cross. Much of that traffic occurs in the most remote, rugged areas of the southwest deserts.

My travels along the border have been done both alone and in the company of Border Patrol agents. I have been granted broad access to photograph field operations and the routine activities that occur within Border Patrol stations.

In total, the resulting pictures are intended to offer a view into locations and situations that we generally do not access and portray a highly complex physical, social, and political topography.

Final Image Discussion: Using the Elements of Photographic Language to Read David Taylor's Working the Line

SUBJECT, CONTENT, AND FORM

Throughout this text I have referenced photographic language to written language because both are used to structure specific contents into a coherent form to communicate about a particular subject or subjects. We might not always fully comprehend what the author of a book or photograph intended, but using the key components of the artist's language thoughtfully to describe the work's contents can bring us closer to understanding.

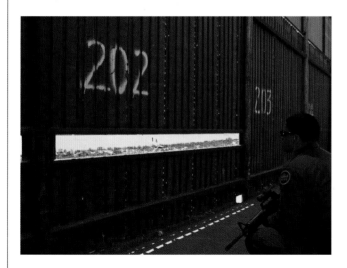

Along the Tijuana River, San Ysidro, California.

A Single Image within a Series

Just as image contents within the same frame relate to one another, a group of images—called a *series*—about the same subject also interrelate, informing one another to help deepen and broaden our understanding of the subject. Each image builds on the next to form a more complete picture of the subject. Perhaps there are several subjects interconnecting at different levels, and perhaps there is a range of legitimate interpretations, but overall a series should bring us closer to an accurate understanding of the subject than the single image can.

Along the Tijuana River, San Ysidro, California is one of several establishing images within David Taylor's series. In it we see a formidably armed man peering through a viewing hole in a border fence between California and Mexico. The two primary contents of the image—the man and the fence through which the landscape is seen—indicate a central theme. Taylor intentionally adopted a vantage point to include the large weapon used "in defense of" the narrow line of land, revealing a significant part of one side's stance on his subject.

Image Content

By describing image contents and how they're captured using photography's technical and compositional elements, we

Awaiting Processing, Arizona.

more fully understand and more richly experience "the whole picture." There is no such thing as digging too deep into image contents and how the elements of photographic language delineate them.

What contents can you identify in this photograph, *Awaiting Processing, Arizona*, and which specific elements of photography act upon those contents? Two men with dark brown skin are sitting on a steel bench in front of a window. One man looks down and is slightly blurred due to his movement during a longer shutter speed, and the other is hunched over, holding himself

in his own arms. But what else do you see? If you interpret the direction of the blur, it looks as though the first man is shaking his head, looking downward dejectedly. The other man, whose expression we can see, appears disappointed, isolated, and perhaps even sick to his stomach. Looking deeper still, we notice that both men are wearing American apparel, one with a star-spangled red-white-and-blue motif "United States" T-shirt and the other with New York ball cap with an additional "NY" on its brim. So what does all this description of content offer us? It adds up to tell us something *about* these men, *who* they are, *where* they come from, or where they might be going. With some outside knowledge of the situation or within the context of the series, it might also indicate *why* the men are wearing so many American logos, and why they seem disappointed with the place they find themselves when the image was made. This highly informative depiction is possible because Taylor combined a long list of photographic elements: solid framing of carefully selected image contents, perfect exposure density, a tripod with a shutter speed just long enough to blur an important aspect of moving content, critical focus on his subjects, and research into the types of images he would need to tell the larger story.

ELEMENT 1: FRAMING

As our first photographic element, we discussed the frame. Within it photographers arrange the three-dimensional world onto a two-dimensional picture plane, and they use

Office Work (shared desk), Texas.

Fingerprinting, Arizona.

juxtaposition within that plane to intertwine the image contents. This, along with *visual variety*, allows photographers to crate a sort-of "meta view" of image content, and what that content denotes about their subject. Framing is the "sentence structure" of photographic language, giving us the ability to encapsulate the meaning of our work.

The Macro View

In the image, *Office Work (shared desk), Texas*, a desk covered with paperwork leads our eye back to barn-side paneling covered with more paperwork and an officer sunken in between. The arrangement of the frame (an overlapping picture plane)

Drugs, Texas.

and the mountain of paperwork in the room relative to the size of the primary subject—the officer—are overwhelming. This is the macro view, pulled back from the details to frame a bigger picture, allowing us to contextualize more information. In this case, it seems to denote that the job is too large for the person (by extension all the people) doing it.

The Micro View and Cropping

Through the previous *macro view*, David Taylor paints with large brushstrokes a significant aspect of the whole story, though it provides few of the details that make the story personal. Within a series, the micro views add visual variety to balance the macro ones; they are up close; providing information that more remote views cannot, and in their relative scale (magnifying image contents) can even become confrontational to viewers. The blue gloves in, *Fingerprinting, Arizona*, jut toward us, the forward hand appearing larger due to wide-angle lens distortion, making the process of being fingerprinted feel even more uncomfortable. By moving in close, Taylor brings us the details, bringing what seem like remote issues very close to home.

But as we discussed, framing isn't only about what to keep in; it's about what to keep out, both for aesthetic and communicative reasons, as well as for practical ones. People are cropped in rather unusual ways in these images, their faces intentionally excluded from the frame. These crops might seem conspicuous, but not when you consider the content of the images, and the nature of the subject they address. His framing and cropping in both

Mural (with border fence), Sonora.

Fingerprinting, Arizona and *Drugs, Texas*, does two things: they lead our eye straight to the primary subject of the photographs (fingerprinting and drugs), while simultaneously protecting the identities of the people in the images. Through sophisticated cropping, Taylor gives us the right information in the right configuration to understand what he left out and why, while simultaneously attending to the practicalities of photographing official agencies.

Juxtaposition

Mural (with border fence), Sonora. We're in the desert, and we come upon a former dwelling's empty shell with its roof caved onto the floor and a still-vibrant (oddly enough) mural painted

on an interior wall. Sounds pretty banal, until you look at the juxtapositions within the frame and interpret what they communicate. First, this is no ordinary scenic mural; it's a contemporary political landscape, it's content depicting the border fence, as well as what could reasonably be a Border Patrol helicopter hovering above. The painted landscape is juxtaposed with the actual landscape in which it exists, their horizon lines meeting in parallel because of the photographer's vantage point,

serving to flatten the picture into a somewhat static plane, and suggesting that our perspectives on the landscape are mirrored reflections of our relationship to it.

Using Multiple Frames

We know that several images can work to inform one another within a series, but what about when several images are placed in proximity to one another to create a singular meaning? We

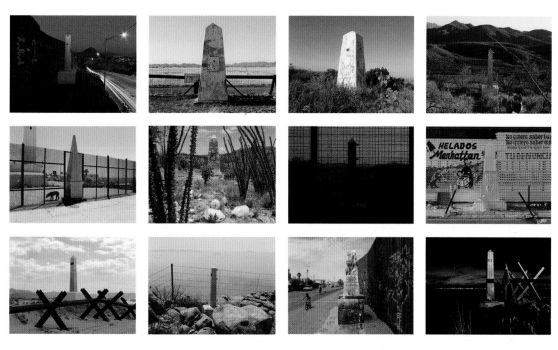

Grid view of 12 border markers from David Taylor's The Line.

can make multipanel panoramic images, diptychs or triptychs, or we can montage images together. These are a few of the methods we discussed, but there are numerous ways to create, configure, and look at multiple frames. The photographic elements are not limited to the scope of this text; their potential and the excitement of using them come from taking the basic concepts and expanding on them in innovative ways to communicate new meanings.

An Alternate Configuration of Multiple Frames

Just what is "the line"? What is its physical shape, and what indicates to us that there is one? Like all political boundaries, the line is a demarcation of possession or control, denoting similarity and safety for the particular group within it. But in terms of the land it divides, no real line exists; it's invisible, so we need to look at color-coded maps to see them. So then, how can we stand out in the land and see it? One way is to travel to its signifiers—the border monuments that dot the line along the United States and Mexico.

These 12 border monument images, which belong to a larger group documenting all the border monuments along the international boundary west of the Rio Grande, are not usually presented in this fashion. I configured them for the purpose of this discussion and to provide a more inclusive look at David Taylor's faceted approach to his subject. One way these images do exist is as an accordion-style printed foldout accompanying his book, *Working the Line*. But for me, photographing *all of the border monuments* west of the Rio Grande creates a kind of typology of "the line" that looking at one of them or a few of them does not. These straightforward images of border monuments juxtapose their similarities and differences, contextualize them within their immediate landscapes, and indicate their diminutive scale against the borderline itself. In addition to that, as a linear exploration they provide a means of visually "connecting the dots" of locations that are in reality very far apart, thereby outlining "the line" of the border itself.

ELEMENT 2: APERTURES, FOCUS, AND LENSES

Viewer attention is focused according to what we most clearly see in an image, and photographers control that focus, combining it with depth of field to maintain attention on the primary subject while allowing us to relate it to the rest of the frame's contents. Focus clarifies, lack of focus obscures, and because of the nature of photographic language, there are appropriate times to use each. Beyond focus, it's lenses that allow us to get where we need to be—whether it's a wide view of a cramped space or a magnified view of a faraway place—focal length grants us the proximity we need to frame the photograph we want.

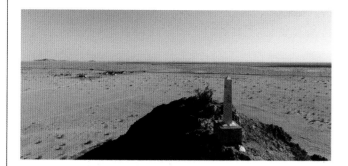

Border Monument No. 198, Desierto de Altar/Yuma Desert.

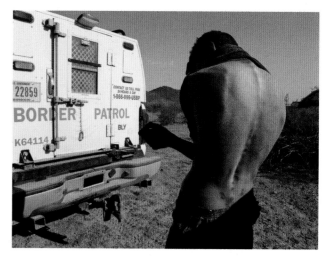

Young Man with Backpack Scars, Arizona.

Broad Depth of Field

Documentary work by nature is generally intended to be informative, and conscious use of broad depth of field allows viewers to get the most information we can. Most all of David Taylor's work has extremely wide depth of field, including this panoramic image of a border monument overlooking a vast landscape. His use of a large-format view camera on a tripod supposes his ability to use longer shutter speeds to establish this needed depth of field. In this image, *Border Monument No. 198, Desierto de Altar/Yuma Desert*, the details reveal one lone cluster of dwellings within a formidable expanse that offers no shelter from the sun and no water for survival. The buildings look nearly abandoned, and only a few soitary cars travel along the road in the distance. Without a printed image border, the expanse seems endless; nonetheless, we realize that innumerable people have trekked across it hoping to survive the journey and begin a new life.

Wide depth of field isn't only beneficial in expansive landscapes; it's useful for more intimate views as well. In this image, *Young Man with Backpack Scars, Arizona*, David Taylor uses it to describe the foreground backpack scars on one Mexican would-be immigrant while maintaining sharp text on the Border Patrol vehicle in the background. Having all relevant contents from foreground to background clearly focused allows viewers to form solid relationships that can't be made

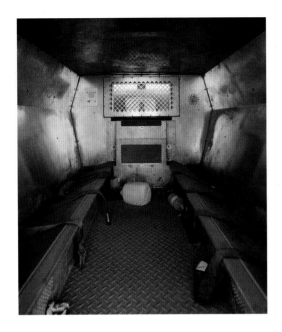

Kilo Vehicle Interior, New Mexico.

otherwise, because shallow depth of field provides a kind of inherent hierarchy. Because of his use of vantage point he also protects the anonymity of the young man.

Wide-Angle View

How is the depth of this tight space in the image *Kilo Vehicle Interior, New Mexico*, squeezed into one frame? It's done with the use of a wide-angle lens. Particular lens focal lengths are as critical as vantage point to making our images contain the contents we need them to. In addition to allowing us access to the vehicle's interior, this wide-angle view includes its significant details—rust, dust, trash, water jugs, the number of seatbelts—all relating to the vehicle's purpose and its passengers. While much of this series takes place in the wide-open desert, the human interaction happens much closer, and images like this place viewers inside the first place many illegal immigrants who don't quite make it across find themselves in. The close view and the details it reveals allow us also to feel the discomfort of being in this dark place.

ELEMENT 3: SHUTTER SPEEDS: TIME AND MOTION

Photographs capture moments in time, but how their contents relate the duration of exposure to the static media creates dramatically different visual and meaningful results. Use of *blurred time* (long shutter speeds) to show passage of time, *frozen time* (fast shutter speeds) to suspend action in time, or *static time* (nothing moves) allows photographers to delineate a sense of how time engages the image contents, and communicate the temporal significance of the subject.

Frozen Time

In *Seized Marijuana Bales, Arizona*, David Taylor captured three Border Patrol agents, in midglance, midspeech, and midstride, to

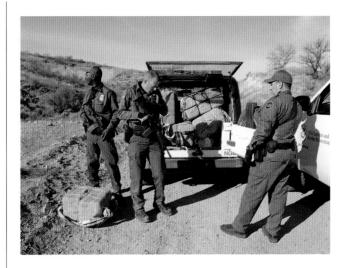

Seized Marijuana Bales, Arizona.

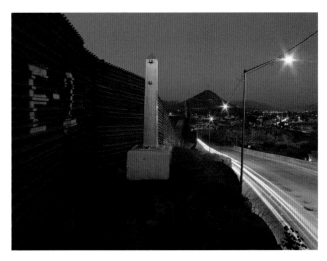

Border Monument No. 244.

fix in time a moment that has now passed. The motion in front of his camera was continuous, happening before and after the image was made, but Taylor chose this particular *decisive moment* to release the shutter, activating the frame and creating an image filled with some of the disparate movements that define this job.

Blurred Time

Border Monument No. 244. An international borderline monument stands still as a sentinel as time passes by, indicated through streams of light from cars driving past during a long exposure. The exposure also allows the streetlights to flare out like stars in the sky, leading our eye along a diagonal line to converge with the border fence inside the perceived depth of the picture plane. If the camera had moved during the exposure, the monument would be blurred as well, and the stark visual contrast created by control of this photographic element could not exist. This image also provides a solid example of the importance of the final element of photography—materials and processes—to the effectiveness of his images. The intense color contrast created by mixed lighting conditions and his color

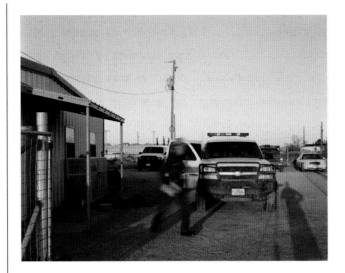

Departure, Texas.

materials adds tension to the image about the passing of time alongside political boundaries.

Blurred Time

In the photograph *Departure, Texas*, David Taylor again uses a long shutter speed, but not for aesthetic reasons or to juxtapose motion with static content. His purpose in addition to creating a feel for hastily moving into the day's work, is again to conceal the identity of a Border Patrol agent. This time, rather than creatively cropping his features, Taylor adds visual variety by

using the slow shutter speed in relation to the subject's speed and direction of motion to blur him. With the camera on a tripod and no other moving content, he can control how this element affects selective parts of the image.

ELEMENT 4: THE AGGREGATE IMAGE

Photographic objects are made of substrates and substances that hold the image. All photographs have them, but not all photographers use them as a communicative tool in their photographic practice. Decisions about whether to use color or

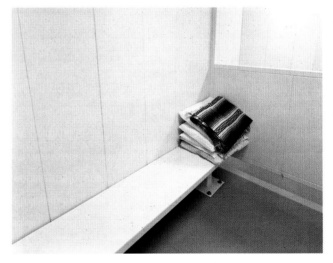

Detention Cell (with sarape), New Mexico.

black and white, heavy imperceptibly fine grain, and so on are there to help convey a subject. Use of color for this documentary work carries connotations of photographic truth and accuracy, enriches the viewer's experience of the story, and captures subtleties while drawing attention to the details.

Materials and Processes

Throughout *Working the Line*, color becomes highly descriptive, whereas black and white would be more emotive; it leaves less to the viewer's imagination and fills in gaps that could be misconstrued or overlooked. In the image, *Detention Cell (with sarape), New Mexico*, a small serape Mexican motif blanket is isolated by stark empty space; it literally provides the only real color in the frame, and that color is what enables us to immediately recognize its cultural pattern. That the blanket, awaiting a detainee, is relegated to a corner and surrounded by white on all sides is a metaphor indicative to the lives of many Mexican immigrants who will or will not manage to make it across the border.

Presentation

Photographs reproduced in books are informative references, but as we know photographs are objects that exist in the world, and as such the way you see them here is not the ideal way to experience them. Images here allow us to see and consider the actual work, but are not substitutes for experiencing the actual photographs.

David Taylor's *Working the Line* exists in the world in two forms, as a gallery exhibition and as a hardbound slip-cased book. *Working* deals with the people whose lives are entwined through the politics of the border, and *The Line* documents all of the monuments along the international boundary of the United States and Mexico west of the Rio Grande. The images from *Working* are complemented by a unique presentation of *The Line*. Its extremely long accordion-style pullout with all the border monuments arranged in a double-sided line is a fitting presentation for the concept he grapples with here. I would urge you, as with any photography, to see the work installed in a gallery or museum setting, and to hold the book and its pullout, *The Line*.

Like the work of most photographers, David Taylor's images are not about the elements of photography; he uses them as writers use grammar—to make a statement, elicit emotions, and enlighten. And as with literary works, a range of reasonable interpretations exist for images because they all have connotative meanings in addition to their denotative ones. Also, we each bring to them our own unique perspectives, and we experience the work in different contexts that affect the way it's received. A person who is educated in photographic history will bring a different perspective (not necessarily a better or more accurate one) to viewing images than someone who is not. A person who comes across a box of images in an estate

sale, for instance, would likely interpret their meaning differently than if they came across the same images in a museum, or accompanying a magazine article, and so on. Still, the elements of photographic language provide a tremendous amount of objective insight to understanding them.

In images, as in texts, there are as many intriguing questions asked as cogent answers provided; these are inherent to the nature of all powerful statements across all media. David

Taylor's *Working the Line* is no exception; the questions that arise from viewing his work are as intriguing as the images themselves. What's important is to try to understand them, to ask our own questions, to add relevant input to the dialogue surrounding them, and to apply the knowledge we've gained through looking at them to strengthening our own photographic practice.

WRAPPING UP: FINAL THOUGHTS ON YOUR USE OF THE ELEMENTS

David Taylor and the other artists in this book aren't the only ones who can use photographic language to make meaningful photographs. Anyone with an idea can translate it into visual images. And anyone who understands that photography is a unique form of language can learn its technical, grammatical underpinnings and use them to express their ideas through this rich medium. *You* can do this too; you can build an arsenal of knowledge that leads to making complex visual statements about subjects that interest you. You can apply the techniques you learned in this book to develop your own visual style and create images that successfully communicate to a wide audience.

If you've read this book and completed its exercises, I advise printing the body of work you've created and discussing it as a whole with your critique group. It represents a portfolio of images that examine a specific subject of interest to you, and it should indicate to viewers *why* it is interesting. Examine what aspects of the elements of photography work best to visually and conceptually represent your subject, and consider how you might merge the most successful elements into a more concentrated exploration to supplement or tie together the entire portfolio. For instance, if some of your most successful images use multiple frames and others use blurred time, consider how you might combine the two, perhaps by using blur within the multiple frame construct. The possibilities are limitless;

all it takes is conceptualizing how photographic gram-mar communicates and relating it to what you want to say about your subject.

I encourage you to continue your practice, so you add your own unique voice to the images in the world. Use your knowledge of how the technical aspects of photographic image making influence the visual appearance and communicative effectiveness of your images. I encourage you to continue refining the work you've already created about your subject, to continue synthesizing the elements into powerful visual statements, and to continue applying the ele-ments to your shooting so that they become second nature.

INDEX

Page numbers followed by *f* indicates a figure and *t* indicates a table.

Check us out at
masteringphoto.com

MasteringPhoto, powered by bestselling Focal Press authors and industry experts, features tips, advice, articles, video tutorials, interviews, and other resources for hobbyist photographers through pro image makers. No matter what your passion is—from people and landscapes to postproduction and business practices—MasteringPhoto offers advice and images that will inform and inspire you. You'll learn from professionals at the forefront of photography, allowing you to take your skills to the next level.